The Humanities
Culture, Continuity & Change

SECOND EDITION

Henry M. Sayre
OREGON STATE UNIVERSITY

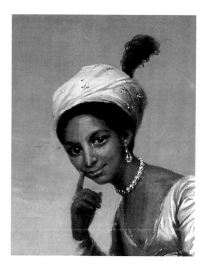

BOOK 4
EXCESS, INQUIRY, AND RESTRAINT: 1600 TO 1800

Prentice Hall

Boston Columbus Indianapolis New York San Francisco Upper Saddle River
Amsterdam Cape Town Dubai London Madrid Milan Munich Paris Montréal Toronto
Delhi Mexico City São Paulo Sydney Hong Kong Seoul Singapore Taipei Tokyo

For Bud Therien, art publisher and editor par excellence, and a good friend.

Editorial Director: Craig Campanella
Editor in Chief: Sarah Touborg
Acquisitions Editor: Billy Grieco
Assistant Editor: David Nitti
Editor-in-Chief, Development: Rochelle Diogenes
Development Editor: Margaret Manos
Media Director: Brian Hyland
Senior Media Editor: David Alick
Media Project Manager: Rich Barnes
Vice President of Marketing: Brandy Dawson
Executive Marketing Manager: Kate Stewart Mitchell
Senior Managing Editor: Ann Marie McCarthy
Associate Managing Editor: Melissa Feimer
Senior Project Manager: Barbara Marttine Cappuccio
Project Manager: Marlene Gassler
Senior Manufacturing Manager: Mary Fisher

Senior Operations Specialist: Brian Mackey
Senior Art Director: Pat Smythe
Interior Design: PreMediaGlobal
Cover Designer: Pat Smythe
Manager, Visual Research: Beth Brenzel
Photo Research: Francelle Carapetyan / Image Research Editorial Services
Pearson Imaging Center: Corin Skidds, Robert Uibelhoer
Full-Service Project Management: PreMediaGlobal
Composition: PreMediaGlobal
Printer/Binder: Courier / Kendallville
Cover Printer: Phoenix Color, Corp.
Cover Image: Johann Zoffany, *Dido Elizabeth Belle Lindsay and Lady Elizabeth Murray*. Oil on Canvas. 35 1/2″ × 28 1/4″. From the Collection of the Earl of Mansfield, Scone Palace, Scotland.

Credits and acknowledgments borrowed from other sources and reproduced, with permission, in this textbook appear on appropriate page within text and beginning on page Credits-1.

Library of Congress Cataloging-in-Publication Data
Sayre, Henry M.
 The humanities: culture, continuity & change / Henry M. Sayre.—2nd ed.
 p. cm.
 Includes bibliographical references and index.
 ISBN-13: 978-0-205-78215-4 (alk. paper)
 ISBN-10: 0-205-78215-9 (alk. paper)
 1. Civilization—History—Textbooks. 2. Humanities—History—Textbooks. I. Title.
CB69.S29 2010
909—dc22
 2010043097

10 9 8 7 6 5 4 3 2 1

Prentice Hall
is an imprint of

www.pearsonhighered.com

ISBN-10: 0-205-01333-3
ISBN-13: 978-0-205-01333-3

SERIES CONTENTS

CONTENTS

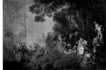

25 The Rococo and the Enlightenment on the Continent
PRIVILEGE AND REASON 799

26 The Rights of Man
REVOLUTION AND THE NEOCLASSICAL STYLE 837

DEAR READER,

You might be asking yourself, why should I be interested in the Humanities? Why do I care about ancient Egypt, medieval France, or the Qing Dynasty of China?

I asked myself the same question when I was a sophomore in college. I was required to take a year long survey of the Humanities, and I soon realized that I was beginning an extraordinary journey. That course taught me where it was that I stood in the world, and why and how I had come to find myself there. My goal in this book is to help you take the same journey of discovery. Exploring the humanities will help you develop your abilities to look, listen, and read closely; and to analyze, connect, and question. In the end, this will help you navigate your world and come to a better understanding of your place in it.

What we see reflected in different cultures is something of ourselves, the objects of beauty and delight, the weapons and wars, the melodies and harmonies, the sometimes troubling but always penetrating thought from which we spring. To explore the humanities is to explore ourselves, to understand how and why we have changed over time, even as we have, in so many ways, remained the same.

I've come to think of this second edition in something of the same terms. What I've tried to do is explore new paths of inquiry even as I've tried to keep the book recognizably the same. My model, I think, has been Bob Dylan. Over the years, I've heard the man perform more times than I can really recall, and I just saw him again in concert this past summer. He has been performing "Highway 61" and "Just Like a Woman" for nearly fifty years, but here they were again, in new arrangements that were totally fresh—recognizably the same, but reenergized and new. That should be the goal of any new edition of a book, I think, and I hope I've succeeded in that here.

ABOUT THE AUTHOR

Henry M. Sayre is Distinguished Professor of Art History at Oregon State University–Cascades Campus in Bend, Oregon. He earned his Ph.D. in American Literature from the University of Washington. He is producer and creator of the 10-part television series, *A World of Art: Works in Progress*, aired on PBS in the Fall of 1997; and author of seven books, including *A World of Art*, *The Visual Text of William Carlos Williams*, *The Object of Performance: The American Avant-Garde since 1970*; and an art history book for children, *Cave Paintings to Picasso*.

The Humanities: Culture, Continuity & Change helps students see context and make connections across the humanities by tying together the entire cultural experience through a narrative storytelling approach. Written around Henry Sayre's belief that students learn best by remembering stories rather than memorizing facts, it captures the voices that have shaped and influenced human thinking and creativity throughout our history.

With a stronger focus on engaging students in the critical thinking process, this new edition encourages students to deepen their understanding of how cultures influence one another, how ideas are exchanged and evolve over time, and how this collective process has led us to where we stand today. With several new features, this second edition helps students to understand context and make connections across time, place, and culture.

To prepare the second edition, we partnered with our current users to hear what was successful and what needed to be improved. The feedback we received through focus groups, online surveys, and reviews helped shape and inform this new edition. For instance, to help students make stronger global connections, the organization of the text and the Table of Contents have been modified. As an example, reflections of this key goal can be seen in Chapters 6 and 7, which are now aligned to show parallels more easily in the developments of urban culture and imperial authority between Rome, China, and India.

Through this dialogue, we also learned how humanities courses are constantly evolving. We learned that more courses are being taught online and that instructors are exploring new ways to help their students engage with course material. We developed MyArtsLab with these needs in mind. With powerful online learning tools integrated into the book, the online and textbook experience is more seamless than ever before. In addition, there are wonderful interactive resources that you, as the instructor, can bring directly into your classroom.

All of these changes can be seen through the new, expanded, or improved features shown here.

NEW
THINKING AHEAD

These questions open each chapter and represent its major sections, leading students to think critically and focus on important issues.

NEW
THINKING BACK

These end-of-chapter reviews follow up on the **Thinking Ahead** questions, helping students further engage with the material they've just read and stimulate thought and discussion.

NEW
CLOSER LOOK

Previously called "Focus" in the first edition, these highly visual features offer an in-depth look at a particular work from one of the disciplines of the humanities. The annotated discussions give students a personal tour of the work–with informative captions and labels–to help students understand its meaning. A new critical thinking question, *Something to Think About*, prompts students to make connections and further apply this detailed knowledge of the work.

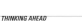

CONTINUITY & CHANGE ESSAYS

These full-page essays at the end of each chapter illustrate the influence of one cultural period upon another and show cultural changes over time.

CONTINUITY & CHANGE ICONS

These in-text references provide a window into the past. The eye-catching icons enable students to refer to material in other chapters that is relevant to the topic at hand.

CONTINUITY & CHANGE
The Pyramids of Menkaure, p. 74

CONTEXT

These boxes summarize important background information in an easy-to-read format.

MATERIALS AND TECHNIQUES

These features explain and illustrate the methods artists and architects use to produce their work.

Materials & Techniques
Methods of Carving

Carving is the act of cutting or incising stone, bone, wood, or another material into a desired form. Surviving artifacts of the Paleolithic era were carved from stone or bone. The artist probably held a sharp instrument, such as a stone knife or a chisel, in one hand and drove it into the stone or bone with another stone held in the other hand to remove excess material and realize the figure. Finer details could be scratched into the material with a pointed stone instrument. Artists can carve into any material softer than the instrument they are using. Harder varieties of stone can cut into softer stone as well as bone. The work was probably painstakingly slow.

There are basically two types of sculpture: sculpture in the round and relief sculpture. **Sculpture in the round** is fully three-dimensional; it occupies 360 degrees of space. The Willendorf statuette (see Fig. 1.3) was carved from stone and is an example of sculpture in the round. **Relief sculpture** is carved out of a flat background surface; it has a distinct front and no back. Not all relief sculptures are

alike. In *high relief* sculpture, the figure extends more than 180 degrees from the background surface. *Woman Holding an Animal Horn*, found at Laussel, in the Dordogne region of France, is carved in high relief and is one of the earliest relief sculptures known. This sculpture was originally part of a great stone block that stood in front of a Paleolithic rock shelter. In *low* or *bas relief*, the figure extends less than 180 degrees from the surface. In *sunken relief*, the image is carved, or incised, into the surface, so that the image recedes below it. When a light falls on relief sculptures at an angle, the relief casts a shadow. The higher the relief, the larger the shadows and the greater the sense of the figure's three-dimensionality.

Woman Holding an Animal Horn, Laussel (Dordogne), France. ca. 30,000–15,000 BCE. Limestone, height 17 ³⁄₈". Musée des Antiquités Nationales, St. Germain-en-Laye, France.

EXPLORE MORE To see a studio video about carving, go to **www.myartslab.com**

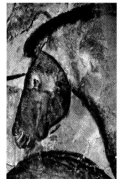

CONTINUITY & CHANGE
Representing the Power of the Animal World

The two images shown here in some sense bracket the six volumes of *The Humanities*. The first (Fig. 1.24), from the Chauvet Cave, is one of the earliest known drawings of a horse. The second (Fig. 1.25), a drawing by contemporary American painter Susan Rothenberg (b. 1945), also represents a horse, though in many ways less realistically than the cave drawing. The body of Rothenberg's horse seems to have disappeared and, eyeless, as if blinded, it leans forward, its mouth open, choking or gagging or gasping for air.

In his catalog essay for a 1993 retrospective exhibition of Rothenberg's painting, Michael Auping, chief curator at the Albright-Knox Museum in Buffalo, New York, described Rothenberg's kind of drawing: "Relatively spontaneous, the drawings are Rothenberg's psychic energy made imminent [They] uncover realms of the psyche that are perhaps not yet fully explicable." The same could be said of the cave drawing executed by a nameless hunter-gatherer more than 20,000 years ago. That artist's work must have seemed just as strange as Rothenberg's, lit by flickering firelight in the dark recesses of the cave, its body disappearing, too, into the darkness that surrounded it.

It seems certain that in some measure both drawings were the expression of a psychic need on the part of the artist—whether derived from the energy of the hunt or of nature itself—to fix upon a surface an image of the power and vulnerability of the animal world. That drive, which we will see in the art of the Bronze Age of the Middle East in the next chapter—for instance, in the haunting image of a dying lion in the palace complex of an Assyrian king at Nineveh—remains constant from the beginnings of art to the present day. It is the compulsion to express the inexpressible, to visualize the mind as well as the world. ∎

Fig. 1.24 Horse. Detail from Chauvet Cave, Vallon-Pont-d'Arc, Ardèche gorge, France (Fig. 1.1). ca. 30,000 BCE. Note the realistic shading that defines the volume of the horse's head. It is a realism that artists throughout history have sometimes sought to achieve, and sometimes ignored, in their efforts to express for the forces that drive them.

Fig. 1.25 Susan Rothenberg. Untitled. 1978. Acrylic, flashe, and pencil on paper, 20" × 20". Collection Walker Art Center, Minneapolis. Art Center Acquisition Fund, 1979. © 2008 Susan Rothenberg/Artist's Rights Society (ARS), NY. Part of the eeriness of this image comes from Rothenberg's use of flashe, a French vinyl-based color that is clear and so creates a misty, ghostlike surface.

PRIMARY SOURCES

Each chapter of *The Humanities* includes Primary Source Readings in two formats. Brief readings from important works are included within the body of the text. Longer readings located at the end of each chapter allow for a more in-depth study of particular works. The organization offers great flexibility in teaching the course.

(for example, "the land shattered like a pot").

Perhaps most important, the epic illuminates the development of a nation or race. It is a national poem, describing a people's common heritage and celebrating its cultural identity. It is hardly surprising, then, that Ashurbanipal preserved the *Epic of Gilgamesh*. Just as Sargon II depicted himself at the gates of Khorsabad in the traditional horned crown of Akkad and the beard of Sumer, containing within himself all Mesopotamian history, the *Epic of Gilgamesh* preserves the historical lineage of all Mesopotamian kings—Sumerian, Akkadian, Assyrian, and Babylonian. The tale embodies their own heroic grandeur, and thus the grandeur of their peoples.

The poem opens with a narrator guiding a visitor (the reader) around Uruk. The narrator explains that the epic was written by Gilgamesh himself and was deposited in the city's walls, where visitors can read it for themselves. Then the narrator introduces Gilgamesh as an epic hero, two parts god and one part human. The style of the following list of his deeds is the same as in hymns to the gods (Reading 2.3a):

READING 2.3a

from the *Epic of Gilgamesh*, Tablet I
(ca. 1200 BCE)

Supreme over other kings, lordly in appearance,
he is the hero, born of Uruk, the goring wild bull.
He walks out in front, the leader,
and walks at the rear, trusted by his companions.
Mighty net, protector of his people,
raging flood-wave who destroys even walls of stone! . . .
It was he who opened the mountain passes,
who dug wells on the flank of the mountain.

READINGS

READING 2.3

from the *Epic of Gilgamesh*, Tablet I (ca. 1200 BCE) (translated by Maureen Gallery Kovacs)
The Epic of Gilgamesh describes the exploits of the Sumerian ruler Gilgamesh and his friend Enkidu. The following passage, from the first of the epic's 12 tablets, recounts how Enkidu, the primal man raised beyond the reach of civilization and fully at home with wild animals, loses his animal powers, and with them his innocence, when a trapper, tired of Enkidu freeing animals from his traps, arranges for a harlot from Uruk to seduce him. The story resonates in interesting ways with the biblical tale of Adam and Eve and their loss of innocence in the Garden of Eden.

TABLET I
THE HARLOT
The trapper went, bringing the harlot, Shamhat, with him,
they set off on the journey, making direct way.
On the third day they arrived at the appointed place,
and the trapper and the harlot sat down at their posts(?).
A first day and a second they sat opposite the watering hole.
The animals arrived and drank at the watering hole,
the wild beasts arrived and slaked their thirst with water.
Then he, Enkidu, offspring of the mountains,
who eats grasses with the gazelles,
came to drink at the watering hole with the animals,
with the wild beasts he slaked his thirst with water.
Then Shamhat saw him—a primitive,
a savage fellow from the depths of the wilderness!
"That is he, Shamhat! Release your clenched arms,
expose your sex so he can take in your voluptuousness.

Shamhat unclutched her bosom, exposed her sex, and he
took in her voluptuousness.
She was not restrained, but took his energy.
She spread out her robe and he lay upon her,
she performed for the primitive the task of womankind.
His lust groaned over her;
for six days and seven nights Enkidu stayed aroused,
and had intercourse with the harlot
until he was sated with her charms.
But when he turned his attention to his animals,
the gazelles saw Enkidu and darted off,
the wild animals distanced themselves from his body.
Enkidu . . . his utterly depleted (?) body,
his knees that wanted to go off with his animals went rigid;
Enkidu was diminished, his running was not as before.
But then he drew himself up, for his understanding had
broadened.

MORE CONNECTIONS TO MyArtsLab

The text is keyed to the dynamic resources on MyArtsLab, allowing instructors and students online access to additional information, music, videos, and interactive features.

The **'SEE MORE'** icon correlates to the Closer Look features in the text, directing students to MyArtsLab to view interactive **Closer Look** tours online. These features enable students to zoom in to see detail they could not otherwise see on the printed page or even in person. **'SEE MORE'** icons also indicate when students can view works of architecture in full 360-degree panoramas.

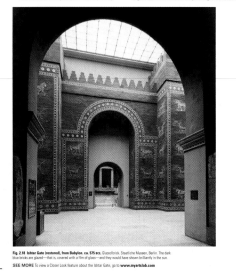

No trace of the city's famous Hanging Gardens survives, once considered among the Seven Wonders of the World, and only the base and parts of the lower stairs of the Marduk ziggurat still remain. But in the fifth century BCE, the Greek historian Herodotus [he-ROD-uh-tus] (ca. 484–430/420 BCE) described the ziggurat as follows:

> There was a tower of solid masonry, a furlong in length and breadth, on which was raised a second tower, and on that a third, and so on up to eight. The ascent to the top is on the outside, by a path which winds round all the towers. . . . On the topmost tower, there is a spacious temple, and inside the temple stands a couch of unusual size, richly adorned with a golden table by its side. . . . They also declare that the god comes down in person into this chamber, and sleeps on the couch, but I do not believe it.

Although the ziggurat has disappeared, we can glean some sense of the city's magnificence from the Ishtar Gate (Fig. 2.18), named after the Babylonian goddess of fertility.

Fig. 2.18 Ishtar Gate (restored), from Babylon. ca. 575 BCE. Glazed brick. Staatliche Museen, Berlin. The dark blue bricks are glazed—that is, covered with a film of glass—and they would have shown brilliantly in the sun.

SEE MORE To view a Closer Look feature about the Ishtar Gate, go to **www.myartslab.com**

Fig. 9.13 Great Mosque of Córdoba. Begun 785, extensions 852, 950, 961–76, and 987. The caliphs of Spain intended their mosque to rival those in Jerusalem, Damascus, and Iraq. The forestlike expanse of the interior is a result of these aspirations. Even though only 80 of the original 1,200 columns survive, the space appears infinite, like some giant hall of mirrors.

LEARN MORE View an architectural simulation of Islamic arches at **www.myartslab.com**

by the Umayyads in Toledo [toh-LEH-doh] soon was responsible for spreading the nearly forgotten texts throughout the West. Muslim mathematicians in Spain invented algebra and introduced the concept of zero to the West, and soon their Arabic numerals replaced the unwieldy Roman system. By the time of Abd ar-Rahman III (r. 912–61), Córdoba was renowned for its medicine, science, literature, and commercial wealth, and it became the most important center of learning in Europe. The elegance of Abd ar-Rahman III's court was unmatched, and his tolerance and benevolence extended to all, as Muslim students from across the Mediterranean soon found their way to the mosque-affiliated madrasa that he founded—the

earliest example of an institution of higher learning in the Western world.

Outside of Córdoba, Abd ar-Rahman III built a huge palace complex, Madinat al-Zahra, to honor his wife. (Its extensive remains are still being excavated.) Its staff included 13,750 male servants along with another 3,500 pages, slaves, and eunuchs. Its roof required the support of 4,300 columns, and elaborate gardens surrounded the site. As many as 1,200 loaves of bread were required daily just to feed the fish in the garden ponds.

The decorative arts of the era are equally impressive. A famous example is a **pyxis**, a small, cylindrical box with a lid, made for Prince al-Mughira, Abd ar-Rahman III's

The **'HEAR MORE'** icons indicate where musical performances can be listened to in streaming audio on www.myartslab.com. Online audio also includes **'Voices'**–vivid first-person accounts of the experiences of ordinary people during the period covered in the chapter.

The **'LEARN MORE'** icons lead students online for additional primary source readings or to watch architectural simulations.

The **'EXPLORE MORE'** icons direct students to videos of artists at work in their studios, allowing them to see and understand a wide variety of materials and techniques used by artists throughout time.

Designed to save instructors time and to improve students' results, MyArtsLab, is keyed specifically to the chapters of Sayre's *The Humanities*, second edition. In addition, MyArts-Lab's many features will encourage students to experience and interact with works of art. Here are some of those key features:

• A complete **Pearson eText** of the book, enriched with multimedia, including: a unique human-scale figure by all works of fine art, an audio version of the text, primary source documents, video demonstrations, and much more. Students can highlight, make notes, and bookmark pages.

• 360-degree **Architectural Panoramas** for major monuments in the book help students understand buildings from the inside and out.

• **Closer Look Tours** These interactive walk-throughs offer an in-depth look at key works of art, enabling students to zoom in to see detail they could not otherwise see on the printed page or even in person. Enhanced with expert audio, they help students understand the meaning and message behind the work of art.

• Robust **Quizzing** and **Grading Functionality** is included in MyArtsLab. Students receive immediate feedback from the assessment questions that populate the instructor's gradebook. The gradebook reports give an in-depth look at the progress of individual students or the class as a whole.

• MyArtsLab is your one stop for instructor material. Instructors can access the Instructor's Manual, Test Item File, PowerPoint images, and the Pearson MyTest assessment-generation program.

MyArtsLab with eText is available for no additional cost when packaged with *The Humanities*, second edition. The program may also be used as a stand-alone item, which costs less than a used text.

To register for your MyArtsLab account, contact your local Pearson representative or visit the instructor registration page located on the homepage of www.myartslab.com.

FLEXIBLE FORMATS

CourseSmart eTextbooks offer the same content as the printed text in a convenient online format—with highlighting, online search, and printing capabilities. With a CourseSmart eText, student can search the text, make notes online, print out reading assignments that incorporate lecture notes, and bookmark important passages for later review. ***Students save 60% over the list price of the traditional book. www.coursesmart.com.***

Books à la Carte editions feature the exact same text in a convenient, three-hole-punched, loose-leaf version at a discounted price—allowing students to take only what they need to class. Books à la Carte editions are available both with and without access to MyArtsLab. ***Students save 35% over the net price of the traditional book.***

Custom Publishing Opportunities

The Humanities is available in a custom version specifically tailored to meet your needs. You may select the content that you would like to include or add your own original material. See you local publisher's representative for further information. **www.pearsoncustom.com**

INSTRUCTOR RESOURCES

Classroom Response System (CRS) In-Class Questions

Get instant, class-wide responses to beautifully illustrated chapter-specific questions during a lecture to gauge students' comprehension—and keep them engaged. Available for download under the "For Instructors" tab within your MyArtsLab account–**www.myartslab.com.**

Instructor's Manual and Test Item File

This is an invaluable professional resource and reference for new and experienced faculty. Each chapter contains the following sections: Chapter Overview, Chapter Objectives, Key Terms, Lecture and Discussion Topics, Resources, and Writing Assignments and Projects. The test bank includes multiple-choice, true/false, short-answer, and essay questions. Available for download from the instructor support section at **www.myartslab.com.**

ClassPrep

Instructors who adopt Sayre's *The Humanities* will receive access to ClassPrep, an online site designed to make lecture preparation simpler and less time-consuming. The site includes the images from the text in both high-resolution JPGs, and ready-made PowerPoint slides for your lectures. ClassPrep can be accessed through your MyArtsLab instructor account.

MyTest

This flexible, online test-generating software includes all questions found in the printed Test Item File. Instructors can quickly and easily create customized tests with MyTest. www.pearsonmytest.com

ADDITIONAL PACKAGING OPTIONS

Penguin Custom Editions: The Western World lets you choose from an archive of more than 1,800 readings excerpted from the Penguin Classics™, the most comprehensive paperback library of Western history, literature, culture, and philosophy available. You'll have the freedom to craft a reader for your humanities course that matches your teaching approach exactly! Using our online book-building system, you get to select the readings you need, in the sequence you want, at the price you want your students to pay. **www.pearsoncustom.com** keyword: penguin

 Titles from the renowned Penguin Classics series can be bundles with *The Humanities* for a nominal charge. Please contact your Pearson Arts and Sciences sales representative for details.

 The Prentice Hall Atlas of World History, second edition includes over 100 full-color maps in world history, drawn by Dorling Kindersley, one of the world's most respected cartographic publishers. Copies of the Atlas can be bundled with *The Humanities* for a nominal charge. Please contact your Pearson Arts and Sciences sales representative for details.

The Epic of Gilgamesh

 Connections: Key Themes in World History. Series Editor Alfred J. Andrea. Concise and tightly focused, the titles in the popular Connections Series are designed to place the latest research on selected topics of global significance, such as disease, trade, slavery, exploration, and modernization, into an accessible format for students. Available for a 50% discount when bundled with *The Humanities*. For more information, please visit **www.pearsonhighered.com.**

THE HUMANITIES: *CULTURE, CONTINUITY & CHANGE*

is the result of an extensive development process involving the contributions of over one hundred instructors and their students. We are grateful to all who participated in shaping the content, clarity, and design of this text. Manuscript reviewers and focus group participants include:

ALABAMA
Cynthia Kristan-Graham, Auburn University

CALIFORNIA
Collette Chattopadhyay, Saddleback College
Laurel Corona, San Diego City College
Cynthia D. Gobatie, Riverside Community College
John Hoskins, San Diego Mesa College
Gwenyth Mapes, Grossmont College
Bradley Nystrom, California State University-Sacramento
Joseph Pak, Saddleback College
John Provost, Monterey Peninsula College
Chad Redwing, Modesto Junior College
Stephanie Robinson, San Diego City College
Alice Taylor, West Los Angeles College
Denise Waszkowski, San Diego Mesa College

COLORADO
Renee Bragg, Arapahoe Community College
Marilyn Smith, Red Rocks Community College

CONNECTICUT
Abdellatif Hissouf, Central Connecticut State University

FLORIDA
Wesley Borucki, Palm Beach Atlantic University
Amber Brock, Tallahassee Community College
Connie Dearmin, Brevard Community College
Kimberly Felos, St. Petersburg College
Katherine Harrell, South Florida Community College
Ira Holmes, College of Central Florida
Dale Hoover, Edison State College
Theresa James, South Florida Community College
Jane Jones, State College of Florida, Manatee-Sarasota
Jennifer Keefe, Valencia Community College
Mansoor Khan, Brevard Community College
Connie LaMarca-Frankel, Pasco-Hernando Community College
Sandi Landis, St. Johns River Community College-Orange Park
Joe Loccisano, State College of Florida
David Luther, Edison College
James Meier, Central Florida Community College
Brandon Montgomery, State College of Florida
Pamela Wood Payne, Palm Beach Atlantic University
Gary Poe, Palm Beach Atlantic University
Frederick Smith, Florida Gateway College
Kate Myers de Vega, Palm Beach Atlantic University
Bill Waters, Pensacola State College

GEORGIA
Leslie Harrelson, Dalton State College
Lawrence Hetrick, Georgia Perimeter College
Priscilla Hollingsworth, Augusta State University
Kelley Mahoney, Dalton State College
Andrea Scott Morgan, Georgia Perimeter College

IDAHO
Jennifer Black, Boise State University
Rick Davis, Brigham Young University-Idaho
Derek Jensen, Brigham Young University-Idaho

ILLINOIS
Thomas Christensen, University of Chicago
Timothy J. Clifford, College of DuPage
Leslie Huntress Hopkins, College of Lake County
Judy Kaplow, Harper College
Terry McIntyre, Harper College
Victoria Neubeck O'Connor, Moraine Valley Community College
Sharon Quarcini, Moraine Valley Community College
Paul Van Heuklom, Lincoln Land Community College

INDIANA
Josephina Kiteou, University of Southern Indiana

KENTUCKY
Jonathan Austad, Eastern Kentucky University
Beth Cahaney, Elizabethtown Community and Technical College
Jeremy Killian, University of Louisville
Lynda Mercer, University of Louisville
Sara Northerner, University of Louisville
Elijah Pritchett, University of Louisville

MASSACHUSETTS
Peter R. Kalb, Brandeis University

MICHIGAN
Martha Petry, Jackson Community College
Robert Quist, Ferris State University

MINNESOTA
Mary Johnston, Minnesota State University

NEBRASKA
Michael Hoff, University of Nebraska

NEVADA
Chris Bauer, Sierra College

NEW JERSEY
Jay Braverman, Montclair State University
Sara E. Gil-Ramos, New Jersey City University

NEW MEXICO
Sarah Egelman, Central New Mexico Community College

NEW YORK
Eva Diaz, Pratt Institute
Mary Guzzy, Corning Community College
Thelma Ithier Sterling, Hostos Community College
Elizabeth C. Mansfield, New York University
Clemente Marconi, New York University

NORTH CAROLINA
Melodie Galloway, University of North Carolina at Asheville
Jeanne McGlinn, University of North Carolina at Asheville

Sophie Mills, University of North Carolina at Asheville
Constance Schrader, University of North Carolina at Asheville
Ronald Sousa, University of North Carolina at Asheville
Samer Traboulsi, University of North Carolina at Asheville

NORTH DAKOTA
Robert Kibler, Minot State University

OHIO
Darlene Alberts, Columbus State Community College
Tim Davis, Columbus State Community College
Michael Mangus, The Ohio State University at Newark
Keith Pepperell, Columbus State Community College
Patrice Ross, Columbus State Community College

OKLAHOMA
Amanda H. Blackman, Tulsa Community College-Northeast Campus
Diane Boze, Northeastern State University
Jacklan J. Renee Cox, Rogers State University
Jim Ford, Rogers State University
Diana Lurz, Rogers State University
James W. Mock, University of Central Oklahoma
Gregory Thompson, Rogers State University

PENNSYLVANIA
Elizabeth Pilliod, Rutgers University-Camden
Douglas B. Rosentrater, Bucks County Community College
Debra Thomas, Harrisburg Area Community College

RHODE ISLAND
Mallica Kumbera Landrus, Rhode Island School of Design

TEXAS
Mindi Bailey, Collin County Community College
Peggy Brown, Collin County Community College
Marsha Lindsay, Lone Star College-North Harris
Aditi Samarth, Richland College
Lee Ann Westman, University of Texas at El Paso

UTAH
Matthew Ancell, Brigham Young University
Terre Burton, Dixie College
Nate Kramer, Brigham Young University
Joseph D. Parry, Brigham Young University

VIRGINIA
Margaret Browning, Hampton University
Carey Freeman, Hampton University
John Long, Roanoke College
Anne Pierce, Hampton University
Jennifer Rosti, Roanoke College

No project of this scope could ever come into being without the hard work and perseverance of many more people than its author. In fact, this author has been humbled by a team at Pearson Prentice Hall that never wavered in their confidence in my ability to finish this enormous undertaking (or if they did, they had the good sense not to let me know); never hesitated to cajole, prod, and massage me to complete the project in something close to on time; and always gave me the freedom to explore new approaches to the materials at hand. At the down-and-dirty level, I am especially grateful to fact-checker, Julia Moore; to Mary Ellen Wilson for the pronunciation guides; for the more specialized pronunciations offered by David Atwill (Chinese and Japanese), Jonathan Reynolds (African), Nayla Muntasser (Greek and Latin), and Mark Watson (Native American); to Margaret Gorenstein for tracking down the readings; to Laurel Corona for her extraordinary help with Africa; to Arnold Bradford for help with critical thinking questions; and to Francelle Carapetyan for her remarkable photo research. The maps and some of the line art are the work of cartographer and artist, Peter Bull, with Precision Graphic drafting a large portion of the line art for the book. I find both in every way extraordinary.

In fact, I couldn't be more pleased with the look of the book, which is the work of Pat Smythe, senior art director. Cory Skidds, senior imaging specialist, worked on image compositing and color accuracy of the artwork. The production of the book was coordinated by Melissa Feimer, associate managing editor, Barbara Cappuccio, senior production project manager, and Marlene Gassler, production project manager, who oversaw with good humor and patience the day-to-day, hour-to-hour crises that arose. Brian Mackey, production-planning and operations specialist, ensured that this project progressed smoothly through its production route. And I want to thank Lindsay Bethoney and the staff at PreMedia Global for working so hard to make the book turn out the way I envisioned it.

The marketing and editorial teams at Prentice Hall are beyond compare. On the marketing side, Brandy Dawson, vice president of marketing, and Kate Mitchell, executive marketing manager, helped us all to understand just what students want and need. On the editorial side, my thanks to Yolanda de Rooy, president of the Social Sciences and the Arts division; to Sarah Touborg, editor-in-chief; Billy Grieco, editor; Bud Therien, special projects manager; David Nitti, assistant editor; and Theresa Graziano, editorial assistant. The combined human hours that this group has put into this project are staggering. This book was Bud's idea in the first place; Billy and Sarah have supported me every step of the way in making it as good, or even better, than I envisioned; and Yolanda's over-arching vision is responsible for helping to make Pearson such an extraordinarily good publisher to write for.

Deserving of special mention is my development team, Rochelle Diogenes, editor-in-chief of development; and Margaret Manos, development editor. Margaret has been an especially valuable partner, helping me literally to "re-vision" this revision and bringing clarity and common sense to those moments where they were lost.

Finally, I want to thank, with all my love, my beautiful wife, Sandy Brooke, who has supported this project in every way. She has continued to teach, paint, and write, while urging me on, listening to my struggles, humoring me when I didn't deserve it, and being a far better wife than I was a husband. In some ways, enduring what she did in the first edition must have been tougher in the second, since she knew what was coming from the outset. She was, is, and will continue to be, I trust, the source of my strength.

BOOK FOUR

Excess, Inquiry, and Restraint

1600 TO 1800

Detail of Jean-Antoine Watteau, ***The Embarkation from Cythera.*** **ca. 1718–19.** Oil on canvas, 50 1/4" × 76 1/8" (See Fig. 25.3).
Staatliche Museen, Schloss Charlottenburg, Berlin.

For more than 200 years, from the late sixteenth century until the dawn of the nineteenth, the entrenched traditions of culture were challenged as never before. Not just in the West, but around the world, no era had been entangled in such a complex web of competing values. Indeed, it began with a civil war and ended with two revolutions. England, in the last half of the sixteenth century, was embroiled in conflict between Catholic and Protestant factions that led to civil war, the execution of a king, and abolition of monarchical authority. Two hundred years later, in the late eighteenth century, the American colonies would rebel against British control, and the French people against their king.

The question of political power—who possessed the right to rule—dominated the age. In the centuries before, the papacy had exercised authority over all people. Now, the rulers of Europe emphatically asserted their divine right to rule with unquestioned authority over their own dominions. In contrast, the thinkers of the age increasingly came to believe that human beings were by their very nature free, equal, and independent, and that they were not required to surrender their own sovereignty to any ruler. In essence, these thinkers developed a secularized version of the contest between Catholicism and Protestantism that had defined the sixteenth century after the Reformation. Protestant churches had freed themselves

from what they believed to be a tyrannical and extravagant papacy. In fact, many people found strong similarities between the extravagances of the European monarchies and the extravagance of Rome. Now, many believed, individuals should free themselves from the tyrannical and profligate rule of any government to which they did not freely choose to submit.

At the beginning of the era, the Counter-Reformation was in full swing, and the Church, out to win back the hearts and minds of all whom the Reformation had drawn away, appealed not just to the intellect, but to the full range of human emotion and feeling. In Rome, it constructed theatrical, even monumental, spaces—not just churches, but avenues, fountains, and plazas—richly decorated in an exuberant style that we have come to call "the Baroque." This dramatic and emotional style found expression in painting and music as well, and artistic virtuosity became the hallmark of this new Baroque style.

The courts of Europe readily adapted the Baroque to their own ends. In France, Louis XIII never missed an opportunity to use art and architecture to impress his grandeur and power upon the French people (and the other courts of Europe). In the arts, the stylistic tensions of the French court were most fully expressed. The rational clarity and moral uprightness of the classical contrasted with the emotional drama and flamboyant sensuality of the Baroque. In music, for example, we find both the clarity of the classical symphony and the spectacle of Baroque opera.

At the same time, scientific and philosophical investigation—the invention, for instance, of new tools of observation like the telescope and microscope—helped to sustain a newfound trust in the power of the rational mind to understand the world. When Isaac Newton demonstrated in 1687, to the satisfaction of just about everyone, that the universe was an intelligible system, well-ordered in its operations and guiding principles, it seemed possible that the operations of human society—the production and consumption of manufactured goods, the social organization of families and towns, the operations of national governments, to say nothing of its arts—might be governed by analogous universal laws. The pursuit of these laws is the defining characteristic of the eighteenth century, the period we have come to call the Enlightenment.

Thus, the age developed into a contest between those who sought to establish a new social order forged by individual freedom and responsibility, and those whose taste favored a decorative and erotic excess—primarily the French court. But even the high-minded champions of freedom found themselves caught up in morally complex dilemmas. Americans championed liberty, but they also defended the institution of slavery. The French would overthrow their dissolute monarch, only to see their society descend into chaos, requiring, in the end, a return to imperial rule. And, when the Europeans encountered other cultures—in the South Pacific, China, India, and, most devastatingly, in the American West—they tended to impose their own values on cultures that were, in many ways, not even remotely like their own. But if the balance of power fell heavily to the West, increasingly the dynamics of global encounter resulted in the exchange of ideas and values.

BOOK FOUR TIMELINE

1625
Artemisia Gentileschi, *Judith and Maidservant with Head of Holofernes*

1609–10
Galileo Galilei observes moon's craters

1632–48
Taj Mahal

1643–1715
Louis XIV, the "Sun King," reigns

1645–52
Bernini, *The Ecstasy of Saint Teresa*

1662–64
Johannes Vermeer, *Lady at the Virginal with a Gentleman*

1666
Fire of London

1687
Isaac Newton, *Principia Mathematica*

1719
Daniel Defoe, *Robinson Crusoe*

1721
Johann Sebastian Bach, *Brandenburg concertos*

1751
William Hogarth, *Gin Lane*

1756–91
Wolfgang Amadeus Mozart

1767
Jean-Honorè Fragonard, *The Swing*

1769
Sidney Parkinson, *Portrait of a Maori*

1770
Captain Cook encounters aboriginal cultures in Australia

1776
James Watt improves steam engine; Declaration of Independence; Adam Smith, *Wealth of Nations*

1778
John Singleton Copley, *Watson and the Shark*

1781
Immanuel Kant, *Critique of Pure Reason*

1789
Fall of the Bastille in Paris; Olaudah Equiano's autobiography describes slave living conditions

1791
Pierre Charles L'Enfant, *Plan for Washington, D.C.*

1792
Mary Wollstonecraft, *Vindication of the Rights of Women*

1799–1812
Napoleon rules France

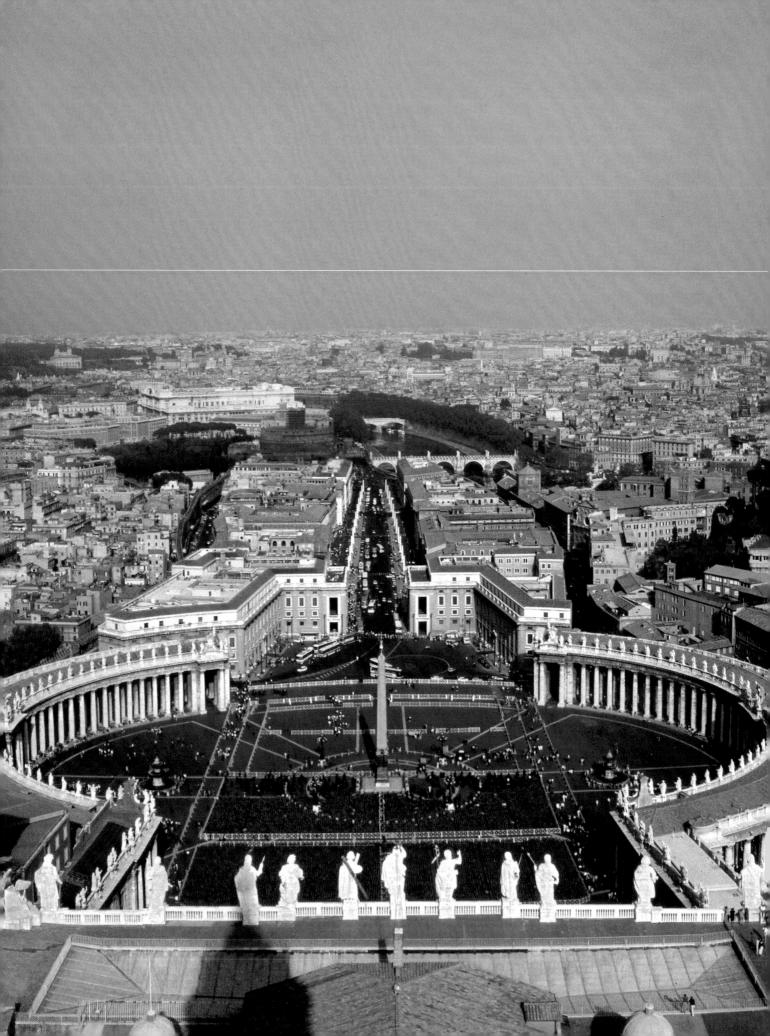

21

The Baroque in Italy
The Church and Its Appeal

THINKING AHEAD

What is the Baroque?

How does the Baroque style manifest itself in painting?

How is the Baroque style manifest in music, particularly in Venice?

As the seventeenth century began, the Catholic Church was struggling to win back those who had been drawn away by the Protestant Reformation. To wage its campaign, the Church took what can best be described as a sensual turn, an appeal not just to the intellect but to the range of human emotion and feeling. This appeal was embodied in an increasingly ornate and grandiose form of expression that came to be known as the Baroque [bah-ROAK] style. Its focal point was the Vatican City, in Rome (Fig. 21.1 and Map 21.1). The oval colonnade defining the square is considered one of greatest works of Gian Lorenzo Bernini [JAHN lor-EN-zoh bair-NEE-nee] (1598–1680), and it fully captures the grandeur and drama of the Baroque style.

Bernini's curved porticoes, composed of 284 huge Doric columns placed in rows of four, create a vast open space—nearly 800 feet across—designed specifically for its dramatic effect. Bernini considered the colonnade enclosing the square to symbolize "the motherly arms of the Church" embracing its flock. Here, as crowds gathered to receive the blessing of the pope, the architecture dramatized the blessing itself.

Attention to the way viewers would emotionally experience a work of art is a defining characteristic of the Baroque, a term many believe takes its name from the Portuguese *barroco* [bah-roh-koh], literally a large, irregularly shaped pearl. It was originally used in a derogatory way to imply a style so heavily ornate and strange that it verges on bad taste. The rise of the Baroque is the subject of this chapter. We look at it first as it developed in Rome, and at the Vatican in particular, as a conscious style of art and architecture dedicated to furthering the aims of the Counter-Reformation, then in Venice, which in the seventeenth century was the center of musical activity in Europe.

Just as in the sixteenth century Pope Julius II (papacy 1503–1513) had attempted to revitalize Rome as the center of the Christian world by constructing a new Saint Peter's Basilica, so at the beginning of the seventeenth century Pope Paul V (papacy 1605–1621) began his own monumental changes to Saint Peter's, which

◀ **Fig. 21.1 Vatican Square as seen from Michelangelo's dome, looking east toward the Tiber.** The long, straight street leading to the Tiber is the Via della Conciliazione, cut by the Fascist dictator Benito Mussolini in the 1930s. Previously, visitors to the Vatican wandered through twisting medieval streets until suddenly they found themselves in the vast, open expanse of the Vatican Square.

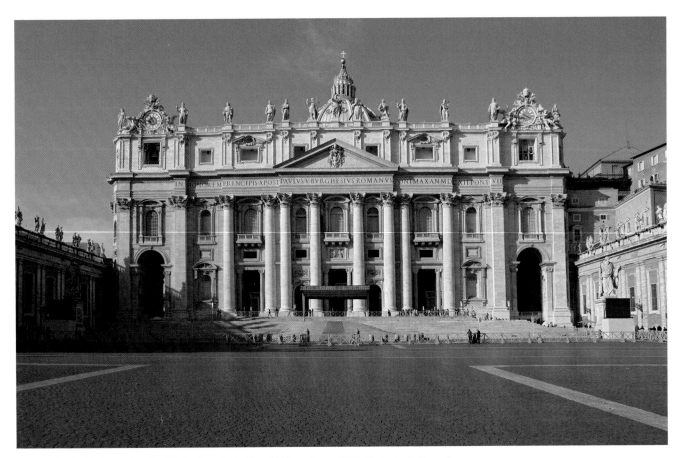

Fig. 21.2 Carlo Maderno, facade of Saint Peter's Basilica, Vatican, Rome. 1607–15. Originally the end bays of the facade had bell towers, but because Saint Peter's stood on marshy ground, with underground springs, the towers cracked, and they had to be demolished.

represented the seat of Roman Catholicism. He commissioned the leading architect of his day, Carlo Maderno [mah-DAIR-noh] (1556–1629), to design a new facade for the building (Fig. **21.2**). The columns on the facade "step out" in three progressively projecting planes: At each corner, two flat, rectangular, engaged columns surround the arched side entrances; inside these, two more sets of fully rounded columns step forward from the wall and flank the rectangular side doors of the portico; and finally four majestic columns, two on each side, support the projecting triangular pediment above the main entrance. Maderno also transformed Michelangelo's central Greek-cross plan into a basilican Latin-cross design, extending the length of the nave to just over 636 feet in order to accommodate the large congregations that gathered to celebrate the elaborate ritual of the new Counter-Reformation liturgy (Fig. **21.3**). The visual impact of this facade, extending across the front of the church to the entire width of Michelangelo's original Greek-cross plan, was carefully conceived to leave viewers in a state of awe. As one writer described the effect in 1652, "Anyone contemplating the new church's majesty and grandeur has to admit . . . that its beauty must be the work of angels or its immensity the work of giants. Because its magnificent

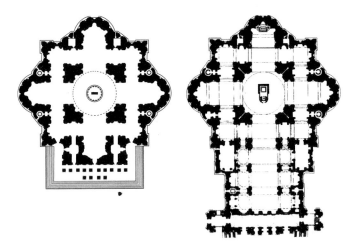

Michelangelo, Plan for New
Saint Peter's. 1546–64

Maderno, Plan of Saint
Peter's Basilica. 1607–12

Fig. 21.3 Left: Michelangelo, plan for New Saint Peter's. 1546–1564. Right: Carlo Maderno, plan of Saint Peter's Basilica. 1607–1612. Maderno's plan was motivated by Pope Paul V's belief that Saint Peter's should occupy the footprint of the original wooden basilica that had stood in the spot until Pope Julius II tore it down in 1506.

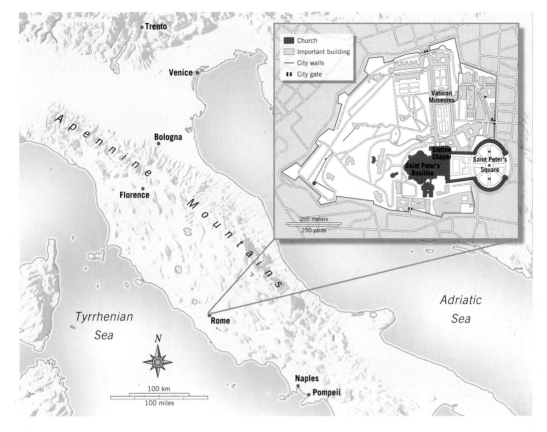

Map 21.1 Vatican City. ca. 1600. From Vatican City, the pope exercised authority over Rome and the Papal States, most of which were in Central Italy.

proportions are such that . . . neither the Greeks, the Egyptians nor the Jews, nor even the mighty Romans ever produced a building as excellent and vast as this one." It was, in short, an embodiment—and an announcement—of the Church's own triumph over the Protestant threat.

BAROQUE STYLE AND THE COUNTER-REFORMATION

As early as the 1540s, the Catholic Church had begun a program of reform and renewal designed to mitigate the appeal of Protestantism that came to be known as the Counter-Reformation (see Chapter 20). The building and decoration programs that developed in response to this religious program gradually evolved into the style known as Baroque. During the Renaissance, composition had tended to be frontal, creating a visual space that moved away from the viewer in parallel planes, following the rules of scientific perspective. This produced a sense of calm and balance or symmetry. In the Baroque period, elements usually are placed on a diagonal and seem to swirl and flow into one another, producing a sense of action, excitement, and sensuality. Dramatic contrasts of light and dark often serve to create theatrical effects designed to move viewers and draw them into the emotional orbit of the composition.

A profound, sometimes brutally direct, naturalism prevails, as well as a taste for increasingly elaborate and decorative effects, testifying to the Baroque artist's technical skill and mastery of the media used.

In Rome, the patronage of the papal court at the Vatican was most responsible for creating the Baroque style. Pope Sixtus V (papacy 1585–1590) inaugurated the renewal of the city. He cut long, straight avenues through it, linking the major pilgrimage churches to one another, and ordered a **piazza** [pee-AHT-sah]—a space surrounded by buildings—to be opened in front of each church, decorating many of them with Egyptian obelisks salvaged from Roman times. In his brief reign, Sixtus also began to renovate the Vatican, completing the dome of Saint Peter's Basilica, building numerous palaces throughout the city, and successfully reopening one of the city's ancient aqueducts to stabilize the water supply. Over the course of the next century, subsequent popes followed his example with building and art programs of their own.

Sculpture and Architecture: Bernini and His Followers

The new interior space of Saint Peter's Basilica inspired the same feelings of vastness and grandeur as did Carlo Maderno's new facade. The crossing, under Michelangelo's dome, was immense, and its enormity dwarfed the main

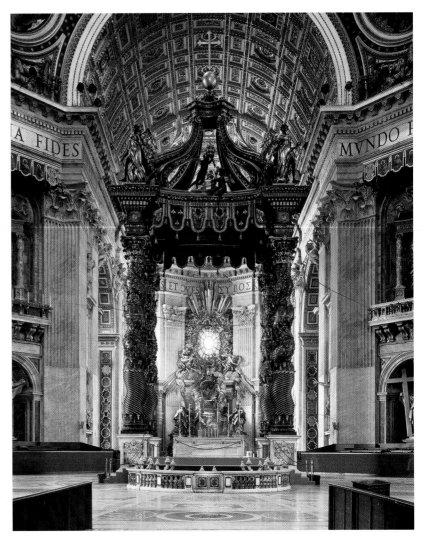

Fig. 21.4 Gian Lorenzo Bernini, baldachino at crossing of Saint Peter's Basilica, Vatican, Rome. 1624–33. Gilt bronze, height approx. 100′. So grand is the space, and so well does Bernini's baldachino fit in it, that the viewer can scarcely recognize that the structure is the height of the tallest apartment buildings in seventeenth-century Rome.

altar. When Urban VIII (papacy 1623–1644) became pope, he commissioned the young Bernini to design a cast bronze **baldachino** [bahl-da-KEE-noh], or canopy, to help define the altar space (Fig. **21.4**). Part architecture, part sculpture, Bernini's baldachino consists of four twisted columns decorated with spiraling grooves and bronze vines. This undulating, spiraling, decorative effect symbolized the union of the Old and New Testaments, the vine of the Eucharist [YOO-kuh-rist] climbing the columns of the Temple of Solomon. Elements that combine both the Ionic and Corinthian orders top the columns. Figures of angels and putti stand along the entablature, which is decorated with tasseled panels of bronze that imitate cloth. Above the entablature, the baldachino rises crownlike to an orb, symbolizing the universe, and is topped by a cross, symbolizing the reign of Christ. In its immense size, its realization of an architectural plan in sculptural terms, and its synthesis of a wide variety of symbolic elements in a single form, the baldachino is uniquely Baroque in spirit.

The Cornaro Chapel Probably no image sums up the Baroque movement better than Bernini's sculptural program for the Cornaro [kor-NAH-roh] Chapel. Located in Carlo Maderno's Church of Santa Maria della Vittoria in Rome (Fig. **21.5**), it was a commission from the Cornaro family and executed by Bernini in the middle of the century, at about the same time he was working on the colonnade for Saint Peter's Square. Bernini's theme is a pivotal moment in the life of Teresa of Ávila [AH-vih-la] (1515–1582), a Spanish nun, eventually made a saint, who at the age of 40 began to experience mystical religious visions (see Chapter 20). She was by no means the first woman to experience such visions—Hildegard of Bingen had recorded similar visions in her *Scivias* in the twelfth century (see Chapter 10). However, Teresa's own *converso* background—her father was a Jew who had converted to Catholicism—adds another dimension to her faith. Teresa was steeped in the mystical tradition of the Jewish Kabbalah [kuh-BAH-luh], the brand of mystical Jewish thought that seeks to attain the perfection of Heaven while still living in this world by transcending the boundaries of time and space. Bernini illustrates the vision she describes in the following passage (**Reading 21.1**):

READING 21.1

from Teresa of Ávila, "Visions," Chapter 29 of *The Life of Teresa of Ávila* (before 1567)

It pleased the Lord that I should sometimes see the following vision. I would see beside me, on my left hand, an angel in bodily form. . . . He was not tall, but short, and very beautiful, his face so aflame that he appeared to be one of the highest types of angel who seem to be all afire. They must be those who are called cherubim; they do not tell me their names but I am well aware that there is a great difference between certain angels and others, and between these and others still, of a kind that I could not possibly explain. In his hands I saw a long golden spear and at the end of the iron tip I seemed to see a point of fire. With this he seemed to pierce my heart several times so that it penetrated to my entrails. When he drew it out, I thought he was drawing them out with it and he left me completely afire with a great love for God. The pain was so sharp that it made me utter several moans; and so excessive was the sweetness caused me by this intense pain that one

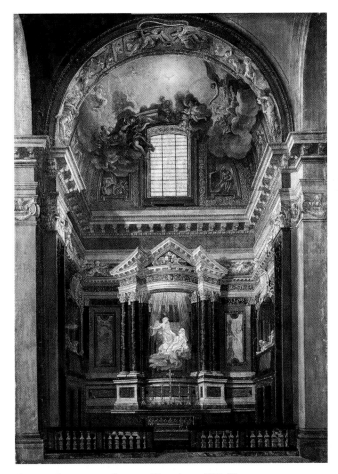

Fig. 21.5 Anonymous, Cornaro Chapel. ca. 1654. Oil on canvas, 5'6¼" × 3'1¼". Staatliches Museum, Schwerin, Germany. This seventeenth-century painting reproduces the relatively shallow and narrow space of the actual chapel and reveals the Cornaro family portraits at each side of the space.

> can never wish to lose it, nor will one's soul be content with anything less than God. It is not bodily pain, but spiritual, though the body has a share in it—indeed, a great share. So sweet are the colloquies of love which pass between the soul and god that if anyone thinks I am lying I beseech God, in His goodness, to give him the same experience.

Bernini recognized in Teresa's words a thinly veiled description of sexual orgasm. And he recognized as well that the sexuality that Protestantism and the Catholic Counter-Reformation had deemed inappropriate to religious art, but which had survived in Mannerism, had found, in Saint Teresa's vision, a properly religious context, uniting the physical and the spiritual. Thus, the sculptural centerpiece of his chapel decoration is Teresa's implicitly erotic swoon, the angel standing over her, having just withdrawn his penetrating arrow from her "entrails," as Teresa throws her head back in ecstasy (Fig. **21.6**).

Bernini's program is far more elaborate than just its sculptural centerpiece. The angel and Teresa are positioned beneath a marble canopy from which gilded rays of light radiate, following the path of the real light entering the chapel from the glazed yellow panes of a window hidden from view behind the canopy pediment. Painted angels, sculpted in stucco relief, descend across the ceiling, bathed in a similarly yellow light that appears to emanate from the dove of Christ at the top center of the composition. On each side of the chapel, life-size marble re-creations of the Cornaro family lean out of what appear to be theater boxes into the chapel proper, as if witnessing the vision of Saint Teresa for themselves. Indeed, Bernini's chapel is nothing less than high drama, the stage space of not merely religious vision, but visionary spectacle. Here is an art designed to appeal to the feelings and emotions of its viewers and draw them emotionally into the theatrical space of the work.

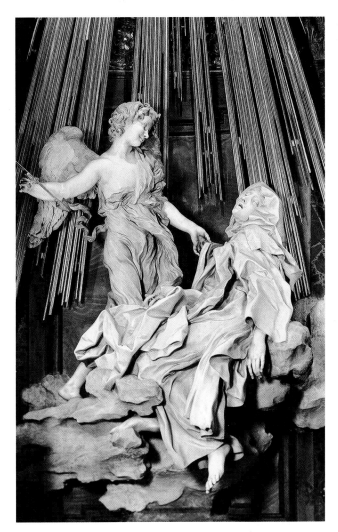

Fig. 21.6 Gian Lorenzo Bernini, *The Ecstasy of Saint Teresa,* Cornaro Chapel, Santa Maria della Vittoria, Rome. 1645–52. Marble, height of group, 11' 6".

LEARN MORE Gain insight from a primary source document on Gian Lorenzo Bernini at **www.myartslab.com**

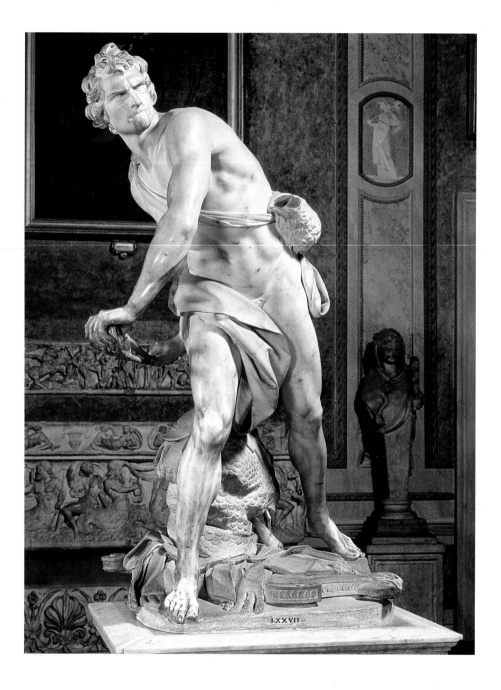

Fig. 21.7 Gian Lorenzo Bernini, *David,* 1623. Marble, height 5′ 7″. Galleria Borghese, Rome. Bernini carved this work when he was 25 years old, but he was already carving sculptures of remarkable quality by age 8.

Bernini's *David* The Cornaro Chapel program suggests that the Baroque style is fundamentally theatrical in character, and the space it creates is theatrical space. It also demonstrates how central action was to Baroque representation. Bernini's *David* (Fig. 21.7), commissioned by a nephew of Pope Paul V, appears to be an intentional contrast to Michelangelo's sculpture of the same subject (see Fig. 14.30). Michelangelo's hero is at rest, in a moment of calm anticipation before confronting Goliath. In contrast, Bernini's sculpture captures the young hero in the midst of action. David's body twists in an elaborate spiral, creating dramatic contrasts of light and shadow. His teeth are clenched, and his muscles strain as he prepares to launch the fatal rock. So real is his intensity that viewers tend to avoid standing directly in front of the sculpture, moving to one side or the other in order, apparently, to avoid being caught in the path of David's shot.

In part, David's action defines Bernini's Baroque style. Whereas Michelangelo's *David* seems to contemplate his own prowess, his mind turned inward, Bernini's *David* turns outward, into the viewer's space as if Goliath were a presence, although unseen, in the sculpture. In other words, the sculpture is not self-contained, and its active relationship with the space surrounding it—often referred to as its **invisible complement**—is an important feature of Baroque art. (The light source in his Cornaro Chapel *Saint Teresa* is another invisible complement.)

Bernini's Fountains Bernini is responsible for a series of figurative fountains that changed the face of Rome. One of

the most celebrated is the *Four Rivers Fountain* in the Piazza Navona [nah-VOH-nuh] (Fig. **21.8**). Bernini designed the fountain for Pope Innocent X, who commissioned it in 1648 to celebrate his diversion of the water from one of Rome's oldest sources of drinking water, the Acqua Vergine [ak-wuh ver-ghin-ee] aqueduct, to the square in front of the Palazzo Pamphili [PAHM-fee-lee], his principal family residence. Rising above the fountain is an Egyptian obelisk that had lain in pieces in the Circus Maxentius [mak-SEN-shus] until restored and re-erected for use here. The sculptor intended the obelisk to represent the triumph of the Roman Catholic Church over the rivers of the world, represented by the four large figures lying on the stones below—the Danube for Europe, the Nile for Africa, the Ganges for Asia, and the Plata for the Americas.

Bernini's fountain was executed by a large group of coworkers under his supervision. In fact, it became commonplace during the Baroque era for leading artists to employ numbers of skilled artists in their studios. This allowed an artist of great stature to turn out massive quantities of work without any apparent loss in quality. Bernini and other Baroque artists like him were admired not so much for the actual finished work, but for the originality of their concepts or designs.

In fact, Bernini spent much of his time writing plays and designing stage sets for them. Only one of his theatrical works survives, a farcical comedy, but we have descriptions of others that suggest his complete dedication to involving the audience in the theatrical event. In a play entitled *Inundation of the Tiber*, he constructed an elaborate set of dikes and dams that seemed to give way as the flooding Tiber advanced from the back of the stage toward the audience. "When the water broke through the last dike," Bernini's biographer tells us, "it flowed forward with such a rush and spread so much terror among the spectators that there was no one, not even among the most knowledgeable, who did not quickly get up to leave in the fear of an actual flood. Then, suddenly, with the opening of a sluice gate, all the water was drained away.

The Society of Jesus

As Bernini conceived it, the Baroque was a compromise between Mannerist exuberance and religious propriety. He fully supported the edicts of the Council of Trent (see Chapter 20) and the teachings of the Society of Jesus founded by the Spanish nobleman Ignatius [ig-NAY-shuhs] of Loyola [loy-OH-luh] (1491–1556). From their headquarters at the

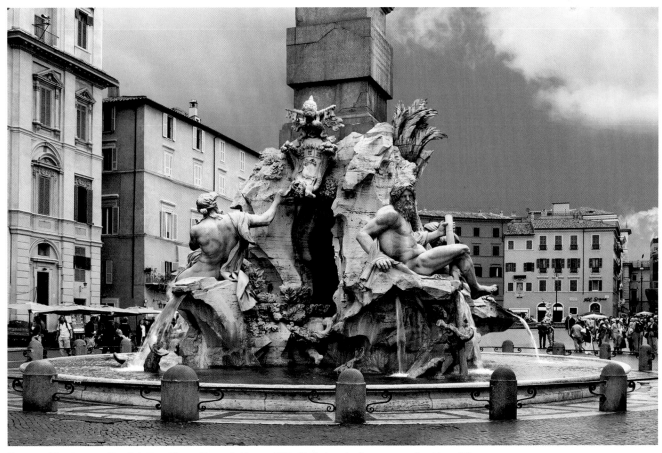

Fig. 21.8 Gian Lorenzo Bernini, *Four Rivers Fountain*, Rome. 1648–51. Each major figure was sculpted by a different artist in Bernini's workshop: the Nile, representing Africa, by Jacopo Antonio Fancelli; the Danube, representing Europe, by Antonio Raggi; the Ganges, representing Asia, by Claude Poussin; and the Plata, representing the Americas, by Francesco Baratta.

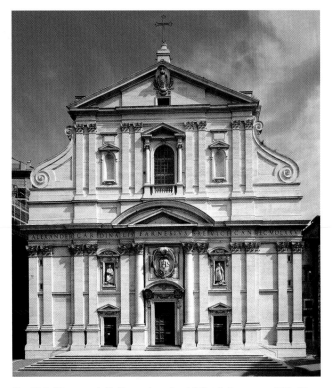

Fig. 21.9 Giacomo della Porta, facade of Il Gesù, Rome. ca. 1575–84. The church originally appeared much plainer—the sculptures are sixteenth-century additions.

many and richly diverse elements of the Baroque style. For instance, in the Fifth Exercise, a meditation on the meaning of Hell, Loyola invokes all five senses (**Reading 21.2a**):

READING 21.2a

from Ignatius Loyola, _Spiritual Exercises_, Fifth Exercise (1548)

FIRST POINT: This will be to see in imagination the vast fires, and the souls enclosed, as it were, in bodies of fire.
SECOND POINT: To hear the wailing, the howling, cries, and blasphemies against Christ our Lord and against His saints.
THIRD POINT: With the sense of smell to perceive the smoke, the sulphur, the filth, and corruption.
FOURTH POINT: To taste the bitterness of tears, sadness, and remorse of conscience.
FIFTH POINT: With the sense of touch to feel the flames which envelop and burn the souls.

Such a call to the senses would manifest itself in an increasingly elaborate church decoration, epitomized, perhaps best, by a ceiling fresco painted by Andrea Pozzo [POH-tzoh] (1642–1709) for the church of Sant'Ignazio in Rome depicting _The Apotheosis of Saint Ignatius_ [sahntig-NAH-tzee-oh] (see _Closer Look_, pages 686–687). But despite this call to sensual experience, Loyola was a strict traditionalist, as is demonstrated by his set of rules for those who comprise what is known as the Church Militant—that is, the living members of the Church who are struggling against sin so that they may one day join those who comprise the Church Triumphant, those who are in heaven (**Reading 21.2b**):

READING 21.2b

from Ignatius Loyola, _Spiritual Exercises_, Rules (1548)

TO HAVE THE TRUE SENTIMENT WHICH WE OUGHT TO HAVE IN THE CHURCH MILITANT
Let the following Rules be observed.
First Rule. All judgment laid aside, we ought to have our mind ready and prompt to obey, in all, the true Spouse of Christ our Lord, which is our holy Mother the Church Hierarchical.
Second Rule. To praise confession to a Priest, and the reception of the most Holy Sacrament of the Altar once in the year, and much more each month, and much better from week to week, with the conditions required and due.
Third Rule. To praise the hearing of Mass often, likewise hymns, psalms, and long prayers, in the church and out of it; likewise the hours set at the time fixed for each Divine Office and for all prayer and all Canonical Hours.

Church of Il Gesù [eel jay-ZOO] in Rome (Fig. **21.9**), the Jesuits, as they were known, led the Counter-Reformation and, as we will see later in the chapter, the influence of the Catholic Church worldwide. All agreed that the purpose of religious art was to teach and inspire the faithful, that it should always be intelligible and realistic, and that it should be an emotional stimulus to piety.

Originally, Michelangelo had agreed, in 1554, to produce drawings and a model for the Church, and although no trace of these survives, the facade, finally designed by Giacomo della Porta (ca. 1533–1602), reflects a certain Michelangelo flair, especially in the swirled volute scrolls flanking the second level, reminiscent of the stairway of the Laurentian Library in Florence (see Fig. 15.17). Likewise, della Porta's use of double pilasters (and, surrounding the portal, a double pilaster and column) is reminiscent of both the double pilasters in Michelangelo's original design for St. Peter's and the double columns surrounding the stairway of the Laurentian Library. Such doubling lends the facade a sense of massive sturdiness—a kind of architectural self-confidence—and a sculptural presence, a three-dimensional play of surfaces in contrast to the two-dimensional effects of the typical Renaissance facade (see _Materials & Techniques_, page 685).

The forcefulness and muscularity of della Porta's design is consistent with Jesuit doctrine. In his _Spiritual Exercises_, published in 1548, Loyola had called on Jesuits to develop all of their senses. By engaging the body, he believed, one might begin to perfect the soul—an idea that surely influenced the

The Facade from Renaissance to Baroque

Typically the facade of a building carries architectural embellishment that announces its style. One of the most influential facades in Renaissance architecture is Leon Battista Alberti's for Santa Maria Novella in Florence. Limited only by the existing portal, doors, and rose window, Alberti designed the facade independently of the structure behind it. He composed it of three squares, two flanking the portal at the bottom and a third set centrally above them. A mezzanine, or low intermediate story, separates them, at once seemingly supported by four large engaged Corinthian columns and serving as the base of the top square. The pediment at the top actually floats free of the structure behind it. Perhaps Alberti's most innovative and influential additions are the two scrolled **volutes** [vuh-LOOTS], or counter-curves. They hide the clerestory structure of the church behind, masking the difference in height of the nave and the much lower side-aisle roofs.

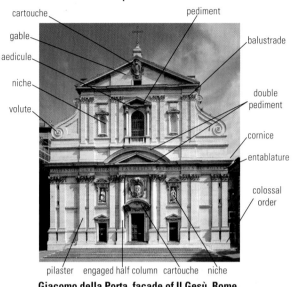

Giacomo della Porta, facade of Il Gesù, Rome. ca. 1575–1584.

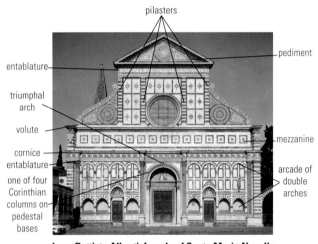

Leon Battista Alberti, facade of Santa Maria Novella, Florence. 1458–70. Dagli Orti/Picture Desk, Inc./Klobal Collection.

Giacomo della Porta's facade for the church of Il Gesù in Rome, constructed more than 100 years later, is still recognizably indebted to Alberti's church, retaining the classic proportions of Renaissance architecture: The height of the structure equals the width. However, it has many more architectural features, and is considered by many the first architectural manifestation of the Baroque. Notice that the architect adds dimensionality to the facade by a projecting entablature and supporting pairs of engaged **pilasters** [pih-LASS-turz] (rectangular columns) that move forward in steps. These culminate in engaged circular columns on each side of the portal. A double pediment, one traditional and triangular, the other curved, crowns the portal itself. Together with the framing column, the double pediment draws attention to the portal, the effect of which is repeated in miniature in the **aedicule** [e-DIK-yool] (composed of an entablature and pediment supported by columns or pilasters) above.

Fourth Rule. To praise much Religious Orders, virginity and continence, and not so much marriage as any of these.

Fifth Rule. To praise vows of Religion, of obedience, of poverty, of chastity and of other perfections of supererogation. And it is to be noted that as the vow is about the things which approach to Evangelical perfection, a vow ought not to be made in the things which withdraw from it, such as to be a merchant, or to be married, etc.

Sixth Rule. To praise relics of the Saints, giving veneration to them and praying to the Saints; and to praise Stations, pilgrimages, Indulgences, pardons, Cruzadas, and candles lighted in the churches.

Seventh Rule. To praise Constitutions about fasts and abstinence, as of Lent, Ember Days, Vigils, Friday and Saturday; likewise penances, not only interior, but also exterior.

Eighth Rule. To praise the ornaments and the buildings of churches; likewise images, and to venerate them according to what they represent.

Ninth Rule. Finally, to praise all precepts of the Church, keeping the mind prompt to find reasons in their defence and in no manner against them. . . .

Thirteenth Rule. To be right in everything, we ought always to hold that the white which I see, is black, if the Hierarchical Church so decides it. . . .

By the middle of the seventeenth century, one of the techniques most widely used by Baroque painters was foreshortening, a technique in which perspective is modified in order to decrease the distortion that results when a figure or object extends backward from the picture plane at an angle approaching the perpendicular (for instance, a hand extended out to the viewer will look larger, and the arm shorter, as they actually are). With this technique, artists could break down the barrier between the painting's space and that of the viewer, thus enveloping the viewer in the painting's space, an effect favored for painting the ceilings of Baroque churches and palaces. To create this illusion, the artist would paint representations of architectural elements—such as vaults or arches or niches—and then fill the remaining space with foreshortened figures that seem to fly out of the top of the building into the heavens above. One of the most dramatic instances was painted by a Jesuit lay brother, Fra Andrea Pozzo, for the Church of Sant'Ignazio. Its subject is the *Triumph of Saint Ignatius of Loyola.*

It is difficult for a visitor to Sant'Ignazio to tell that the space above the nave is a barrel vault. Pozzo painted it over with a rising architecture that seems to extend the interior walls an extra story and then explode into the open sky above. A white marble square in the pavement below indicates to the viewer just where to stand to appreciate the perspective properly. On each side of the space overhead are allegorical figures representing the four continents. Inscriptions on each end of the ceiling read, in Latin, "I am come to send fire on the earth," Christ's words to Luke (Luke 12:49), and Ignatius's last words to Francis Xavier as he set out on his mission to Asia, "Go and set the world aflame." Both passages are plays between Ignatius's name and the Latin word for fire, *ignis*, but both also refer to the Jesuit belief in the power of the gospel to transform the world.

Something to Think About . . .

Although Pozzo creates a highly dramatic space by means of foreshortening, how does the painting also impart a sense of physical—and hence moral—order?

America sits on a cougar, spear in hand, and wearing a feathered headdress.

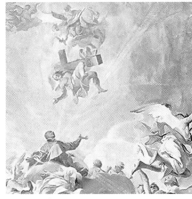

Saint Ignatius follows Christ into heaven, beams of light emanating from his chest to the four corners of the globe.

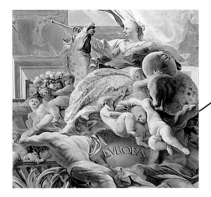

Europe, sitting on a stallion, holds a sceptre in one hand, while her other rests on an orb, signifying her domination of the world.

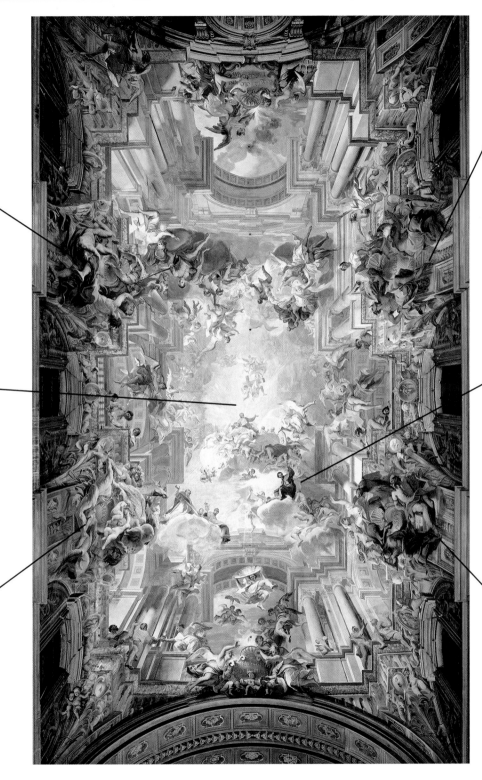

Africa sits atop a crocodile and holds an elephant tusk in her hand.

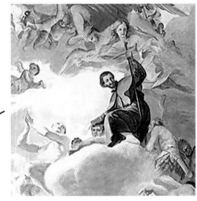

Saint Francis Xavier, co-founder of the Jesuits, who in 1541 left Portugal for India, Indonesia, Japan, and China, where he died in 1552. He was the model for all subsequent Jesuit missionary zeal.

Asia rides a camel, while the small putti to the left offers her a blue-and-white porcelain bowl, presumably from China.

Fra Andrea Pozzo, *Triumph of Saint Ignatius of Loyola.* 1691–94. Ceiling fresco, approx. 56′ × 115′. Sant'Ignazio, Rome.

Loyola's rules are a clear response to the attacks and positions taken up by the Protestant Reformation. They are a call for a discipline that many in the Church seemed to have forgotten, but, perhaps above all, they ask—particularly in Rule 13—for unquestioning submission to Church doctrine, something the Reformation, from the Catholic point of view, had forsaken altogether. Thus, on the one hand, Loyola encouraged the sensual ornamentation of the Church even as he called for an austere intellectual discipline.

San Carlo alle Quattro Fontane Thus it was the grandiose, the elaborate, the ornate—all used to involve the audience in a dramatic action—that came to characterize the Baroque style of the Counter-Reformation. Yet another characteristic is *surprise*. Perhaps the most stunning demonstration of this principle is the Church of San Carlo alle Quattro Fontane (Saint Charles at the Four Fountains) (Fig. **21.10**), the work of Bernini's pupil Francesco Borromini [bor-roh-MEE-nee] (1599–1667). In undertaking this church, Borromini was challenged by a narrow piece of property, its corner cut off for one of the four fountains from which the church takes its name. The nave is a long, oval space—unique in church design—with curved walls and chapels that create an uncanny feeling of movement, as if the walls are breathing in and out (Fig. **21.11**). The dome seems to float above the space. Borromini achieved this effect by inserting windows, partially hidden, at the base of the dome. Light coming through illuminates coffers of alternating hexagons, octagons, and crosses growing smaller as they approach the apex so that they appear visually to ascend to a much greater height than they actually do (Fig. **21.12**).

The church facade is equally bold (see Fig. 21.10). In Baroque church architecture, the facade would increasingly leave the Renaissance traditions of architecture behind, replacing the clarity and balance of someone like Alberti with increasingly elaborate ornamentation (see *Materials & Techniques*, page 685). San Carlo's facade is distinguished

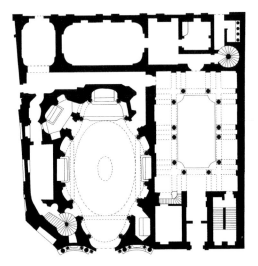

Fig. 21.11 Francesco Borromini, plan of San Carlo alle Quattro Fontane, Rome. 1638.

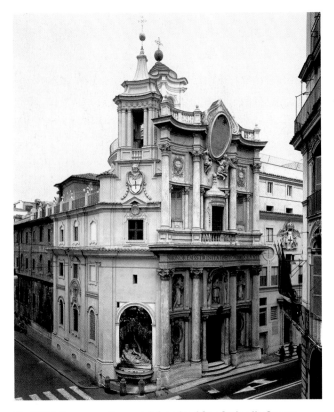

Fig. 21.10 Francesco Borromini, facade of San Carlo alle Quattro Fontane, Rome. 1665–67. Borromini's innovative church had little impact on Italian architecture, but across the rest of Europe, it freed architecture from the rigors of Renaissance symmetry and balance.

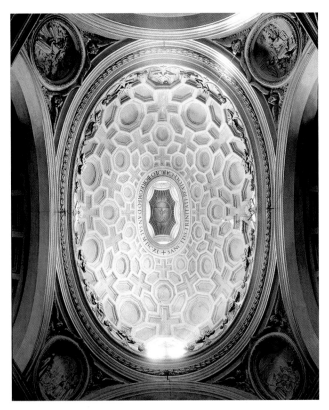

Fig. 21.12 Francesco Borromini, dome of San Carlo alle Quattro Fontane. 1638–41. At the top of the dome is a golden dove. A symbol of the Holy Spirit, it seems about to fly out to the roof to the heavens above.

by colossal columns and concave niches, oval windows on the first floor and square ones above, all topped by a decorative railing, or **balustrade** [BAL-uh-strade], that peaks over a giant **cartouche** [car-TOOCH] (oval frame) supported by angels who seem to hover free of the wall. One four-sided and pointed tower sits oddly at the corner above the fountain; another tower, five-sided, rounded, and slightly taller, stands over the middle of the structure. The balance and symmetry that dominated Church architecture since the early Renaissance are banished. In their stead is a new sense of the building as a living thing, as an opportunity for innovation and freedom. So liberating, in fact, was the design of San Carlo Quattro Fontane that Church fathers answered requests for its plan from all over Europe.

THE DRAMA OF PAINTING: CARAVAGGIO AND THE CARAVAGGISTI

One of the characteristics of San Carlo alle Quattro Fontane is the play of light and dark that its irregular walls and geometries create. Ever since the Middle Ages, when Abbot Suger [soo-ZHAY] of Saint-Denis [san duh-NEE], Paris, had insisted on the power of light to heighten spiritual feeling in the congregation, particularly through the use of stained glass, light had played an important role in church architecture (see Chapter 12). Bernini used it to great effect in his *Ecstasy of Saint Theresa* (see Fig. 21.6), and Baroque painters, seeking to intensify the viewer's experience of their paintings, sought to manipulate light and dark to great advantage as well. The acknowledged master of light and dark, and perhaps the most influential painter of his day, was Michelangelo Merisi, known as Caravaggio [kah-rah-VAH-gee-oh] (1571–1610), after the town in northern Italy where he was born. His work inspired many followers, who were called the Caravaggisti [kah-rah-vah-GEE-stee].

Master of Light and Dark: Caravaggio

Caravaggio arrived in Rome in about 1593 and began a career of revolutionary painting and public scandal. His first major commission in Rome was *The Calling of Saint Matthew* (Fig. **21.13**), arranged for by his influential patron Cardinal del Monte and painted about 1599 to 1600 for the Contarelli [con-tah-RAY-lee] Chapel in the Church of San Luigi dei Francesi [sahn LWEE-gee day frahn-CHAY-zee], the church of the French community (dei Francesi) in Rome. The most dramatic element in this work is light.

Fig. 21.13 Caravaggio, *The Calling of Saint Matthew.* **ca. 1599–1600.** Oil on canvas, 11′ 1″ × 11′ 5″. Contarelli Chapel, San Luigi dei Francesi, Rome. The window at the top of the painting is covered by parchment, often used by painters to diffuse light in their studios. This makes the intensity of light entering the room from the right especially remarkable.

The light that streams in from an unseen window at the upper right of the painting is almost palpable. It falls onto the table where the tax collector Levi (Saint Matthew's name before becoming one of Jesus' apostles) and his four assistants count the day's take, highlighting their faces and gestures. They are dressed not of Jesus' time, but of Caravaggio's, making it more possible for his audience to identify with them. With Saint Peter at his side, Christ enters from the right, a halo barely visible above his head. He reaches out with his index finger extended in a gesture derived from Adam's gesture toward God in the Sistine Chapel ceiling *Creation*—an homage, doubtless, by the painter to his namesake (see Fig. 15.11). One of the figures at the table—it is surely Levi, given his central place in the composition—points with his left hand, perhaps at himself, as if to say, "Who, me?" or perhaps at the young man bent over at the corner of the table intently counting money, as if to say, "You mean him?" All in all, he seems to find the arrival of Jesus uninteresting. In fact, the assembled group is so ordinary—reminiscent of gamblers seated around a table—that the transformation of Levi into Saint Matthew, which is imminent, takes on the aspect of a miracle, just as the light flooding the scene is reminiscent of the original miracle of creation: "And God said, 'Let there be light: and there was light'" (Gen. 1:3). The scene also echoes the New Testament, specifically John 8:12, where Christ says: "I am the light of the world; he that followeth me shall not walk in darkness, but shall have the light of life."

Caravaggio's insistence on the reality of his scene is thus twofold: He only depicts real people of his own day engaged in real tasks (by implication, Christ himself assumes a human reality as well), but he also insists on the reality of its psychological drama. The revelatory power of light—its ability to reveal the world in all its detail—is analogous, in Caravaggio's painting, to the transformative power of faith. Faith, for Caravaggio, fundamentally changes the way we *see* the world, and the way we *act* in it. Time and again, his paintings dramatize this moment of conversion through use of the technique known as **tenebrism** [TEN-uh-briz-um]. As opposed to *chiaroscuro*, which many artists employ to create spatial depth and volumetric forms through slight gradations of light and dark, a tenebrist style is not necessarily connected to modeling at all. Tenebrism makes use of large areas of dark contrasting sharply with smaller brightly illuminated areas. In *The Calling of Saint Matthew*, Christ's hand and face rise up out of the darkness, as if his very gesture creates light itself—and by extension Matthew's salvation.

One of the clearest instances of Caravaggio's use of light to dramatize moments of conversion is the *Conversion of Saint Paul*, painted around 1601 (Fig. **21.14**). Though

Fig. 21.14 Caravaggio, *Conversion of Saint Paul*. ca. 1601. Oil on canvas, 90 $\frac{1}{2}$″ × 68 $\frac{7}{8}$″. Santa Maria del Popolo, Rome. This painting was designed to fill the right wall of the narrow Carasi family chapel in Santa Maria del Popolo. Caravaggio had to paint it to be seen at angle of about 45 degrees, a viewpoint that can be replicated by tipping this page inward about half open to an angle of 45 degrees to the reader's face. The resulting space is even more dramatic and dynamic.

LEARN MORE Gain insight from a primary source document on Caravaggio at **www.myartslab.com**

painted nearly 50 years before Bernini's *Ecstasy of Saint Teresa* (see Fig. 21.6), its theme is essentially the same, as is its implied sexuality. Here, Caravaggio portrays the moment when the Roman legionnaire Saul (who will become Saint Paul) has fallen off his horse and hears the words, "Saul, Saul, why persecutest thou me?" (Acts 9:4). Neither Saul's servant nor his horse hears a thing. Light, the visible manifestation of Christ's words, falls on the foreshortened soldier. Saul reaches into the air in both a shock of recognition and a gesture of embrace. A sonnet, "Batter My Heart," by the English metaphysical poet John Donne [dun] (1572–1631), published in 1618 in his *Holy Sonnets*, captures Saul's experience in words (**Reading 21.3**):

READING 21.3

John Donne, "Batter My Heart" (1618)

Batter my heart, three-person'd God, for you
As yet but knock, breathe, shine, and seek to mend;
That I may rise and stand, o'erthrow me, and bend
Your force to break, blow, burn, and make me new.
I, like an usurp'd town to'another due,
Labor to'admit you, but oh, to no end;
Reason, your viceroy in me, me should defend,
But is captiv'd, and proves weak or untrue.
Yet dearly' I love you, and would be lov'd fain,
But am betroth'd unto your enemy;
Divorce me,'untie or break that knot again,
Take me to you, imprison me, for I,
Except you'enthrall me, never shall be free,
Nor ever chaste, except you ravish me.

There is no reason to believe the English poet—who was raised a Catholic but converted to the Anglican church for his own safety and prosperity—knew the Italian's painting, but the fact that the two men share so completely in the ecstasy of the moment of conversion, imaged as physical ravishment, suggests how widespread such conceits were in the seventeenth century. Both share with Teresa of Ávila a profound mysticism, the pursuit of achieving communion or identity with the divine through direct experience, intuition, or insight. All three believe that such experience is the ultimate source of knowledge or understanding, and they seek to convey that in their art. Such mystical experience, in its extreme physicality and naturalistic representation, also suggests how deeply the Baroque as a style was committed to sensual experience.

Caravaggio would openly pursue this theme in a series of homoerotic paintings commissioned by the same Cardinal del Monte [MON-tay] who arranged for the painting of *The Calling of Saint Matthew*. These paintings depict seminude young men, quite clearly youths from the streets of Rome, dressed in Bacchic [BAK-ik] costume. In his *Bacchus* (Fig. **21.15**), the slightly plump but also attractively muscular boy offers the viewer a glass of wine at the same time that he seems, with his right hand, to be undoing the belt of his robe. This is not the mythic Bacchus, but a boy dressed up as Bacchus, probably

Fig. 21.15 Caravaggio, *Bacchus*. ca. 1597. Oil on canvas, 37 ³/₈″ × 33 ¹/₂″. Galleria degli Uffizi, Florence. One of the ways in which Caravaggio exhibits his skill in this painting is the handle of the wine goblet held by the boy. It is at once volumetric and transparent.

pulled off the street by Caravaggio to pose, as the dirt beneath his fingernails attests. The bowl of fruit in the foreground is a still life that suggests not only Caravaggio's virtuosity as a naturalistic painter, but, along with the wine, the pleasures of indulging the sensual appetites and, with them, carnal pleasure. In fact, paintings such as this one suggest that Caravaggio transformed the religious paintings for which he received commissions into images that he preferred to paint—scenes of everyday people, of erotic and dramatic appeal, and physical (not spiritual) beauty. These same appetites are openly celebrated, in the same spirit, in many of John Donne's poems, such as "The Flea" (see **Reading 21.4**, page 701).

Elisabetta Sirani and Artemisia Gentileschi: Caravaggisti Women

Caravaggio had a profound influence on other artists of the seventeenth century. Two of these were women. Like her sixteenth-century Bolognese [boh-loh-NEEZ] predecessor, Lavinia Fontana (see Chapter 20), Elisabetta Sirani [sih-RAH-nee] (1638–1665) was the daughter of a painter. Although trained in the refined, classical tradition, Sirani developed a taste for realism much like Caravaggio's and shared his willingness to depict the miracles of Christianity as if they were everyday events. Most of her paintings were for private patrons, and she produced more than 190 works before her early death at age 27; by then she had become a cultural hero and tourist attraction in Bologna for the easy way she could dash off a picture. She painted portraits, religious

Fig. 21.16 Elisabetta Sirani (1638–1665), *Virgin and Child*. 1663. Oil on canvas, 34 " × 27 ¹/₂ ". National Museum of Women in the Arts, Washington, D.C. Gift of Wallace and Wilhelmina Holladay. Conservation funds generously provided by the Southern California State Committee of the National Museum of Women in the Arts. The artist signed and dated this picture in gold letters as if sewn into the horizontal seam of the pillow.

works, allegorical works, and occasionally mythological works and stories from ancient history.

Sirani's *Virgin and Child* of 1663 portrays Mary as a young Italian mother, wearing a turban of the kind favored by Bolognese peasant women (Fig. **21.16**). The Virgin's white sleeve, thickly painted to emphasize the rough texture of homespun wool, is consistent with the lack of ornamentation in the painting as a whole. The only decorative elements are the pillow on which the baby sits and the garland with which he is about to crown his mother, in a gesture that seems nothing more than playful.

One of Caravaggio's most important followers, and one of the first women artists to achieve an international reputation, was Artemisia Gentileschi [jen-tee-LESS-key] (1593–1652/3). Born in Rome, she was raised by her father, Orazio, himself a painter and Caravaggisto. Orazio was among Caravaggio's closest friends. As a young girl, Artemisia could not have helped but hear of Caravaggio's frequent run-ins with the law—for throwing a plate of artichokes at a waiter, for street brawling, for carrying weapons illegally, and, ultimately, in 1606, for murdering a referee in a tennis match. Artemisia's own scandal would follow. It and

much of her painting must be understood within the context of this social milieu—the loosely renegade world of Roman artists at the start of the seventeenth century. In 1612, when she was 19, she was raped by Agostino Tassi, a Florentine artist who worked in her father's studio and served as her teacher. Orazio filed suit against Tassi for injury and damage to his daughter. The transcript of the seven-month trial survives. Artemisia accused Tassi of repeatedly trying to meet with her alone in her bedroom and, when he finally succeeded, of raping her. When he subsequently promised to marry her, she freely accepted his continued advances, naïvely assuming marriage would follow. When he refused to marry her, the lawsuit followed.

At trial, Tassi accused her of having slept with many others before him. Gentileschi was tortured with thumbscrews to "prove" the validity of her testimony, and was examined by midwives to ascertain how recently she had lost her virginity. Tassi further humiliated her by claiming that Artemisia was an unskilled artist who did not even understand the laws of perspective. Finally, a former friend of Tassi's testified that Tassi had boasted about his exploits with Artemisia. Ultimately, he was convicted of rape but served only a year in prison. Soon after the long trial ended, Artemesia married an artist and moved with him to Florence. In 1616, she was admitted to the Florentine Academy of Design.

Beginning in 1612, Artemisia painted five separate versions of the biblical story of Judith and Holofernes [hol-uh-FUR-neez]. The subject was especially popular in Florence, which identified with both the Jewish hero David and the Jewish heroine Judith (both of whom had been celebrated in sculptures by Donatello and Michelangelo). When Artemisia moved there, her personal investment in the subject found ready patronage in the city. Nevertheless, it is nearly impossible to see the paintings outside the context of her biography. She painted her first version of the theme during and just after the trial itself, and the last, *Judith and Maidservant with Head of Holofernes*, in about 1625 (Fig. **21.17**), suggesting that in this series she transforms her personal tragedy in her painting. In all of them, Judith is a self-portrait of the artist. In the Hebrew Bible's Book of Judith, the Jewish heroine enters the enemy Assyrian camp intending to seduce their lustful leader, Holofernes, who has laid siege to her people. When Holofernes falls asleep, she beheads him with his own sword and carries her trophy back to her people in a bag. The Jews then go on to defeat the leaderless Assyrians.

Gentileschi lights the scene by a single candle, dramatically accentuating the Caravaggesque [kah-rah-vah-JESK] tenebrism of the presentation. Judith shades her eyes from its light, presumably in order to look out into the darkness that surrounds her. Her hand also invokes our silence, as if danger lurks nearby. The maid stops wrapping Holofernes's head in a towel, looking on alertly herself. Together, mistress

and maid, larger than life-size and heroic, have taken their revenge on not only the Assyrians, but on lust-driven men in general. As is so often the case in Baroque painting, the space of the drama is larger than the space of the frame. The same invisible complement outside Bernini's *David* (see Fig. 21.7) hovers in the darkness beyond reach of our vision here.

Gentileschi was not attracted to traditional subjects like the Annunciation. She preferred biblical and mythological heroines and women who played major roles. In addition to Judith, she dramatized the stories of Susannah, Bathsheba, Lucretia, Cleopatra, Esther, Diana, and Potiphar. A good business woman, Gentileschi also knew how to exploit the taste for paintings of female nudes.

Fig. 21.17 Artemisia Gentileschi, *Judith and Maidservant with Head of Holofernes*. ca. 1625. Oil on canvas, 72 $\frac{1}{2}$″ × 55 $\frac{3}{4}$″. The Detroit Institute of Arts. Gift of Leslie H. Green. 52.253. Photo © 1984 Detroit Institute of Art. Judith is a traditional symbol of fortitude, a virtue with which Artemisia surely identified.

EXPLORE MORE Gain insight from a primary source document on Artemisia Gentileschi at **www.myartslab.com**

VENICE AND BAROQUE MUSIC

In the sixteenth century, the Council of Trent had recognized the power of music to convey moral and spiritual ideals. "The whole plan of singing," it wrote in an edict issued in 1552,

> should be constituted not to give empty pleasure to the ear, but in such a way that the words be clearly understood by all, and thus the hearts of the listeners be drawn to the desire of heavenly harmonies, in the contemplation of the joys of the blessed. . . . They shall also banish from church all music that contains, whether in the singing or in the organ playing, things that are lascivious or impure.

In other words, the Council rejected the use of secular music, which by definition it deemed lascivious and impure, as a model for sacred compositions. Renaissance composers such as Guillaume Dufay and Josquin des Prez (see Chapters 14 and 15) had routinely used secular music in composing their masses, and Protestants had adapted the chorales of their liturgy from existing melodies, both religious and secular.

The division between secular and religious music was far less pronounced in Venice, a city that had traditionally chafed at papal authority. As a result, Venetian composers felt freer to experiment and work in a variety of forms, so much so that in the seventeenth century, the city became the center of musical innovation and practice in Europe.

Giovanni Gabrieli and the Drama of Harmony

Venice earned its place at the center of the musical world largely through the efforts of Giovanni Gabrieli [gah-bree-AY-lee] (1556–1612), the principal organist at Saint Mark's Cathedral. Gabrieli composed many secular madrigals, but he also responded to the Counter-Reformation's edict to make church music more emotionally engaging. To do this, he expanded on the polychoral style that Adrian Willaert had developed at Saint Marks in the mid-1500s (see Chapter 15). Gabrieli located contrasting bodies of sound in different areas of the cathedral's interior, which already had two organs, one on each side of the chancel (the space containing the altar and seats for the clergy and choir). Playing them against one another, he was able to produce effects of stunning sonority. Four choirs—perhaps a boy's choir, a women's ensemble, basses and baritones, and tenors in another group—sang from separate balconies above the nave. Positioned in the alcoves were brass instruments, including trombones and cornetts. (A cornett was a hybrid wind instrument, combining a brass mouthpiece with woodwind finger technique. The nineteenth-century band instrument has a similar name but is spelled with a single "t."). Both the trombone and the cornett were staples of Venetian street processions. And the street processions of the Venetian confraternities or *scuole* (see Chapter 15) are in many ways responsible for the development of instrumental music in Venice. By 1570, there were approximately 40 street processions a year, with each of the six confraternities participating. Each *scuola* was accompanied through the streets by singers, bagpipes, shawms (a double reed instrument similar to a bagpipe, but without the bag), drums, recorders, viols, flutes, and *pifarri*, or ensembles of wind instruments often composed of cornetts and trombones (two or three of each) (Fig. **21.18**). The Venetian love for these ensembles quickly led to the adaptation from secular ceremonies to religious ones (many of the *scuole* processions were associated with religious feast days in the first place).

Gabrieli was among the first to write religious music intended specifically for wind ensemble—music that was independent of song and that could not, in fact, be easily sung. One such piece is his 1597 *Canzona Duodecimi Toni* [kan-ZOH-na doo-oh-DAY-chee-me TOH-nee] (*Canzona in the Twelfth Mode [or Tone]*), in which two brass ensembles create a musical dialogue (track **21.1**). A **canzona** is a type of instrumental contrapuntal work, derived from Renaissance secular song, like the madrigal, which was increasingly performed in the seventeenth century in church settings. It is particularly notable for its dominant rhythm, LONG-short-short, known as the "canzona rhythm." In Saint Mark's, the two ensembles would have been placed across from one another in separate lofts. The alternating sounds of cornett and trombone or, in other compositions, brass ensemble, choir, and organ coming from various parts of the cathedral at different degrees of loudness and softness create a total effect similar to stereo "surround sound."

HEAR MORE at
www.myartslab.com

For each part of his composition, Gabrieli chose to designate a specific voice or instrument, a practice we have come to call **orchestration**. Furthermore, he controlled the **dynamics** (variations and contrast in force or intensity) of the composition by indicating, at least occasionally, the words *piano* ("soft") or *forte* ("loud"). In fact, he is the first known composer to specify dynamics. The dynamic contrasts of loud and soft in the *Canzona Duodecimi Toni*, mirroring the taste for tenebristic contrasts of light and dark in Baroque painting, is a perfect example of Gabrieli's use of dynamic variety. As composers from across Europe came to Venice to study, they took these terms back with them, and Italian became the international language of music.

Finally, and perhaps most important, Gabrieli organized his compositions around a central note, called the **tonic note** (usually referred to as the **tonality** or **key** of the composition). This tonic note provides a focus for the composition. The ultimate resolution of the composition into the tonic, as in the *Canzona Duodecimi Toni*, where the tonic note is C, the twelfth mode (or "tone") in Gabrieli's harmonic system, provides the heightened sense of harmonic drama that typifies the Baroque.

Fig. 21.18 Detail of Gentile Bellini, _Procession of the Reliquary of the True Cross in Piazza San Marco._ 1496.
Oil on canvas, 12 $^1/_2$" × 24' 5 $^1/_4$". Gallerie dell'Accademia, Venice. (See Fig. 15.23) The procession here includes six _trombe lunghe,_ or long silver trumpets, followed by three shawms, and two trombonists.

Claudio Monteverdi and the Birth of Opera

A year after Gabrieli's death, Claudio Monteverdi [KLAU-dee-oh mohn-tay-VAIR-dee] (1567–1643) was appointed musical director at Saint Mark's in Venice. A violinist, Monteverdi had been the music director at the court of Mantua. In Venice, Monteverdi proposed a new relation of text (words) and music. Where traditionalists favored the subservience of text to music—"Harmony is the ruler of the text," proclaimed Giovanni Artusi, the most ardent defendant of the conservative position—Monteverdi proclaimed just the opposite: "Harmony is the mistress of the text!" Monteverdi's position led him to master a new, text-based musical form, the **opera**, a term that is the plural of _opus_, or "work." Operas are works consisting of many smaller works. (The term _opus_ is used, incidentally, to catalogue the musical compositions of a given composer, usually abbreviated _op._, so that "op. 8" would mean the eighth work or works published in the composer's repertoire.)

The form itself was first developed by a group known as the Camerata of Florence (_camerata_ means "club" or "society"), a group dedicated to discovering the style of singing used by the ancient Greeks in their drama, which had united poetry and music but was known only through written accounts. The group's discussions stimulated the composer Giulio Caccini to write _New Works of Music_. Here, he describes what the Camerata considered the ancient Greek ideal of music (**Reading 21.5**):

READING 21.5

from Giulio Caccini, _New Works of Music_ (1602)

At the time . . . the most excellent _camerata_ of the Most Illustrious Signor Giovanni Bardi, Count of Vernio, flourished in Florence. . . . I can truly say, since I attended well, that I learned more from their learned discussions than I did in more than thirty years of studying counterpoint. This is because these discerning gentlemen always encouraged me and convinced me with the clearest arguments not to value the kind of music which does not allow the words to be understood well and which spoils the meaning and the poetic meter by now lengthening and now cutting the syllables short to fit the counterpoint, and thereby lacerating the poetry. And so I thought to follow that style so praised by Plato and the other philosophers who maintained music to be nothing other than rhythmic speech with pitch added (and not the reverse!), designed to enter the minds of others and to create those wonderful effects that writers admire, which is something that cannot be achieved with the counterpoint of modern music.

Over the course of the 1580s and 1590s, Caccini and others began to write works that placed a solo vocal line above an instrumental line, known as the **basso continuo**, or

"continuous bass," usually composed of a keyboard instrument (organ, harpsichord, etc.) and bass instrument (usually a cello), that was conceived as a supporting accompaniment, not as the harmonic equivalent, to the vocal line. This combination of solo voice and *basso continuo* came to be known as **monody**.

The inspiration for Monteverdi's first opera, *Orfeo* [or-FAY-oh] (1607), was the musical drama of ancient Greek theater. The **libretto** [lih-BRET-toh] (or "little book") for Monteverdi's opera was based on the Greek myth of Orpheus [OR-fee-us] and Eurydice [yoor-ID-ih-see]. In the opera, shepherds and nymphs celebrate the love of Orpheus and Eurydice in a dance that is interrupted by the news that Eurydice has died of a snake bite. The grieving Orpheus, a great musician and poet, travels to the underworld to bring Eurydice back. His plea for her return so moves Pluto, the god of the underworld, that he grants it, but only if Orpheus does not look back at Eurydice as they leave. But anxious for her safety, he does glance back and loses her forever. Monteverdi did, however, offer his audience some consolation (if not really a happy ending): Orfeo's father, Apollo, comes down to take his son back to the heavens where he can behold the image of Eurydice forever in the stars.

Although *Orfeo* is by no means the first opera, it is generally accepted as the first to successfully integrate music and drama. Monteverdi tells the story through a variety of musical genres—choruses, dances, and instrumental interludes. Two particular forms stand out—the *recitativo* [ray-chee-tah-TEE-voh] and the **aria** [AH-ree-uh]. *Recitativo* is a style of singing that imitates very closely the rhythms of speech. Used for dialogue, it allows for a more rapid telling of the story than might be possible otherwise. The *aria* would eventually develop into an elaborate solo or duet song that expresses the singer's emotions and feelings, expanding on the dialogue of the recitative (in Monteverdi's hands, the aria could still be sung in recitative style). "The modern composer," Monteverdi wrote, "builds his works on the basis of truth," and he means by this, most of all, the emotional truth that we have come to expect of the Baroque in general. Orfeo's *recitativo* after learning of

((● **HEAR MORE** at www.myartslab.com the death of Eurydice is one of the most moving scenes in this opera (track **21.2**). He sings passionately first of his grief:

Tu se' morta, se' morta mia vita ed io respiro?	You are dead, my life, and I am still breathing?
Tu se' de me partita, se' da me partitat per mai piu, mia piu non tonare, ed io rimango?	You have left me, left me, Never more to return, and I remain here?

The melody imitates speech by rising at the end of each question. Then, when Orfeo decides to go back to the underworld and plead for Eurydice's return, the music reflects his shift from despair to determination. But even in this second section, as he expresses his dream of freeing

Eurydice, when he sings of the "lowest depths" (*profundi abissi* [pro-FOHN-dee ah-BEE-see]) of the underworld or of "death" (*morte* [MOR-tay]) itself, the melody descends to low notes in harmony with the words. Moment by moment, Monteverdi's music mirrors the emotional state of the character.

Orfeo required an orchestra of three dozen instruments—including ten viols, three trombones, and four trumpets—to perform the overture, interludes, and dance sequences, but generally only a harpsichord or lute accompanied the arias and recitatives so that the voice would remain predominant. For the age, this was an astonishingly large orchestra, financed together with elaborate staging by the Mantuan court where it was composed and first performed, and it provided Monteverdi with a distinct advantage over previous opera composers. He could achieve what his operatic predecessors could only imagine—a work that was both musically and dramatically satisfying, one that could explore the full range of sound and, with it, the full range of psychological complexity.

Arcangelo Corelli and the Sonata

The *basso continuo* developed by Caccini and others to support the solo voice also influenced purely instrumental music, especially in the sonatas of the Roman composer and violinist Arcangelo Corelli (1653–1713). The term **sonata** as we use it today, did not develop until the last half of the eighteenth century. In the Baroque era, it had a much more general meaning. In Italian, *sonata* simply means "that which is sounded," or played by instruments, as opposed to that which is sung, the *cantata*. By the end of the seventeenth century, the **trio sonata** had developed a distinctive form. As the word "trio" suggests, it consists of three parts: two higher voices, usually written for violins, but often performed by two flutes, or two oboes, or any combination of these, that play above a *basso continuo*. One of the results of this arrangement is that the *basso continuo* harmonizes with the higher voices, resulting in distinct chord clusters that often provide a dense textural richness to the composition.

There were two main types of sonata, a secular form, the **sonata da camera** (chamber sonata), and a religious form, the **sonata da chiesa** (church sonata). Corelli wrote both. The *sonata da camera* consists of a suite of dances, and the *sonata da chiesa* generally consists of four **movements**, or independent sections, beginning with a slow, dignified movement, followed by a fast, imitative movement, then slow and fast again. The distinctive feature of both forms is the primacy of a particular major or minor scale. At the least, the first and last movements of such works share the same key; in the case of the *sonata da camera*, every movement might be in the same key.

Corelli quickly adopted the form because it allowed him, as a virtuoso violinist, to compose pieces for himself that showcased his talents. It was further expected that virtuoso violinists would embellish their musical lines. The following, from a single piece of sheet music from Corelli's violin sonata, Opus no. 5, shows the *basso continuo* in the bass clef

and the complex violin part, filled with intricate runs of musical notes, as Corelli actually played it in the treble clef:

From Arcangelo Corelli, Opus no. 5. Dagli Orti/Picture Desk, Inc./Klobal Collection.

Thus, against the clear notation of the melody in the music, the solo voice performs with rhythmic freedom.

Antonio Vivaldi and the Concerto

Corelli's instrumental flair deeply influenced Venice's most important composer of the early eighteenth century, Antonio Vivaldi [vee-VAHL-dee] (1678–1741). Vivaldi, son of the leading violinist at Saint Mark's, assumed the post of musical director at the Ospedale della Pietà [oh-spay-DAH-lay DAY-lah pee-ay-TAH] in 1703, one of four orphanages in Venice that specialized in music instruction for girls. (Boys at the orphanages were not trained in music since it was assumed they would enter the labor force.) As a result, many of the most talented harpsichordists, lutenists, and other musicians in Venice were female, and many of Vivaldi's works were written specifically for performance by Ospedali [oh-spay-DAH-lee] girl choirs and instrumental ensembles (Fig. **21.19**). By and large, the Ospedali musicians were young girls who would subsequently go on to either a religious life or marriage, but several were middle-aged women who remained in the Ospedali, often as teachers, for their entire lives. The directors of the Ospedali hoped that wealthy members of the audience would be so dazzled by the performances that they would donate money to the orphanages. Audiences from across Europe attended these concerts, which were among the first in the history of Western music that took place outside a church or theater and were open to the public. And they were, in fact, dazzled by the talent of these female musicians; by all accounts, they were as skilled and professional as any of their male counterparts in Europe.

Fig. 21.19 Jacopo Guarana, *Apollo Conducting a Choir of Maidens.* 1776. Oil on canvas. Ospedaletto, Salla della Musica, Venice. The Ospedaletto church was the performance space for the girls of the orphanage of Santa Maria dei Derelitti. Although Apollo conducts in this painting, the ensemble director can be seen in yellow, just behind the right column, score in hand.

Vivaldi specialized in composing **concertos** [kun-CHAIR-tohs], a three-movement secular form of instrumental music, popular at court, which had already been established, largely by Corelli. Vivaldi systematized its form. The first movement of a concerto is usually *allegro* (quick and cheerful), the second slower and more expressive, like the pace of an opera aria, and the third a little livelier and faster than the first. Concertos usually feature one or more solo instruments that, in the first and third movements particularly, perform passages of material, called *episodes*, that contrast back and forth with the orchestral score—a form known as **ritornello** [re-tor-NEL-loh], "something that returns" (i.e., returning thematic material). At the outset, the entire orchestra performs the *ritornello* in the tonic—the specific home pitch around which the composition is organized. Solo episodes interrupt alternating with the *ritornello*, performed in partial form and in different keys, back and forth, until the *ritornello* returns again in its entirety in the tonic in the concluding section.

Ritornello

In the course of his career, Vivaldi composed nearly 600 concertos—for violin, cello, flute, piccolo, oboe, bassoon, trumpet, guitar, and even recorder. Most of these were performed by the Ospedale ensemble. The most famous is a group of four violin concertos, one for each season of the year, called *The Four Seasons*. It is an example of what would later come to be known as **program music**, or purely instrumental music in some way connected to a story or idea. **HEAR MORE at** The program of the first of these concertos, *Spring* **www.myartslab.com** (track **21.3**) is supplied by a sonnet, written by Vivaldi himself, at the top of the score. The first eight lines suggest the text for the first movement, and the last six lines, divided into two groups of three, the text for the second and third movements:

> Spring has arrived, and full of joy
> The birds greet it with their happy song.
> The streams, swept by gentle breezes,
> Flow along with a sweet murmur.
> Covering the sky with a black cloak,
> Thunder and lightning come to announce the season.
> When all is quiet again, the little birds
> Return to their lovely song.

The *ritornello* in this concerto is an exuberant melody played by the whole ensemble. It opens the movement, and corresponds to the poem's first line. Three solo violins respond in their first episode—"the birds greet it with their happy song"—imitating the song of birds. In the second episode, they imitate "streams swept by gentle breezes," then, in the third, "thunder and lightning," and finally the birds again, which "Return to their lovely song." The whole culminates with the *ritornello*, once again resolved in the tonic.

In its great rhythmic freedom (the virtuoso passages given to the solo violin, recalling the improvisational embellishments of Corelli) and the polarity between orchestra and solo instruments (the contrasts of high and low timbres, or sounds, such as happy bird song and clashing thunder), Vivaldi's concerto captures much of what differentiates Baroque music from its Renaissance predecessors. Gone are the balanced and flowing rhythms of the *prima prattica* and the polyphonic composition in which all voices are of equal importance. Perhaps most of all, the drama of beginning a composition in a tonic key, moving to different keys and then returning to the tonic—a process known as **modulation**—could be said to distinguish Baroque composition from what had come earlier. The dramatic effect of this modulation, together with the rich texture of the composition's chord clusters, parallels the dramatic lighting of Baroque painting, just as the embellishment of the solo voice finds its equivalent in the ornamentation of Baroque architecture.

As an instrumental composition, *The Four Seasons* naturally foregoes the other great innovation of the Baroque, the *secunda prattica*'s emphasis on an actual text, as found particularly in opera. Even in Rome, where sacred music dominated the scene, opera began to take hold. In 1632, an opera by Stefano Landi (1590–1639), with stage designs by Gian Lorenzo Bernini, premiered at a theater seating no fewer than 3,000 spectators inside the walls of the Barberini [bar-buh-REE-nee] palace, home of the Barberini pope Urban VIII (papacy 1622–1623). Like many of the Roman operas that followed, its subject was sacred, *Sant'Allessio* [sahnt-ah-LESS-ee-oh] (Saint Alexander), and it convinced the Church that sung theater could convey moral and spiritual ideas. This conviction would shortly give rise to a new genre of vocal music, the **oratorio** [or-uh-TOR-ee-oh]. Generally based on religious themes, the oratorio shared some of opera's musical elements, including the *basso continuo*, the aria, and the recitative, but it was performed without the dazzle of staging and costume. This development of Baroque music will be discussed in Chapter 24.

The End of Italian Ascendency

In France, the finance minister to King Louis [loo-EE] XIV was wise in matters far beyond finance. Jean-Baptiste Colbert [kohl-BAIR] counseled the king that "apart from striking actions in warfare, nothing is so well able to show the greatness and spirit of princes than buildings; and all posterity will judge them by the measure of those superb habitations which they have built during their lives." The king was looking for an architect to design a new east facade for the Palais du Louvre [pah-LAY dew loov] in Paris, which would house the new royal apartments. For such grand plans, the world's most famous—and original—architect, Gian Lorenzo Bernini, was the obvious choice. With the pope's permission, Bernini departed for Paris. Large and adoring crowds greeted him in every city through which he passed.

In Paris, he received a royal welcome, but the king was far from happy with Bernini's plans for the Louvre (Fig. 21.20). Although he accepted the plans, and foundations were poured, he concluded, after Bernini returned to Rome, that the Italian's design was too elaborate and ornate. Furthermore, French architects were protesting the award of such an important commission to a foreigner. The architect Louis Le Vau [loo-EE leh voh], the painter Charles Le Brun [sharl leh brun], and the physician, mathematician, and architectural historian Claude Perrault [peh-ROH] together designed a simpler, more classically inspired facade (Fig. 21.21), consisting of five units, centered by a triangular pediment and paired Corinthian colonnades. Louis was so pleased that he added paired colonnades to the other facades of the palace.

This debate between the ornate and the classical, the sensuous and the austere, would define the art of the eighteenth century. Baroque ornamentation, epitomized in the seventeenth century by Bernini, would become even more exaggerated in the eighteenth, transformed into the fanciful and playful decoration of the so-called Rococo style. Ironically, this happened especially at the French court. The forms of classical Greek and Roman architecture offered a clear alternative, countering what seemed to many an art of self-indulgence, even moral depravity. Painting, too, could abandon the emotional theatrics of the Baroque and appeal instead to the intellect and reason, assuming a solidity of form as stable as architecture.

Louis XIV's rejection of Bernini's plan marks the end of the ascendency of Italian art and architecture in European culture. From 1665 on, the dominant artists of Europe would be Northern in origin. Even in the field of music, northerners like Bach [bahk] and Handel, then Mozart [MOH-tzart] and Beethoven [BAY-toh-vun], were about to triumph. In Holland, France, and England, the Baroque would become an especially potent cultural force, permanently redefining the centers of European culture. ∎

Fig. 21.20 Gian Lorenzo Bernini, design for the east facade of the Palais du Louvre, Paris. 1664. Musée du Louvre, Paris.

Fig. 21.21 Louis Le Vau, Claude Perrault, and Charles Le Brun, east facade, Palais du Louvre, Paris. 1667–70.

What is the Baroque?

As part of its strategy to respond to the Protestant Reformation, the Catholic Church in Rome championed a new Baroque style of art that appealed to the range of human emotion and feeling, not just the intellect. Bernini's majestic new colonnade for the square in front of Saint Peter's in Rome helped to reveal the grandeur of the basilica itself, creating the dramatic effect of the Church embracing its flock. How does his sculptural program for the Cornaro Chapel in Rome epitomize the Baroque? How are Baroque sensibilities reflected in his sculpture of the biblical hero David? How do action, excitement, and sensuality fulfill the Counter-Reformation objectives in Baroque religious art? What role do the senses play in the theological writings of Saint Ignatius? What role does art play in his set of "Rules"? How is this reflected in Andrea Pozzo's ceiling for the church of Sant'Ignazio?

One of the most influential pieces of Baroque architecture is Francesco Borromini's Church of San Carlo alle Quattro Fontane in Rome. Borromini replaces the traditions of Renaissance architecture with a facade of dramatic oppositions and visual surprises. How does the architecture of Bernini and Borromini express the theatrical urge to draw the viewer into the drama?

How does the Baroque style manifest itself in painting?

Caravaggio used the play of light and dark to create paintings of stunning drama and energy that reveal a new Baroque taste for vividly realistic detail. His followers, among them Elisabetta Sirani and Artemisia Gentileschi, inherited his interest in realism and the dramatic. What does Caravaggio share with the mystical writings of Teresa of Ávila and the poetry of Englishman John Donne? What social conditions and aesthetic values of the Italian Baroque particularly interested the artists Elisabetta Sirani and Artemisia Gentileschi?

How is the Baroque style manifest in music, particularly in Venice?

If Rome was the center of Baroque art and architecture, Venice was the center of Baroque music. Giovanni Gabrieli took advantage of the sonority of Saint Mark's Cathedral to create canzonas in which he carefully controlled the dynamics (loud/soft) of the composition and its tempo. What is a canzona? It was in Venice that a new form of musical drama known as *opera* was born in the hands of Claudio Monteverdi, who gave text precedence over harmony for the first time in the history of Western music. His opera *Orfeo* successfully married music and drama. What is an opera? The sonata, popularized as an instrumental genre by virtuoso violinist Arcangelo Corelli, provided a model for all instrumental music. Finally, Antonio Vivaldi perfected the concerto as a genre, and many of his concertos were performed by the women at the Ospedale della Pietà, where he was musical director. What are the chief features of the concerto? In general, what features of Venetian Baroque music are analogous to Baroque painting and sculpture?

PRACTICE MORE Get flashcards for images and terms and review chapter material with quizzes at **www.myartslab.com**

GLOSSARY

aedicule The architectural frame of an opening composed of an entablature and pediment supported by columns or pilasters.

aria An elaborate solo or duet song that expresses the singer's emotions and feelings.

baldachino A canopy.

balustrade A decorative railing.

basso continuo A "continuous bass" line that serves as the supporting accompaniment to the solo instrumental or vocal line above it; also, the performers playing that part.

canzona A type of instrumental contrapuntal work increasingly performed in the seventeenth century in church settings.

cartouche An oval frame.

concerto A three-*movement* secular form of instrumental music.

dynamics Variations and contrast in loudness or intensity.

invisible complement The space surrounding a sculpture, with which it often has an active relationship.

key The central note of a musical composition; also called *tonic note*.

libretto The text of a musical work such as an *opera*.

modulation The process of beginning a composition in a tonic *key*, moving to different keys and then returning to the tonic.

monody A work consisting of a solo voice supported by a *basso continuo*.

movements The independent sections of a composition.

opera A text-based musical drama.

oratorio A form of vocal music, generally on religious themes.

orchestration A musical arrangement in which each part of the composition has been designated with a specific voice or instrument.

piazza A space surrounded by buildings.

pilaster A flat column, usually in relief, which appears to support weight but is essentially ornamental..

program music Purely instrumental music connected in some way to a story or idea.

recitativo A style of singing that imitates very closely the rhythms of speech.

ritornello A musical passage in which an instrument performs episodes that contrast back and forth with the orchestral score.

sonata Literally, "that which is sounded," referring in the broadest sense to a work for an instrument or instruments in any combination.

sonata da camera Literally, a "sonata of the chamber," usually featuring dance-related movements.

sonata da chiesa Literally, a "sonata of the church," often composed of four movements, slow-fast-slow-fast.

tenebrism An exaggerated form of chiaroscuro.

tonality The key of a composition.

tonic note The central note of a musical composition; also called the *key*.

trio sonata A sonata for two instruments of a high range and a *basso continuo*.

volute A coiled or scrolled and counter-curved architectural element.

READINGS

READING 21.4

John Donne, "The Flea" (1633)

Donne's poetry is often labeled "metaphysical" because it borrowed words and images from seventeenth-century science. It reflects a Baroque taste for dramatic contrast and the ability to synthesize discordant images. This last is reflected particularly in the elaborate metaphor, or "conceit," of the following poem, first published posthumously, in which a flea is taken for the image of love's consummation.

Mark but this flea, and mark in this,
How little that which thou deny'st me is;
Me it sucked first, and now sucks thee,
And in this flea, our two bloods mingled be;[1]
Confess it, this cannot be said
A sin, or shame, or loss of maidenhead,
 Yet this enjoys before it woo,
 And pampered swells with one blood made of two,
 And this, alas, is more than we would do.
Oh stay, three lives in one flea spare,[2] 10
Where we almost, nay more than married are,
This flea is you and I, and this
Our marriage bed, and marriage temple is;
 Though parents grudge, and you, we are met,
And cloistered in these living walls of jet.[3]
Though use make you apt to kill me,
Let not to this, self murder added be,
 And sacrilege,[4] three sins in killing three.

Cruel and sudden, has thou since
Purpled thy nail, in blood of innocence? 20
In what could this flea guilty be,
Except in that drop which it sucked from thee?
Yet thou triumph'st, and say'st that thou
Find'st not thyself, nor me the weaker now;
 'Tis true, then learn how false, fears be;
 Just so much honour, when thou yield'st to me,
 Will waste, as this flea's death took life from thee.

READING CRITICALLY

How would you describe the tone of this poem? Is it sincere? Playful? How does this tone affect how we understand its argument?

[1]United in the flea are the flea itself, the lover, and the mistress, thus echoing the Trinity, an elaborate metaphor that continues on throughout the poem.
[2]The mistress is about to kill the flea.
[3]Jet: black; in other words, the living body of the flea.
[4]Sacrilege because the flea is portrayed as a "marriage temple."

22

The Secular Baroque in the North
The Art of Observation

THINKING AHEAD

What forces were at work in Amsterdam in the seventeenth century?

How did developments in philosophy and science underpin the Dutch attention to visual detail?

How does the vernacular manifest itself in Dutch painting?

What are the characteristic features of Baroque keyboard music?

Seventeenth-century Amsterdam was arguably the best-known city in the world. In Europe, it might have competed for pre-eminence with Rome, Paris, Venice, and London, but in the far regions of the Pacific and Indian oceans, in Asia, Africa, and even South America, if you knew of Europe, you had heard of Amsterdam. No city was more heavily invested in commerce. No port was busier. The city's businessmen traded in Indian spices and Muscovy furs, grain from the Baltic, sugar from the Americas, Persian silk, Turkish carpets, Venetian mirrors, Italian maiolica, Japanese lacquerware, saffron, lavender, and tobacco. Tea from China, coffee from the Middle East, and chocolate from South America introduced the West to caffeine, the stimulant that would play a key role in igniting the Industrial Revolution a century later.

The Geographer (Fig. 22.1), a painting by Dutch artist Jan Vermeer (1632–1675), celebrates Amsterdam's geographical self-esteem. A sea chart on the back wall shows "all the Sea coasts of Europe," a map published in Amsterdam. The globe above his head was also produced in Amsterdam. (So detailed is this painting that the viewer can read the dates and names of the manufacturers of the map and the globe.) He holds a set of dividers, used to mark distances on what must be a chart or map on the table in front of him; the table covering is bunched up behind it as if he has pushed it out of his way. With his left hand resting on a book, he stares intently to his right, as if caught up in a profound intellectual problem.

Vermeer's *Geographer* not only embodies the intellectual fervor of the age, but also many of the themes and strategies of Dutch vernacular painting in the seventeenth century. It reveals, first of all, a rigorous attention to detailed observation, which is why we can readily identify the originals of things like the map and globe. It actively seeks to capture something of the personality of the figure, increasingly the aim of Dutch portraiture. It represents a domestic interior—a favorite theme in Dutch painting—even as it suggests an interest, through the practice of geography, in the natural **landscape**.

◀ **Fig. 22.1 Jan Vermeer, *The Geographer*. 1668–69.** Oil on canvas, 20$\frac{1}{8}$" × 18$\frac{1}{4}$". Städelsches Kunstinstitut, Frankfurt. Courtesy Blauel/Gramm–ARTHOTEK, Peissenberg. The Granger Collection, New York. Many scholars believe this to be a portrait of the Dutch lens maker, Antoni van Leeuwenhoek, whose scientific investigations are discussed later in the chapter. One of the details supporting the notion that Leeuwenhoek served as a model for this image is the carpet draped across the front of the desk on which he works. Leeuwenhoek worked in the textile industry.

HEAR MORE Listen to an audio file of your chapter at **www.myartslab.com**

(The word "landscape" derives, in fact, from the Dutch *landschap*—that is, "land form.") And, in all likelihood, the painting possesses an allegorical or symbolic meaning in keeping with the strict Dutch Calvinist discipline: The geographer not only charts the landscape but, as he looks forward into the light of revelation, the proper course in life itself. The *Geographer* is also a simple expression of joy in the world of things— carpets, globes, even pictures—and the Dutch desire to possess them.

And yet, for all their wealth and knowledge of foreign lands, the Dutch remained somewhat conservative, as if the very flatness of the landscape, recovered from the sea, led the Netherlandish mind to a condition of restraint. Between 1590 and 1640, nearly 200,000 acres of land intersected by canals and dikes were created by windmills that pumped water out of the shallows and into the sea. The resulting landscape was an austere geometry of right angles and straight lines (Fig. 22.2). The homes of the rich merchants of Amsterdam were distinguished by this same geometric understatement, their facades typically avoiding Baroque asymmetry and ornamentation. In life as in architecture, in Calvinist Holland, the values of a middle class intent on living well but not making too public a show of it eclipsed the values of European court culture elsewhere. Especially avoided were what the Dutch deemed the lavish Baroque excesses of the Vatican in Rome.

This chapter outlines the forces that defined Amsterdam as the center of the more austere Baroque style that dominated northern Europe in the seventeenth century. As Amsterdam's port established itself as the center of commerce in the north, the city's economy thrived, sometimes too hotly, as when mad speculation sent the market in tulip bulbs skyrocketing. But this tendency to excess was balanced by the conservatism of the Dutch Reformed Church. The Calvinist fathers of the Dutch Reformed Church found no place for art in the Calvinist liturgy, by and large banning art from its churches. The populace as a whole, however, embraced a new vernacular art depicting the material reality and everyday activities of middle-class Dutch society. The art of portraiture was especially popular, as average citizens sought to affirm their well-being in art.

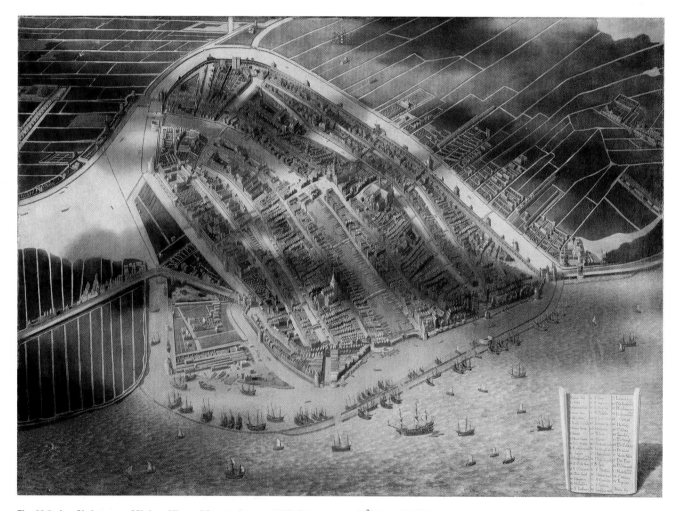

Fig. 22.2 Jan Christaensz-Micker, *View of Amsterdam.* ca. 1630. Oil on canvas, 39 3/8″ × 54″. Collection Amsterdam Historical Museum, Amsterdam. By 1640, the city would expand well into the fields on both sides of this image and continue expanding throughout the century. Note the realism of the shadows of passing clouds falling over the city.

CALVINIST AMSTERDAM: CITY OF CONTRADICTIONS

Seventeenth-century Amsterdam was a city of contradictions. It was a society at once obsessed with the acquisition of goods of all kinds, yet rigidly austere in its spiritual life. It was intolerant of what it deemed religious heresy among Protestants, but tolerant of Catholics and Jews; its people avidly collected art for their homes but forswore art in the church. The city was also the curious beneficiary of its sworn enemy, Catholic Spain. Throughout the first three-quarters of the sixteenth century, the provinces of the Netherlands, which correspond roughly to modern-day Belgium and Holland, had been ruled by Charles I of Spain and then his son, Philip II, as part of their Habsburg kingdom (see Chapter 20). Antwerp was their banking center, and through its port passed much of the colonial bounty of the Western Hemisphere, especially from the great silver mines of Potosí, Bolivia (see Chapter 18), and Zacatecas, Mexico. At Potosí alone, a minimum of 7.6 million pesos, minted into coins near the mine, were produced annually between 1580 and 1650, all destined to pay off the ever-increasing debt of the Spanish royal family.

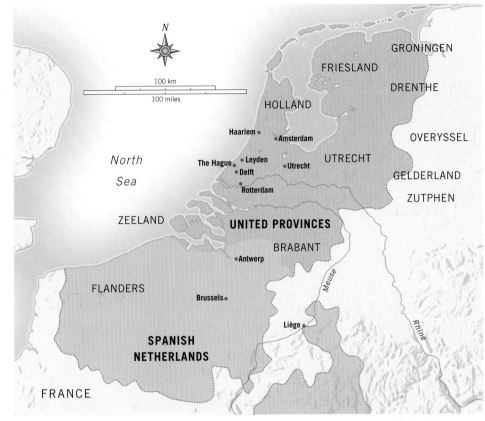

Map 22.1 The United Provinces of the Netherlands in 1648.

Gaining Independence from Spain

Charles I had been born in Flanders and spoke no Spanish when he assumed the Spanish throne in 1519 (see Chapter 20). But Philip II was born in Spain, and, in 1559, he left the Netherlands permanently for his native land, entrusting the northern provinces to the regency of Margaret of Parma, his half-sister. From Spain, Philip tried unsuccessfully to impose Catholic rule on the north by breaking down the traditional autonomy of the 17 Netherlands provinces and asserting rule from Madrid. To this end, he imposed the edicts of the Council of Trent (see Chapter 20) throughout the Netherlands and reorganized its churches under Catholic hierarchy. The Calvinists roundly rejected both moves, especially in the northern seven provinces of Holland centered at Amsterdam. Ten thousand mercenaries led by the Duke of Alba arrived in 1567 to force the Calvinist resistance into cooperation, but the Dutch opened their dikes, flooding the countryside in order to repulse the Spanish. Finally, in 1576, Spanish soldiers, rioting over lack of pay, killed 7,000 citizens in the streets of

Antwerp in a four-day battle that became known as the Spanish Fury. Appalled at the slaughter, the southern ten provinces of the Netherlands, which had remained Catholic up to this point, united with the north to form the United Provinces of the Netherlands (see Map 22.1). The union lasted only three years, at which point five southern provinces made peace with Spain. Throughout this period, Protestants migrated in mass numbers out of the south, and out of Antwerp particularly, to the north. So did intellectuals and merchants. Of Antwerp's 100,000 inhabitants in 1570, no more than about 40,000 remained by 1590.

Meanwhile, in 1581, the northern provinces declared their independence from Spain, even as Philip reinvigorated his efforts to reconquer them. In 1584 and 1585, when the Spanish under Alessandro of Farnese captured Antwerp after a 14-month siege, the city's fate was sealed. The northern provinces felt that Antwerp was too closely associated with the Spanish for comfort. Thus, at the end of the Thirty Years' War, when the Treaty of Westphalia in 1648 permanently excluded Spain from meddling in Netherlands affairs, Amsterdam closed the port of Antwerp by closing off the river Scheldt to commerce. As Amsterdam clearly understood, no viable commercial enterprise could remain in the city. The wealth that had flowed through the port at Antwerp would thereafter flow through the port of Amsterdam. Amsterdam's prize of war was largely this: What Antwerp had been to the sixteenth century, Amsterdam would be to the seventeenth.

Tulipomania

No single incident captures Amsterdam's commercial success and the wealth at its disposal better than the great tulip "madness" of 1634 to 1637. During those three years, frenzied speculation in tulip bulbs nearly ruined the entire Dutch economy. The tulip had arrived in Europe in 1554, when the Austrian Habsburg ambassador to the court of Suleiman the Magnificent (1494–1566) in Constantinople shipped home a load of bulbs for the enjoyment of the royal court. Its Turkish origin lent the flower a certain exotic flavor (the word *tulip*, in fact, derives from the Turkish word for "turban"), and soon the tulip became the flower of fashion throughout northern Europe. The more flamboyant and extravagant a tulip's color, the more it was prized.

Especially valued were examples of what the Dutch called a "broken" tulip. Tulips, by nature, are a single color—red or yellow, for instance—but in any planting of several hundred bulbs, a single flower might contain feathers or flames of a contrasting hue. Offsets of these "broken" flowers would retain the pattern of the parent bulb, but they produced fewer and smaller offsets than ordinary tulips. Soon, the bulbs of certain strains—most notably the *Semper Augustus* [SEM-per aw-GUS-tus], with its red flames on white petals—became the closely guarded treasures of individual botanists.

We know, today, that a virus spread from tulip to tulip by the peach potato aphid causes the phenomenon of "breaking." The flower produces fewer and smaller offsets because it is diseased. As a result of this deterioration, by 1636 there were reportedly only two of the red-flamed *Semper Augustus* root bulbs in all of Holland. The one in Amsterdam sold for 4,600 florins [FLOR-inz] (fifteen or twenty times the annual income of a skilled craftsman), a new carriage and harness, and two gray horses. Some idea of what value these prices represent can

Fig. 22.3 From the Tulip Book of P. Cos. 1637. Wageningen University and Research Center Library, The Netherlands. In the first half of the seventeenth century, 34 "tulip books," cataloguing the flower's many varieties, were published in Holland.

be understood by looking at some of the "in-kind" dealings that transpired in the tulip trade. In his history of the Dutch seventeenth century, *The Embarrassment of Riches*, Simon Schama reports that one man, presumably a farmer leaping into the market, paid two *last* of wheat (approximately 4,000 pounds), four of rye, four fat oxen, eight pigs, a dozen sheep, two oxheads of wine, four tons of butter, a thousand pounds of cheese, a bed, some clothing, and a silver beaker, for a single Viceroy bulb, valued at 2,500 guilders [GILL-durz]. Presumably the farmer planned on planting it and selling its offsets for 2,500 guilders each.

We cannot know for certain what caused the burst of speculation in "broken" flowers, although the Dutch taste for beauty certainly contributed to the madness. Tulip books, illustrated nursery catalogues of available bulbs and the flowers they produced, added to the frenzy (Fig. 22.3). But by the autumn of 1635, trade in actual bulbs had given way to trade in promissory notes, listing what flowers would be delivered and at what price. At the stock exchange in Amsterdam and elsewhere in Holland, special markets were established for their sale. Suddenly, good citizens sold all their possessions, mortgaged their homes, and invested their entire savings in "futures"—bulbs not yet even lifted from the ground. In a matter of months, the price of a single Switsers bulb, a yellow tulip with red feathers, soared from 60 to 1,800 guilders. Speculation was so frenzied that the paper "futures" began to be traded, not the bulbs themselves, and when in the winter of 1637 the tulip market faced the prospect of fulfilling paper promissory notes with actual bulbs, it collapsed. Suddenly no one could sell a tulip bulb in Holland for any price.

In Amsterdam, the assembled deputies declared any debt incurred in the tulip market before November 1636 null and void, and the debt of any purchaser whose obligation

was incurred after that date to be considered met upon payment of 10 percent. Those holding debts were outraged, but the court in Amsterdam unanimously ruled that any debt contracted in gambling, which they deemed the tulip market to be, was no debt at all under the law.

The Dutch Reformed Church: Strict Doctrine and Whitewashed Spaces

The excesses of Dutch society so evident in the tulip craze were strongly countered by the conservatism of the Calvinist Dutch Reformed Church, which actively opposed speculation in the tulip market. In the 1560s, as the Spanish had tried to impose Catholicism upon the region, many Dutch religious leaders, almost all of them Calvinist (see Chapter 17), fled the country. Finally, in October 1571, 23 of these Calvinist leaders gathered in Emden, Germany, and proclaimed the creation of the Dutch Reformed Church. By 1578, they had returned to Holland.

This strict Calvinist sect did not become, as many believe, an official state religion, but the state did require that any person in public service be a member of the Dutch Reformed Church. The Church was itself split over questions of doctrine: In the saving of souls, could good deeds overcome predestination? On one side were those who held that the faith and good deeds of the believer might to some extent affect the bestowal of grace and their ultimate salvation. Opposing them were those who believed that salvation was predestined by God. Those who would ascend to heaven (the elect) were numbered from the moment of birth, and no good works could affect the outcome of the damned. By 1618, this doctrinal conflict would erupt into what narrowly escaped becoming civil war, and those who believed in good works were soon expelled from the Reformed Church, their leader tried for treason and beheaded, and others imprisoned.

The doctrinal rigidity of the Reformed Church is reflected in the austerity of its churches. Ever since the Calvinist's iconoclastic destruction of religious imagery in 1566 (see Chapter 17), when van Eyck's *Ghent Altarpiece* at Saint Bavo Cathedral in Ghent (see Figs. 16.5 and 16.6) was dismantled

and hidden away, Dutch churches had remained devoid of paintings. A depiction of a different church dedicated to Saint Bavo, in Haarlem [HAR-lum] (Fig. 22.4), painted by Pieter Saenredam [SAHN-ruh-dahm] (1597–1665) nearly a century after the removal of the *Ghent Altarpiece*, shows a typical Dutch Reformed interior stripped of all furnishings, its walls whitewashed by Calvinist iconoclasts. A single three-tiered chandelier hangs from the ceiling above three gentlemen whom Saenredam includes in the composition in order to establish the almost spiritual vastness of the medieval church's interior. This stripped-down, white space is meant to reflect the purity and propriety of the Reformed Church and its flock.

Fig. 22.4 Pieter Saenredam, *Interior of the Choir of Saint Bavo's Church at Haarlem.* 1660. Oil on panel, 27⅞″ × 21⅝″. Worcester Art Museum, Worcester, MA. The Bridgeman Art Library, New York. Charlotte E. W. Buffington Fund. 1951.29. The only adornments of the space are an escutcheon, bearing the coat of arms of Saint Bavo, hanging on the left wall, and a memorial tablet on the right.

THE SCIENCE OF OBSERVATION

As stark and almost barren as Saenredam's painting is, it nevertheless reveals an astonishing attention to detail, capturing even the texture of the whitewashed walls with geometric precision. This attention to detail, typical of Northern Baroque art, reflects both religious belief and scientific discovery. Protestants believed that all things had an inherent spiritual quality, and the visual detail in Northern art was understood as the worldly manifestation of the divine. But perhaps more significantly, new methods of scientific and philosophical investigation focused on the world in increasing detail. In the seventeenth century, newly invented instruments allowed scientists to observe and measure natural phenomena with increasing accuracy. Catholics and Protestants were equally appalled at many of the discoveries, since they seemed to challenge the authority of Scripture. Also problematic for both religions were new methods of reasoning that challenged the place of faith in arriving at an understanding of the universe. According to these new ways of reasoning, *Scientia*, the Latin word for "knowledge," was to be found in the world, not in religious belief.

Francis Bacon and the Empirical Method

One of the most fundamental principles guiding the new science was the proposition that, through the direct and careful observation of natural phenomena, one could draw general conclusions from particular examples. This process is known as **inductive reasoning**, and with it, scientists believed they could predict the workings of nature as a whole. When inductive reasoning was combined with scientific experimentation, it produced a manner of inquiry that we call the **empirical method.** The leading advocate of the empirical method in the seventeenth century was the English scientist Francis Bacon (1561–1626). His *Novum Organum Scientiarum* (*New Method of Science*), published in 1620, is the most passionate plea for its use. "One method of delivery alone remains to us," he wrote, "which is simply this: we must lead men to the particulars themselves, and their series and order; while men on their side must force themselves for a while to lay their notions by

CONTINUITY & CHANGE and begin to familiarize themselves
Aristotle, p. 159 | with facts." The greatest obstacle to human understanding, Bacon believed, was "superstition, and the blind and immoderate zeal of religion." For Bacon, Aristotle represented a perfect example (see Chapter 5). While he valued Aristotle's emphasis on the study of natural phenomena, he rejected as false doctrine Aristotle's belief that the experience coming to us by means of our senses (things as they *appear*) automatically presents to our understanding things as they *are*. Indeed, he felt that reliance on the senses frequently led to fundamental errors.

A proper understanding of the world could only be achieved, Bacon believed, if we eliminate the errors in

reasoning developed through our unwitting adherence to the false notions that every age has worshiped. He identified four major categories of false notion, which he termed Idols, all described in his *Novum Organum Scientiarum* (*The New Method of Science*) (see **Reading 22.1,** page 729). The first of these, the Idols of the Tribe, are the common fallacies of all human nature, derived from the fact that we trust, wrongly, in our senses. The second, the Idols of the Cave, derive from our particular education, upbringing, and environment—an individual's religious faith or sense of his or her ethnic or gender superiority or inferiority would be examples. The third, the Idols of the Market Place, are errors that occur as a result of miscommunication, words that cause confusion by containing, as it were, hidden assumptions. For instance, the contemporary use of "man" or "mankind" to refer to people in general (common well into the twentieth century), connotes a worldview in which hierarchical structures of gender are already assumed. Finally, there are the Idols of the Theater, the false dogmas of philosophy—not only those of the ancients but those that "may yet be composed." The object of the empirical method is the destruction of these four Idols through intellectual objectivity. Bacon argued that rather than falling back on the preconceived notions and opinions produced by the four Idols, "Man, [using the last idol] being the servant and interpreter of Nature, can do and understand so much and so much only as he has observed in fact or in thought of the course of Nature; beyond this he neither knows anything nor can do anything."

Bacon's insistence on the scientific observation of natural phenomena led, in the mid-1640s, to the formation in England of a group of men who met regularly to discuss his new philosophy. After a lecture on November 28, 1660, by Christopher Wren, the Gresham College Professor of Astronomy and architect of Saint Paul's Cathedral in London (see Chapter 24), they officially founded "a College for the Promoting of Physico-Mathematicall Experimentall Learning." It met weekly to witness experiments and discuss scientific topics. Within a couple of years, the group became known as "The Royal Society of London for Improving Natural Knowledge," an organization that continues to the present day as the Royal Society. It is one of the leading forces in international science, dedicated to the recognition of excellence in science and the support of leading-edge scientific research and its applications.

René Descartes and the Deductive Method

Bacon's works circulated widely in Holland, where they were received with enthusiasm. As one seventeenth-century Dutch painter, Constantijm Huygens [HOY-guns] (1596–1687), put it in his *Autobiography*, Bacon offered the Dutch "most excellent criticism of the useless ideas, theorems, and axioms which, as I have said, the ancients possessed." But equally influential were the writings of the French-born René Descartes [day-CART] (1596–1650).

Descartes (Fig. **22.5**), in fact, lived in Holland for over 20 years, from 1628 to 1649, moving between 13 different cities, including Amsterdam, and 24 different residences. It was in Holland that he wrote and published his *Discourse on the Method of Rightly Conducting the Reason and Seeking for Truth in the Sciences* (1637). As opposed to Bacon's inductive reasoning, Descartes proceeded to his conclusions by the opposite method of **deductive reasoning**. He began with clearly established general principles and moved from those to the establishment of particular truths.

Like Bacon, Descartes distrusted almost everything, believing that both our thought and our observational senses can and do deceive us. In his *Meditations on the First Philosophy*, he draws an analogy between his own method and that of an architect (**Reading 22.2**):

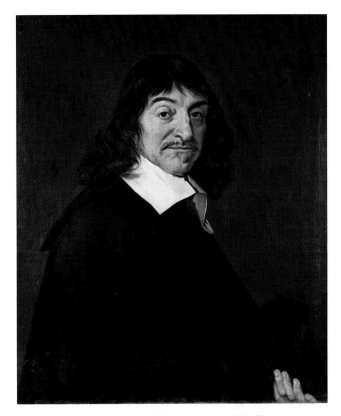

Fig. 22.5 Frans Hals, *Portrait of René Descartes*. 1649. Oil on wood, 7³⁄₈" × 5¹⁄₂". Musée du Louvre/RMN Réunion des Musées Nationaux, France. Erich Lessing/Art Resource, New York. Hals was renowned for his portraiture. Here he seems to reveal the very essence of Descartes. The philosopher appears to be thinking, with some evident amusement, perhaps about the prospect of any painter "capturing" his essence on canvas.

> ### READING 22.2
>
> **from René Descartes, *Meditations* (1641)**
>
> Throughout my writings I have made it clear that my method imitates that of the architect. When an architect wants to build a house which is stable on ground where there is a sandy topsoil over underlying rock, or clay, or some other firm base, he begins by digging out a set of trenches from which he removes the sand, and anything resting on or mixed in with the sand, so that he can lay his foundations on firm soil. In the same way, I began by taking everything that was doubtful and throwing it out, like sand.

He wants, he says, "to reach certainty—to cast aside the loose earth and sand so as to come upon rock and clay." The first thing, in fact, that he could not doubt was that he was thinking, which led him to the inevitable conclusion that he must actually exist in order to generate thoughts about his own existence as a thinking individual, which he famously expressed in *Discourse on Method* in the Latin phrase "*Cogito, ergo sum*" [KOH-guh-toh er-goh sum] ("I think, therefore I am").

At the heart of Descartes's thinking—we refer to Descartes's method as *Cartesian*—is an absolute distinction between mind and matter, and hence between the metaphysical soul and the physical body, a system of oppositions that has come to be known as *Cartesian dualism*. The remarkable result of this approach is that, beginning with this one "first principle" in his *Discourse on Method*, Descartes comes to prove, at least to his own satisfaction, the existence of God. He would repeat this argument many times, most formally in his 1641 *Meditations*, but the logic, simply stated, is as follows: (1) I think, and I possess an idea of God (that is, the idea exists in me and I can be aware of it as an object of my understanding); (2) The idea of God is the idea of an actually infinite perfect being; (3) Such an idea could only originate in an actually infinite perfect being ("it had been placed in me by a Nature which was really more perfect than mine could be, and which had within itself all the perfections of which I could form any idea"); and (4) Therefore, there is an infinitely perfect being, which we call God. This line of thinking established Descartes as one of the most important founders of **deism** (from the Latin *deus* [DAY-us], "god"), the brand of faith that argues that the basis of belief in God is reason and logic rather than revelation or tradition. Descartes's did not believe that God was at all interested in interfering in human affairs. Nor was God endowed, particularly, with human character. He was, in Descartes's words, "the mathematical order of nature." Descartes was himself a mathematician of considerable inventiveness, founding analytic geometry, the bridge between algebra and geometry crucial to the invention of calculus. The same year that he published *Discourse on Method*, Descartes also published a treatise entitled *Optics*. There, among other things, he used geometry to calculate the angular radius of a rainbow (42 degrees).

Johannes Kepler, Galileo Galilei, and the Telescope

Descartes's *Optics* was built upon the earlier discoveries in optics of the German mathematician Johannes Kepler [KEP-lur] (1571–1630). In fact, Descartes was so taken with Kepler's insights that he included Kepler's illustration of the working of the human eye in his *Optics* (Fig. **22.6**). Kepler had made detailed records of the movements of the planets, substantiating Copernicus's theory that the planets orbited the sun, not the Earth (see Chapter 20). The long-standing tradition of a **geocentric** (Earth-centered) cosmos was definitively replaced with a **heliocentric** (sun-centered) theory. Kepler also challenged the traditional belief that the orbits of the planets were spherical, showing that the five known planets moved around the sun in elliptical paths determined by the magnetic force of the sun and their relative distance from it. His interest in optics was spurred on when he recognized that the apparent diameter of the moon differed when observed directly and when observed using a **camera obscura** [ob-SKYOOR-uh], a device that temporarily reproduces an image on a screen or wall (Fig. **22.7**).

Meanwhile, in Italy, Kepler's friend Galileo Galilei [gal-uh-LAY] had improved the design and magnification of the telescope (invented by a Dutch eyeglass-maker, Hans Lippershey; see Chapter 24). Through the improved telescope, Galileo saw and described the craters of the moon, the phases of Venus, sunspots, and the moons of Jupiter. Galileo also theorized that light takes a certain amount of time to travel from one place to the next, and that either as a particle or as a wave, it travels at a measurable uniform speed. He proposed, too, that all objects, regardless of shape, size, or density, fall at the same rate of acceleration—the law of

Fig. 22.6 Illustration of the theory of the retinal image as described by Johannes Kepler. From René Descartes, *Optics (La Dioptrique)*, Leiden, 1637. Bancroft Library, Berkeley, CA. Descartes was more interested in what happened to the image in the brain after it registered itself on the retina, while Kepler was interested in the physical optics of the process itself.

Fig. 22.7 An artist drawing in a large camera obscura. Courtesy George Eastman House, Buffalo, NY. The camera obscura works by admitting a ray of light through a small hole that projects a scene, upside down, directly across from the hole. Recent studies have shown that Vermeer made extensive use of such a device.

falling bodies, or gravity. Inspired by Galileo's discoveries, Kepler wrote a study on the optical properties of lenses, in which he detailed a design for a telescope that became standard in astronomical research. Kepler's and Galileo's work did not meet with universal approval. The Church still officially believed that the Earth was the center of the universe and that the sun revolved around it. Protestant churches were equally skeptical. The theories of Kepler and Galileo contradicted certain passages in the Bible. Joshua, for instance, is described in the Old Testament as making the sun stand still, a feat that would be impossible unless the sun normally moved around the Earth: "So the sun stood still in the midst of the heaven, and hasted not to go down about a whole day. And there was no day like that before it or after it" (Joshua 10:13–14). Furthermore, it seemed to many that the new theories relegated humankind to a marginal space in God's plan. Thus, in 1615, when Galileo was required to defend his ideas before Pope Paul V in Rome, he failed to convince the pontiff. He was banned from both publishing and teaching his findings. When his old friend Pope Urban VIII was elected pope, Galileo appealed Paul's verdict, but Urban went even further. He demanded that Galileo admit his error in public and sentenced him to life in prison. Through the intervention of friends, the sentence was reduced to banishment to a villa outside Florence. Galileo was lucky. In 1600, when the astronomer Giordano Bruno had asserted that the universe was infinite and without center and that other solar systems might exist in space, he was burned at the stake.

Antoni van Leeuwenhoek, Robert Hooke, and the Microscope

In the last decade of the sixteenth century, two Dutch eyeglass-makers, Hans Lippershey and Zaccharias Janssen, discovered that if one looked through several lenses in a single tube, nearby objects appeared greatly magnified. This discovery led to the compound microscope (a microscope that uses more than one lens). Early compound microscopes were able to magnify objects only about 20 or 30 times their natural size. Another Dutch lens maker, Antoni van Leeuwenhoek [vahn LAY-ven-hook] (1632–1723), was able to grind a lens that magnified over 200 times. The microscope itself was a simple instrument, consisting of two plates with a lens between, which was focused by tightening or loosening screws running through the plates. Two inches long and one inch across, it could easily fit in the palm of one's hand. Leeuwenhoek was inspired by the 1665 work *Micrographia* by Robert Hooke, Curator of Experiments for the Royal Society of London. It was illustrated by drawings of Hooke's observations with his compound microscope: a flea that he said was "adorn'd with a curiously polish'd suite of sable Armour, neatly jointed," and a thin slice of cork, in which he observed "a Honey-comb [of] . . . pores, or cells"—actually, cell walls (Fig. 22.8).

Fig. 22.8 Robert Hooke, illustrations from *Micrographia*: a flea (top), and a slice of cork (bottom). London. 1665. Courtesy the University of Virginia Library. Hooke was the first person to use the word *cell* to describe the basic structural unit of plant and animal life.

Leeuwenhoek wrote letters to the Royal Society of London to keep them informed about his observations. In his first letter, of 1673, he described the stings of bees. Then, in 1678, he wrote to the Royal Society with a report of discovering "little animals"—actually, bacteria and protozoa—and the society asked Hooke to confirm Leeuwenhoek's findings, which he successfully did. For the next 50 years, Leeuwenhoek's regular letters to the Royal Society, describing, for the first time, sperm cells, blood cells, and many other microscopic organisms, were printed in the Society's *Philosophical Transactions*, and often reprinted separately. In 1680, Leeuwenhoek was elected a full member of the Society.

Many scholars believe that Leeuwenhoek served as the model for the 1668 to 1669 painting by Jan Vermeer, *The Geographer* (see Fig. 22.1). Leeuwenhoek was interested in more than microscopes. A biographer described him six years after his death as equally interested in "navigation, astronomy, mathematics, philosophy, and natural science." He would serve as trustee for Vermeer's estate in 1676, and we know that Vermeer actively used a camera obscura to plan his canvases, so the painter shared something of Leeuwenhoek's fascination with lenses.

DUTCH VERNACULAR PAINTING: ART OF THE FAMILIAR

The prosperous Dutch avidly collected pictures. A visiting Englishman, John Evelyn, explained their passion for art this way, in 1641: "The reason of this store of pictures and their cheapness proceeds from want of land to employ their stock [wealth], so that it is an ordinary thing to find a common farmer lay out two or three thousand pounds in this commodity. Their houses are full of them and they vend them at their fairs to very great gains." If Evelyn exaggerates the sums invested in art—a typical landscape painting sold for only three or four guilders, still the equivalent of two or three days' wages for a Delft clothworker—he was accurate in his sense that almost everyone owned at least a few prints and a painting or two.

Despite Dutch Reformed distaste for religious history painting—commissions from the Church had dried up almost completely by 1620—about a third of privately owned paintings in the city of Leiden (one of the most iconoclastic in Holland) during the first 30 years of the seventeenth century represented religious themes. But other, more secular forms of painting thrived. Most Calvinists did not object to sitting for their portraits, as long as the resulting image reflected their Protestant faith. And most institutions wanted visual documentation of their activities, resulting in a thriving industry in group portraiture. Painting also came to reflect the matter-of-fact materialism of the Dutch character—its interest in all manner of things, from carpets, to furnishings, to clothing, collectibles, foodstuffs, and everyday activities. And the Dutch artists themselves were particularly interested in technical developments in the arts, particularly Caravaggio's dramatic lighting (see Fig. 21.13). To accommodate the taste of the buying public, Dutch artists developed a new visual vocabulary that was largely vernacular, reflecting the actual time and place in which they lived.

Still Lifes

Among the most popular subjects were **still lifes**, paintings dedicated to the representation of common household objects and food. At first glance, they seem nothing more than a celebration of abundance and pleasure. But their subject is also the foolishness of believing in such apparent ease of life. Johannes Goedaert's (1621–1668) *Flowers in a Wan-li Vase with Blue-Tit* (Fig. **22.9**) is, on the one hand, an image of pure floral exuberance. The arrangement contains four varieties of tulip—somewhat ominously, given the memories of tulipomania—and a wide variety of other flowers, including a Spanish iris, nasturtiums from Peru, fritallaria [FRIT-ul-air-ee-uh] from Persia, a stripped York and Lancaster Rose—a whole empire's worth of blossoms. The worldliness of the blooms is underscored by the Wan-li vase in which they are placed, a type of Ming dynasty porcelain (see Fig. 18.20) that became popular with Dutch traders around the turn of the century. The short life of the blooms is suggested by the yellowing leaves, the impermanence of the scene by the fly perched on one of the tulips. But perhaps the most telling detail is the bird at the bottom left of the painting, a blue-tit depicted in the act of consuming a moth. Dutch artists of this period used such details to remind the viewer of the frivolous quality of human existence, our vanity in thinking only of the pleasures of the everyday. Such *vanitas* [VAN-ih-tahss] **paintings**, as they are called, remind us that pleasurable things in life inevitably fade, that the material world is not as long-lived as the spiritual, and that the spiritual should command our attention. They

Fig. 22.9 Johannes Goedaert, *Flowers in a Wan-li Vase with Blue-Tit.* ca. 1660. Medium. Photo: Charles Roelofsz/RKD Images. Bob P. Haboldt & Co., Inc. Art Gallery, N.Y. The shell in the lower right corner is a symbol of worldly wealth, but as it is broken and empty, it is also a reminder of our vanity and mortality.

Fig. 22.10 Jacob van Ruisdael, *View of Haarlem from the Dunes at Overveen*. ca. 1670. Oil on canvas, 22″ × 24 3/8″. Mauritshuis, The Hague. The play of light and dark across the landscape can be understood in terms of the rhythms of life itself.

are, in short, examples of the *momento mori*—reminders that we will die. Paintings such as Goedaert's were extremely popular. Displayed in the owner's home, they were both decorative and imbued with a moral sensibility that announced to a visitor the owner's upright Protestant sensibility.

Landscapes

Another popular subject was landscapes. Landscape paintings such as Jacob van Ruisdael's [vahn ROYS-dahl] (ca. 1628–1682) *View of Haarlem from the Dunes at Overveen* reflect national pride in the country's reclamation of its land from the sea (Fig. **22.10**). The English referred to the United Provinces as the "united bogs," and the French constantly poked fun at the baseness of what they called the *Pays-Bas* [PAY-ee bah] (the "Low Countries"). But the

Dutch themselves considered their transformation of the landscape from hostile sea to tame farmland, in the century from 1550 to 1650, as analogous to God's recreation of the world after the Great Flood.

In Ruisdael's landscape painting, this religious undertone is symbolized by the great Gothic church of Saint Bavo at Haarlem, which rises over a flat, reclaimed landscape where figures toil in a field lit by an almost celestial light. (See Fig. 22.4 for Pieter Saenredam's depiction of the interior of the church.) It is no accident that two-thirds of Ruisdael's landscape is devoted to sky, the infinite heavens. In flatlands, the sky and horizon are simply more evident, but more symbolically, the Dutch thought of themselves as *Nederkindren*, the "children below," looked after by an almighty God with whom they had made an eternal covenant.

Genre Scenes

Paintings that depict events from everyday life were another favorite of the Dutch public. *The Dancing Couple* (Fig. **22.11**) by Jan Steen (1626–1679) is typical of such **genre scenes**. Like many of Steen's paintings, it depicts festivities surrounding some sort of holiday or celebration. Steen was both a painter and a tavern keeper, and the scene here is most likely a tavern patio in midsummer. An erotic flavor permeates the scene, an atmosphere of flirtation and licentiousness. To the right, musicians play as a seated couple drunkenly watch the dancers. To the left, two men enjoy food at the table, a woman lifts a glass of wine to her lips, and a gentleman—a self-portrait of the artist—gently touches her chin. Steen thus portrays his own—and, by extension, the Dutch—penchant for merrymaking, but in typical Dutch fashion he also admonishes himself for taking such license. On the tavern floor lie an overturned pitcher of cut flowers and a pile of broken eggshells, both *vanitas* symbols. Together with the church spire in the distance, they remind us of the fleeting nature of human life as well as the hellfire that awaits those who have fallen into the vices so openly displayed in the rest of the painting.

One of the most popular genre painters of the day—and, incidentally, illustrator of a favorite tulip catalogue as well—was Judith Leyster [LY-ster] (1609–1660) of Haarlem (see Fig. 22.3). We do not know much about her life, but she was admitted to the Haarlem painter's guild in 1633, in her early twenties, and married another genre painter, Jan Miense Molenaer, in 1636. The moral severity of her 1631 painting *The Proposition* is unmistakable (Fig. **22.12**). Taking advantage of the contrast of light and dark, a Baroque technique probably learned from the example of Caravaggio (see Figs. 21.13 and 21.14), Leyster creates a small drama of considerable tension and opposition. A woman sits quietly, intent on her needlework, as a lusty man leans over her, grinning. His left hand rests on her shoulder and his right offers her a handful of coins. Even as she ignores his clear proposition, her virtue is compromised. Perhaps her physical safety is in jeopardy as well, for the man's good humor will probably crumble under her rejection of him—a premonition signaled by the tension, even pain, evident in her concentration. The painting is, furthermore, remarkable for contrasting the domestic world of women with the commercial world of men, associating the former with

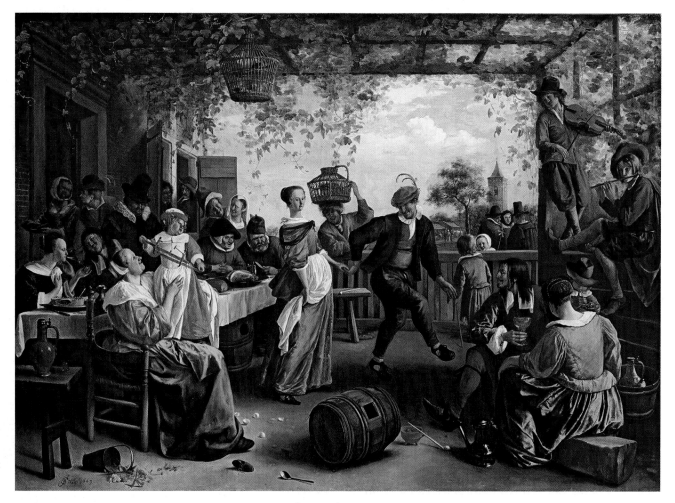

Fig. 22.11 Jan Steen, *The Dancing Couple*. 1663. Oil on canvas, 40 3/8″ × 56 1/8″. National Gallery of Art, Washington, D.C., Widener Collection. 1942.9.81. Photograph © 2007 Board of Trustees, National Gallery of Art, Washington, D.C. Steen's paintings, whatever their moralizing undercurrents, remind us that the Dutch were a people of great humor and happiness. They enjoyed life.

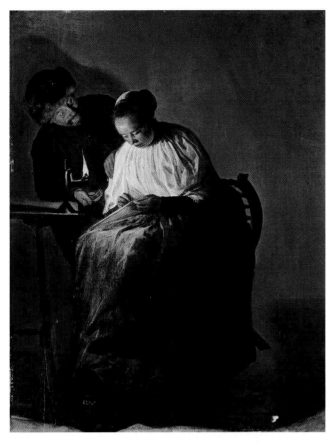

Fig. 22.12 Judith Leyster, *The Proposition*. 1631. Oil on canvas, 11⁷⁄₈″ × 9¹⁄₂″. Mauritshuis, The Hague. The Netherlands. SCALA/Art Resource, New York. The small size of the work underscores the intimacy of the scene, its detail almost as precise as the woman's needlework.

virtue and the latter with lust and greed. *The Proposition* stops short of submission, but Leyster frankly depicts the polarity of gender roles in Dutch society: the tension between private and social space, the awkward collision of domesticity and sexuality.

Johannes Vermeer and the Domestic Scene

As his painting *The Geographer* (see Fig. 22.1) suggests, Johannes Vermeer was, above all, a keen observer of his world. His paintings illuminate—and celebrate—the material reality of Dutch life. We know very little of Vermeer's life, and his painting was largely forgotten until the middle of the nineteenth century. But today he is recognized as one of the great masters of the Dutch seventeenth century. Vermeer painted only 34 works that modern scholars accept as authentic, and most depict intimate genre scenes that reveal a moment in the domestic world of women.

The example here is *Woman with a Pearl Necklace* (Fig. 22.13). Light floods the room from a window at the left, where a yellow curtain has been drawn back, allowing the young woman to see herself better in a small mirror beside the window. She is richly dressed, wearing an ermine-trimmed yellow satin jacket. On the table before her are a basin and a powder brush; she has evidently completed the process of putting on makeup and arranging her hair as

she draws the ribbons of her pearl necklace together and admires herself in the mirror. From her ear hangs a pearl earring, glistening in the light. The woman brims with self-confidence, and nothing in the painting suggests that Vermeer intends a moralistic message of some sort. While the woman's pearls might suggest her vanity—to say nothing of pride because of the way she gazes at them—they also traditionally symbolize truth, purity, even virginity. This latter reading is supported by the great, empty, and white stretch of wall that extends between her and the mirror. It is as if this young woman is a *tabula rasa* [TAB-yuh-luh RAHZ-uh], a blank slate, whose moral history remains to be written.

Vermeer's paintings of interiors are, for many art historians, a celebration of Dutch domestic culture. As much as anything else, they extol the comforts of home. In fact, the home is the chief form of Dutch architecture. Decorated with paintings and maps, furnished with comfortable furniture and carpets, its larder filled with foodstuffs from around the world, the home was the center of Dutch life.

The basic household consisted of a husband and wife, who married late, compared to the custom in other European countries: Men were generally over 26 and women over 23. Almost all families had at least one servant, usually a young

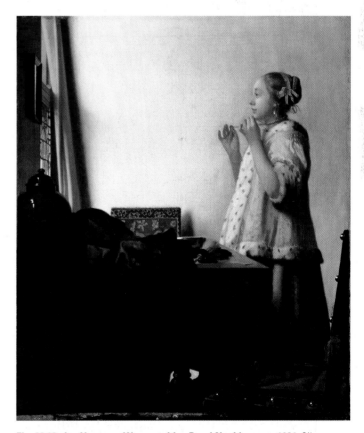

Fig. 22.13 Jan Vermeer, *Woman with a Pearl Necklace*. ca. 1664. Oil on canvas, 22⁵⁄₃₂″ × 17³⁄₄″. Post-restoration. Inv.: 912 B. Photo: Joerg P. Anders. Gemäldegalerie, Staatliche Museen zu Berlin, Berlin, Germany. Bildarchiv Preussischer Kulturbesitz/Art Resource, New York. The mirror can symbolize both vanity—self-love—and truth, the accurate reflection of the world.

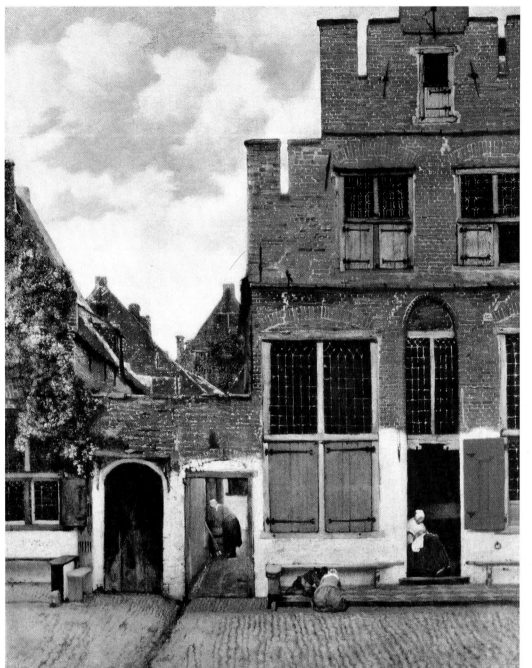

Fig. 22.14 Jan Vermeer, *The Little Street.* ca. 1657–58. Oil on canvas, 21 1/16″ × 17 1/8″. Rijksmuseum, Amsterdam. Note how the shape of the sky imitates the gables of the houses, but in reverse—an example of just how carefully Vermeer composed the piece.

woman who helped with domestic chores. She often was of the same social status as her employer and might stay on for eight to ten years, or until her own marriage. By working, she could accumulate a dowry large enough to contribute to the establishment of her own household when she married.

Vermeer's *The Little Street* (Fig. **22.14**) is a celebration of such domestic life. Seen from across the cobblestone street, the house is typical, presenting a symmetrical, step-gabled, and red-brick facade (against which Vermeer plays the asymmetry of his painting) that rises at a steep pitch to the central ridge of the roof. Its windows are rectangular but are set below decorative brick arches. Their shutters—on the first floor, two green shut ones on the left, a open red one at the right—underscore the asymmetry of Vermeer's composition. Similarly, the doorways to the passageways that run between the two houses contrast dramatically, the one open and light-filled, the other closed and dark. (Notice, as well, that the closed door is arched and set in a rectangular niche, while the open door is rectangular and set in an arched niche.) The painting is an exercise in contrasts, and yet it presents a scene of quiet and peaceful harmony. By means of these contrasts—and such details as the whitewash that extends incompletely up the wall, and the mortar filling the cracked facade—Vermeer acknowledges the tensions of domestic life, even as he presents a scene of quiet

harmony. A woman sits in the doorway, absorbed in her needlework. Children play at some game at the edge of the street. In the passageway that leads to an inner courtyard, the maidservant works at her chores. Not coincidentally, the vines growing on the house at the left are traditional symbols of love, fidelity, and marriage.

Marriage manuals were, in fact, extremely popular, even bestsellers. All advocated friendship between husband and wife as a major goal of a good marriage. The man was head of the household, his authority was absolute, and all external affairs were his responsibility. The woman maintained a certain status. She not only ruled over the workings of the house itself, but, as the marriage manuals uniformly suggested, was expected to be a true partner in her husband's affairs. She counseled him, encouraged him, and shared equally with him his burdens and successes. Probably the most popular of the marriage manuals was Jacob Cats's *Houwelick* (*Marriage*), first published in 1625, which devoted one chapter to each of six different roles in a woman's life: maiden, sweetheart, bride, housewife, mother, and widow. The book preached piety and virtue, but it also described, in tantalizing detail, the carnal acts that would inevitably lead to dire consequences. *Marriage* was, in short, a thinly disguised sex manual. Much like Dutch still-life painting, it was full of succulent treats and delicious morsels, but couched in the moral rhetoric of *vanitas*.

The Group Portrait

The leading portrait painter of early seventeenth-century Holland was Frans Hals (1581–1666) of Haarlem. Hals worked quickly, probably without preliminary sketches (none survive), with the loose and gestural brushstrokes apparent in his lively portrait of Descartes (see Fig. 22.5). He avoided flattering his sitters by softening or altering their features, seeking instead to convey their vitality and personality. Hals was particularly successful at the **group portrait**, a large canvas commissioned by a civic institution to document or commemorate its membership at a particular time.

Between 1616 and 1639, Hals painted five enormous group portraits for the two Haarlem militias: the Civic Guard of Saint George and the Cluveniers, who were also known as the Civic Guard of Saint Adrian. This was a mammoth task, because the five canvases alone contain 68 portraits of 61 different prominent Haarlem citizens, plus one dog. Group portraits of the civic guards had been commissioned before, but these set a new standard. Until this series, such group portraits had tended to be little more than formal rows of individual portraits. In the first of these paintings, *Banquet of the Officers of the St. George Civic Guard*, Hals turns the group portrait into a lively social event, capturing in specific detail a fleeting moment at the farewell banquet for the officers who had completed their three-year stint (Fig. **22.15**). Despite the casualness of the scene, Hals shows the hierarchy of the company by arranging its highest officers under the tip of the flag that tops an imaginary pyramid of figures. Alone at the head of the table and closest to the viewer sits the colonel, with the provost marshal, the second in command, on his right. They are the highest-ranking officers. Three captains sit down along the side of the table to the

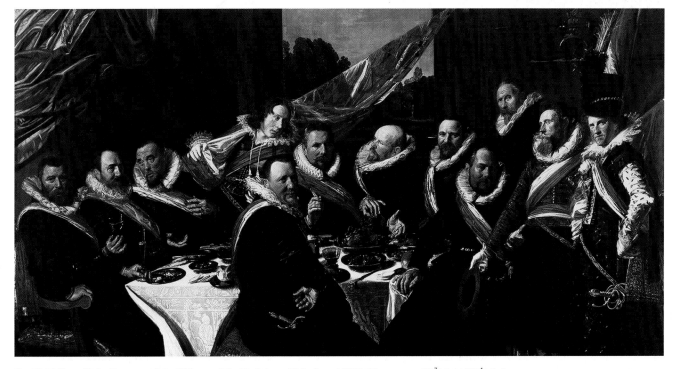

Fig. 22.15 Frans Hals, *Banquet of the Officers of the St. George Civic Guard*. 1616. Oil on canvas, 68 $^7/_8$″ × 137 $^1/_2$″. Frans Halsmuseum, Haarlem. The enormous scale of this painting reflects the Baroque taste for colossal theatrical settings. It is, in effect, the Northern vernacular equivalent in painting of Bernini's architectural colonnade for Vatican square (see Fig. 25.1)—both conceived essentially to consume the viewer within their space.

colonel's left, and three lieutenants sit at the far end of the table between the colonel and the provost. Three ensigns, not technically part of the officers' corps, stand at the right. Holding the flag at the back of the composition is a servant. So vigorous are Hals's portraits that this painting quickly became a symbol of the strength and healthy optimism of the men who established the new Dutch Republic.

Rembrandt van Rijn and the Drama of Light

In the hands of Rembrandt van Rijn (1606–1669), the group portrait took on an even more heightened sense of drama. The leading painter in Amsterdam and 25 years Hals's junior, Rembrandt learned much from the elder Dutchman, not least of all how to build up the figure with short dashes of paint or, alternately, long, fluid lines of loose, gestural brushwork. The result, paradoxically, is an image of extreme clarity, a clarity that has not always been apparent in his group portrait of *Captain Frans Banning Cocq Mustering His Company* (Fig. **22.16**). The enormous canvas (which was originally even larger) was so covered by a layer of grime and darkened varnish that for years it was thought to represent the Captain's company on a night patrol of Amsterdam's streets, and it was known, consequently, as *The Night Watch*. But after a thorough cleaning and restoration in 1975–76, its true subject revealed itself—the company forming for a parade in a side street of the city. Perhaps more important, the cleaning also revealed one of Rembrandt's important contributions to the art of portraiture— his use of light to animate his figures. Captain Cocq's hand extends toward us in the very center of the painting,

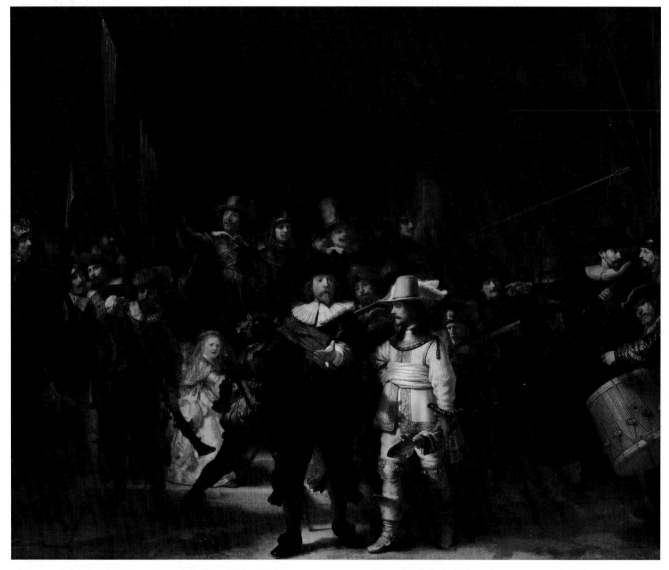

Fig. 22.16 Rembrandt van Rijn, *Captain Frans Banning Cocq Mustering His Company (The Night Watch).* 1642.
Oil on canvas, 11′11″ × 14′4″ (3.63 × 4.37 m). Rijksmuseum, Amsterdam. Recently, Dutch scholar Dudok van Heel has made a convincing case that the main character in the painting is not Frans Banning Cocq but Frans Bannink Cocq, a member of a much richer and more influential family than Banning Cocq.

LEARN MORE Gain insight from a primary source document on Rembrandt van Rijn at **www.myartslab.com**

Fig. 22.17 Rembrandt van Rijn, *Christ Preaching* **(the "Hundred-Guilder Print").** **ca. 1648–50.** Etching, 11″ × 15¹/₂″. Rijksmuseum, Amsterdam. Many of the figures in this etching were suggested by Spanish and Jewish refugees who crowded the streets of Amsterdam and whom Rembrandt regularly sketched.

casting a shadow across the lemon-yellow jacket of his lieutenant. Competing for our attention is a young woman, also dressed in yellow satin studded with pearls, to the Captain's right. A chicken hangs from her waist, and below it a money-bag, as if she has encountered the company on her way home from the market. She is such an odd addition to the scene that scholars have for years tried to account for her presence as, for instance, a symbolic representation of the company itself or, alternately, an ironic commentary on the company's relation to mercantile interests. That said, she certainly adds a dimension of liveliness to the scene, asserting herself as a dramatic presence who underscores the motion and action of the painting as a whole. Everyone seems to be looking in different directions; different conversations abound; the figure in red, at the left, seems to have just discharged his rifle; a dog barks at a drummer entering from the right. Compared to the sedentary group portrait of Hals (see Fig. 22.16), with its linear hierarchy, in which everybody seems literally to sit still for the portraitist, Rembrandt's group is animated, even noisy. As his figures move in and out of light and shadow, it seems as if the artist has barely managed to capture them.

In one of his most famous group portraits, *The Anatomy Lesson of Dr. Tulp* (see *Closer Look*, pages 720–721), Rembrandt would use this symbolic light for ironic effect. But in his religious works, especially, it would come to stand for the redemption offered to humankind by the example of Christ. This is especially apparent in his prints, where the contrast

between rich darks and brilliant lights could be exploited to great effect. Among the greatest of these is *Christ Preaching* (Fig. 22.17), also known as the "Hundred-Guilder Print" because it sold for 100 guilders at a seventeenth-century auction, at that time an unheard-of price for a print. The image illustrates the Gospel of Matthew, showing Christ addressing the sick and the lame, grouped at his feet and at his left, and the Pharisees, at his right. Always aware of Albrecht Dürer's great achievements in the medium (see Figs. 17.8 and 17.9), Rembrandt here constructs a triangle of light that seems to emanate from the figure of Christ himself, which seems to burst from the deep black gloom of the night. What the light is meant to offer, of course, is hope—and life.

Of all the artists of his era, Rembrandt was certainly the most interested in self-portraiture. A painter's own face is always freely available for study, and the self-portrait offered Rembrandt the opportunity to explore technical and compositional problems using himself as a means to do it. Over 60 self-portraits survive, most of them imbued with the same drama of light and dark that characterizes his other work. Beginning in 1640, he endured a series of tragedies, beginning with the death of his mother. Two years later, Rembrandt's wife Saskia died shortly after giving birth to Titus, the only one of their four children to survive to adulthood. Furthermore, Rembrandt lived notoriously beyond his means. In 1656, he was forced to declare bankruptcy, a public humiliation. The inventory of the collection he had put together to satisfy his eclectic taste is astonishing. There

EXPLORE MORE View a studio technique video about etching at **www.myartslab.com**

The *Anatomy Lesson of Dr. Tulp* was commissioned by Dr. Tulp to celebrate his second public anatomy demonstration performed in Amsterdam on January 31, 1632. Public dissections were always performed in the winter months in order to better preserve the cadaver from deterioration. The body generally was that of a recently executed prisoner. The object of these demonstrations was purely educational—how better to understand the human body than to inspect its innermost workings? By understanding the human body, the Dutch believed, one could come to understand God. As the Dutch poet Barlaeus put it in 1639, in a poem dedicated to Rembrandt's painting:

> *Listener, learn yourself! And while you proceed through the parts, believe that, even in the smallest, God lies hid.*

Public anatomies, or dissections, were extremely popular events. Town dignitaries would generally attend, and a ticket-paying public filled the amphitheater. As sobering as the lessons of an anatomy might be, the event was also an entertaining spectacle. An example of the Dutch group portrait, this one was designed to celebrate Tulp's medical knowledge as well as his following. He is surrounded by his students, all of whom are identified on the sheet of paper held by the figure standing behind the doctor. Their curiosity underscores Tulp's prestige and the scientific inquisitiveness of the age.

Like Frans Hals's group portrait *Banquet of the Officers of the St. George Civic Guard* (see Fig. 26.16), the figures are arranged in a triangle. Dr. Tulp, in the bottom right corner, holds forceps that are the focus of almost everyone's attention. As is characteristic of Rembrandt's work, light plays a highly symbolic role. It shines across the room, from left to right, directly lighting the faces of the three most inquisitive students, suggesting the light of revelation and learning. And it terminates at Tulp's face, almost as if he himself is the source of their light. Ironically, the best-lit figure in the scene is the corpse. Whereas light in Rembrandt's work almost always suggests the kind of lively animation we see on the students' brightly lit faces, here it illuminates death.

Dr. Frans van Loenen points at the corpse with his index finger as he engages the viewer's eyes. The gesture is meant to remind us that we are all mortal.

The pale, almost bluish skin tone of the cadaver contrasts dramatically with the rosy complexions of the surgeons. Typically, the cadaver's face was covered during the anatomy, but Rembrandt unmasked the cadaver's face for his painting. In fact, we know the identity of the cadaver. He is Adriaen Adriaenszoon, also known as "Aris Kindt"— "the Kid"—a criminal with a long history of thievery and assault who was hanged for beating an Amsterdam merchant while trying to steal his cape. Dr. Tulp and his colleagues retrieved the body from the gallows. In another context, a partly draped nude body so well lit would immediately evoke the entombment of Christ with its promise of Resurrection. It is the very impossibility of that fate for Adriaen Adriaenszoon that the lighting seems to underscore here.

Dr. Tulp is displaying the flexor muscles of the arm and hand and demonstrating their action by activating various muscles and tendons. It is the manual dexterity enabled by these muscles that physically distinguishes man from beast.

Something to Think About . . .

While it is the hand that distinguishes man from beast, why would an artist like Rembrandt be especially drawn to representing its dissection?

SEE MORE For a Closer Look at Rembrandt van Rijn's *The Anatomy Lesson of Dr. Tulp*, go to **www.myartslab.com**

Dr. Hartman Hartmanszoon holds in his hand a drawing of a flayed body upon which someone later added the names of all the figures in the scene.

Dr. Tulp was born Claes Pieterszoon but took the name *Tulp*—Dutch for "tulip"—sometime between 1611 and 1614 when still a medical student in Leiden, where he encountered the flower in the botanical gardens of the university. Throughout his career, a signboard painted with a single golden yellow tulip on an azure ground hung outside his house.

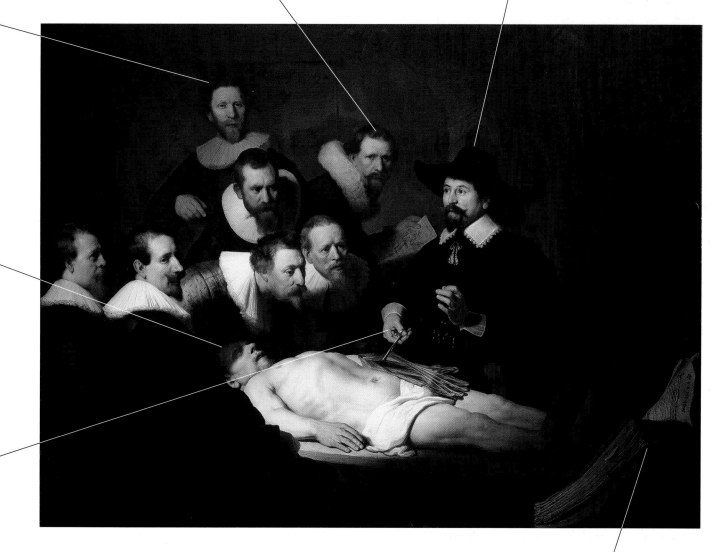

This large book may be the *De humani corporis fabrica,* the first thorough anatomy, published in 1543 by the Dutch scientist Andreis van Wesel (1514–1564), known as Vesalius, who had taught anatomy at the University of Padua. Tulp thought of himself as *Vesalius redivivus,* "Vesalius revived."

Rembrandt van Rijn, ***The Anatomy Lesson of Dr. Tulp.*** **1632.** Oil on canvas, 5'3 3/4" × 7'1 1/4" (169.5 × 216.5 cm). Royal Cabinet of Paintings Maurithsuis Foundation, The Hague, Netherlands.

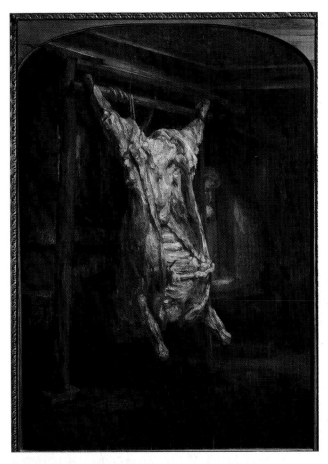

Fig. 22.18 Rembrandt van Rijn, *Slaughtered Ox*. 1655. Oil on panel, 37″ × 27 1/8″. Musée du Louvre/RMN Réunion des Musées Nationaux, France. Erich Lessing/Art Resource, New York. The painting lies fully within the tradition of Dutch still life (see Fig. 21.13), though it is much more starkly realistic than the norm.

Saskia—another 20,000 guilders. Within the context of these difficulties, he must have identified with the flayed body of the ox. Yet the image is also one of plenty and well-being—suggesting a feast to come. This reading is supported by the emergence from the doorway behind the crossbeams of a kitchen maid, bathed in a soft light. A similar optimism pervades all of Rembrandt's late work, perhaps because he saw light, a requirement of the painter's act of seeing, as inherently imbued with divine goodness, or at least its promise.

His *Self-Portrait* of 1658 tends to confirm this reading of the *Slaughtered Ox* as a kind of self-portrait (Fig. **22.19**). Here Rembrandt sits kinglike, dressed in rich robes, leaning forward in his chair, his legs wide apart, scepter or staff in hand, bathed in light. His hands, especially the left one, show the same ferocity and rough brushwork as the *Slaughtered Ox* and look quite meaty. In this painting, Rembrandt seems to rise above his impoverished condition long enough to play the part of the victor, not the vanquished. The ferocity of Rembrandt's brushwork suggests that the function of art is to transform mere flesh by the stroke of imagination, to wrest from the inevitable misfortune of humanity a certain dignity, even a kind of triumph. In the drama of light that pervades his art, he asserted both the psychological complexity of a profoundly individual personality and a more general, but deeply felt, compassion for humanity.

THE BAROQUE KEYBOARD

In the late eighteenth century, the philosopher and sometimes composer Jean-Jacques Rousseau [roo-SOH] (whose work will be discussed in Chapter 25) described Baroque music in the most unflattering terms: "A baroque music is that in which the harmony is confused, charged with modulation and dissonances, the melody is harsh and little natural, the intonation difficult, and the movement constrained." In many ways, the description is accurate, although Rousseau's negative reaction to these characteristics reveals more about the musical taste of his own later age than it does the quality of music in the Baroque era itself. Stylistically, the music of the Baroque era is as varied as the Baroque art of Rome and Amsterdam. Like the art created in both centers, it is purposefully dramatic and committed to arousing emotion in the listener. Religious music, particularly, was devoted to evoking the Passion of Christ. Also like Baroque art in both cities, Baroque music sought to be new and original, as Catholic and Protestant churches, north and south, constantly demanded new music for their services. At the same time, Baroque musicians created new secular forms of music as well. (See the discussion of Corelli and the *sonata da camera* in Chapter 21.) Perhaps most significant of all, the Baroque era produced more new instruments than any other. Additionally, even traditional instruments were almost totally transformed. This was the golden age of the organ. The deep intonations of this very ancient instrument, dating from the

were South American Indian costumes, shells, sponges, and coral from around the world's oceans, a stuffed New Guinea bird of paradise, Chinese ceramics, Turkish and Persian textiles, musical instruments of all kinds and from all periods, Javanese shadow puppets, and arms and armor. Works of art included sculpture busts of the Roman emperors from Augustus through Marcus Aurelius, "a little child by Michelangelo," and a huge collection of works on paper, including examples by Bruegel and Rubens, and a "precious book" (perhaps a collection of drawings) by Mantegna. He had used many of these items in his paintings. Suddenly he found himself without his things.

It is tempting to read his *Slaughtered Ox* of 1655, painted just before his bankruptcy, as a psychological self-portrait, reflecting the artist's anguish as he saw ruin approaching (Fig. **22.18**). Disemboweled and lashed to a wooden frame, its hind legs spread in some grotesque parody of the Crucifixion, the carcass is an exercise in the furious brushwork, the signature "rough style," for which Rembrandt was by now famous. At this point, he was over 13,000 guilders in debt, creditors were threatening to take his home, and he had spent all of Titus's inheritance from

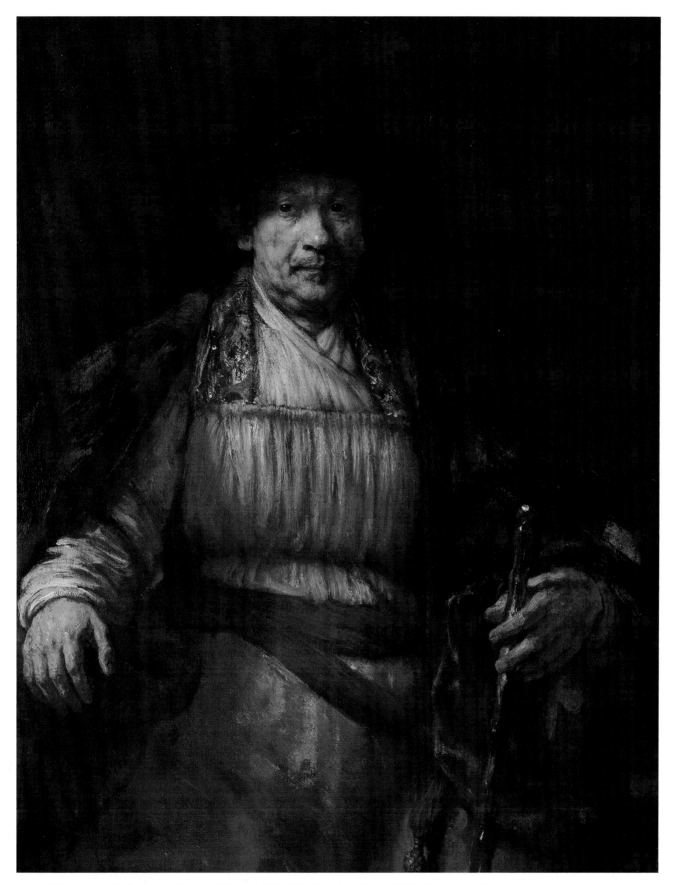

Fig. 22.19 Rembrandt Harmensz van Rijn, *Self-Portrait*. 1606–1669. Dutch, "Self-Portrait". 1658. Oil on Canvas (lined) 52⅝″ × 40⅞″. (133.7 × 103.8 cm). Signed and dated on the arm of the chair at right: Rembrandt/f.1658. Purchased in 1906. Acc #06.1.97. The Frick Collection, NY. Looking past the viewer, Rembrandt's gaze removes him from the cares of everyday life, and transports him into an almost purely imaginative space.

third century BCE, reached new heights as it commanded the emotions of both Catholic and Protestant churchgoers alike. By the first half of the eighteenth century, the piano began to emerge as a vital instrument even as the harpsichord was perfected technically. And for the first time in the history of music, instrumental virtuosos, especially on violin and keyboard, began to rival vocalists in popularity.

One of the primary forms of entertainment at Dutch family gatherings was the performance of keyboard music by the lady of the house, and indeed most of the surviving compositions from the period are scores made for home use. In fact, Vermeer's several paintings of young women playing the virginal, a keyboard instrument, such as his *Lady at the Virginal with a Gentleman*, also known as *The Music Lesson* (Fig. 22.20), are emblems of domestic harmony. In Vermeer's painting, the idea of harmony is further asserted by the empty chair and bass viol behind the young woman, which, we can assume, the young gentleman will soon take up in a duet. Inscribed on the lid of the virginal are the words "MVSICA LETITIAE CO[ME]S MEDICINA DO-LOR[VM]" ("Music is the companion of joy and balm for sorrow"). In the context of Dutch domestic life, it would not be far-fetched to substitute *marriage* for *music*, so close is the analogy.

Jan Pieterszoon Sweelinck's Fantasies for the Organ

Amsterdam was home to one of the greatest keyboard masters of the seventeenth century, Jan Pieterszoon Sweelinck [SWAY-lingk] (1562–1621). As the official organist of Amsterdam, he performed on the great organ at the Oude Kerk (Old Church) for 40 years. Calvinist doctrine required that, at church services, he play standard hymns from the early years of the Reformation. Nevertheless, he was famous for his preludes and postludes to the services, which were virtuoso improvisations. These helped to draw large congregations on Sundays, and he routinely gave public concerts during the week as well. Students from all over Europe flocked to Amsterdam to study with Sweelinck, and, by the time of his death in 1621, he had transformed keyboard composition, especially in Germany. A long line of his pupils came to be regarded as members of the North German school.

Sweelinck was especially noted for his **fantasias**, keyboard works that lack a conventional structure but follow, or at least give the impression of following, the composer's free flight of fantasy. In fact, by the 1620s, when Sweelinck's compositions were in wide circulation, the terms *fantasia* and *prelude* were used interchangeably to refer to this purely instrumental form.

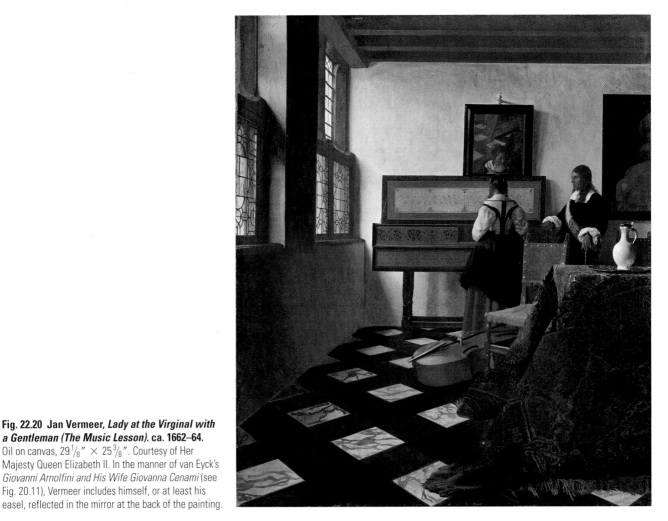

Fig. 22.20 Jan Vermeer, *Lady at the Virginal with a Gentleman (The Music Lesson).* **ca. 1662–64.** Oil on canvas, 29 1/8″ × 25 3/8″. Courtesy of Her Majesty Queen Elizabeth II. In the manner of van Eyck's *Giovanni Arnolfini and His Wife Giovanna Cenami* (see Fig. 20.11), Vermeer includes himself, or at least his easel, reflected in the mirror at the back of the painting.

In his 1597 *Plain and Easy Introduction to Practical Music*, the English composer Thomas Morley (1558–1602) described fantasias as follows:

> The most principal and chiefest kind of music which is made without a ditty [i.e., without words to be sung] is the Fantasy, that is when a musician taketh a point [i.e., a theme] at his pleasure and wresteth and turneth it as he list [chooses], making either much or little of it according as shall seem best in his own conceit. In this may more art be shown than in any other music because the composer is tied to nothing, but that he may add, diminish, and alter at his pleasure.

Sweelinck's displays of virtuosity were heightened by his use of the pedalboard. (The organ normally had two keyboards playable by the hands, and a third keyboard playable by the feet.) Using the pedalboard as an independent part of the composition allowed Sweelinck, and the many composers who followed his lead, to create highly dramatic works that, in Morley's words, "wresteth and turneth" in surprisingly original ways. In their variety of forms—"discords, quick motions, slow motions"—in the composer's ability "to add, diminish, and alter at his pleasure," but above all in their ability to surprise their audience, Sweelinck's compositions were the musical equivalent of the Baroque architecture embodied in Francesco Borromini's Church of San Carlo alle Quattro Fontane (see Fig. 21.10).

The North German School: Johann Sebastian Bach

Perhaps the greatest heir to Sweelinck's innovations was Johann Sebastian Bach [bakh] (1685–1750). Born 60 years after Sweelinck's death and at the end of the seventeenth century, Bach was very much a master of the keyboard in Sweelinck's Baroque tradition. Like Sweelinck, Bach sought to convey the devotional piety of the Protestant tradition through his religious music. And like Sweelinck, he was an organist, first in the churches of small German towns, then in the courts of the Duke of Weimar [VY-mahr] and the Prince of Cöthen, and finally at Saint Thomas's Lutheran Church in Leipzig [LIPE-zig]. There he wrote most of the music for the Lutheran church services, which were much more elaborate than the Calvinist services in Amsterdam.

Vocal Music For each Sunday service, Bach also composed a **cantata**, a multimovement musical commentary on the chosen text of the day sung by soloists and chorus accompanied by one or more instruments, usually the organ. The first half of the cantata was performed after the scriptural lesson and the second half after the sermon, concluding with a chorale, a hymn sung in the vernacular by the entire congregation. Like operas, cantatas include both recitative parts and arias.

Bach's cantatas are usually based on the simple melodies of Lutheran chorales, but are transformed by his genius for **counterpoint**, the addition of one or more independent melodies above or below the main melody, in this case the line of the Lutheran chorale. The result is an ornate musical texture that is characteristically Baroque. *Jesu, der du meine Seele* ("Jesus, It Is By You That My Soul") provides a perfect example, and it reveals the extraordinary productivity of Bach as a composer, driven as he was by the Baroque demand for the new and the original. He wrote it in 1724, a week after writing another entirely new cantata, and a week before writing yet another. (Bach was compelled to write them in time for his choir and orchestra to HEAR MORE at rehearse.) The opening chorus (track **22.1**) is www.myartslab.com based on the words and melody of a chorale that would have been familiar to all parishioners. That melody is always presented by the soprano, and is first heard 21 measures into the composition after an extended passage for the orchestra. Even the untrained ear can appreciate the play between this melody and the others introduced in counterpoint to it.

Over the course of his career, Bach composed more than 300 cantatas, or five complete sets, one for each Sunday and feast day of the church calendar. In addition, he composed large-scale **oratorios**. These are lengthy choral works, either sacred or secular, but without action or scenery, performed by a narrator, soloists, chorus, and orchestra (see Chapter 21) for Christmas and Easter. Bach's *Christmas Oratorio* is a unique example of the form. It consists of six cantatas, written to be sung on six separate days over the course of the Christmas season from 1734 to 1735, beginning on Christmas Day and ending on Epiphany (January 6). Based on the gospels of Saint Luke and Saint Matthew, the story is narrated by a tenor soloist in the role of an Evangelist. Other soloists include an Angel, in the second cantata, and Herod, in the sixth. The chorus itself assumes several roles: the heavenly host singing "Glory to God" in the second cantata; the shepherds singing "Let us, even now, go to Bethlehem" in the third; and, in the fifth, the Wise Men, singing "Where is this new-born child; the king of the Jews?" Solo arias interrupt the narrative in order to reflect upon the meanings of the story.

One of Bach's greatest achievements in vocal music is *The Passion According to Saint Matthew*, written for the Good Friday service in Leipzig in 1727. A **passion** is similar to an oratorio in form but tells the story from the Gospels of the death and Resurrection of Jesus. Composed of the sung texts of chapters 26 and 27 of the Gospel of Matthew, it narrates the events between the Last Supper and the Resurrection. It is a huge work, over three hours long. A double chorus assisted by a boys' choir alternates with soloists (representing Matthew, Jesus, Judas, and others) who sing arias and recitatives, all accompanied by a double orchestra and two organs. As in the *Christmas Oratorio*, the story is narrated by a tenor Evangelist. The words of Jesus are surrounded by a lush string accompaniment, Bach's way of creating a musical halo around them. All told, in the *Passion of Saint Matthew* Bach seems to have captured the entire range of human emotion, from terror and grief to the highest joy.

Instrumental Music Bach wrote instrumental music for almost all occasions, including funerals, marriages, and civic celebrations. Among his most famous instrumental works are the six *Brandenburg* concertos, dedicated to the Margrave of

Brandenburg in 1721. (A margrave was a German title, of lesser rank than a duke.) Each of the six is scored differently, and in fact Bach seems to have been intent on exploring the widest possible range of orchestral instruments in often daring combinations. Technically, concertos number one, two, four, and five are examples of the **concerto grosso** large concerts—which feature several solo instruments accompanied by a **ripieno** (Italian for "full") ensemble. The second, for instance, is scored for trumpet, recorder (often performed by a flute today), oboe, and violin as soloists. In the third movement of the second concerto, the main melody is stated by the solo trumpet and subsequently imitated in counterpoint by all the other soloists, and subsequently restated by both the violin and oboe, until at the conclusion the trumpet makes a final statement accompanied by all the soloists and the orchestra (track **22.2**). The third concerto is a **ripieno concerto**, a form which features no solo instruments at all and is scored for strings. The sixth is unique, calling for low strings (no violins or violas) to accompany two solo violas and two solo viola da gambas (a bass stringed instrument slightly smaller than a cello).

(((• HEAR MORE at www.myartslab.com

One of Bach's great contributions to secular instrumental musical history is his *Well-Tempered Clavier*. It is an attempt to popularize the idea of **equal temperament** in musical tuning, especially the tuning of keyboard instruments like the harpsichord, the virginal (a smaller harpsichord), and the clavichord. The harpsichord is a piano-like instrument whose strings are plucked rather than struck as with a piano. A clavichord's brass or metal strings are struck by metal blades (Fig. **22.21**). Equal temperament consists in dividing the octave into 12 half-steps of equal size. *The Well-Tempered Clavier* is a two-part collection of musical compositions, the first part completed in 1722, and the second around 1740. Each part consists of 24 preludes and fugues, one prelude and one fugue in each of the 12 major and minor keys.

The **fugue** is a genre that carries a single thematic idea for the entire length of the work. As Bach wrote on the title page to the first part, the pieces were intended "for the profit and use of musical youth desirous of learning and especially for the pastime of those already skilled in this study." Bach's fugues, of which the *Fugue in D major* from Part II of *The Well-Tempered Clavier* is a remarkable example, consist of four independent parts (or occasionally three), one part, or *voice*, of which states a theme or melody—called a *subject*—and is then imitated by a succession of the other voices. The parts constantly overlap as the first voice continues playing in counterpoint, using material other than the main subject, while the second takes up the subject, and so on. The trick is to give each voice a distinctly independent line and to play all four voices simultaneously with two hands on a single instrument (track **22.3**). In the end, the fugues in *The Well-Tempered Clavier* are almost sublime examples of Cartesian rationalism. In his 1649 *The Passions of the Soul*, Descartes had argued that human emotions—love, hate, joy, sadness, or exaltation—were objective in nature and susceptible to rational description, particularly in the language of music. Bach's fugues are a demonstration of this, laying out a range of feeling with a virtually mathematical clarity.

HEAR MORE at •))) www.myartslab.com

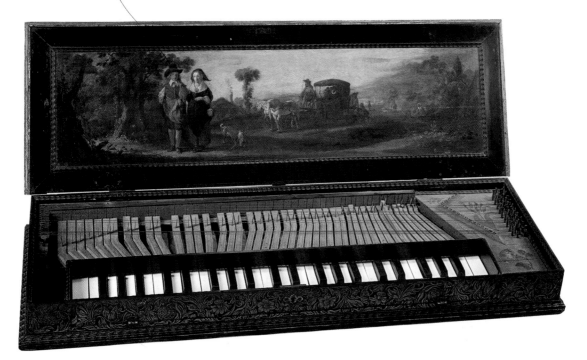

Fig. 22.21 Clavichord with painted images, Dirk Stoop (painter). ca. 1660–80. Painted musical instrument, 4″ × 32 1/2″ × 10 3/4″. Collection Rijksmuseum, Amsterdam. Item # NM -9487. Clavichords were built as early as the fifteenth century, perhaps even earlier. It was at once the most personal and quietest of European keyboard instruments, perfect for the household chamber.

The Art of the People and the Tastes of the Court

If, as many believe, Rembrandt was the leading painter of the vernacular in Baroque Amsterdam, the leading court painter of the period is Peter Paul Rubens (1577–1640). Rubens's career in Antwerp, the Catholic city in the Spanish Netherlands, overlapped Rembrandt's in Amsterdam. Rubens was 30 years older than Rembrandt and had long been an international sensation by the time Rembrandt left Leiden for Amsterdam in 1631. The list of Rubens's accomplishments is long and impressive: chief painter to the Habsburg governors of Flanders, then in the 1620s to the Queen Mother of France, Marie de' Medici, and to Charles I of England; knighted in Brussels, London, and Madrid; successful diplomat who negotiated the treaty of peace between England and Spain in 1629 to 1630; and owner of what many considered the greatest collection of antique sculpture in the world, housed in what was also arguably the finest house in all Antwerp.

Across Europe in the seventeenth century, Rubens's exuberant style would dominate. It was a style more attuned to the lavish, even sensual lifestyle of the royal courts. The Dutch Reformists had managed to expel the excesses of Baroque style from Holland, but still, Rubens was the artist whom every young painter sought to emulate in the early seventeenth century. Rembrandt, despite his far more conservative and Protestant leanings, was no exception. What distinguished him was that he possessed the talent to compete with the master.

In 1633, at age 27, Rembrandt painted a *Descent from the Cross* (Fig. **22.22**) based directly on an engraving of Rubens's own *Descent from the Cross* in Antwerp Cathedral (Fig. **22.23**), painted 20 years earlier. The differences are more revealing than the similarities. For one thing, the scale of Rembrandt's intimate painting is much smaller than Rubens's original altarpiece, probably the result of Rembrandt's working from the etching. Furthermore, Rembrandt pushes the scene deeper into the space of the canvas, filling the foreground with shadow and deepening the picture plane so that viewers are more removed from the action. Many of his figures, too, are removed from the action, helplessly looking on, whereas in the Rubens everyone is engaged in the scene. The greatest difference, however, is that Rubens's *Descent* luxuriates in color and sensually curving line. Rembrandt's painting seems positively austere beside it. Nowhere in the seventeenth century can we more plainly see the tension between the art of the people, embodied in the taste of the middle-class Dutch, and the art of the royal courts of France, Spain, and England, the subject of the next chapter. ∎

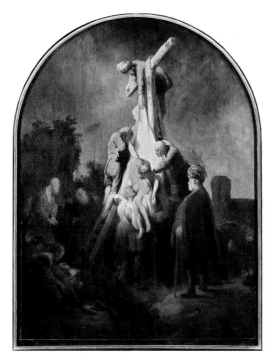

Fig. 22.22 Rembrandt van Rijn, *Descent from the Cross.* ca. 1633. Oil on panel, 35¼″ × 25⅝″. Antwerp Cathedral, Belgium. SCALA/Art Resource, New York.

Fig. 22.23 Peter Paul Rubens, *Descent from the Cross.* 1611–14. Oil on panel, 13′9⅝″ × 10′2″. Alte Pinakothek, Munich, Germany. SCALA/Art Resource, New York.

What forces were at work in Amsterdam in the seventeenth century?

As Holland asserted its independence from Spain at the end of the sixteenth century, Amsterdam replaced Antwerp as the center of culture and commerce in the north. Its commercial ascendancy was underscored by the wealth at the city's disposal during the tulipomania, or tulip madness, of 1634 to 1637. How were the forces that drove the tulip craze balanced by the conservatism of the Dutch Reformed Church?

How did developments in philosophy and science underpin the Dutch attention to visual detail?

Developments in philosophy and science challenged the authority of both the Catholic and Protestant churches. In England, Francis Bacon developed the empirical method, a process of inductive reasoning. Bacon's writings circulated widely in Holland, where, for over 20 years, René Descartes developed a separate brand of philosophy based on deductive reasoning. What is the difference between inductive and deductive reasoning? Why would the Church—Catholic and Protestant alike—feel threatened by the philosophies of both Francis Bacon and René Descartes?

Scientific discoveries supported the philosophies of Bacon and Descartes. Johannes Kepler described functional properties of the human eye, the optical properties of lenses, and the movement of the planets in the solar system. His friend Galileo Galilei perfected the telescope, described the forces of gravity, and theorized the speed of light. How would the Church react to Galileo's discoveries? Meanwhile, in Holland, the microscope had been developed, and soon Antoni van Leeuwenhoek began to describe, for the first time, "little animals"—bacteria and protozoa—sperm cells, blood cells, and many other organisms.

How does the vernacular manifest itself in Dutch painting?

Still lifes, landscapes, and genre paintings, including many like Vermeer's that depict domestic life, were especially popular. Most popular of all, however, were portrait paintings, including large-scale group portraits, such as those by Hals and Rembrandt, commemorating the achievements of community leaders, civic militia, and the like. How does the Dutch taste in painting reflect Francis Bacon's philosophical principles? How do you account for the popularity of portraiture in Dutch society? How might you connect it to Descartes's sense of self? Rembrandt van Rijn's paintings are especially notable for their dramatic liveliness. How does his mastery of light and dark contribute to this?

What are the characteristic features of Baroque keyboard music?

Keyboard music was a prominent feature of Dutch domestic life. What role did it play in the home? In Amsterdam, Jan Pieterszoon Sweelinck, organist for 40 years at the Oude Kerk (Old Church), developed the distinctly Baroque brand of keyboard work known as the fantasy, or alternately, the prelude. These works were widely imitated across Europe, reaching a height in the composition of Johann Sebastian Bach in Germany. How would you characterize these keyboard works? Bach's many compositions reflect one of the distinct features of Baroque music, the drive to create new and original compositions at a sometimes unheard-of pace. What did his *Well-Tempered Clavier* contribute to secular musical history?

PRACTICE MORE Get flashcards for images and terms and review chapter material with quizzes at **www.myartslab.com**

GLOSSARY

camera obscura A device that anticipates the modern camera but lacks the means of capturing an image on film.

cantata A multimovement musical commentary on the chosen text of the day sung by soloists and chorus accompanied by one or more instruments, most often the organ.

concerto grosso A Baroque concerto featuring both soloists and a larger ensemble (the *ripieno*).

counterpoint The addition of one or more independent melodies above or below the main melody.

deductive reasoning A method that begins with clearly established general principles and proceeds to the establishment of particular truths.

deism The brand of faith that argues that the basis of belief in God is reason and logic rather than revelation or tradition.

empirical method A manner of inquiry that combines *inductive reasoning* and scientific experimentation.

equal temperament A system of tuning that consists of dividing the octave into 12 half-steps of equal size.

fantasias A keyboard work that possesses no conventional structure but follows, or at least gives the impression of following, the composer's free flight of fantasy.

fugue A contrapuntal work in which a musical theme is played by a series of musical lines, each in turn, until all the lines are playing at once.

genre scene A painting that depicts events from everyday life.

geocentric Earth-centered.

group portrait A large canvas commissioned by a civic institution to document or commemorate its membership at a particular time.

heliocentric Sun-centered.

inductive reasoning A process in which, through the direct and careful observation of natural phenomena, one can draw general conclusions from particular examples and predict the operations of nature as a whole.

landscape A painting that shows natural scenery.

oratorio A lengthy choral work of a sacred or secular nature but without action or scenery and performed by a narrator, soloists, chorus, and orchestra.

passion A musical setting, similar to an *oratorio*, that recounts the last days of the life of Jesus.

ripieno In Baroque music, the name for the large ensemble within a *concerto grosso*.

ripieno concerto A concerto for a large ensemble lacking any soloists.

still life A painting dedicated to the representation of common household objects and food.

***vanitas* painting** A type of painting that reminds the viewer that pleasurable things in life inevitably fade, that the material world is not as long-lived as the spiritual, and that the spiritual should command our attention.

READING

READING 22.1

from Francis Bacon, *Novum Organum Scientiarum (The New Method of Science)* (1620)

As a lawyer, member of Parliament and Queen's Counsel, the Englishman Francis Bacon wrote on questions of law, state, and religion, as well as on contemporary politics, but he is best known for his empirical essays on natural philosophy, including the Novum Organum Scientiarum (The New Method of Science). *In that work, he presents the following theory of "Idols," the false notions that must be purged from the mind before it can properly engage in the acquisition of knowledge. Empiricism is, in fact, the "new method of science" that will restore the senses by freeing them from the Idols.*

36 One method of delivery alone remains to us which is simply this: we must lead men to the particulars themselves, and their series and order; while men on their side must force themselves for a while to lay their notions by and begin to familiarize themselves with facts.

38 The idols and false notions which are now in possession of the human understanding, and have taken deep root therein, not only so beset men's minds that truth can hardly find entrance, but even after entrance is obtained, they will again in the very instauration[1] of the sciences meet and trouble us, unless men being forewarned of the danger fortify themselves as far as may be against their assaults.

39 There are four classes of Idols which beset men's minds. To these for distinction's sake I have assigned names, calling the first class *Idols of the Tribe*; the second, *Idols of the Cave*; the third, *Idols of the Market Place*; the fourth, *Idols of the Theater*.

41 The Idols of the Tribe have their foundation in human nature itself, and in the tribe or race of men. For it is a false assertion that the sense of man is the measure of things. On the contrary, all perceptions as well of the sense as of the mind are according to the measure of the individual and not according to the measure of the universe. And the human understanding is like a false mirror, which, receiving rays irregularly, distorts and discolors the nature of things by mingling its own nature with it.

42 The Idols of the Cave are the idols of the individual man. For everyone (besides the errors common to human nature in general) has a cave or den of his own, which refracts and discolors the light of nature, owing either to his own proper and peculiar nature; or to his education and conversation with others; or to the reading of books, and the authority of those whom he esteems and admires; or to the differences of impressions, accordingly as they take place in a mind preoccupied and predisposed or in a mind indifferent and settled; or the like. So that the spirit of man (according as it is meted out to different individuals) is in

fact a thing variable and full of perturbation, and governed as it were by chance. Whence it was well observed by Heraclitus[2] that men look for sciences in their own lesser worlds, and not in the greater or common world.

43 There are also Idols formed by the intercourse and association of men with each other, which I call Idols of the Market Place, on account of the commerce and consort of men there. For it is by discourse that men associate, and words are imposed according to the apprehension of the vulgar. And therefore the ill and unfit choice of words wonderfully obstructs the understanding. Nor do the definitions or explanations wherewith in some things learned men are wont to guard and defend themselves, by any means set the matter right. But words plainly force and overrule the understanding, and throw all into confusion, and lead men away into numberless empty controversies and idle fancies.

44 Lastly, there are Idols which have immigrated into men's minds from the various dogmas of philosophies, and also from wrong laws of demonstration. These I call Idols of the Theater, because in my judgment all the received systems are but so many stage plays, representing worlds of their own creation after an unreal and scenic fashion. Nor is it only of the systems now in vogue, or only of the ancient sects and philosophies, that I speak; for many more plays of the same kind may yet be composed and in like artificial manner set forth; seeing that errors the most widely different have nevertheless causes for the most part alike. Neither again do I mean this only of entire systems, but also of many principles and axioms in science, which by tradition, credulity, and negligence have come to be received.

READING CRITICALLY

Can you identify, in your own place and time, an example of each of Bacon's "Idols" playing itself out and determining the way people think fallaciously?

[1] Reorganization or renewal.

[2] A Greek philosopher, ca. 500 BCE, who taught that nature was in a state of flux.

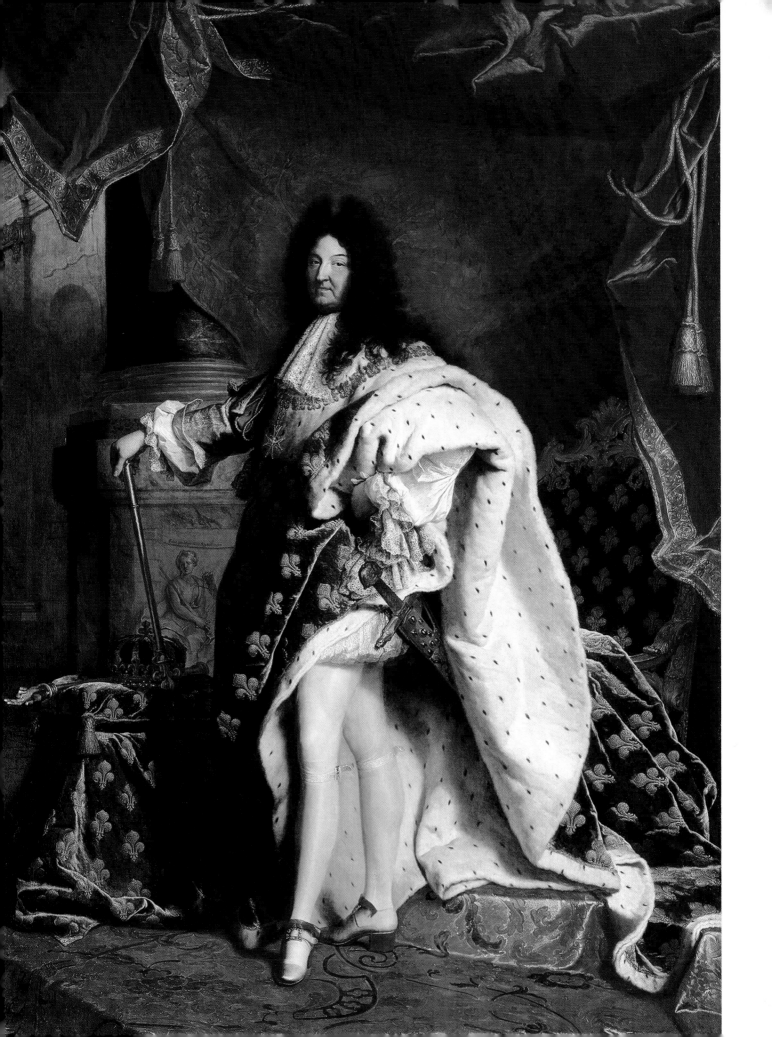

23 | The Baroque Court
Absolute Power and Royal Patronage

THINKING AHEAD

What is absolutism?

What tastes in art competed for Louis XIV's favor?

How did political conflict affect the arts in England?

What role did the arts play in the Spanish court?

How did Native American traditions affect the Baroque style in the Americas?

L ouis XIV (r. 1643–1715), King of France, thought of himself as *Le Roi Soleil* [leh wah so-LAY], "the Sun King," because like the sun (associated with Apollo, god of peace and the arts) he saw himself dispensing bounty across the land. His ritual risings and retirings (the *levée du roi* [leh-VAY dew wah] and the *couchée du roi* [koo-SHAY]) symbolized the actual rising and setting of the sun. They were essentially state occasions, attended by either the entire court or a select group of fawning aristocrats who eagerly entered their names on waiting lists.

Louis's sense of his own authority—to say nothing of his notorious vanity—is wonderfully captured in Hyacinthe Rigaud's [ree-GOH] (1659–1743) official state portrait of 1701 (Fig. **23.1**). The king has flung his robes over his shoulder in order to reveal his white stockings and red high-heeled shoes. He designed the shoes himself to compensate for his 5-foot-4-inch height. He is 63 years old in this portrait, but he means to make it clear that he is still a dashing courtier.

Louis's control over the lives of his courtiers had the political benefit of making them financially dependent on him. According to the memoirs of the duc de Saint Simon, Louis de Rouvroy (1675–1755):

> He loved splendour, magnificence, and profusion in all things, and encouraged similar tastes in his Court; to spend money freely on equipages and buildings, on feasting and at cards, was a sure way to gain his favour, perhaps to obtain the honour of a word from him. Motives of policy had something to do with this; by making expensive habits the fashion, and, for people in a certain position, a necessity, he compelled his courtiers to live beyond their income, and gradually reduced them to depend on his bounty for the means of subsistence.

Louis, in fact, encouraged the noblewomen at court to consider it something of an honor to sleep with him; he had many mistresses and many illegitimate children. Life in his court was entirely formal, governed by custom and rule, so

◀ **Fig. 23.1 Hyacinthe Rigaud, *Louis XIV, King of France*. 1701.** Oil on canvas, 9'1" × 6'4³⁄₈". Musée du Louvre/RMN Réunion des Musées Nationaux, France. Herve Lewandowski/Art Resource, New York. In his ermine coronation robes, his feet adorned in red high-heeled shoes, Louis both literally and figuratively looks down his nose at the viewer, his sense of superiority fully captured by Rigaud.

SEE MORE For a Closer Look at Hyacinthe Rigaud's *Louis XIV*, go to **www.myartslab.com**

HEAR MORE Listen to an audio file of your chapter at **www.myartslab.com**

etiquette became a way of social advancement. He required the use of a fork at meal times instead of using one's fingers. Where one sat at dinner was determined by rank. Rank even determined whether footmen opened one or two of his palace's glass-paneled "French doors" as each guest passed through.

By the start of the eighteenth century, almost every royal court in Europe modeled itself on Louis XIV's court. Louis so successfully asserted his authority over the French people, the aristocracy, and the Church that the era in which he ruled has become known as the Age of Absolutism. **Absolutism** is a term applied to strong, centralized monarchies that exert royal power over their dominions, usually on the grounds of divine right. The principle had its roots in the Middle Ages, when the pope crowned Europe's kings, and went back even further to the man/god kings of ancient Mesopotamia and Egypt. But by the seventeenth century, the divine right of kings was assumed to exist even without papal acknowledgment. The most famous description of the nature of absolutism is by Bishop Jacques-Bénigne Bossuet [BOS-sway] (1627–1704), Louis's court preacher and tutor to his son. While training the young dauphin for a future role as king, Bossuet wrote *Politics Drawn from the Very Words of Holy Scripture*, a book dedicated to describing the source and proper exercise of political power. In it, he says the following:

> God is infinite, God is all. The prince, as prince, is not regarded as a private person: he is a public personage, all the state is in him; the will of all the people is included in his. As all perfection and all strength are united in God, so all the power of individuals is united in the person of the prince. What grandeur that a single man should embody so much! . . .

> Behold an immense people united in a single person; behold this holy power, paternal and absolute; behold the secret cause which governs the whole body of the state, contained in a single head: you see the image of God in the king, and you have the idea of royal majesty. God is holiness itself, goodness itself, and power itself. In these things lies the majesty of God. In the image of these things lies the majesty of the prince.

The role of absolutism in defining and controlling developments in the arts in the seventeenth century is the subject of this chapter. Although the monarchs of Europe were often at war with one another, they were united in their belief in the power of the throne and the role of the arts in sustaining their authority. In France, Louis XIV never missed an opportunity to use the arts to impress upon the French people (and the other courts of Europe) his grandeur and power. In England, the monarchy struggled to assert its divine right to rule as it fought for power against Puritan factions that denied absolutism. Royalist and Puritan factions each developed distinctive styles of art and literature. In Spain, the absolute rule of the monarchy was deeply troubled by the financial insolvency of the state. Nevertheless, royal patronage brought about what has been called the Golden Age of Spanish arts and letters. Finally, in the Americas, the Spanish monarch asserted his absolute authority by encouraging the creation of art and architecture as symbols of his divine right to rule over the two continents. In the Americas, the European Baroque merged with Native American decorative tastes to produce what is possibly the era's most elaborate expression of the Baroque.

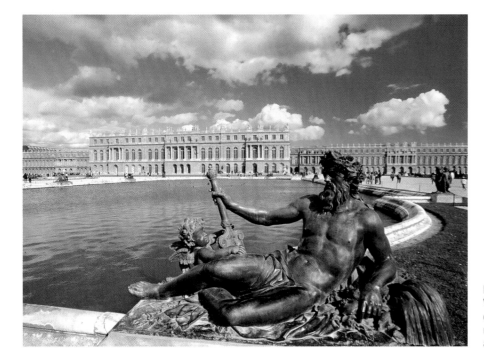

Fig. 23.2 Grand facade, Palace of Versailles, France. 1669–85. Versailles could house over 10,000 people—servants, members of the court, and ambitious aristocrats on the rise.

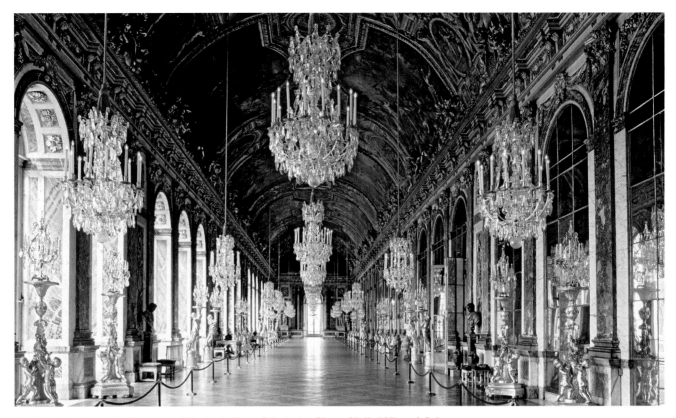

Fig. 23.3 Jules Hardouin-Mansart and Charles Le Brun, Galerie des Glaces (Hall of Mirrors), Palace of Versailles. Begun 1678. The Galerie des Glaces is 233 feet long and served as a reception space for state occasions. It gets its name from the Venetian mirrors—extraordinarily expensive at the time—that line the wall opposite windows of the same shape and size, creating by their reflection a sense of space even vaster than it actually is.

VERSAILLES AND THE RISE OF ABSOLUTISM

From a young age, Louis had detested the Louvre, the royal palace in Paris that had been the seat of French government since the Middle Ages. He had assumed the throne at five years of age, and a year later, he had been forced to flee Paris after an angry mob broke into the Louvre and demanded to see their child king. (Louis in his bedchamber feigned sleep, and the mob left after simply looking at him.) But the episode made Louis feel unsafe in the Louvre. Thus, in 1661, when he was 23 years of age, he began construction of a new residence in the small town of Versailles [vair-SIGH], 12 miles southeast of Paris. For 20 years, some 36,000 workers labored to make Versailles the most magnificent royal residence in the world (Fig. **23.2**). When Louis permanently moved his court and governmental offices there in 1682, Versailles became the unofficial capital of France and symbol of Louis's absolute power and authority.

More than any other art, French architecture was designed to convey the absolute power of the monarchy. From the moment that Louis XIV initiated the project at Versailles, it was understood that the new palace must be unequaled in grandeur, unparalleled in scale and size, and unsurpassed in lavish decoration and ornament. It would be the very image of the king, in whose majesty, according to the bishop, "lies the majesty of God."

The elaborate design of the his new palace at Versailles was intended to leave the attending nobility in awe. Charles Le Brun, who had participated in designing the new east facade of the Louvre (see Fig. 21.21), now served as chief painter to the king, and directed the team of artists who decorated the palace's interior. The Hall of Mirrors (Fig. **23.3**) was begun in 1678 to celebrate the high point of Louis XIV's political career, the end of six years of war with Holland. With the signing of the Treaty of Nijmegen [NY-may-gun], France gained control of the Franche-Comté [frahnsh-cohn-tay] region of eastern France.

Louis asked Le Brun to depict his government's accomplishments on the ceiling of the hall in 30 paintings, framed by stuccowork, showing the monarch as a Roman emperor, astute administrator, and military genius. Le Brun balanced the 17 windows that stretch the length of the hall and overlook the garden with 17 arcaded mirrors along the interior wall, all made in a Paris workshop founded to compete with

Venice's famous glass factories. Originally, solid silver tables, lamp holders, and orange-tree pots adorned the gallery. Louis later had them all melted down to finance his ongoing war efforts. Such luxury was in stark contrast to how the common people lived throughout France. Louis's centralized government did not address the enemies of their daily lives: drought, famine, and plague.

Landscape architect André Le Nôtre [leh NOHT] was in charge of the grounds at Versailles. He believed in the formal garden, and his methodical, geometrical design has come to be known as the **French garden**. (See Chapter 25 for its counterpart, the English garden.) The grounds were laid out around a main axis, emphasized by the giant cross-shaped Grand Canal, which stretched to the west of the palace (Figs. **23.4** and **23.5**). Pathways radiated from this central axis, circular pools and basins surrounded it, and both trees and shrubbery were groomed into abstract shapes to match the geometry of the overall site. The king himself took great interest in Le Nôtre's work, even writing a guide to the grounds for visitors. Neat boxwood hedges lined the flower beds near the chateau, and a greenhouse provided fresh flowers to be planted in the gardens as the seasons changed. Over 4 million tulip bulbs, imported from Holland, bloomed each spring.

THE ARTS OF THE FRENCH COURT

Louis asserted control over the nobility in a number of subtle ways. First, he made sure that the nobility benefited from the exercise of his own authority, by creating the largest army in Europe, numbering a quarter of a million men, and he modernized the army as well. Where previously local recruits and mercenaries had lived off the land, draining the resources of the nobility and pillaging and stealing to obtain their everyday needs, now Louis's forces were well-supplied, regularly paid, and extremely disciplined. The people admired them, understanding that this new army was not merely powerful, but also designed to protect them and guarantee their well-being—another benefit of centralized, absolute authority. However, as the army was always a present threat, Louis made no effort to limit the authority of regional *parlements*, and he generally made at least a pretense of consulting with these provincial governmental bodies before making decisions that would affect them. He also consulted with the nobility

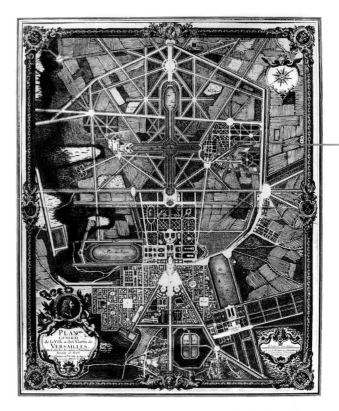

Fig. 23.4 André Le Nôtre, plan of the gardens and park, Versailles. Designed 1661–68, executed 1662–90. Drawing by Leland Roth after Delagive's engraving of 1746. To the right are the main streets of the town of Versailles. Three grand boulevards cut through it to converge on the palace itself.

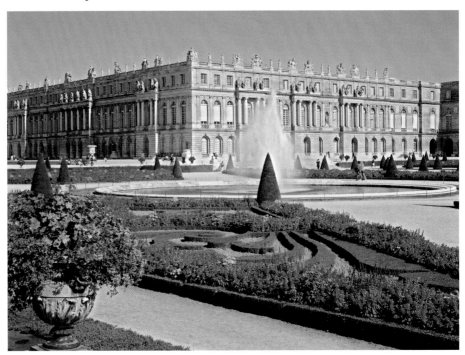

Fig. 23.5 André Le Nôtre, north flower bed, formal French gardens, Versailles. 1669–85. The gardens are most formal near the palace and become increasingly less elaborate further out in the park. Louis's gardener had more than 2 million flowerpots at his disposal.

at court. In fact, he required their presence in court in order to prevent them from developing regional power bases of their own that might undermine his centralized rule. He barred them from holding high government positions as well, even as he cultivated them socially and encouraged them to approach him directly.

Louis also established his authority through his control of the arts. He was the absolute judge of taste at the French court and a great patron of the arts. He inherited some 200 paintings from his father but increased the royal collection tenfold during his reign. Over the course of his career, he established the national academies of painting and sculpture, dance, music, and architecture. His motives were simple enough: Championing the greatest in art would establish him as the greatest of kings. "Gentlemen," he is reputed to have said to a group of academicians, "I entrust to you the most precious thing on earth—my fame."

Louis's aesthetic standards modulated between the balance, harmony, and proportions of classical art and the decorative exuberance of the Italian Baroque. Both the new east facade of the Louvre (see Fig. 21.21) and the geometric symmetry and clarity of Versailles and its grounds reflect his identification with classical precedent, and by extension, the order, regularity, and rational organization of the Roman Empire. On the other hand, he fully understood the attractions of Baroque scale and decorative effect, its power to move, even awe, its audience. So Louis promoted an essentially classical architecture with Baroque dramatic effects, in the process creating a style that is something of a contradiction, the Classical Baroque.

It was in painting that the stylistic tensions of the French court found their most complete expression. These tensions—which by extension were philosophical and even moral—were between the rational clarity of the classical and the emotional drama of the Baroque, the rule of law and the rule of the heart. These styles shared the common ground of grandeur and magnificence. Furthermore, in private, the court tended to prefer the frank sensuality of the Baroque, but in public, for political reasons, it chose the rationality and clarity of the classical in order to present an image of moderation as opposed to excess.

The Painting of Peter Paul Rubens: Color and Sensuality

One of Louis's favorite artists was the Flemish painter Peter Paul Rubens (1577–1640), and although Rubens died when Louis was only 2 years of age, the taste for Rubens's painting dominated Louis's court. Louis's grandmother, Marie de' Medici [deh-MED-ih-chee], had commissioned Rubens in 1621 to celebrate her life in a series of 21 monumental paintings. This series was to be paired with a similar (but never completed) series extolling Henry IV, her late husband. She was, by this time, serving as regent of France for her young son, Louis XIII—Louis XIV's father—and the cycle was conceived to decorate the Luxembourg Palace in Paris, which today houses the French Senate. Rubens was 44 years old, had spent eight formative years (1600–08) in Italy in the service of the Duke of Mantua, and had already provided paintings for numerous patrons in his native Flanders, especially altarpieces for Catholic churches in Antwerp (see Fig. 22.23). He had spent time in most of Europe's royal or princely courts fulfilling commissions for large-scale paintings and gaining an international reputation. The cycle took four years (1621–25) to complete with the help of studio assistants.

Rubens's pictorial approach to such self-promoting biographical commissions was through lifelike allegory. *The Arrival and Reception of Marie de' Medici at Marseilles* depicts the day Marie arrived in France from her native Italy on route to her marriage to King Henry IV (Fig. 23.6). The figure of Fame flies above her, blowing a trumpet, while

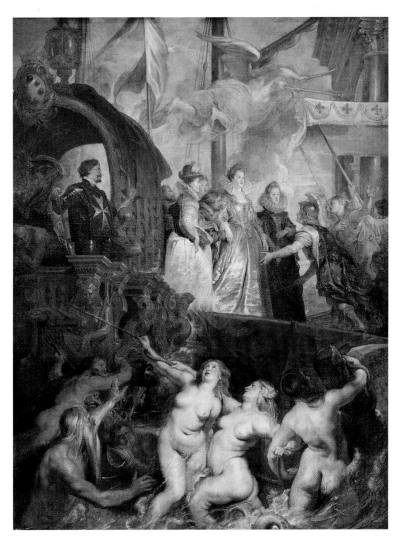

Fig. 23.6 Peter Paul Rubens and his workshop, *The Arrival and Reception of Marie de' Medici at Marseilles.* 1621–25. Oil on canvas, 13' × 10'. Musée du Louvre/ RMN Réunion des Musées Nationaux, France. Erich Lessing/Art Resource, New York. The point of view here is daringly low, perhaps in the water, or oddly floating above it. This creates a completely novel relationship between viewer and painting.

Fig. 23.7 Peter Paul Rubens, *The Kermis (La Kermesse)*. ca. 1635. Oil on canvas, 56 5/8″ × 102 3/4″. Musée du Louvre/RMN Réunion des Musées Nationaux, France. Erich Lessing/Art Resource, New York. In this painting, Rubens reveals his Flemish heritage, taking up the traditional subject matter of Bruegel and others, a genre scene of everyday life.

Neptune, god of the sea, and his son Triton, accompanied by three water nymphs, rise from the waves to welcome her. A helmeted allegorical figure of France, wearing a *fleur-de-lis* robe like that worn by Louis XIV in his 1701 portrait, bows before her. Marie herself, not known for her beauty, is so enveloped by rich textures, extraordinary colors, and sensuous brushwork, that she seems transformed into a vision as extraordinary as the scene itself.

The fleshy bodies of the nymphs in this painting are a signature stylistic component of Rubens's work In fact, Rubens's style is almost literally a "fleshing out" of the late Italian Renaissance tradition. It is so distinctive that it came be known as "Rubenesque." His nudes, which often startle contemporary viewers because we have developed almost entirely different standards of beauty, are notable for the way in which their flesh folds and drapes across their bodies. Their beauty rests in the sensuality of this flesh, which in some measure symbolizes the sensual life of self-indulgence and excess. Rubens pushed to new extremes the Mannerist sensibilities of Michelangelo's *Last Judgment* and Bronzino's *Allegory with Venus and Cupid*, the color and textures of the Venetian school as embodied in Titian's *Rape of Europa* (see Chapter 20 for all), and the play of light and dark of the Caravaggisti [kah-rah-vah-GEE-stee] (see Chapter 21). He brought to the Italian tradition a Northern appreciation for observed nature—in particular, the realities of human flesh—and an altogether inventive and innovative sense of

space and scale. Only rarely are Rubens's paintings what might be called frontal, where the viewer's position parallels the depicted action. Rather, the action moves diagonally back into space from either the front left or right corner of the composition. Rubens's 1611 to 1614 *Descent from the Cross*, created for Antwerp Cathedral, is an early example of these features (see Fig. 22.23).

In a painting like *The Kermis* [ker-miss], or *Peasant Wedding*, Rubens transforms a simple tavern gathering—a genre common to Northern painting (see Fig. 22.11)—into a monumental celebration (Fig. **23.7**). *The Kermis* is over 8 feet wide. Its wedding celebration spills in a diagonal out of the confines of the tavern into the panoramic space of the Flemish countryside. At the pinnacle of this sideways pyramid of entwined flesh, a young man and a disheveled woman, her blouse fallen fully from her shoulders, run off across the bridge, presumably to indulge their appetites behind some hedge. Like the Hall of Mirrors at Versailles, with its mathematical regularity overlaid with sumptuously rich ornamentation, Rubens's painting seems at once moralistic and libertine. Arms and legs interlace in a swirling, twirling riot that can be interpreted as either a descent into debauchery or a celebration of sensual pleasure, readings that Rubens seems to have believed were not mutually exclusive.

Such frank sensuality is a celebration of the simple joy of living in a world where prosperity and peace extend

even to the lowest rungs of society. Yet in keeping with his northern roots, Rubens gave the painting moralistic overtones. The posture of the dog with its nose in the cloth-draped tub at the bottom center of the canvas echoes the form of the kissing couple directly behind it and the dancing couples above it and, once more, represents the base, animal instincts that dominate the scene. The nursing babes at breast throughout the painting do not so much imply abundance as animal hunger, the desire to be fulfilled. Rubens knew full well that the bacchanal was not merely an image of prosperity but also of excess. In his later years, excess enthralled him, and *The Kermis* is a product of this sensibility.

Some 50 years later, in April 1685, Louis XIV purchased *The Kermis* for Versailles. What did the monarch who turned down Bernini's design for the new east wing of the Louvre (see Fig. 21.20) because he found it too extravagant see in this painting? For one thing, it was probably important to the man who considered himself Europe's greatest king to possess the work of the artist widely considered to be Europe's greatest painter. For another, Louis must have appreciated the painting's frank sexuality, which the artist emphasized by his sensual brushwork and color. It recalled the king's own sexual exploits.

The Painting of Nicolas Poussin: Classical Decorum

By the beginning of the eighteenth century, 14 other Rubens paintings had found their way to the court of Louis XIV. Armand-Jean du Plessis [dewplay-SEE], duc de Richelieu [duh REESH-uh-lee-yuh] (1629–1715), the great-nephew of Cardinal Richelieu (1585–1642), who had served as artistic advisor to Marie de' Medici and Louis XIII, purchased 14 other paintings that had remained in Rubens's personal collection after his death in 1640. Before he acquired his own collection of Rubens's work, Richelieu had wagered and lost his entire collection of paintings by Nicolas Poussin [poo-SEHN] (1594–1665) against Louis's own collection of works by Rubens in a tennis match between the two. A debate had long raged at court as to who was the better painter—Poussin or Rubens. Charles Le Brun had gone so far as to declare Poussin the greatest painter of the seventeenth century. Although a Frenchman, Poussin had spent most of his life in Rome. He particularly admired the work of Raphael and, following Raphael's example, advocated a classical approach to painting. A painting's subject matter, he believed, should be drawn from classical mythology or Christian tradition, not everyday life. There was no place in his theory of painting for a genre scene like Rubens's *Kermis*, even if portrayed on a monumental scale. Painting technique itself should be controlled and refined. There could be no loose brushwork, no "rough style." Restraint and decorum had to govern all aspects of pictorial composition.

This *poussiniste* [poo-sehn-EEST] style is clearly evident in *The Shepherds of Arcadia* of 1638 to 1639 (Fig. 23.8). Three shepherds trace out the inscription on a tomb, *Et ego in Arcadia,* "I too once dwelled in Arcadia," suggesting that death comes to us all. The Muse of

Fig. 23.8 Nicolas Poussin, *The Shepherds of Arcadia* (also called *Et in Arcadia Ego*). 1638–39. Oil on canvas, 33$\frac{1}{2}$" × 47$\frac{5}{8}$". INV7300. Photo: Renè-Gabriel Ojèda. Musée du Louvre/RMN Réunion des Musées Nationaux, France. Art Resource, New York. Note how even the bands on the shepherds' sandals parallel other lines in the painting.

LEARN MORE Gain insight from a primary source document from Nicolas Poussin at **www.myartslab.com**

History, standing to the right, affirms this message. Compared to the often exaggerated physiques of figures in Rubens's paintings, the muscular shepherds seem positively understated. Color, while sometimes brilliant, as in the yellow mantle robe of History, is muted by the evening light. But it is the compositional geometry of horizontals and verticals that is most typically *poussiniste*. Note how the arms of the two central figures form right angles and how they all fit within the cubical space suggested by the tomb itself. This cubic geometry finds its counterpoint in the way the lighted blue fold of History's dress parallels both the red-draped shepherd's lower leg and the leftmost shepherd's staff. These lines suggest a diagonal parallelogram working both against and with the central cube.

Louis XIV was delighted when he defeated the duc de Richelieu at tennis and ac-

CONTINUITY & CHANGE
School of Athens, p. 505

quired his Poussins. But to Louis's surprise, Richelieu quickly rebuilt his collection by purchasing the 14 Rubens paintings and then commissioning Roger de Piles [deh peel] to write a catalogue describing his acquisitions. De Piles was a *rubeniste* [roo-bayn-EEST]. He argued that color was the essence of painting. Color is to painting as reason is to man, as he put it. The *poussinistes*, by contrast, were dedicated to drawing, what Vasari called *disegno*, particularly the art of Raphael (see *Closer Look*, pages 750–751).

Poussin's paintings addressed the intellect, Rubens's the senses. For Poussin, subject matter, the connection of the picture to a classical narrative tradition, was paramount; for Rubens, the expressive capabilities of paint itself were primary. In 1708, de Piles scored each painter on his relative merits. Rubens received 18 points for composition, 13 for design, 17 for color, and 17 for expression. Poussin earned 15 points for composition, 17 for design, 6 for color, and 15 for expression. By de Piles's count, Rubens won 65 to 53. In essence, Rubens represented Baroque decorative expressionism and Poussin, classical restraint—the two sides of the Classical Baroque. Both would have their supporters in the Academy over the course of the following decades.

Music and Dance at the Court of Louis XIV

Louis XIV loved the pomp and ceremony of his court and the art forms that allowed him to most thoroughly

Fig. 23.9 Louis XIV as the sun in the *Ballet de la Nuit*. 1653.
Bibliothèque Nationale, Paris. Louis, who was 15 years old at the time, appeared as himself wearing this costume during the ballet's intermezzo, a short musical entertainment between the main acts.

engage this taste: dance and music. The man largely responsible for entertaining the king at court was Jean-Baptiste Lully [lew-LEE] (1632–1687), who was born in Florence but moved to France in 1646 to pursue his musical education.

Jean-Baptiste Lully Lully composed a number of popular songs, including the famous "Au Clair de la Lune." By the 1660s, he had become a favorite of the king, who admired in particular his ***comédie-ballets*** [koh-may-DEE bah-LAY],

performances that were part opera (see Chapter 21) and part ballet and that often featured Louis's own considerable talents as a dancer (Fig. 23.9). Louis commissioned many ballets that required increasingly difficult movements of the dancers. As a result, his Royal Academy of Dance soon established the rules for the five positions of ballet that became the basis of classical dance. They valued, above all, clarity of line in the dancer's movement, balance, and, in the performance of the troop as a whole, symmetry. But in true Baroque fashion, the individual soloist was encouraged to elaborate upon the classical foundations of the ballet in exuberant, even surprising expressions of virtuosity.

Lully used his connections to the king to become head of the newly established Royal Academy of Music, a position that gave him exclusive rights to produce all sung dramas in France. In this role, he created yet another new operatic genre, the **tragédie en musique** [trah-zhay-DEE on moo-ZEEK], also known as the *tragédie lyrique* [leer-EEK]. Supported and financed by the court, Lully composed and staged one of these *tragédies* each year from 1673 until 1687, when he died of gangrene after hitting his foot with the cane he used to pound out the beat while conducting.

Lully's *tragédies en musique* generally consist of:

- An overture, distinguished by a slow, homophonic melody (associated with the royal dignity) that built to a faster contrapuntal section, a form today known as the **French overture**
- An allegorical prologue, which established the drama's connection to recent events at court, always flattering to the king
- Five acts of sung drama, subdivided into several scenes
- A multitude of **intermezzi**—called **divertissements** [dee-ver-tees-MOHN] in France—short displays of dance, song, or instrumental music

Lully's *tragédies* seamlessly blended words and music. The meter of the music constantly shifts, but the rhythms closely follow the natural rhythms of the French language.

One of the most powerful scenes in Lully's repertoire occurs at the end of Act II of *Armide* [ar-MEED], first performed in Paris in 1686 and the last of his *tragédies*. Based on *Jerusalem Liberate*, an epic poem by Torquato Tasso [TAHS-so] (1544–1595), the story concerns the crusader knight Renaud [ruh-NOH], whose virtue, according to the allegorical prologue, is like that of Louis XIV. Renaud is desperately trying to resist the temptations of the sorceress Armida. But in a ballet sequence, demons disguised as satyrs and shepherds put him under a spell. Armida enters, intending to kill Renaud as he sleeps. But she is overcome by her love for him and decides, instead, to hold him forever in her power and to make him love her through the wiles of her sorcery. Her recitative

monologue, *Enfin, il est en ma puissance* [en-fan eel ay-t-on mah pwee-SAHNSS] ("At last, he is in my power"), is considered among the greatest of Lully's works (track **23.1**). One contemporary of Lully's, a French nobleman who saw the *tragédie* many times, recalls the scene's effect on its audience: "I have twenty times seen the entire audience in the grip of fear, neither breathing nor moving, their whole attention in their ears and eyes, until the instrumental air which concludes the scene allowed them to draw breath again, after which they exhaled with a murmur of pleasure and admiration." Lully's music, with its ever-intensifying repetitions, creates a dramatic tension fully in keeping with Baroque theatricality.

HEAR MORE at www.myartslab.com

Dance Forms Louis's love of the dance promoted another new musical form at his court, the **suite**, a series of dances, or dance-inspired movements, usually all in the same key, though varying between major and minor modes. Most suites consist of four to six dances of different tempos and meters. These might include the following:

- Allemande [ah-luh-MAHND], a dance of continuous motion in double meter (marked by two or a multiple of two beats per measure) and moderate tempo
- Bourrée [boo-RAY], a dance of short, distinct phrasing, in double meter and moderate to fast in tempo
- Courante [koo-RAHNT], a dance often in running scales, in triple meter, and moderate to fast in tempo
- Gavotte [gah-VOT], a "bouncy" dance, in double meter, and moderate to fast in tempo
- Gigue [zheeg], a very lively dance, fast in tempo, and usually employing a 6/8 meter
- Sarabande [sah-rah-BAHND], a slow and stately dance, with accent on the second beat, in triple meter

In a suite, two moderately fast dances—say, an allemande and a courante—might precede a slower, more elegant dance—perhaps a sarabande—and then conclude with an exuberant gigue. The structure is closely related to the *sonata da camera* (see Chapter 25). Although it did not commonly occur in the dance suites themselves, the most important of the new dance forms was the **minuet**, an elegant triple-time dance of moderate tempo. It quickly became the most popular dance form of the age.

To help the courtiers learn the fashionable dances, members of Louis's court developed a system of dance notation—a way of putting the steps of a dance down on paper. The notation system facilitated the adoption of French dances in other courts across Europe. The 1700 publication of *Choreography, or the Art of Describing Dance in Characters*, by Raoul-Auger Feuillet [oh-ZHAY foy-YAY] (ca. 1653–ca. 1710), catalogued the entire repertoire of dance steps. It was widely imitated across Europe. As a general rule, Feuillet noted, dancers should perform

a *plié* [plee-AY], or bend, on the upbeats of the music, and an *élevé* [ay-luh-VAY], or rise, on the downbeats.

Elisabeth-Claude Jacquet de la Guerre One of Louis's favorite composers of dance suites was Elisabeth-Claude Jacquet de la Guerre [deh la ghair] (1665–1729), who performed for him beginning at age five. Her *Pièces de clavecin* [pee-ESS deh klav-SEHN] ("Pieces for the Harpsichord") was published in 1687, when she was just 22 years old. The courante in Jacquet de la Guerre's suite is, like most dances, in **binary form**—it has a two-part structure—and both sections are repeated (track **23.2**). This repetition derives from the primary function of social dance, which is not to challenge the dancer but to provide for interaction with one's partner. It consists of a prescribed pattern of dance steps repeated over and over. In addition, Jacquet de la Guerre's courante features what the French called a *double*—a second dance based on the first and essentially a variation on it. Always a court favorite for her skill at improvising on the harpsichord, Jacquet de la Guerre would become the first French

(((• HEAR MORE at www.myartslab.com

woman to compose an opera: *Cephale et Procris* [say-FAHL ay pro-KREE] (1694).

Theater at the French Court

When, in 1629, Louis XIII appointed Cardinal Richelieu as his minister of state, he coincidentally inaugurated a great tradition of French theater. This tradition would culminate in 1680 with the establishment of the *Comédie Française* [koh-may-DEE frahn-SEZ], the French national theater (Fig. **23.10**). It was created as a cooperative under a charter granted by Louis XIV to merge three existing companies, including the troupe of the playwright Molière [moh-lee-AIR].

Pierre Corneille Cardinal Richelieu loved the theater. When a comedy by Rouen lawyer Pierre Corneille [COR-nay] (1606–1684) was first performed in Paris soon after the cardinal's appointment, Richelieu urged the company to settle in Paris's Marais Theater, a former indoor tennis court. There, under Richelieu's direction, Corneille dedicated himself to writing tragedies in the classical manner

Fig. 23.10 The Comédie Française. Interior of the Comédie Française Theatre in 1791, color lithograph after an original nineteenth-century French watercolor. Bibliotheque Nationale, Paris, France, Archives Charmet/The Bridgeman Art Library. The feuding that marked the Parisian theater world led Louis XIV to establish the Comédie Française in 1680 as a cooperative venture among the three major companies.

based on Greek or Roman themes that alluded to contemporary events. Richelieu exerted a great deal of control over the plays. He outlined each idea and then asked his author to fill in the dialogue. But Corneille resisted Richelieu's direction and took liberties that the cardinal found to be appalling lapses of taste, and so the playwright struck out on his own.

In 1637, Corneille opened a new play, *Le Cid*. It was based on the legend of El Cid, a Spanish nobleman who conquered and governed the city of Valencia in the eleventh century. The play was an immediate hit, moving Louis XIII to send his compliments. But Richelieu was furious. Corneille had ignored the **classical unities**, a notion derived from Aristotle's *Poetics* that requires a play to have only one action that occurs in one place and within one day. At Richelieu's insistence, the Académie Française [ah-kah-day-MEE frahn-SEZ] officially condemned the play as "dramatically implausible and morally defective." Although deeply hurt by this censure, Corneille followed with three masterpieces: *Horace* [or-AHSS] (1640), which dramatizes the conflict between the ancient Romans and their Alban neighbors; *Cinna* (1641), which tells the story of a conspiracy against the first Roman emperor, Augustus Caesar; and *Polyeucte* (1643), perhaps his greatest work, telling the story of an Armenian nobleman newly converted to Christianity who finds that his wife is in love with another man. Twenty-one more plays followed. In their allusion to antiquity, Corneille's plays embrace the classical side of the French Classical Baroque. And while Richelieu found their highly complex plots dramatically implausible, the plays embrace the Baroque love for elaborate moral and emotional range and possibility.

CONTINUITY & CHANGE
Poetics, *p. 160*

Molière Meanwhile, comedy had taken center stage in Paris, pushing the moral vision of Corneille to the wings. The son of a court upholsterer, Molière had been touring France for 13 years with a troupe of actors when he was asked, in 1658, to perform Corneille's tragedy *Nicomède* [nee-koh-MED] before the young king Louis XIV. The performance was a miserable failure, but Molière asked if he might perform a farce of his own, *Le Docteur Amoureux* [leh DOK-ter ah-moo-REH] ("The Amorous Doctor"). The king was delighted with this comedy, and Molière's company was given what was intended to be a permanent home.

Molière's first play to be performed was *Les Précieuses Ridicules* [lay PRAY-see-erz ree-dee-KEWL] ("The Pretentious Ladies"), in 1659. It satirized a member of the French court named Madame de Rambouillet [deh RAHM-boo-yeh], who fancied herself the chief guardian of good taste and manners in Parisian society. At her Parisian home, ladies of the court routinely gather to discuss matters of love, reviving in particular the elegance, manners, and high moral character of Platonic courtly love as they imagined it was practiced in the medieval courts of figures such as Eleanor of Aquitaine (see Chapter 10). Molière scoffed at

their pretensions, and the success of the play soon led him to double the admission price. The king himself was so delighted that he honored the playwright with a large monetary reward. But not so, Madame de Rambouillet. Outraged, she tried to drive Molière from the city but succeeded only in having the company's theater demolished. The king struck back by immediately granting Molière the right to perform in the Théâtre du Palais Royal [tay-AT-ruh dew pah-LAY roy-AHL], in Richelieu's former palace, and there he staged his productions for the rest of his life.

Molière spared no one his ridicule, attacking religious hypocrisy, misers, hypochondriacs, pretentious doctors, aging men who marry younger women, the gullible, and all social parasites. (Ironically, he himself was capable of the most audacious flattery.) His play *Tartuffe* [tar-TEWF], or *The Hypocrite* (1664), concludes, for instance, with an officer praising the ability of the king to recognize hypocrisy of the kind displayed by Tartuffe in earlier scenes from the play (**Reading 23.1a**):

READING 23.1a

from Molière, *Tartuffe*, Act V (1664)

We serve a Prince to whom all sham is hateful,
A Prince who sees into our inmost hearts,
And can't be fooled by any trickster's arts.
His royal soul, though generous and human,
Views all things with discernment and acumen;
His sovereign reason is not lightly swayed,
And all his judgments are discreetly weighed.
He honors righteous men of every kind,
And yet his zeal for virtue is not blind,
Nor does his love of piety numb his wits 10
And make him tolerant of hypocrites.
'Twas hardly likely that this man could cozen
A King who's foiled such liars by the dozen.

These words undoubtedly warmed the heart of the king, described here as if he were a god. But until Molière's sudden death of an aneurysm during a coughing fit onstage, the playwright remained in disfavor with many in Louis's court who felt threatened by his considerable insight and piercing wit. They recognized what perhaps the king could not—the irony of flattering the king by saying he is above flattery.

The plot of *Tartuffe*, like most of Molière's plays, is relatively simple. Character, not plot, is its chief concern. Tartuffe himself is a great ego who disguises his massive appetites behind a mask of piety. He is completely amoral, and his false morality makes a mockery of all it touches. (For a selection from the play, in which Tartuffe tries to seduce Orgon's wife Elmire [el-MEER], see **Reading 23.1**, pages 761–763). While the hypocrite Tartuffe is himself a great comic creation, the naïve Orgon is almost as interesting. Why, the audience wonders, is he so blind to Tartuffe's true nature? What drives human beings to ignore the evil that surrounds them?

Jean Racine In 1664, Molière befriended the struggling young playwright Jean Racine [rah-SEEN] (1639–1699) and offered to stage his first play to be performed in Paris, a tragedy. Racine was disappointed in the quality of the production that Molière's comedic company was able to muster, so he offered his next play to another company after seducing Molière's leading actress and convincing her to join him. Molière was deeply offended and never spoke to Racine again.

Racine went on to write a string of successful tragedies, to the dismay of the aging and increasingly disfavored Corneille. The feud between those two reached its height in 1670, when, unknown to each other, both were asked to write a play on the subject of Bérénice, an empress from Cilicia, in love with the Roman emperor Titus. Well aware that Rome opposes Bérénice, Titus chooses to reject her. Corneille's play was unenthusiastically received, but Racine's proved a triumph. Of all his plays, it thoroughly embraces the classical unities, which Corneille had rejected. There is only one action in Racine's play—Titus's announcement to Bérénice that he is leaving her—but it takes place over five acts in the course of a single day. The audience knows his intentions from the outset, and the play reaches its climax at the end of the fourth act, when Titus explains that he must forsake his love for the good of the state. Bérénice at first rejects his decision, but in the fifth act, they both come to terms with their duty—and their tragic fate.

Such successes made Racine the first French playwright to live entirely on earnings from his plays. But he had also acquired a large number of powerful enemies, many of whom were offended by his seeming humiliation of Corneille and Molière. Determined to destroy Racine's career, these enemies conspired to buy tickets for the opening night of *Phèdre* [FED-ruh] (1677) and leave their seats unoccupied. This and the other intrigues of the court so depressed Racine that he retired from the theater altogether in that year and accepted a post as royal historiographer, chronicling the reign of Louis XIV.

THE ART AND POLITICS OF THE ENGLISH COURT

The arts in England were dramatically affected by tensions between the absolutist monarchy of the English Stuarts and the much more conservative Protestant population. As in France, throughout the seventeenth century, the English monarchy sought to assert its absolute authority, although it did not ultimately manage to do so. The first Stuart monarch, James I (1566–1625), succeeded Queen Elizabeth I in 1603. "There are no privileges and immunities which can stand against a divinely appointed King," he quickly insisted. His son, Charles I (1600–1649), shared these absolutist convictions, but Charles's reign was beset by religious controversy. Although technically head of the Church of England, he married a Catholic, Henrietta Maria, sister of the French king Louis XIII.

Charles proposed changes in the Church of England's liturgy that brought it, in the opinion of many, dangerously close to Roman Catholicism. Puritans (English Calvinists) increasingly dominated the English Parliament and strongly opposed any government that even remotely appeared to accept Catholic doctrine.

Parliament raised an army to oppose Charles, and civil war resulted, lasting from 1642 to 1648. The key political question was who should rule the country—the king or the Parliament? Led by Oliver Cromwell (1599–1658), the Puritans defeated the king in 1645, and, while peace talks dragged on for three years, Charles made a secret pact with the Scots. Cromwell retaliated by suppressing the Scots, along with other royalist brigades, in 1648. Charles was executed for treason on January 30, 1649, a severe blow to the divine right of kings, and hardly lost on young Louis XIV across the Channel in France.

Initially, Cromwell tried to lead a commonwealth—a republic dedicated to the common well-being of the people—but he soon dissolved the Parliament and assumed the role of Lord Protector. His protectorate occasionally called the Parliament into session, but only to ratify his own decisions. Cromwell's greatest difficulty was requiring the people to obey "godly" laws—in other words, Puritan doctrine. He forbade swearing, drunkenness, and cockfighting. No shops or inns could do business on Sunday. The country, used to the idea of a freely elected parliamentary government, could not tolerate such restriction, and when, in September 1658, Cromwell died, his system of government died with him. A new Parliament was convened, which issued an invitation to Prince Charles (1630–1685), who was exiled in the Netherlands, to return to his kingdom as Charles II.

The new king landed in Dover in May 1660. A predominantly royalist Parliament was elected, somewhat easing the king's relations with the people. The threat of the monarchy adopting Catholicism, however, continued to cause dissension among Puritans, especially after Charles's brother, James, converted to Catholicism in 1667. James became king (James II) in 1685, and quickly antagonized the Puritans by appointing Roman Catholics to the highest government posts and establishing a large standing army with Roman Catholics heading several key regiments. Finally, in September 1688, William of Orange, married to the Protestant daughter of James II, invaded Britain from Holland at the invitation of the Puritan population. James II fled, and what has come to be called the Glorious Revolution ensued. Parliament enacted a Bill of Rights endorsing religious tolerance and prohibiting the king from annulling parliamentary law. Constitutional monarchy was re-established once and for all in Britain, and the divine right of kings permanently suspended. Yet tensions between those who believed in the absolute power of the monarchy and those who believed in the self-determination of the people were by no means diffused.

Fig. 23.11 Anthony Van Dyck, *Portrait of Charles I Hunting.* 1635. Oil on canvas, 8′ × 6′11″. Inv 1236. Musée du Louvre/RMN Réunion des Musées Nationaux, France. SCALA/Art Resource, New York. Charles's posture, his left hand on his hip, and his right extended outward where it is supported by a cane, adopts the positions of the arms in court dance.

Anthony Van Dyck: Court Painter

The tension between the Catholic-leaning English monarchy and the more Puritan-oriented Parliament is clearly visible in two portraits by Flemish artist Anthony Van Dyck [dike] (1599–1641), court painter to Charles I. Sometime in his teens, Van Dyck went to work in Rubens's workshop in Antwerp, and he led the studio by the time he was 17. Van Dyck's great talent was portraiture. After working in Italy in the 1620s, in 1632 he accepted the invitation of Charles I of England to come to London as court painter. He was knighted there in 1633. Van Dyck's *Portrait of Charles I Hunting* is typical of the work that occupied him (Fig. 23.11). He often flattered his subjects by elongating their features and portraying them from below to increase their stature. In the case of the painting shown here, Van Dyck positioned Charles so that he stands a full head higher than the grooms behind him, lit in a brilliant light that glimmers off his silvery doublet. The angle of his jauntily cocked cavalier's hat is echoed in the trees above his head and the neck of his horse, which seems to bow to him in respect. He is, in fact, the very embodiment of the

Cavalier [kav-uh-LEER] (from the French *chevalier* [shuh-vahl-YAY], meaning "knight"), as his royalist supporters were known. Like the king here, Cavaliers were famous for their style of dress—long, flowing hair, elaborate clothing, and large, sometimes feathered hats.

Cavaliers are the very opposite in style and demeanor from the so-called **Roundheads**, supporters of the Puritan Parliament who cropped their hair short and dressed as plainly as possible. Just before his death in 1641, Van Dyck painted one such Roundhead, Alexander Henderson, one of the most important figures in the Church of Scotland in the early seventeenth century (Fig. 23.12). Henderson was one of the authors of the National Covenant, a document that pledged to maintain the "true reformed religion" against the policies of Charles I. This portrait was probably painted when Henderson was in London negotiating with Charles I. Henderson's short-cropped hair and dark, simple clothing contrast dramatically with Van Dyck's portrait of Charles I, as does the shadowy interior of the setting. Henderson's finger holds his place in his Bible, seeming to announce that here is a man of the Book, little interested in things of this world.

Fig. 23.12 Anthony Van Dyck, *Alexander Henderson.* ca. 1641. Oil on canvas, 50′ × 41¹/₂″. National Galleries of Scotland. PG 2227. Van Dyck probably came to paint this portrait because Charles I admired Henderson for his forthrightness and honesty in their troubled negotiations over the liturgy.

Fig. 23.13 John Foster, *Richard Mather*. ca. 1670. Woodblock print, 50′ × 41 ½″. Graphic Arts Division, Princeton University. Given in memory of Frank Jewett Mather Jr. by his wife, his son, Frank Jewett Mather III, and his daughter, Mrs. Louis A. Turner. GA 2006.00728. The Mather family was arguably the most prominent of the early Puritan settlers.

Portraiture in the American Colonies

The Puritans who arrived in America in the seventeenth century did not think of themselves as Americans but as subjects of the crown and Parliament. They brought with them the prejudices against ostentation that are embodied in Van Dyck's portrait of Alexander Henderson, as is evident in the first woodcut portrait printed in America, a portrait of Richard Mather (1569–1669) by John Foster, printed around 1670 to accompany the publication of *The Life and Death of that Reverend Man of God, Mr. Richard Mather* (Fig. **23.13**). Richard Mather was born in Lancashire, England, where he was a clergyman until emigrating to Dorchester, Massachusetts, in 1635. The following year, he became the minister of the church in Dorchester, where, according to his grandson, Cotton Mather (1663–1728), "His way of preaching was very plain, studiously avoiding obscure and foreign terms and unnecessary citation of Latin sentences; and aiming to shoot his arrows not over the heads, but into the hearts of his hearers." Mather was also one of the translators of *The Whole Booke of Psalmes* (1640), commonly referred to as the *Bay Psalm Book*, the first book printed in the colonies.

Foster's portrait of Mather is as different from John Closterman's portrait of the American monarchist Daniel Parke II (Fig. **23.14**) as Van Dyck's *Alexander Henderson* is from his *Charles I Hunting*. The two American paintings reflect the same debate between monarchists and Puritans that informs Van Dyck's two works, and they underscore as well a deep division in the American colonies that would have lasting impact on their history. Where New England was dominated by the Puritan sensibility, the southern colonies were led by men of Cavalier attitudes and tastes. Thus the political division that marks seventeenth-century England manifested itself as a regional division in the colonies—the simple, God-fearing people of the North versus the luxury-loving aristocracy of the South.

The portrait of Parke hung, as part of the largest portrait collection in the American colonies, in the home of William Byrd of Westover, Virginia, head of one of the most prominent Cavalier families in Virginia. Parke's daughter, Lucy, was Byrd's wife. In his portrait, Parke's elaborately embroidered vest and rich satin coat announce his taste for luxury and wealth. Both the king and his admirer sport long, curly locks and a jaunty air, and they look out of the canvas with a similar sense of haughtiness. Parke sought appointment as governor of Virginia from the king, but

Fig. 23.14 John Closterman, *Daniel Parke II*. 1706. Oil on canvas. Virginia Historical Society. Gift of Mr. and Mrs. D. Tennant Bryan, 1985. On his chest, Parke wears a miniature portrait of Queen Anne, the niece of Charles I, who ascended to the British throne in 1702, presented to him by the queen and set in a diamond frame.

Fig. 23.15 Artist unknown, *John Freake*. ca. 1671–74. Oil on canvas, 42$\frac{1}{2}$″ × 36$\frac{3}{4}$″. American School, seventeenth century/Worcester Art Museum, Massachusetts/The Bridgeman Art Library. Freake's portrait lacks objects, as if to understate his wealth and underscore his Puritan moderation.

Fig. 23.16 Artist unknown, *Elizabeth Freake and Baby Mary*. ca. 1671–74. Oil on canvas, 42$\frac{1}{2}$″ × 36$\frac{3}{4}$″. American School, seventeenth century/Worcester Art Museum, Massachusetts/The Bridgeman Art Library. Almost everything in this image was imported, suggesting the scope of the merchant trade in seventeenth-century Boston.

failing that was appointed governor of the Leeward Islands in the Caribbean. There, he was killed in 1710 by a rebellion among the island's planters, who resented, among other things, his ardent defense of royal rule, his suppression of smuggling, his uncompromising personality, and his "debauching many of the[ir] wives and daughters."

Still, however remote the sensibilities of a Parke might have seemed to the Puritan immigrants of New England, as those immigrants achieved a measure of prosperity, they celebrated their success in portraits commissioned from a growing group of portrait painters, most of whom remain anonymous. Prosperity was, after all, the reward a good Calvinist could expect in fulfilling his Christian duties in the world. Worldly effort—what we have come to call the Protestant work ethic—was a way to praise God, and prosperity was a sign that God was looking on one's effort with favor. (The term "Protestant work ethic" is a twentieth-century invention. German sociologist Max Weber used it to describe the forces that motivated individuals to acquire wealth in the Protestant West.)

We see something of this sensibility in a pair of portraits of John and Elizabeth Freake and their child Mary painted in Boston in the early 1670s (Figs. **23.15** and **23.16**). John Freake was born in England and came to

America in 1658. He was a merchant and lawyer, and owned a brewery, a mill, an interest in six ships, and two homes, including one of the city's finest. His wife, Elizabeth, was the daughter of another Boston merchant. While avoiding ostentation, the Freake portraits are careful to suggest their sitters' wealth. John's collar, of imported Spanish or Italian lace, is set off against a rich brown—not black—velvet coat. He holds a pair of gloves, symbolizing his status as a gentleman, and with his left hand, decorated with a large gold ring, he touches an ornate brooch that tops a row of silver buttons. His hair is Cavalier length, perhaps suggesting aristocratic sympathies but certainly aristocratic taste. Elizabeth's dress is made of French satin trimmed with rich brocade and topped by a beautiful lace collar. She wears three strands of pearls around her neck, a garnet bracelet, and a gold ring. She sits on what is known as a "Turkey-work" chair, so named because its upholstery imitates the designs of Turkish carpets. John owned over a dozen such chairs, the finest known in Boston in the seventeenth century. In this context, the child Mary, born after the paintings were begun and added late in the painting process, is another sign of the Freakes' prosperity, a sign of God's grace being bestowed upon them.

Puritan and Cavalier Literature

The debate between the monarchy and the Puritans had distinct literary ramifications. As the flamboyant style of Cavalier dress suggests, writers of a Cavalier bent were sensualists and often wrote frankly erotic works. These contrasted strongly with the moral uprightness of even the most emotional Puritan writing.

One of the most moving Puritan writers of the day was Anne Bradstreet (ca. 1612–1672), who was born in Northampton, England, but migrated to Massachusetts in 1630 to avoid religious persecution. In order to entertain herself in the wilderness of rural Massachusetts, she took to composing epic poetry, eventually publishing in England *The Tenth Muse Lately Sprung Up in America* (1650), the first volume of poetry written by an English colonist. But it is her personal poetry, most of it published after her death, for which she is renowned. Consider, for instance, "To My Dear and Loving Husband" (**Reading 23.2a**):

READING 23.2a

Anne Bradstreet, "To My Dear and Loving Husband" (1667)

If ever two were one, then surely we.
If ever man were loved by wife, then thee;
If ever wife was happy in a man,
Compare with me, ye women, if you can.
I prize thy love more than whole mines of gold
Or all the riches that the East doth hold.
My love is such that rivers cannot quench,
Nor ought but love from thee, give recompense.
Thy love is such I can no way repay,
The heavens reward thee manifold, I pray. 10
Then while we live, in love let's so persevere
That when we live no more, we may live ever.

This poem is a pious and direct statement of true affection from a devoted wife. While only the last line suggests its author's religious foundation, in its reference to an afterlife, Bradstreet's Puritan faith is a constant theme in many of her other poems, such as "Here Follows Some Verses upon the Burning of Our House" (**see Reading 23.2**, page 763). The poem narrates Bradstreet's conviction that she must give up all her worldly goods in order to pursue the path to salvation.

In its sense of progressing from the material world to spiritual redemption, Bradstreet's "Here Follows Some Verses . . ." anticipates what is perhaps the most influential Puritan text of the era, *The Pilgrim's Progress* by John Bunyan (1628–1688). After the Restoration of the monarchy in 1660, Bunyan spent 12 years in prison for his fiery preaching, during which time he wrote an autobiography, *Grace Abounding*. But it is *The Pilgrim's Progress*, first published in 1678, that established the symbolism of the Puritan quest for salvation. It narrates the allegorical story of Christian who, with friends Hopeful and Faithful, journeys to the Celestial City. On the way, they learn to resist the temptations

of Mr. Worldly Wiseman and Vanity Fair in the city of Vanity. They also navigate the Slough of Despond and endure a long dark night in the Doubting Castle. Their faith is tested at every turn. Eventually they realize they must deny the joys of family and society, all earthly security, and even physical well-being, to attain "Life, life, eternal life."

Except for the clarity of their diction, and their rejection of complicated metaphor, Bradstreet and Bunyan share almost nothing with the Cavalier poets of their generation. All were admirers of Ben Jonson (1572–1637), a playwright and poet who flourished during the reign of James I. His comedies *Volpone* (1605) and *The Alchemist* (1610) were immediate hits. Collaborating with the designer and architect Inigo Jones (1573–1652), Jonson also wrote a series of **masques** [masks], a type of performance that combined speech, dance, and spectacle. These were performed for James's court, and they are closely related to the *comedies en musique* composed by Lully for Louis XIV's court. The Cavalier poets of the next generation appreciated especially the erudition and wit of his lyric poetry. Robert Herrick's (1591–1674) Cavalier poem "To the Virgins, To Make Much of Time," descends directly from Jonson's example (**Reading 23.3**):

READING 23.3

Robert Herrick, "To the Virgins, To Make Much of Time" (1648)

Gather ye Rose-buds while ye may,
Old Time is still a flying:
And this same flower that smiles to-day,
To-morrow will be dying.

The glorious Lamp of Heaven, the Sun,
The higher he's a getting;
The sooner will his Race be run,
And neerer he's to Setting.

That Age is best, which is the first,
When Youth and Blood are warmer; 10
But being spent, the worse, and worst
Times, still succeed the former.

Then be not coy, but use your time;
And while ye may goe marry:
For having lost but once your prime,
You may for ever tarry.

First published in 1648 in a 1,200-poem volume called *Hesperides* [hess-PER-ih-deez], the poem addresses not merely young women but youth generally and is an example of a carpe diem [CAR-peh DEE-em] (Latin for "seize the day") poem admonishing the reader to make merry while one can. The poem is a forthright argument for making love. There is nothing of the traditional Renaissance conceit portraying the poet's love for his mistress as a metaphor for his higher love of God. Some Puritans saw Herrick's poem as a call to fornication, but it ends with a more traditional call to "marry." The poem's carpe diem argument is here turned to the purpose of Christian

orthodoxy (although when heard out loud, "marry" would have been impossible to distinguish from a more high-spirited "merry").

The ribald Cavalier sensibility is most pronounced in Restoration drama. Here the sensual, "fleshy" spirit of Rubens's paintings was expressed on stage, in a theater made possible by the Restoration of the monarchy in 1660. For 18 years, under Cromwell and the Puritan Parliament, theater had been banned in England, but when Charles II lifted the ban, a lewd anti-Puritanical theater ascended to the stage. The most notorious of these plays is *The Country Wife*, written by William Wycherley (1640–1716) in 1675. For the first time in British history, women were allowed on stage. Like many of his Cavalier colleagues, Wycherley stunned audiences by having his female characters cross-dress as males, in tight-fitting breeches, and engage their male counterparts in sexual banter. *The Country Wife* itself revolves around the exploits of Harry Horner (the name is suggestive) who has spread a rumor throughout London male society that he is impotent so that he may more easily seduce respectable ladies. The play consists of a series of Horner's seductions, in which he is always at the brink of being found out but just manages to escape detection. In keeping with its libertine spirit, the play is totally unrepentant; even at the end, it is clear that Horner's behavior will never change.

Henry Purcell and English Opera

Just as they were of the theater, Puritans were suspicious of secular music in all its forms, and special contempt was reserved for opera. Even after the Restoration, the English resisted drama that consisted entirely of singing, preferring plays and masques that combined drama, song, and dance. One of the very few operas of its time is *Dido* [DY-doh] *and Aeneas* [uh-NEE-us], the work of Henry Purcell [PUR-sul] (ca. 1659–1695). *Dido and Aeneas* was first performed in 1689 by students at a school for young ladies in Chelsea, west of London, but was not performed again until 1700, after Purcell's death. King William, the foreign king, and Queen Mary, the native daughter of Charles I, may have suppressed it, finding the alliance of Aeneas and Dido a story too close to their own. But the opera's Roman subject is in keeping with the Classical Baroque. It is the same story that Virgil tells in the *Aeneid* (see Chapter 6). There, Aeneas falls in love with Dido, queen of Carthage, but knowing he must continue his journey and found Rome, he abandons her and she commits suicide. The final piece in Purcell's opera, known as "Dido's Lament," begins with a recitative, moves to an emotional aria, followed by a short orchestral conclusion. The lament itself is a ground bass aria, in which the melody is set over a repeated pattern in the bass (track **23.3**). The opening recitative moves steadily downward, setting the stage for the grief-stricken Dido's aria. Then the ground bass by itself descends by half steps, like some slowly accumulating sadness. It repeats 11 times during the course of the aria. Over it, Dido's

CONTINUITY & CHANGE

Aeneid, **p. 209**

HEAR MORE at www.myartslab.com

words repeat themselves for dramatic effect, and convey her increasingly despairing emotional state. At the lament's conclusion, Dido dies. Despite its ability to move the listener, Purcell's opera did not capture the English imagination until 1711, when it helped to inaugurate an English passion for opera as a form.

THE ARTS OF THE SPANISH COURT

Even as England endured its divisive religious wars, Spain remained dogmatically Catholic. Yet after the death of Philip II (see Chapter 22), and despite the wealth flowing into the country from its American empire, Spain entered a period of decline during which deteriorating economic and social conditions threatened the absolutist authority of its king. Severe inflation, a shift of population away from the countryside and into the cities, and a loss of population and tax revenue brought the absolutist Spanish court to bankruptcy. To make matters worse, if the reign of Philip III (r. 1598–1621) was marked by the corruption of his inner court, the regime of Philip IV (r. 1621–1665) was marked by disastrous, highly costly military campaigns. These culminated in 1659 when Spain accepted a humiliating peace with France and, in 1668, agreed to total independence for Portugal. As early as 1628, the Dutch had captured the entire Spanish treasure fleet in the Caribbean, taking 177,537 pounds of gold and silver valued at 4.8 million silver pesos. One might have suspected Spanish citizens to be angry with the Dutch, but in fact, they were delighted. As the painter Peter Paul Rubens, at work on a commission for Philip IV, reported, "Almost everyone here is very glad about it, feeling that this public calamity can be set down as a disgrace to their rulers." Nevertheless, even as the Spanish throne seemed to crumble, the arts flourished under the patronage of a court that recklessly indulged itself. So remarkable was the outpouring of Spanish arts and letters in the seventeenth century that the era is commonly referred to as the Spanish Golden Age.

Diego Velázquez and the Royal Portrait

The Spanish court understood that in order to assert its absolutist authority, it needed to impress the people through its patronage of the arts. So when Philip IV assumed the Spanish throne at the age of 16, his principal advisor suggested that his court should strive to rival all the others of Europe by employing the greatest painters of the day. The king agreed, hiring Rubens in the 1630s to paint a cycle of 112 mythologies for his hunting lodge. But when the 24-year-old Diego Rodríguez de Silva y Velázquez [vah-LASS-kez] (1599–1660) was summoned to paint a portrait of the king in the spring of 1623, both the king and his advisor recognized that one of the great painters of seventeenth-century Europe was homegrown. An appointment as court painter quickly followed, and Velázquez became the only artist permitted to paint the king.

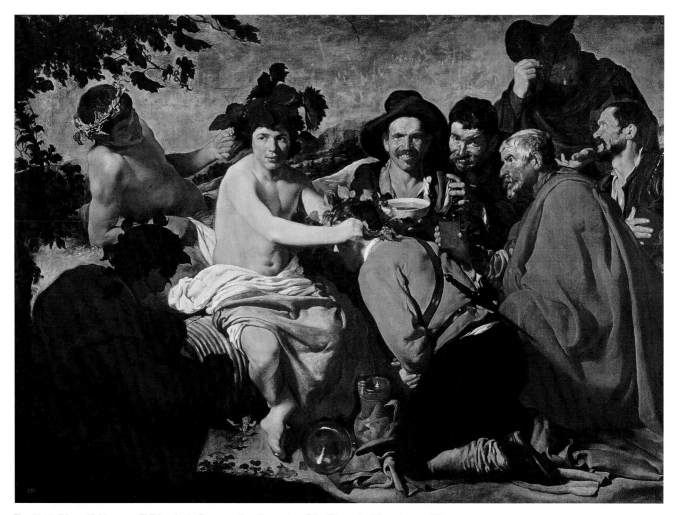

Fig. 23.17 Diego Velázquez, *El Triumfo de Baco,* or *Los Borrachos (The Triumph of Bacchus,* or *The Drunkards).* 1628–29. Oil on canvas, 65 $^1/_8$″ × 87 $^1/_2$″. Museo del Prado, Madrid, Spain. SCALA/Art Resource, New York. Velázquez's canvases consist of loosely painted layers of paint that appear totally coherent from even a few feet away, but which dissolve into a seemingly random amalgamation of individual brushstrokes when studied at close range. Dashes of white, lemon, and pale orange give the effect of light reflecting off the surface of his forms.

In 1628, when Rubens visited the Spanish court, Velázquez alone among artists in Madrid was permitted to visit with the master at work. And Velázquez guided Rubens through the royal collection, which included Bosch's *Garden of Earthly Delights* (see *Closer Look,* Chapter 16) and, most especially, Titian's *The Rape of Europa* (see Fig. 20.8), which had been painted expressly for Philip II. Rubens copied both. He also persuaded Velázquez to go to Italy in 1629 to 1630, where he studied the work of Titian in Venice. In Florence and Rome, Velázquez disliked the paintings of Raphael, whose linear style he found cold and inexpressive.

By the time Rubens met the young painter, he was already deeply affected by Caravaggio. The figure of Bacchus in *The Triumph of Bacchus,* also known as *Los Borrachos* [bor-RAH-chohs] (*The Drunkards*) (Fig. **23.17**), painted around the time of Rubens's visit, is directly indebted to

Caravaggio's realistic and tightly painted treatments of the same mythological figure (see Fig. 21.15). And the peasants gathered around the youth are reminiscent of the ruddy working-class types that populate Caravaggio's canvases. But Rubens's own taste for bacchanalian themes was at work as well.

Bacchus, **p. 691**

Velázquez's chief occupation as painter to Philip IV was painting court portraits and supervising the decoration of rooms in the various royal palaces and retreats. Most were portraits of individuals, but *Las Meninas* [las may-NEE-nahss] (*The Maids of Honor*) is a life-size group portrait and his last great royal commission. It elevates the portrait to a level of complexity almost unmatched in the history of art.

The source of this complexity is the competing focal points of the composition (see *Closer Look*, pages 750–751). This work, with its unusual spatial scheme that includes a likeness of the painter and permits us into his studio, continues to inspire later artists.

The Literature of the Spanish Court

Under Philip III and Philip IV, the literary arts in Spain flourished as never before. Cervantes's great novel *Don Quixote* appeared in two parts, the first in 1605 and the second in 1615 (see Chapter 20). A transitional text, it represents the culmination of Renaissance thought even as it announces the beginning of an age of great innovation and originality. Especially influential was Cervantes's willingness to criticize, by means of good humor and satire, the social structures of Spanish society, particularly its aristocracy and religious institutions. Above all, the example of Cervantes freed Spanish writers to be entertaining.

The Plays of Lope de Vega and Calderón The Golden Age of Spanish drama lasted for nearly 100 years, spanning the years when Lope Félix de Vega [LOH-pay FAY-leeks day VAY-gah] (1562–1635) produced his first play in 1592, and 1681, when the playwright who succeeded him as the favorite of the Spanish court, Pedro Calderón de la Barca [PAY-droh kahl-day-ROHN day la BAR-kah] (1600–1681), died. Literally thousands of plays were written and produced in these years, an estimated 1,800 by Lope de Vega alone (only 500 of these are considered authentic), a pace of some 42 plays a year, or one every eight or nine days. As a rule, plays in Golden Age Spain were intended for a single performance, and yet despite the pace at which they were produced, which would tend to encourage formulaic and repetitive strategies, inventiveness was highly prized. Actors struggled to learn their lines and often begged forgiveness of their audiences for errors they committed. Set designers, many of them engineers imported from Italy, were encouraged to create as many changeable scenes as possible, and playwrights obliged them by creating plays of ten or more scene changes.

So extensive are Lope's writings in every genre—novels, short stories, epistles, epic poems, and lyric poetry in addition to plays—that a complete edition of his works has never been assembled. But beyond his extraordinary energy, his innovative approach to drama sets him apart. Before Lope, Spanish drama had been governed by strict observance of the classical unities. He offered instead a new model, the *comedia nueva* [koh-MAY-dee-ah noo-WAY-vah] ("new comedy"), fast-paced, romantic treatments taking as their themes national history or everyday Spanish life. According to Lope, the classical unities were to be abandoned. Furthermore, comedy and tragedy should be mixed in the same play, and noble and base characters intermingled. Puns, disguises, mistaken identities, and fixed types or caricatures should facilitate the plot. Finally, any theme was admissible. Lope's new comedies were a smashing success, performed again and again for both Philip III and Philip IV.

Calderón's temperament was very different from Lope's. He lived a quiet life dedicated to his books and thoughts. He wrote almost exclusively for the court, not the public, and produced some 120 plays, most of which followed models established by Lope. Some of them even recast Lope's original works. But it would be a mistake to think of Calderón as unoriginal. He was more philosophical and profound than Lope, and the beauty of his poetry far exceeded his mentor's. His so-called court-and-sword plays are especially interesting. His theme is the conflict between love and honor.

The point of honor (*pundonor* [poon-doh-NOR]) in Spanish society was based primarily on a notion of marital fidelity that extended to a man's entire household, including all women in the house, married or unmarried. Any violation of female honor had to be avenged as a matter of reputation and self-respect. In actual practice, the *pundonor* often led to horrific outcomes. If a wife was even suspected of infidelity, her husband was permitted to kill her and had to murder her suspected lover as well. Calderón's plays take full advantage of the dramatic possibilities of such a social code. He weaves the intrigues of lovers—and the accompanying disguises, mistaken identities, false accusations, and humiliating loss of honor—into complex and entangled plots that capture the sometimes horrid depths and sometimes glorious heights of Spanish passion.

The Satires of Francisco de Quevedo No writer of Golden Age Spain understood so well or confronted so thoroughly the country's political, economic, and moral bankruptcy as Francisco de Quevedo y Villegas [day kay-VAY-doh ee veel-YAY-gahss] (1580–1645). Most of his literary life was dedicated to exposing the corruption and weakness of the Spanish court, the foolish ways and misplaced values of his contemporaries, and especially the dishonesty and deceit of Spain's professional and merchant classes—lawyers, doctors, judges, barbers, tailors, and actors. His greatest work along these lines is *Sueños* [soo-AYN-yohss] (*Visions*). The work consists of five visions written between 1606 and 1622. In the first, *El Sueño del Juicio Final* [el soo-AY-noh del hoo-EE-see-oh fee-NAHL] (*The Vision of the Last Judgment*), Quevedo recalls a dream in which on the day of the Last Judgment, the dead rise from their graves. Their bones detached and scattered, the dead must reassemble themselves. While every soul finally gets it right, Quevedo witnesses considerable procrastination. A scribe pretends his own soul is not his own in order to be rid of it. Slanderers are slow to

Diego Velázquez's *Las Meninas*, or *The Maids of Honor*, is a painting remarkable in conception and extraordinary in execution. This group portrait captures in a passing moment ten individuals in the vast room that was the painter's studio in the royal palace of Spain. The competing focal points of the composition are the source of the work's complexity. At the very center of the painting, bathed in light, is the Infanta Margarita, beloved daughter of King Philip IV and Queen Mariana. In one sense, the painting is the Infanta's portrait, as she seems the primary focus. Yet the title *Las Meninas*, "The Maids of Honor," implies that her attendants are the painting's real subject. However, Velázquez has painted himself into the composition at work on a canvas, so the painting is, at least partly, also a self-portrait. The artist's gaze, as well as the gaze of the Infanta and her dwarf lady-in-waiting, and perhaps also of the courtier who has turned around in the doorway at the back of the painting, is focused on a spot outside the painting, in front of it, where we as viewers stand. The mirror at the back of the room, in which Philip and Mariana are reflected, suggests that the king and queen also occupy this position, acknowledging their role as Velázquez's patrons.

Difficult to see even in person, this painting on the back wall is a reproduction of Rubens's *Pallas and Arachne* of 1636 to 1637, commissioned by Philip IV, and is thus an homage to that painter.

The **red cross** on the artist's breast is the symbol of the Order of Santiago, to which the painter was nominated in 1658. The order had formerly banned membership to those who worked with their hands. In winning his nomination, Velázquez affirmed not only his own nobility, but also that of his craft. Philip IV ordered the addition of the cross in the painting after Velázquez's death in 1660.

No other Velázquez painting is as tall as *Las Meninas,* which suggests that the back of the canvas in the foreground is, in fact, *Las Meninas* itself. Velázquez thus paints himself painting this painting.

One of two **maids of honor** who give the painting its title. The other stands just to the Infanta's left. This one hands the Infanta a terra-cotta jug on a gold plate. The jug probably contained cold, scented water.

Something to Think About . . .

At the time that Velázquez was at work on *Las Meninas*, Jan van Eyck's painting *Giovanni Arnolfini and His Wife Giovanna Cenami* (see Fig. 16.7) was hanging in Philip IV's palace. How might van Eyck's painting have influenced Velázquez's?

SEE MORE For a Closer Look at Diego Velázquez's *Las Meninas,* go to **www.myartslab.com**

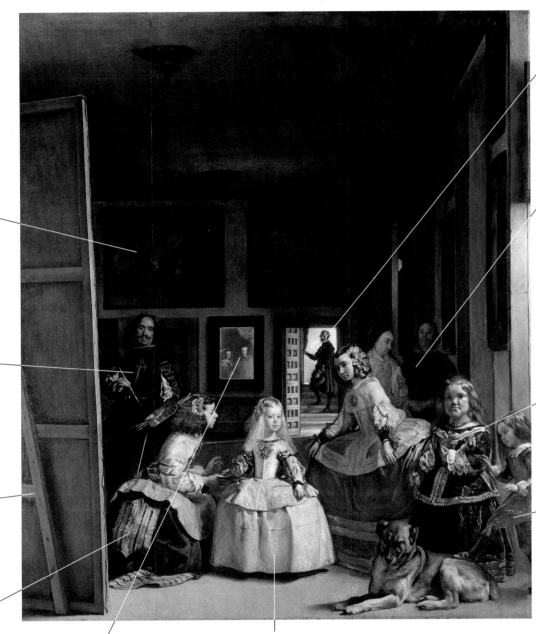

José Nieto, the queen's chamberlain, responsible for the day-to-day operations of the royal household. His gesture and the light that surrounds him draw attention to the mirror reflecting the king and queen.

The **nun and priest** emphasize the importance of the Catholic faith in the Spanish court.

Dwarfs were a common feature in the royal courts of Europe, a source of entertainment and amusement. They were dressed in fine costume, lavished with jewelry and gold, and shown off at court ceremonies and festivals. Often, they were presented as gifts to court dignitaries. Velázquez paints them with compassion, for their status in court was not much better than his own.

Court Jester Nicolasito, shown tormenting the huge dog in front of him by stepping on its back.

If the king and queen were really situated where the viewer stands, their reflection in the mirror at the back of the room would be much smaller. Velázquez is playing games with the space of the painting.

Infanta Margarita, five years old at the time of the painting, was heir to the Spanish throne.

Diego Velázquez. *Las Meninas (The Maids of Honor).* **1656.** Oil on canvas, 10′ 3/4″ × 9′ 3/4″. Museo del Prado, Madrid.

find their tongues, and the lustful fear to find their eyes lest these organs bear witness against them. Thieves and murderers spend hours trying to avoid their hands. Among the dead, Adam, Herod, Pilate, Judas, Mohammed, and Martin Luther are all tried and condemned until an astrologer arrives and declares that there is a great mistake—it is not Judgment Day at all. Devils promptly carry him off to Hell.

The other *Sueños* follow this same pattern. They are plotless catalogs of social types and historical characters, each exposed in succession to Quevedo's biting wit. Seeing themselves and their neighbors in Quevedo's sketches, and apparently capable of laughing at his often sardonic vision, Spaniards responded enthusiastically to the *Sueños*. Philip IV was less enthused. Perhaps that explains why Quevedo was arrested in 1639. He remained in prison until 1643 and died

profoundly pessimistic that Spain would long remain a force in world politics.

THE BAROQUE IN THE AMERICAS

Don Quixote, Cervantes's great character (see Chapter 20), is in part a spoof of the Spanish conquistador mentality that had taken control of the Americas and whose chivalry both Lope de Vega and Quevedo later likewise spoofed. The Americas were Spain's greatest source of wealth, and Spanish culture quickly took hold in both North and South America. This was a politically important enterprise, because it underscored that the absolute authority in the Americas was the Spanish monarchy. In Cuzco [KOOS-koh], Peru, the Spanish adopted the structures of the Inca to their own purposes, constructing their own buildings, as we saw in Chapter 11, on original Inca foundations. As we have seen, they even converted the most magnificent of the Inca sacred sites, the Temple of the Sun, into a Dominican church and monastery (see *Continuity & Change*, Chapter 11). Over time, Spanish leaders and missionaries believed, the distinction between worshiping the Inca gods and worshipping the sacred in general would become increasingly less clear, and Christianization of the native population would occur naturally.

The Cuzco School

In truth, the indigenous native populations Indianized the Christian art imposed upon them, creating a unique visual culture, part Baroque, part Indian. A case in point is the city of Lima, founded by the conquistador Francisco Pizarro in 1535 as capital of the Viceroyalty of Peru (see Map **23.1**) on the coast, convenient to harbor and trade. As opposed to Cuzco, with its narrow, winding streets, Lima was laid out in a formal grid, with wide, open vistas, the very image of imperial order. By the start of the seventeenth century, the city was a fully Baroque testament to the Spanish culture of its founders. The stones for its mansions were shipped in from Panama as ballast for ships

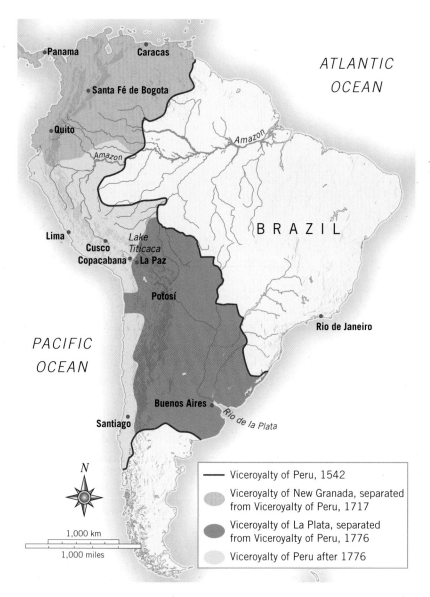

Viceroyalty of Peru, 1542

Viceroyalty of New Granada, separated from Viceroyalty of Peru, 1717

Viceroyalty of La Plata, separated from Viceroyalty of Peru, 1776

Viceroyalty of Peru after 1776

Map 23.1 Spanish Viceroyalties in South America, 1542–1824.

Fig. 23.18 Palacio Tore Tagle, Lima, Peru, 1735. Today the Palacio houses the Peruvian Foreign Ministry. Such ornately carved Baroque balconies were part of the facades of many colonial mansions in Lima.

that carried gold from the highlands and silver from Potosí (see Chapter 18) to Mexico and then on to Spain. The wood for its mansions, with their elaborately carved Baroque balconies (Fig. **23.18**), was imported oak and cedar.

The artisans who carved these Baroque panels were increasingly native, as were the metalworkers who created fine objects to satisfy colonists' tastes and the painters who decorated their churches. Especially in Cuzco, they brought to their work techniques and motifs from their Inca background. *Our Lady of the Victory of Málaga* (Fig. **23.19**) by Luis Niño (active 1730–1760) employs **brocateado** [broh-kah-tay-AH-doh], the application of gold leaf to canvas, a technique extremely popular among the Cuzco painters, especially for creating elaborate, brocadelike effects on saints' garments. Here the Virgin stands on a silver crescent moon above the tiled roofs and trees of the Cuzco countryside, recalling the Inca association of silver with religious worship of the moon, while the flat symmetry of the *brocateado* evokes the flat patterns of Inca textile design (see Fig. 11.34) and the Inca association of gold with worship of the sun. In fact, some scholars argue that the crescent at the virgin's feet, together with the two vertical red lines that rise straight up

from its center, take the shape of the curved blade and handle of the Inca ceremonial knife used in traditional sacrifices, a shape also worn as a pin by Inca princesses as a symbol of good luck. Thus Catholic and native traditions are compounded in a single image, a syncretism mirrored in the increasingly mestizo fabric of the population as a whole (see Chapter 18).

Baroque Music in the Americas: Sor Juana Inés de la Cruz

The syncretism in the work of the Cuzco artists is also evident in Baroque music as it developed in New Spain. As the Church sought to convert native populations to the Catholic faith, the musical liturgy became a powerful tool.

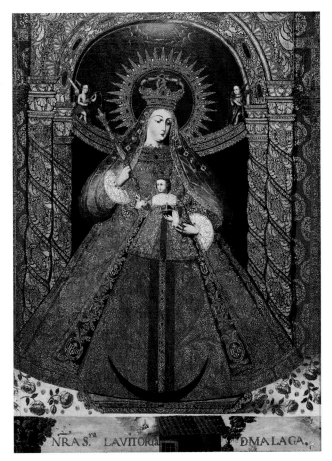

Fig. 23.19 Luis Niño (Bolivian), *Our Lady of the Victory of Málaga.* **Southern Cuzco school, Potosí, Bolivia. ca. 1740.** Oil on canvas overlaid with gold and silver, 59¹/₂″ × 43³/₄″ Gift of John C. Freyer for the Frank Barrows Freyer Collection. Denver Art Museum, CO. This particular manifestation of the Virgin is associated with the Minimi order of the Catholic Church, founded in the fifteenth century by Francis of Paula (Italy). He was present at the Spanish victory over the Moors at Málaga in 1487, and claimed to have seen the Virgin appear. He was eventually sanctified by the pope, and was the patron saint of travelers, sailors, and navigators. A Minimi monastery was established in Peru in the seventeenth century.

As early as 1523, Spanish monks created a school for Native Americans in Texcoco, Mexico (just east of Mexico City), and began teaching music, including Gregorian chant, the principles of polyphony, and composition, on an imported organ. Throughout the sixteenth century, missionaries used music, dance, and religious dramas to attract and convert the indigenous population to Christianity. These forms were sometimes adapted to local conditions. For example, the religious drama *Battle of the Christians and Moors* became the *Battle of Pizarro and Atahuallpa* (see Chapter 18), a dance-drama still performed in Peru.

An interesting example of syncretism in the cultures of New Spain is in the work of Sor Juana Inés de la Cruz (1648–1695). The illegitimate daughter of an America-born mother of pure Spanish descent and a Basque father, she was recognized as a prodigy at an early age, and at 16 was named lady-in-waiting to the wife of the Spanish viceroy. Four years later, seeking freedom to pursue her education, she entered the Convent of San Jerónimo in Mexico City, where she spent the rest of her life. She is remembered today largely as the author of an important tract, *Reply to Sor Philotea* (1691), in which she defended the rights of women to pursue any form of education they might desire, and as a poet. Her sonnet "To Her Self-Portrait" is representative of her work (**Reading 23.4**):

READING 23.4

Sor Juana Inés de la Cruz, "To Her Self-Portrait" (posthumous publication 1700)

What you see here is colorful illusion,
an art boasting of beauty and its skill,
which in false reasoning of color will
pervert the mind in delicate delusion.
Here where the flatteries of paint engage
to vitiate the horrors of the years,
where softening the rust of time appears
to triumph over oblivion and age,
all is a vain, careful disguise of clothing,
it is a slender blossom in the gale, 10
it is a futile port for doom reserved,
it is a foolish labor that can only fail;
it is a wasting zeal and, well observed,
is corpse, is dust, is shadow, and is nothing.

The poem expresses the poet's profound distrust in what is apparent in the self-portrait only through the observational senses. If "well observed," she concludes, one should see there the inevitable fact of death, which the color, beauty, and skill of the portrait masks. The poem is a profound example of Baroque self-awareness, the product of a mind that loves beauty even as it recognizes its fleeting nature.

Many of Sor Juana's poems were originally songs written to be accompanied by music, the notation to which is now lost. Nevertheless, they tell us much about music in

Baroque New Spain. Her hymn *Tocatín*, written in the Aztec language of Nahuatl, in which she was fluent, aligns the Virgin Mary with the Aztec Earth Mother and was probably sung to the tune of a popular Spanish folk tune. Among her most popular musical productions are several collections of *villancicos*. The *villancico* is a form similar to the Italian *frottola* (see Chapter 14), and it developed in fifteenth- and sixteenth-century Spain. Simple polyphonic songs, on a light, rustic, or pastoral theme, in which the upper voice dominates while the lower voices fill in the polyphony, many early *villancicos* were originally written for voice and guitar. In New Spain, the form developed over the course of the next hundred years into a religious genre that made increasing use of recitative and aria, often employing as many as five solo voices. Because the New World *villancico* made use of vernacular texts and told popular stories, it was a particularly effective means of addressing the native populations.

In Sor Juana's hands, the *villancico* was a means to dramatize the diversity of language and culture in New Spain. In her suite of eight *villancicos* known as *San Pedro Nolasco* (1677), the story of a Mexican saint known for freeing slaves of both African and Indian descent, her soloists sang in three languages. An Aztec sang in Nahuatl. A female poet introduced and narrated the performance in proper Spanish. A common man of the street sang in less refined Spanish. An African-American slave also sang in Spanish, but in a very colloquial and African-inflected dialect. Finally, a student sang in Latin. All of these voices came together in a story of profound miscommunication about the possibilities of salvation. What the music might have sounded like is open to question, but it is likely that the different languages would have been sung in different rhythms with accents falling in different places. For instance, we know because the female poet narrator says so when she introduces him that the African-American slave's opening refrain was sung "to the music of a calabazo song," that is, a song accompanied by a percussive gourd. The introduction of a folk instrument into the religious *villancico* speaks to the heterogeneous complexity of Mexican Baroque music.

The Churrigueresque Style: *Retablos* and Portals in New Spain

The taste for elaborate decorative effects and complexity evident in the Cuzco Madonna and the Lima balconies as well as in Sor Juana's *villancicos* found its most extraordinary expression in large altarpiece ensembles, known as **retablos** [ray-TAH-blohs], which began to appear in the churches of Mexico in the late seventeenth century. In Spain, a family of architects and sculptors known as the Churriguera [choor-ree-GAY-rah] had introduced and given their name to an extremely lavish Baroque style called Churrigueresque [choor-ree gay-RESK], used to decorate *retablos* and church portals. (These Baroque

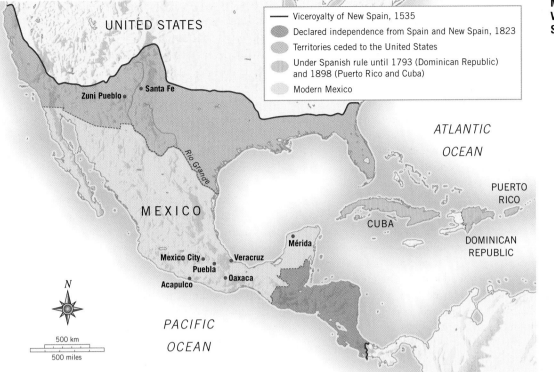

Map 23.2 The Viceroyalty of New Spain, 1535–1821.

— Viceroyalty of New Spain, 1535
Declared independence from Spain and New Spain, 1823
Territories ceded to the United States
Under Spanish rule until 1793 (Dominican Republic) and 1898 (Puerto Rico and Cuba)
Modern Mexico

UNITED STATES

Zuni Pueblo • Santa Fe

Rio Grande

MEXICO

ATLANTIC OCEAN

PUERTO RICO

CUBA

DOMINICAN REPUBLIC

Mérida

Mexico City • Veracruz
Puebla • Oaxaca
Acapulco

N

500 km
500 miles

PACIFIC OCEAN

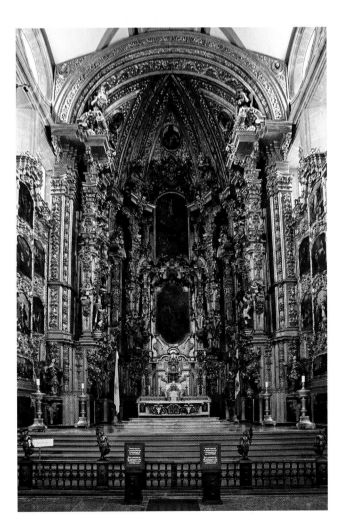

Fig. 23.20 Jerónimo de Balbás, Altar of the Kings, principal *retablo* of the Cathedral, Mexico City. 1718–37. Polychrome and gilded wood, height 85'. Balbás was the first architect to employ the distinctive *estípite* column in Spanish-colonial America. Before coming to Mexico in 1717, Balbás had been a leading *retablo* maker in Seville.

retablos are distinct from the folk art *retablos* that originated in the late nineteenth century as devotional oil paintings sold to devout believers who displayed them in home altars to honor their patron saints.) In the Viceroyalty of New Spain, comprising most of modern Mexico, Central America, and the American Southwest (see Map **23.2**), Baroque *retablos* were at first the work of teams of European artists, then later *criollos* [kree-OHL-yoh], Mexican-born descendants of Spaniards. These *retablos* were generally designed to frame, in the most extravagant style, paintings and sculptures brought to the Americas from Europe.

A good example of the Churrigueresque *retablo* is the vast Altar of the Kings, designed by Jerónimo de Balbás [day bahl-BAHSS] (ca. 1680–1748) for the cathedral in Mexico City (Fig. **23.20**). Here artisans used gold leaf unsparingly in a radical vertical design distinguished by a new form of engaged column, narrow at the base and top, wider in the middle, known as the **estípite** [es-TEE-pee-tay] **column**. The column is constructed of segmented, upside-down, and tapered pyramids and other sculpted forms of the kind previously found

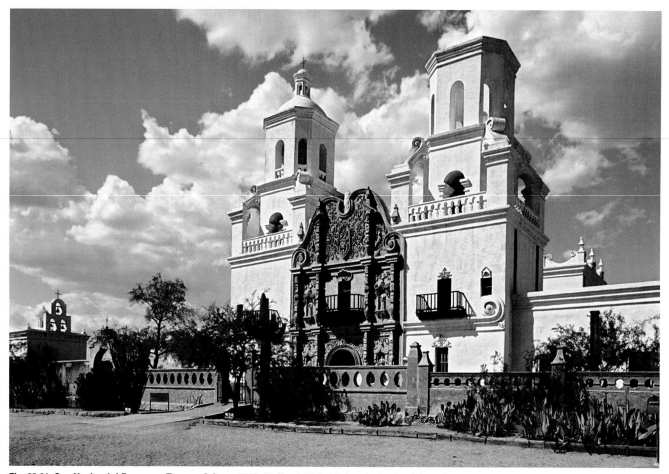

Fig. 23.21 San Xavier del Bac, near Tucson, Arizona 1783–97. Nearly 99 feet in length, the church is made of brick and mortar, instead of adobe (earth and straw), the usual building material of the Southwest. The material was probably chosen to assert the Church's permanence.

only on the finials of furniture. Surrounded by decorative scrolls, garlands, and sculptures of angels and saints, all gilded and flickering in the candlelight, these *estípite* columns rise column upon column to an awe-inspiring height of 85 feet!

The extravagance of the Mexico City *retablo* is hardly unique. On the one hand, *retablos* were designed to impress the indigenous population, which the Spanish missionaries were intent on converting to Christianity. Thus nearly every church of any size in New Spain possessed a *retablo* that aspired to the magnificence of the one in the Mexico City Cathedral. On the other hand, *retablos* were a manifestation of the extraordinary wealth that Mexico enjoyed as the center of a trade for precious metals. It coordinated a network of sources and outlets that through its Atlantic and Pacific ports linked the silver mines of Peru in the south, its own silver mines in the Sierra Madre of central Mexico, and other mining towns in the north, to Spain, the Philippines, and China. Thus, as far north as New Mexico and

Arizona, new missionary churches built in the seventeenth and eighteenth centuries were modeled on churches built in the same era to the south.

One of the most beautiful of these northern churches is San Xavier del Bac [sahn KSAH-vee-ay del bahk], just south of present-day Tucson, built in 1783 to 1797. The mission was founded in the early eighteenth century to serve the Tohono O'odham, or "Desert People," and the settlement these people called Bac, "place where the water appears." The name of the settlement refers to the fact that the Santa Cruz River, which runs underground for some distance, reappears on the surface nearby. Surrounding the church's portal are niches framed by *estípite* columns (Fig. **23.21**). Elaborate volutes, almost certainly deliberate echoes of the facade of Il Gésu, the Jesuit church in Rome (see Fig. 21.9), decorate the facade and support the two towers (one of which was mysteriously never completed). The magnificent *retablo* inside has

unusual twin *estípite* columns that rise from floor to ceiling (Fig. **23.22**).

Despite Spain's program to convert Native Americans to Christianity, the Native American cultures of the Southwest never comfortably assimilated Western religion. In August 1680, the Pueblo peoples of present-day New Mexico and Arizona simultaneously revolted under the leadership of a San Juan Indian named Popé [POH-pay]. They killed 21 of the province's 33 Franciscans and 308 Spanish settlers, including men, women, and children.

Survivors fled south to El Paso del Norte [el–PAH-soh del NOR-tay].

Not until 1692 would the Spanish reassert control of the region, but they had learned their lesson. They no longer practiced *encomienda* or *repartimiento*, they formally recognized the Pueblos' rights to their lands, and they abandoned their attempt to force Christianity upon the population. As a result, the Pueblo peoples today still retain the greater part of their pre-Conquest culture. But interestingly, from 1692 on, the two traditions, native and

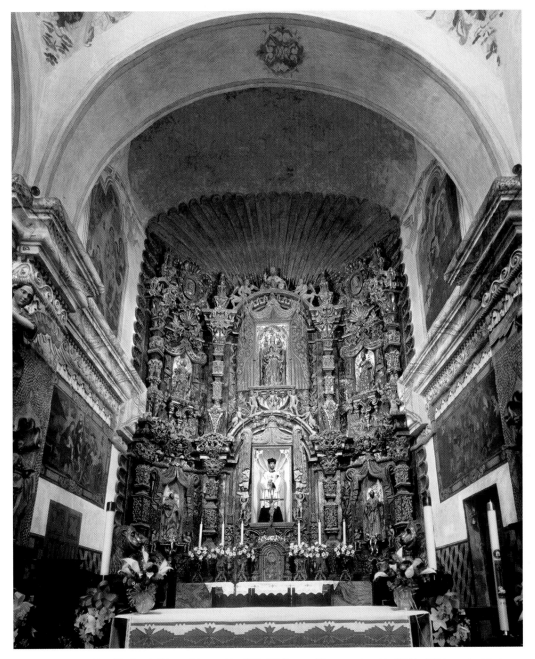

Fig. 23.22 Nave of San Xavier del Bac with *retablo*. 1783–97. The *retablo* was restored in 1992 to 1997, a project that included the delicate cleaning of its gold and silver leaf.

Christian, have stood side by side, especially in mission architecture and decoration, to create a composite and syncretic style.

The decorative program of the Church of San José at Old Laguna Pueblo, the first church to be rebuilt after the reconquest in 1699 to 1706, is a case in point (Fig. **23.23**). The altar and *retablo* are the work of an unknown artist known as the Laguna Santero, an itinerant Mexican artist who created altar ensembles from the 1780s to about 1810, not only at Laguna but also at Acoma, Zia, Santa Ana, and Pojoaque pueblos and for churches in Santa Cruz de la Cañada and Santa Fe. The high altar at Laguna is decorated with floral motifs—that may have once covered the walls to both right and left of the altar as well—probably meant to replicate the European woven tapestries found in the wealthier cathedrals to the south. The carved wooden *retablo* behind the high altar consists of four spiraling columns—reminiscent of the solomonic columns popular in European Baroque architecture in the seventeenth century—topped by a painting of the Holy Trinity. In the center of the columns is Saint Joseph (San José), the patron saint of the church, holding the Christ child in one arm. To the left is Saint John Nepomuk, sainted for refusing to violate the secrecy of the confessional, and to the right, Saint Barbara, patron saint of those who work with explosives, and hence associated with thunder and lightning. Attached to the top of the *retablo* and extending above the altar is a buffalo hide, painted with a sun on the left, a moon on the right, between them a rainbow and stars. Extending from the sun are zigzag lines that culminate in a triangular head, symbol of the Pueblo deity, the Horned Water Snake, god of lightning and rain. At each side of the altar are three mountains set beneath an overarching rainbow. Each possesses the eyes and mouth of a kachina. They echo the Holy Trinity at the top of the *retablo*, who stand beneath the overarching rainbow on the buffalo hide above and each of which is backed by a triangular green halo. Thus Pueblo and Christian traditions are unified in the design, and this syncretic impulse is underscored not only by the Pueblo designs which run the length of the nave but also by the fact that the Christ child in Saint Joseph's arms carries a green peyote button.

Fig. 23.23 The Laguna Santero, *Retablo* **and high altar of the Church of San José, Old Laguna Pueblo. ca. 1780–1810.** A *santero* is a New Mexico artist whose carvings and paintings depict saints, angels, or other religious figures.

Excess and Restraint

An underlying characteristic of the Baroque age is its ultimate trust in the powers of reason. Major breakthroughs in mathematics, astronomy, geology, physics, chemistry, biology, and medical science dominate the history of the age. These products of empirical reasoning constituted a so-called **Scientific Revolution** that transformed the way the Western mind came to understand its place in the universe.

It may seem odd that painters like Caravaggio, Rubens, and Rembrandt, who appealed to the emotional and dramatic, the sensual and the spectacular, should be products of the same age as the Scientific Revolution. It would seem more reasonable to say that the scientific energies of the age found their painterly expression more in the likes of Poussin than Rubens, their literary expression more in Corneille than Molière. And yet Rembrandt's *Anatomy Lesson of Dr. Tulp* (see Chapter 22 *Closer Look*, pages 720–721) clearly engages the scientific mind, and Rubens's swirling, flowing lines are the product of a mind confident that order and wholeness are the basic underpinnings of experience. In a very real sense, then, Rubens and Rembrandt, Molière and Wycherley, Calderón and Quevedo, can best be understood in terms of their ability to look beneath the surface of experience for the human truths that motivate us all. Their work—like the autobiographical writings of Montaigne in the sixteenth century—announces the dawn of modern psychology.

Still, the Baroque age does embody a certain tension between reason and emotion, decorum and excess, clearly defined in the contest between the *poussinistes* and the *rubenistes* for ascendancy in the arts. This tension is evident in a painting that shows Louis XIV visiting the Académie des Sciences in 1671 (Fig. **23.24**). Following the lead of King Charles II of England, who had chartered the Royal Society in 1662, Louis created the French Academy of Sciences in 1666. He stands surrounded by astronomical and scientific instruments, charts and maps, skeletal and botanical specimens. Out the window, the ordered geometry of a classical French garden dominates the view. At the same time, Louis seems alien to his surroundings. Decked out in all his ruffles, lace, ribbons, and bows, he is the very image of ostentatious excess. The tension he embodies will become a defining characteristic of the following century. In the next two chapters, we will examine the tension in the eighteenth century between the demands of reason, the value that defines the so-called Enlightenment, and the limits of excess, the aristocratic style that has come to be known as the Rococo. Both equally were the product of the Baroque age that precedes them. ■

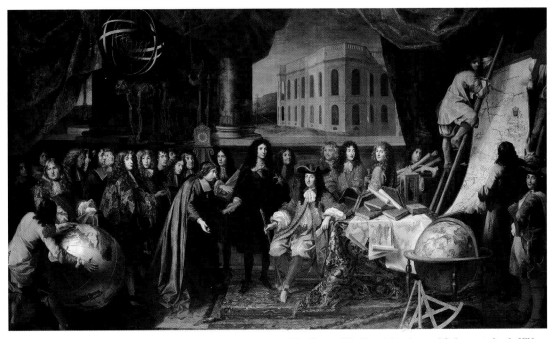

Fig. 23.24 Henri Testelin, *Jean-Baptiste Colbert Presenting the Members of the Royal Academy of Science to Louis XIV.* ca. 1667. Oil on canvas. © Chateau de Versailles, France/Lauros/Giraudon/The Bridgeman Art Library.

What is absolutism?

The court and government of Louis XIV of France were centered at Versailles, the magnificent palace outside Paris designed by Charles Le Brun. André le Nôtre laid out the grounds in the geometric style called the French garden. In what ways does Versailles reflect Louis's sense of his absolute authority? What did he mean to suggest by calling himself *Le Roi Soleil*, "the Sun King"?

What tastes in art competed for Louis XIV's favor?

Various members of the court favored one or the other of two competing styles of art, represented, on the one hand, by the work of Peter Paul Rubens and, on the other, by that of Nicolas Poussin. What compositional features characterize the painting of Rubens, and how do they contrast with the painting of Poussin?

Louis indulged his taste for pomp and ceremony in music and dance, and especially entertainments written by Jean-Baptiste Lully, who created a new operatic genre, the *tragédie en musique*. What characterizes Lully's operas? Louis also strongly promoted dance, the most important form of which was the minuet.

Under a charter granted by Louis, the *Comédie Française*, the French national theater, was established. How did the plays of Pierre Corneille reflect the aesthetic tastes of Poussin? Molière's comedies, such as *Tartuffe*, spared no one from ridicule. What is the central focus of his works? Jean Racine wrote such successful tragedies that he became the first French playwright to live entirely on the earnings from his plays.

How did political conflict affect the arts in England?

The greatest artist of the English court was Anthony Van Dyck, who had worked in Rubens's studio as his chief assistant. His great talent was portraiture. How did the political climate in England—the rivalry between Roundhead Puritan factions and Cavalier royalists—complicate his career? Can you briefly describe the political maneuverings of the era? How did this rivalry manifest itself in literature? And how did it manifest itself in the burgeoning art and literature of the American colonies?

What role did the arts play in the Spanish court?

Philip IV of Spain strove to rival the other great courts of Europe by employing the greatest painters of the day, including Peter Paul Rubens. The young court painter Diego Velázquez, already deeply influenced by Caravaggio, visited Rubens at work. Velázquez's greatest work is *Las Meninas*, ostensibly a portrait of the royal princess, but a self-portrait as well, and a complex realization of space. There are many different gazes that ricochet throughout Velázquez's painting *Las Meninas* and act as focal points. Describe as many of them as you can find. Under Philip III and Philip IV, the literary arts thrived, especially in the drama of Lope de Vega and Calderón, who were central to what has come to be known as the Golden Age of Spanish drama. What is the central theme of Calderon's work? What characterizes Lope de Vega's plays? What theme predominates the satires of Francisco de Quevedo?

How did Native American traditions affect the Baroque style in the Americas?

By the start of the seventeenth century, Lima, Peru, was a fully Baroque city. Native painters decorated their paintings of saints with elaborate *brocateado*. How does the technique reflect their Inca heritage? In New Spain, the poet Sor Juana Inés de la Cruz wrote *villancicos*. How would you describe these complex Baroque musical compositions? What do they celebrate? The Baroque found particular expression in the *retablos*, or altarpiece ensembles, in the churches of New Spain. What characterizes them? This style spread throughout the Viceroyalty of Mexico, as far north as San Xavier del Bac, near present-day Tucson, Arizona. After the Pueblo revolt of 1680, the Church became more tolerant of native traditions. How does the Church of San José at Old Laguna Pueblo reflect this new tolerance?

PRACTICE MORE Get flashcards for images and terms and review chapter material with quizzes at **www.myartslab.com**

GLOSSARY

absolutism A term applied to strong, centralized monarchies that exert royal power over their dominions, usually on the grounds of divine right.

binary form Having a two-part structure.

brocateado The application of gold leaf to canvas.

Cavalier The term for the aristocratic royalist supporters of Charles I of England.

classical unities The notion, derived from Aristotle's *Poetics*, that requires a play to have only one action that occurs in one place and within one day.

comédie-ballet A drama that is part opera and part ballet.

divertissement An intermezzo.

estípite column A form of engaged column, narrow at the base and top, wider in the middle, that is constructed of

segmented, upside-down, and tapered pyramids and other sculpted forms.

French garden A style of formal garden that is characterized by a methodical, geometrical design.

French overture An overture distinguished by a slow, homophonic melody (associated with the royal dignity) that built to a faster contrapuntal section.

intermezzo A short display of dance, song, or instrumental music.

masque A type of performance that combined speech, dance, and spectacle.

minuet An elegant triple-time dance of moderate tempo.

retablo A large altarpiece ensemble.

Roundhead Supporter of the Puritan Parliament who cropped his hair short and dressed plainly.

Scientific Revolution A time of major breakthroughs in mathematics, astronomy, geology, physics, chemistry, biology, and medical science, all the result of empirical reasoning.

suite An ordered series of instrumental dances.

tragédie en musique An operatic genre that generally consists of an overture, an allegorical prologue, five acts of sung drama, and many intermezzos.

READINGS

READING 23.1

from Molière, *Tartuffe*, Act III, scenes 2 and 3 (1664)

A remarkable feature of Molière's play is that its central character, Tartuffe, does not come on stage until Act III, scene 2. Up to that point, however, he has been the focus of all conversation, and the family maid Dorine has tried valiantly to expose his calumny. In these two scenes, the perceptive Dorine mocks his hypocrisy even as she announces the arrival of Orgon's wife, Elmire, whom Tartuffe attempts to seduce.

SCENE II

TARTUFFE, LAURENT, DORINE

TARTUFFE [Observing Dorine and calling to his manservant off stage]
 Hang up my hair shirt, put my scourge in place,
 And pray, Laurent, for Heaven's perpetual grace.
 I'm going to the prison now, to share
 My last few coins with the poor wretches there.
DORINE [Aside:] Dear God, what affectation! What a fake!
TARTUFFE You wished to see me?
DORINE Yes . . .
TARTUFFE [Taking a handkerchief from his pocket]
 For mercy's sake,
 Please take this handkerchief, before you speak.
DORINE What? 10
TARTUFFE Cover that bosom, girl. The flesh is weak,
 And unclean thoughts are difficult to control.
 Such sights as that can undermine the soul.
DORINE Your soul, it seems, has very poor defenses,
 And flesh makes quite an impact on your senses.
 It's strange that you're so easily excited;
 My own desires are not so soon ignited,
 And if I saw you naked as a beast,
 Not all your hide would tempt me in the least.
TARTUFFE Girl, speak more modestly; unless you do, 20
 I shall be forced to take my leave of you.
DORINE Oh, no, it's I who must be on my way;
 I've just one little message to convey.
 Madame is coming down, and begs you, Sir,
 To wait and have a word or two with her.
TARTUFFE Gladly.

DORINE (Aside) That had a softening effect!
 I think my guess about him was correct.
TARTUFFE Will she be long?
DORINE No: that's her step I hear. 30
 Ah, here she is, and I shall disappear.

SCENE III

ELMIRE, TARTUFFE

TARTUFFE May Heaven, whose infinite goodness we adore,
 Preserve your body and soul forevermore,
 And bless your days, and answer thus the plea
 Of one who is its humblest votary.
ELMIRE I thank you for that pious wish. But please,
 Do take a chair and let's be more at ease.
 [They sit down.]
TARTUFFE I trust that you are once more well and strong?
ELMIRE Oh, yes: the fever didn't last for long.
TARTUFFE My prayers are too unworthy, I am sure, 40
 To have gained from Heaven this most gracious cure;
 But lately, Madam, my every supplication
 Has had for object your recuperation.
ELMIRE You shouldn't have troubled so. I don't deserve it.
TARTUFFE Your health is priceless, Madam, and to preserve it
 I'd gladly give my own, in all sincerity.
ELMIRE Sir, you outdo us all in Christian charity.
 You've been most kind. I count myself your debtor.
TARTUFFE It was nothing. Madam. I long to serve you better. 50
ELMIRE There's a private matter I'm anxious to discuss.
 I'm glad there's no one here to hinder us.

TARTUFFE I too am glad: it floods my heart with bliss
 To find myself alone with you like this.
 For just this chance I've prayed with all my power—
 But prayed in vain, until this happy hour.
ELMIRE This won't take long, Sir, and I hope you'll be
 Entirely frank and unconstrained with me.
TARTUFFE Indeed, there's nothing I had rather do
 Than bare my inmost heart and soul to you. 60
 First, let me say that what remarks I've made
 About the constant visits you are paid
 Were prompted not by any mean emotion.
 But rather by a pure and deep devotion.
 A fervent zeal . . .
ELMIRE No need for explanation.
 Your sole concern, I'm sure, was my salvation.
TARTUFFE [Taking Elmire's hand and pressing her fingertips]
 Quite so:
 and such great fervor do I feel . . .
ELMIRE Ooh! Please! You're pinching!
TARTUFFE 'T was from excess of zeal. 70
 I never meant to cause you pain, I swear.
 I'd rather . . .
 [He places his hand on Elmire's knee.]
ELMIRE What can your hand be doing there?
TARTUFF Feeling your gown; what soft, fine-woven stuff!
ELMIRE Please, I'm extremely ticklish. That's enough.
 [She draws her chair away; Tartuffe pulls his after her.]
TARTUFFE [Fondling the lace collar of her gown] My, my, what
 lovely lacework on your dress!
 The workmanship's miraculous, no less.
 I've not seen anything to equal it.
ELMIRE Yes, quite. But let's talk business for a bit. 80
 They say my husband means to break his word
 And give his daughter to you, Sir. Had you heard?
TARTUFFE He did once mention it. But I confess
 I dream of quite a different happiness.
 It's elsewhere, Madam, that my eyes discern
 The promise of that bliss for which I yearn.
ELMIRE I see: you care for nothing here below.
TARTUFFE Ah, well—my heart's not made of stone, you know.
ELMIRE All your desires mount heavenward, I'm sure,
 In scorn of all that's earthly and impure. 90
TARTUFFE A love of heavenly beauty does not preclude
 A proper love for earthly pulchritude;
 Our senses are quite rightly captivated
 By perfect works our Maker has created.
 Some glory clings to all that Heaven had made;
 In you, all Heaven's marvels are displayed.
 On that fair face, such beauties have been lavished.
 The eyes are dazzled and the heart is ravished;
 How could I look on you, O flawless creature,
 And not adore the Author of all Nature, 100
 Feeling a love both passionate and pure
 For you, his triumph of self-portraiture?
 At first, I trembled lest that love should be
 A subtle snare that Hell had laid for me;
 I vowed to flee the sight of you, eschewing
 A rapture that might prove my soul's undoing;
 But soon, fair being, I became aware
 That my deep passion could be made to square
 With rectitude, and with my bounden duty.
 I thereupon surrendered to your beauty. 110

It is, I know, presumptuous on my part
To bring you this poor offering of my heart,
And it is not my merit, Heaven knows,
But your compassion on which my hopes repose.
You are my peace, my solace, my salvation;
On you depends my bliss—or desolation;
I bide your judgment and, as you think best,
I shall be either miserable or blest.
ELMIRE Your declaration is most gallant, Sir.
 But don't you think it's out of character? 120
 You'd have done better to restrain your passion
 And think before you spoke in such a fashion.
 It ill becomes a pious man like you . . .
TARTUFFE I may be pious, but I'm human too:
 With your celestial charms before his eyes,
 A man has not the power to be wise.
 I know such words sound strangely, coming from me,
 But I'm no angel, nor was meant to be,
 And if you blame my passion, you must needs
 Reproach as well the charms on which it feeds. 130
 Your loveliness I had no sooner seen
 Than you became my soul's unrivaled queen;
 Before your seraph glance, divinely sweet,
 My heart's defenses crumbled in defeat,
 And nothing fasting, prayers, or tears might do
 Could stay my spirit from adoring you.
 My eyes my sighs have told you in the past
 What now my lips make bold to say at last,
 And if, in your great goodness, you will deign
 To look upon your slave, and ease his pain,— 140
 If in compassion for my soul's distress,
 You'll stoop to comfort my unworthiness,
 I'll raise to you, in thanks for that sweet manna,
 An endless hymn, an infinite hosanna.
 With me, of course, there need be no anxiety.
 No fear of scandal or of notoriety.
 These young court gallants, whom all the ladies fancy,
 Are vain in speech, in action rash and chancy;
 When they succeed in love, the world soon knows it;
 No favor's granted them but they disclose it 150
 And by the looseness of their tongue profane
 The very altar where their hearts have lain.
 Men of my sort, however, love discreetly,
 And one may trust our reticence completely.
 My keen concern for my good name insures
 The absolute security or yours;
 In short, I offer you, my dear Elmire,
 Love without scandal, pleasure without fear.
ELMIRE I've heard your well-turned speeches to the end,
 And what you urge I clearly apprehend. 160
 Aren't you afraid that I may take a notion
 To tell my husband of your warm devotion,
 And that, supposing he were duly told,
 His feelings toward you might grow rather cold?
TARTUFFE I know, dear lady, that your exceeding charity
 Will lead your heart to pardon my temerity;
 That you'll excuse my violent affection
 As human weakness, human imperfection;
 And that—O fairest!—you will bear in mind
 That I'm but flesh and blood, and am not blind. 170
ELMIRE Some women might do otherwise, perhaps,
 But I shall be discreet about your lapse;

I'll tell my husband nothing of what's occurred
If, in return, you'll give your solemn word
To advocate as forcefully as you can
The marriage of Valère and Mariane,
Renouncing all desire to dispossess
Another of his rightful happiness,
And . . .

READING CRITICALLY

Why do you suppose that Molière leaves it to the maid of the house to see through Tartuffe's hypocrisy, while the more educated members of the household seem blind to it?

READING 23.2

Anne Bradstreet, "Here Follows Some Verses upon the Burning of Our House, July 10th, 1666" (1667)

This poem is a poignant statement of the author's Puritan faith in the face of terrible personal tragedy. The opening lines, in which Bradstreet confesses her attraction to fire, refer not to the actual burning of her house, but to the day of judgment and the second coming of Christ. The poem then goes on to explore the tension between worldly desires and spiritual salvation.

In silent night when rest I took
For sorrow near I did not look
I wakened was with thund'ring noise
And piteous shrieks of dreadful voice.
That fearful sound of "Fire!" and "Fire!"
Let no man know is my desire.
I, starting up, the light did spy,
And to my God my heart did cry
To strengthen me in my distress
And not to leave me succorless. 10
Then, coming out, beheld a space
The flame consume my dwelling place.
And when I could no longer look,
I blest His name that gave and took,
That laid my goods now in the dust.
Yea, so it was, and so 'twas just.
It was His own, it was not mine,
Far be it that I should repine;
He might of all justly bereft
But yet sufficient for us left. 20
When by the ruins oft I past
My sorrowing eyes aside did cast,
And here and there the places spy
Where oft I sat and long did lie:
Here stood that trunk, and there that chest,
There lay that store I counted best.
My pleasant things in ashes lie,
And them behold no more shall I.
Under thy roof no guest shall sit,
Nor at thy table eat a bit. 30
No pleasant tale shall e'er be told,

Nor things recounted done of old.
No candle e'er shall shine in thee,
Nor bridegroom's voice e'er heard shall
In silence ever shall thou lie,
Adieu, Adieu, all's vanity.
Then straight I 'gin my heart to chide,
And did thy wealth on earth abide?
Didst fix thy hope on mold'ring dust?
The arm of flesh didst make thy trust? 40
Raise up thy thoughts above the sky
That dunghill mists away may fly.
Thou hast an house on high erect,
Framed by that mighty Architect,
With glory richly furnished,
Stands permanent though this be fled.
It's purchased and paid for too
By Him who hath enough to do.
A price so vast as is unknown
Yet by His gift is made thine own; 50
There's wealth enough, I need no more,
Farewell, my pelf, farewell my store.
The world no longer let me love,
My hope and treasure lies above.

READING CRITICALLY

In the middle of the poem, Bradstreet points to the places where her former possessions used to rest—"here" and "there." How is the "here" and "there" of the poem transformed in its second half?

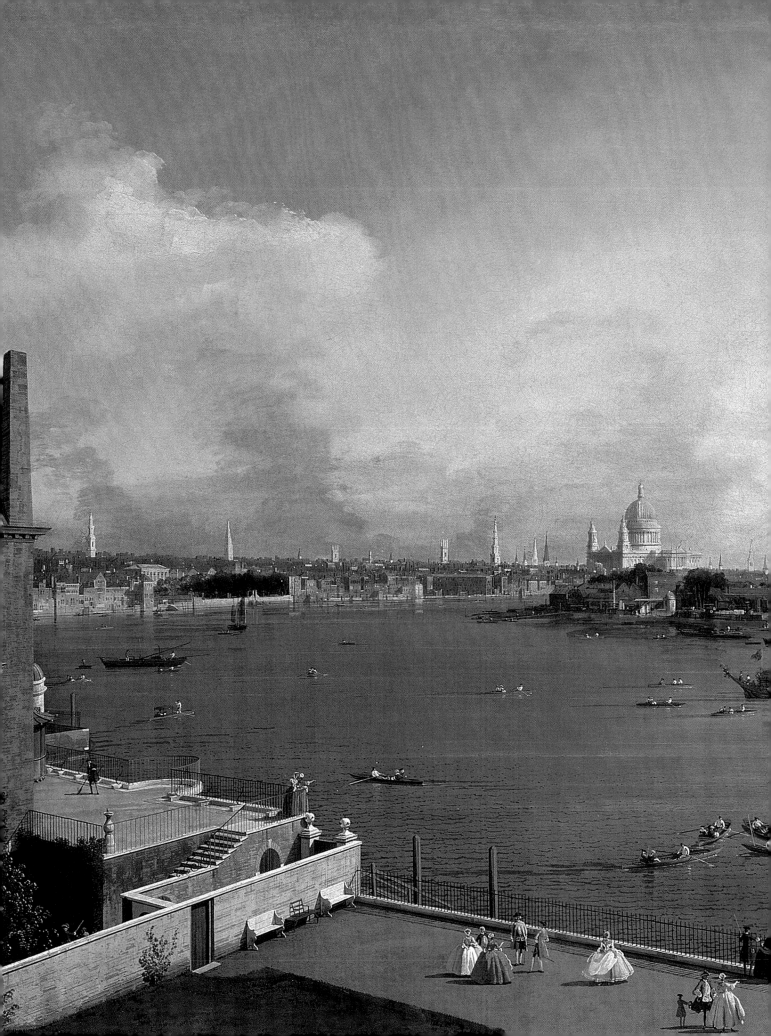

The Rise of the Enlightenment in England

The Claims of Reason

THINKING AHEAD

Who were Hobbes and Locke?

What is satire, and how did it shape the Enlightenment in England?

What gave rise to the novel?

What was the purpose of Captain Cook's voyages to the Pacific Ocean?

London, the city of elegance and refinement painted in 1747 by Venetian master of cityscapes Canaletto (Giovanni Antonio Canal; 1697–1768), was rivaled only by Paris as the center of European intellectual culture in the eighteenth century (Fig. **24.1**). Neither the map showing the growth of London from 1720 to 1820 (Map **24.1**) nor Canaletto's painting offers any hint that the city had been devastated by fire 80 years earlier. Before dawn on the morning of September 2, 1666, a baker's oven exploded on Pudding Lane in London. A strong east wind hastened the fire's spread until, by morning, some 300 houses were burning (Fig. **24.2**). In his private diaries, Samuel Pepys [peeps] (1633–1703) recorded what he saw on that fateful day:

> I rode down to the waterside, . . . and there saw a lamentable fire. . . . Everybody endeavoring to remove their goods, and flinging into the river or bringing them into lighters that lay off; poor people staying in their houses as long as till the very fire touched them, and then running into boats, or clambering from one pair of stairs by the waterside to another. . . .
>
> [I hurried] to [Saint] Paul's; and there walked along Watling Street, as well as I could, every creature coming away laden with goods to save and, here and there, sick people carried away in beds. Extraordinary goods carried in carts and on backs. At last [I] met my Lord Mayor in Cannon Street, like a man spent, with a [handkerchief] about his neck. . . . "Lord, what can I do? [he cried] I am spent: people will not obey me. I have been pulling down houses, but the fire overtakes us faster than we can do it." . . . So . . . I . . . walked home; seeing people all distracted, and no manner of means used to quench the fire. The houses, too, so very thick thereabouts, and full of matter for burning, as pitch and tar, in Thames Street; and warehouses of oil and wines and brandy and other things.

From Samuel Pepys, *Diary* (September 2, 1666)

◀ **Fig. 24.1 Canaletto, *London: The Thames and the City of London from Richmond House* (detail). 1747.** Oil on canvas, 44⁷/₈″ × 39³/₈″. Trustees of the Goodwood House, West Sussex, UK. From May 1746 until at least 1755, interrupted by only two visits to Venice in 1750 to 1751 and 1753 to 1754, the Venetian painter Canaletto occupied a studio in Beak Street, London. The geometric regularity and perspectival inventiveness of his paintings reflect the Enlightenment's taste for rationality. But his sense of grandeur and scale is, like Louis XIV's Versailles (see Chapter 27), purely aristocratic.

HEAR MORE Listen to an audio file of your chapter at **www.myartslab.com**

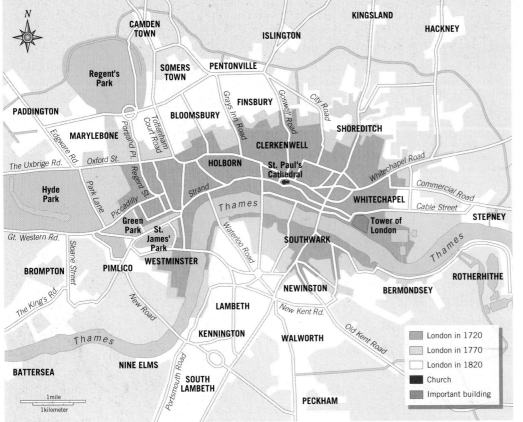

Map 24.1 The growth of London 1720 to 1820.

London in 1720
London in 1770
London in 1820
Church
Important building

The fire in these warehouses so fueled the blaze that over the course of the next two days it engulfed virtually the entire medieval city and beyond (Map **24.2**). Almost nothing was spared. About 100,000 Londoners were left homeless. Eighty-seven churches had burned. Businesses, particularly along the busy wharves on the north side of the Thames, were bankrupted. Taken together with the Great Plague that had killed some 70,000 Londoners just the year before, John Evelyn, one of the other great chroniclers of the age, summed up the situation in what amounts to typical British understatement: "London was, but is no more."

Such devastation was both a curse and a blessing. While the task of rebuilding London was almost overwhelming, the fire gave the city the opportunity to modernize its center in a way that no other city in the world could even imagine. By 1670, almost all the private houses destroyed by the fire had been rebuilt, and businesses were once again thriving. Over the course of the next century, the city would prosper as much or more than any other city in the world, "London," as one writer put it, "is the centre to which almost all the individuals who fill the upper and middle ranks of society are successively attracted. The country pays its tribute to the supreme city."

This chapter surveys developments in London, the literary center of what would come to be known as the Age of Enlightenment. Across Europe, intellectuals began to advocate rational thinking as the means to achieving a comprehensive system of ethics, aesthetics,

and knowledge. The rationalist approach owed much to scientist Isaac Newton (1642–1727), who in 1687 demonstrated to the satisfaction of just about everyone that the universe was an intelligible system, well ordered in its operations and guiding principles. The workings of human society—the production and consumption of manufactured goods, the social organization of families and towns, the functions of national governments, even the arts—were believed to be governed by analogous universal laws. The intellectuals of Enlightenment England thought of themselves as the guiding lights of a new era of progress that would leave behind, once and for all, the irrationality, superstition, and tyranny that had defined Western culture, particularly before the Renaissance. The turmoil that had led to Civil War in 1642 to 1648 was followed in 1688 by a bloodless "Glorious Revolution," the implementation of a Bill of Rights, and the establishment of a constitutional monarchy, all of which seemed proof that reason could triumph over political and religious intolerance. Still, recognizing that English society was deeply flawed, they also satirized it, attacking especially its aristocracy. At the same time, an expanding publishing industry and an increasingly literate public offered Enlightenment writers the opportunity to instruct their readers in moral behavior, even as they described English vice in prurient detail. Finally, the voyages of Captain James Cook (1728–1779) to the Pacific suggested that Enlightenment thinkers might have much to learn from the peoples of the world.

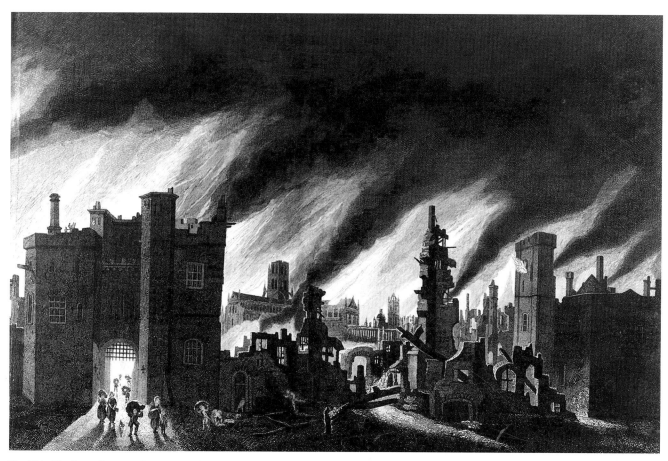

Fig. 24.2 *The Great Fire, 1666.* Engraving. The tower in the middle is Old Saint Paul's. It too would be destroyed. In the words of John Evelyn, "The stones of St. Paules flew like grenados, the Lead mealting down the streetes in a streame and the very pavements of them glowing with fiery rednesse, so as no horse, nor man, was able to tread on them."

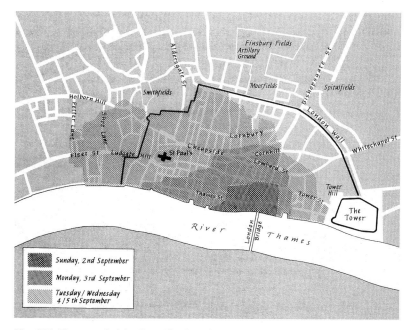

Map 24.2 **The spread of the Great Fire from September 2nd to 5th, 1666.** From Roy Porter, *London: A Social History* (New York: Penguin Books, 1996), p. 86. Reproduced by permission. Porter's highly regarded history informs much of the discussion concerning England in these pages.

THE NEW LONDON: TOWARD THE ENLIGHTENMENT

After the Great Fire, architect Christopher Wren (1632–1723) proposed a grand redesign scheme that would have replaced the old city with wide boulevards and great squares. But the need to rebuild the city's commercial infrastructure quickly made his plan impractical, and each property owner was essentially left to his own devices.

Nevertheless, certain real improvements were made. Wood construction was largely banned; brick and stone were required. New sewage systems were introduced, and streets had to be at least 14 feet wide. Just a year after the fire, in a poem celebrating the devastation and reconstruction, "Annus Mirabilis" ("year of wonders"), the poet John Dryden (1631–1700) would equate London to the mythological Phoenix rising from its own ashes, reborn: "a wonder to all years and Ages . . . a *Phoenix* in her ashes." Moved by the speed of the city's

LEARN MORE Gain insight from a primary source document on the burning of Old Saint Paul's at **www.myartslab.com**

rebuilding, Dryden is sublimely confident in London's future. Under the rule of Charles II, the city would become even greater than before (**Reading 24.1**):

READING 24.1

from John Dryden, "Annus Mirabilis" (1667)

More great than human, now, and more august,[1]
New-deified she from her fires does rise:
Her widening streets on new foundations trust,
And, opening, into larger parts she flies. . . .

Now like the maiden queen, she will behold
From her high turrets, hourly suitors come:
The East with incense, and the West with gold,
Will stand like suppliants, to receive her doom.

[1]**Augusta,** the old name of London.

For Dryden, the Great Fire was not so much a disaster as a gift from God. And Charles II must have thought so as well, for as a way of thanking Dryden for the poem, the king named him poet laureate of the nation in 1668.

Although Christopher Wren's plans to redesign the entire London city center after the Great Fire proved impractical, he did receive the commission to rebuild 52 of the churches destroyed in the blaze. Rising above them all was Saint Paul's Cathedral, a complex yet orderly synthesis of the major architectural styles of the previous 150 years (see *Closer Look*, pages 770–771). According to Wren's son, "a memorable omen" occurred on the occasion of his father's laying the first stone on the ruins of the old cathedral in 1675:

> When the SURVEYOR in Person [Wren himself, in his role as King's Surveyor of Works] had set out, upon the Place, the Dimensions of the great Dome and fixed upon the centre; a common Labourer was ordered to bring a flat stone from the Heaps of Rubbish . . . to be laid for a Mark and Direction to the Masons; the Stone happened to be a piece of Grave-stone, with nothing remaining on the Inscription but the simple word in large capitals, RESURGAM [the Latin for "REBORN"].

"RESURGAM" still decorates the south transept of the cathedral above a figure of a phoenix rising from the ashes.

Something of the power of Wren's conception can be felt in Canaletto's view of *The Thames and the City of London from Richmond House* (see Fig. 24.1). The cathedral does indeed rise above the rest of the city, not least because, in rebuilding, private houses had been limited to four stories. Only other church towers, almost all built by Wren as well, rise above the roof lines, as if approaching the giant central structure in homage.

Absolutism versus Liberalism: Thomas Hobbes and John Locke

The new London was, in part, the result of the rational empirical thinking that dominated the Royal Society (see Chapter 26). Following the Civil War and the Restoration, one of the most pressing issues of the day was how best to govern the nation, and one of the most important points of view had been published by Thomas Hobbes [hobz] (1588–1679) in 1651, in *Leviathan; or the Matter, Forme, and Power of a Commonwealth, Ecclesiasticall and Civil* (Fig. **24.3**). His classical training had convinced Hobbes that the reasoning upon which Euclid's geometry was based could be extended to political and social systems. A visit to Galileo in Italy in 1636 reaffirmed that Galileo's description of the movement of the solar system—planets orbiting the central sun—could be extended to human relations—a people orbiting their ruler. Hobbes argued that people are driven by two things—the fear of death at someone else's hands and the desire for power—and that the government's role is to

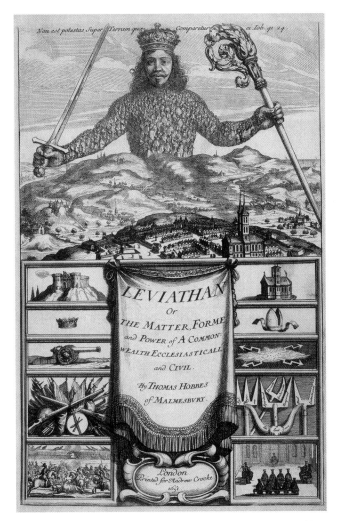

Fig. 24.3 Frontispiece to *Leviathan*. 1651. Bancroft Library, Berkeley, CA. At the top of the image, the body of the king is composed of hundreds of his subjects. Below his outstretched arms holding sword and scepter, the world is orderly and peaceful.

check both of these instincts, which if uncontrolled would lead to anarchy. Given the context in which *Leviathan* was written—the English Civil War had raged throughout the previous decade—Hobbes's position is hardly surprising. Most humans, Hobbes believed, recognize their own essential depravity and therefore willingly submit to governance. They accept the **social contract**, which means giving up sovereignty over themselves and bestowing it on a ruler. They carry out the ruler's demands, and the ruler, in return, agrees to keep the peace. Humankind's only hope, Hobbes argued (see **Reading 24.2**, pages 793–794), is to submit to a higher authority, the "Leviathan" [luh-VY-uh-thun], the biblical sea monster who is the absolutist "king over all the sons of pride" (Job 41:34).

John Locke (1632–1704) disagreed. In his 1690 *Essay on Human Understanding*, Locke repudiated Hobbes, arguing that people are perfectly capable of governing themselves. The human mind at birth, he claimed, is a *tabula rasa*, a "blank slate," and our environment—what we learn and how we learn it—fills this slate (**Reading 24.3**):

READING 24.3

from Locke's *Essay on Human Understanding* (1690)

1. Idea is the object of thinking. Every man being conscious to himself that he thinks; and that which his mind is applied about whilst thinking being the ideas that are there, it is past doubt that men have in their minds several ideas—such as are those expressed by the words whiteness, hardness, sweetness, thinking, motion, man, elephant, army, drunkenness, and others: it is in the first place then to be inquired, How he comes by them? . . .

2. All ideas come from sensation or reflection. Let us then suppose the mind to be, as we say, white paper, void of all characters, without any ideas—How comes it to be furnished? Whence comes it by that vast store which the busy and boundless fancy of man has painted on it with an almost endless variety? Whence has it all the materials of reason and knowledge? To this I answer, in one word, from EXPERIENCE. In that all our knowledge is founded; and from that it ultimately derives itself. Our observation employed either, about external sensible objects, or about the internal operations of our minds perceived and reflected on by ourselves, is that which supplies our understandings with all the materials of thinking. These two are the fountains of knowledge, from whence all the ideas we have, or can naturally have, do spring.

3. The objects of sensation one source of ideas. First, our Senses, conversant about particular sensible objects, do convey into the mind several distinct perceptions of things . . . [and] thus we come by those ideas we have of yellow, white, heat, cold, soft, hard, bitter, sweet, and all those which we call sensible qualities. . . .

4. The operations of our minds, the other source of them. Secondly, the other fountain from which experience furnisheth the understanding with ideas, is the perception of the operations of our own mind within us, as it is employed about the ideas it has got; which operations, when the soul comes to reflect on and consider, do furnish the understanding with another set of ideas, which could not be had from things without. And such are perception, thinking, doubting, believing, reasoning, knowing, willing, and all the different actings of our own minds. . . .

Given this sense that we understand the world through experience, if we live in a reasonable society, it should follow, according to Locke's notion of the *tabula rasa*, that we will grow into reasonable people. In his *Second Treatise of Government* (see **Reading 24.4**, pages 794–796), also published in 1690, Locke went further. He refuted the divine rights of kings and argued that humans are "by nature free, equal, and independent." They agree to government in order to protect themselves, but the social contract to which they admit does not require them to surrender their own sovereignty to their ruler. The ruler has only limited authority that must be held in check by a governmental system balanced by a separation of powers. Finally, they expect the ruler to protect their rights, and if the ruler fails, they have the right to revolt in order to reclaim their natural freedom. This form of **liberalism**—literally, from the Latin, *liberare*, "to free"—sets the stage for the political revolutions that will dominate the Western world in the eighteenth and nineteenth centuries.

John Milton's *Paradise Lost*

The debate between absolutism and liberalism also informs what is arguably the greatest poem of the English seventeenth century, *Paradise Lost* by John Milton (1608–1674). Milton had served in Oliver Cromwell's government during the Commonwealth. (He had studied the great epics of classical literature, and he was determined to write his own, one which would, as he puts it in the opening verse of the poem, "justifie the wayes of God to men.") In 12 books, Milton composed a densely plotted poem with complex character development, rich theological reasoning, and long, wave-like sentences of blank verse. The subject of the epic is the Judeo-Christian story of the loss of Paradise by Adam and Eve and their descendents. As described in the Bible, the couple, enticed by Satan, disobey God's injunction that they not eat the fruit of the Tree of Knowledge. Satan had revolted against God and then sought to destroy humanity.

While occasionally virulently anti-Catholic, the poem is, among other things, a fair-minded essay on the possibilities of liberty and justice. In many ways, God assumes the position of royal authority that Hobbes argues for in his *Leviathan*. In Book 5 of Milton's poem, God sends the angel Raphael to Adam to warn him of the nearness of Lucifer

aint Paul's is the first cathedral ever built for the Anglican Church of England. It rises above the foundations of an earlier church destroyed in the Great Fire of London in 1666. In its design, architect Christopher Wren drew on classical, Gothic, Renaissance, and Baroque elements. Its imposing two-story facade is crowned by symmetrical twin clock towers and a massive dome. The floor plan—an elongated, cruciform (crosslike) design—is Gothic. The dome is Renaissance, purposefully echoing Bramante's Tempietto (see Fig. 15.6) but maintaining the monumental presence of Michelangelo's dome for Saint Peter's (see Fig. 15.7). The facade, with its two tiers of paired Corinthian columns, recalls the French Baroque Louvre in Paris (see Fig. 21.21). And the two towers are inspired by a Baroque church in Rome. Wren manages to bring all these elements together into a coherent whole.

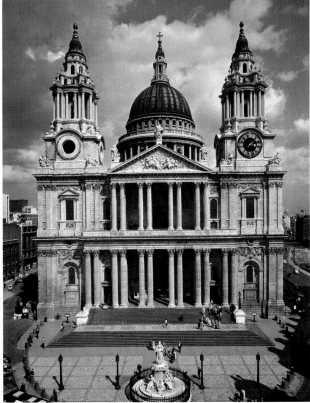

Christopher Wren, Saint Paul's Cathedral, London, western facade.
1675–1710. A statue of Saint Paul stands on top of the central portico, flanked by statues of Saint John (*right*) and Saint Peter (*left*). The sculptural detail in the portico pediment depicts the conversion of Paul following his vision on the road to Damascus.

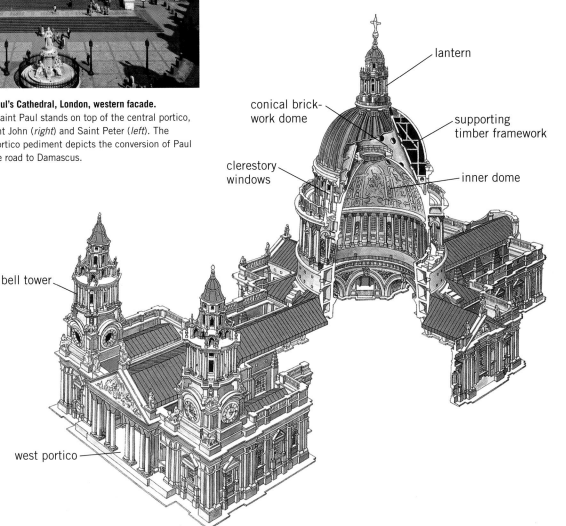

lantern

conical brick-
work dome

supporting
timber framework

clerestory
windows

inner dome

bell tower

west portico

Wren's Saint Paul's Cathedral

The church was laid out so that the congregation would directly face the sunrise on Easter morning, metaphorically revisiting the Resurrection itself. Rather than its ornamentation, the geometry of the building—especially the relationships established between geometric units—was at the heart of Wren's design. Notice the extraordinarily refined symmetry of the whole, particularly the relationships of the paired freestanding columns and the square embedded ones on the western facade. As Wren himself would write, "It seems very unaccountable that the generality of our late architects dwell so much on the ornamental, and so lightly pass over the geometrical, which is the most essential part of architecture." This reliance on geometric regularity is wholly consistent with Enlightenment thinking, reflecting Newton's description of the universe as an intelligible system, well-ordered in its operations and guiding principles.

SEE MORE For a Closer Look at Christopher Wren's Saint Paul's Cathedral, go to **www.myartslab.com**

Something to Think About...

If Wren believed that the overall design should reflect a classical sense of balance, symmetry, and proportion, he also believed that within that framework there was room for a variety of features. How does the facade of St. Paul's reflect Wren's sense of variety and diversity?

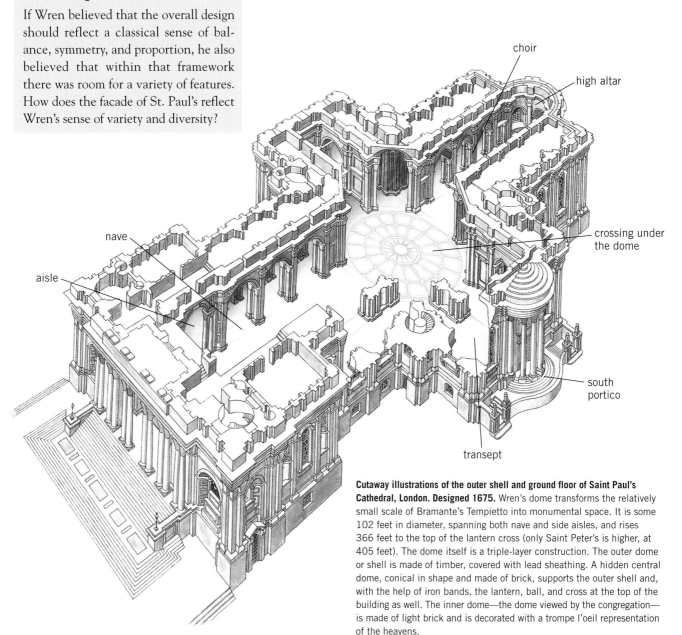

Cutaway illustrations of the outer shell and ground floor of Saint Paul's Cathedral, London. Designed 1675. Wren's dome transforms the relatively small scale of Bramante's Tempietto into monumental space. It is some 102 feet in diameter, spanning both nave and side aisles, and rises 366 feet to the top of the lantern cross (only Saint Peter's is higher, at 405 feet). The dome itself is a triple-layer construction. The outer dome or shell is made of timber, covered with lead sheathing. A hidden central dome, conical in shape and made of brick, supports the outer shell and, with the help of iron bands, the lantern, ball, and cross at the top of the building as well. The inner dome—the dome viewed by the congregation—is made of light brick and is decorated with a trompe l'oeil representation of the heavens.

(Satan) and to explain how Lucifer became God's enemy. Raphael recounts how God had addressed the angels to announce that he now had a son, Christ, whom all should obey as if he were God, and he did so with the authority of hereditary kingship (**Reading 24.5a**):

READING 24.5a

from John Milton, *Paradise Lost*, Book 5 (1667)

"Hear all ye angels, Progeny of Light,
Thrones, Dominations, Princedoms, Virtues, Powers,
Hear my Decree, which unrevoked shall stand.
This day I have begot whom I declare
My only Son, and on this holy hill
Him have anointed, whom ye now behold
At my right hand; your head I him appoint;
And by my Self have sworn to him shall bow
All knees in heav'n, and shall confess him Lord."

Lucifer, formerly God's principal angel, is not happy about the news of this new favorite. Motivated by his own desire for power, he gathers the angels loyal to him, and addresses them in terms more in the spirit of Locke than Hobbes. He begins his speech as God had begun his, invoking the imperial titles of those present; he reminds them, "which assert / Our being ordain'd to govern, not to serve" (**Reading 24.5b**):

READING 24.5b

from John Milton, *Paradise Lost*, Book 5 (1667)

Thrones, Dominations, Princedoms, Virtues, Powers,
If these magnific titles yet remain
Not merely titular, since by decree
Another now hath to himself engrossed
All power, and us eclipsed under the name
Of King anointed. . . .

Will ye submit your necks, and choose to bend
The supple knee? ye will not, if I trust
To know ye right, or if ye know yourselves
Natives and sons of heav'n possessed before
By none, and if not equal all, yet free,
Equally free; for orders and degrees
Jar not with liberty. . . .

Who can in reason then or right assume
Monarchy over such as live by right
His equals, if in power and splendor less,
In freedom equal?

Lucifer's is a "reasonable" argument. Like Locke, he thinks of himself and the other angels as "by nature free, equal, and independent." The battle that ensues between God and Lucifer (see **Reading 24.5**, pages 796–797) is reminiscent of the English Civil War, with its complex protagonists, its councils, and its bids for leadership on both sides. It results in Lucifer's expulsion from Heaven to Hell, where he is henceforth known as Satan. While many readers understood God as a figure for the Stuart monarchy, and Satan as Cromwell, it is not necessary to do so in order to understand the basic tensions that inform the poem. The issues that separate God from Satan are clearly the issues dividing England in the seventeenth century: the tension between absolute rule and the civil liberty of the individual.

THE ENGLISH ENLIGHTENMENT

Under the rule of William and Mary, the turmoil that had marked British political life for at least a century was replaced by a period of relative stability. The new king and queen moved quickly to reaffirm the Habeas Corpus Act, passed during the reign of Charles II in 1679. The act required a warrant for the arrest of anyone, detailing the reasons for the arrest, and the right to a speedy trial. It was a revolutionary abridgement of royal power. At least since the time of Henry VIII, English kings had imprisoned their enemies—or their suspected enemies—for as long as they liked without a trial. Parliament also passed a Bill of Rights, guaranteeing that no Catholic could ever rule England and no British king could ever marry a Catholic. Additionally, it required monarchs to obey the law like other British citizens, and banned them from raising taxes without the consent of Parliament. The Toleration Act provided Puritans with the freedom to worship as they chose, though neither Puritans nor Roman Catholics were allowed to hold positions in the government or attend universities. By the middle of the 1690s, the royal privilege of press censorship was permanently abandoned.

As royal power was being curtailed, Parliament also brought the succession of the monarchy under the rule of law. The Settlement Act of 1701 provided for the peaceful succession of the English crown. The act named Anne, Mary's younger sister, as heir to the throne upon William's death (Mary had died of smallpox in 1694). Should none of Anne's children survive her (and in fact none did), the act called for the Protestant House of Hanover in Germany to succeed to England's throne. Anne succeeded William in 1702, and upon her death, in 1714, George I, who spoke only German at the time, became King of England.

Even before George assumed the throne, Parliament's two factions, the Whigs and the Tories, had been at odds. The Whig faction tended to support constitutional monarchy as opposed to absolutism, and non-Anglican Protestants, such as the Presbyterians. The Tories tended to support the Anglican church and English gentry. Naturally, they preferred a strong monarchy, while the Whigs favored Parliament retaining final sovereignty. Nevertheless, the Whigs gained favor with George, and so, when he assumed the throne, George was predisposed to the Whigs and to their leading the government. For the next 40 years, the Whigs had access to public office and enjoyed royal patronage, and the Tories were effectively

eliminated from public life. The end result was that Whig leadership, chiefly that of Robert Walpole (1676–1745), who can be regarded as the first English prime minister and who dominated the English political scene from 1721 to 1742, was consistent and predictable. Nothing could have fostered the Enlightenment more. Above all else, England's transformation from a state in near chaos to one in comparative harmony demonstrated what is probably the fundamental principle of Enlightenment thought—that social change and political reform are not only desirable but possible.

Satire: Enlightenment Wit

Not every Englishman was convinced that the direction England was heading in the eighteenth century was for the better. London was a city teeming with activity; Canaletto's painting (see Fig. 24.1) was an idealized view of city life. Over the course of the eighteenth century, the rich and the middle class largely abandoned the city proper, moving west into present-day Mayfair and Marylebone, and even to outlying villages such as Islington and Paddington. At the start of the century, these villages were surrounded by meadows and market gardens, but by century's end they had been absorbed into an ever-growing suburbia (see Map 24.1).

In the heart of London, a surging population of immigrants newly arrived from the countryside filled the houses abandoned by the middle class, which had been subdivided into tenements. The very poor lived in what came to be called the East End, a semicircle of districts surrounding the area that extended from Saint Paul's in the west to the Tower of London in the East (the area contained by the old London Wall). Here, in the neighborhoods of Saint Giles, Clerkenwall, Spitalfields, Whitechapel, Bethnal Green, and Wapping, the streets were narrow and badly paved, the houses old and constantly falling down, and drunkenness, prostitution, pickpocketing, assault, and robbery were the norm. On the outer edges, pig keepers and dairymen labored in a landscape of gravel pits, garbage dumps, heaps of ashes, and piles of horse manure.

Whatever the promise offered by the social order established by Robert Walpole and the Georgian government, thoughtful, truly enlightened persons could look beneath the surface of English society and detect a cauldron of social ferment and moral bankruptcy. By approaching what might be called the "dark side" of the Enlightenment and exposing it to all, dissenting writers and artists like William

Hogarth (1697–1764), Jonathan Swift (1667–1745), and Alexander Pope (1688–1744) believed they might, by means of irony and often deadpan humor that marks their satire, return England to its proper path.

Hogarth and the Popular Print By 1743, thousands of Londoners were addicted to gin, their sole means of escape from the misery of poverty. In 1751, just four years after Canaletto painted his view of London, William Hogarth published *Gin Lane*, a print that illustrated life in the gin shops (Fig. **24.4**). In the foreground, a man so emaciated by drink that he seems a virtual skeleton lies dying, half-naked, presumably having pawned the rest of his clothes. A woman takes snuff on the stairs as her child falls over the railing beside her. At the door to the thriving pawnshop behind her, a carpenter sells his tools, the means of his livelihood, as a woman waits to sell her kitchen utensils, the means of her nourishment. In the background, a young woman is laid out in a coffin, as her child weeps beside her.

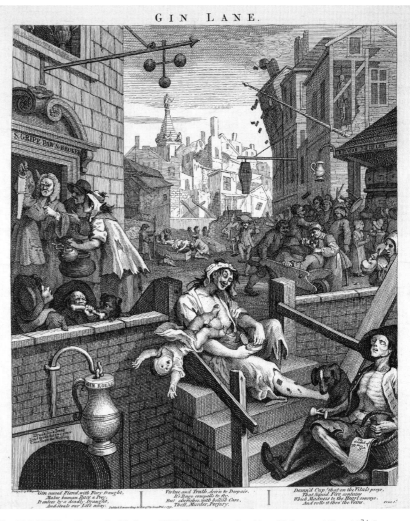

Fig. 24.4 William Hogarth, *Gin Lane*. 1751. Engraving and etching, third state, 14" × 11⁷/₈".
Copyright The Trustees of the British Museum, London/Art Resource, New York. In his *Autobiographical Notes*, Hogarth wrote: "In gin lane every circumstance of its [gin's] horrid effects are brought to view; nothing but Idleness, Poverty, misery, and ruin are to be seen . . . not a house in tolerable condition but Pawnbrokers and the Gin shop."

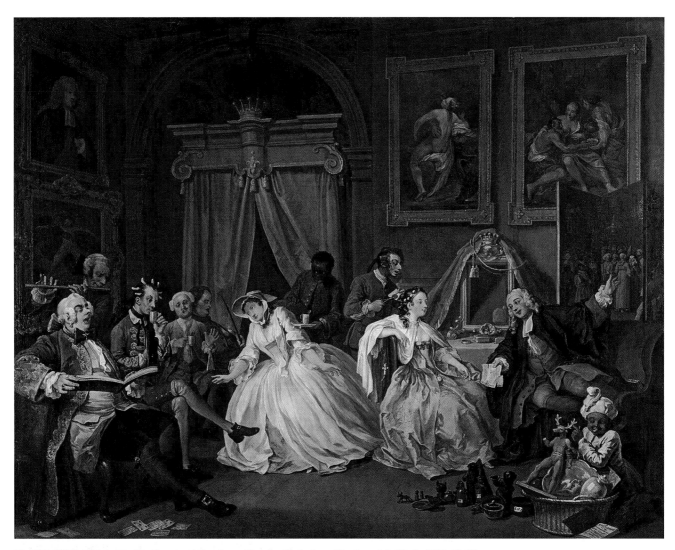

Fig. 24.5 William Hogarth, *The Countess's Levée*, or *Morning Party*, from *Marriage à la Mode*. 1743–45. Oil on canvas, 27″ × 35″. The National Gallery, London. The reproductions on the wall tell us much about the sexual proclivities of the Countess and her court. Those directly above the Countess are Correggio's *Jupiter and Io* (see Figure 22.7) and a representation of Lot's seduction by his daughters. On the table between the Countess and Silvertongue is a French pornographic novel.

A building comes tumbling down, a man parades down the street with a bellows on his head and a child skewered on his staff—an allegorical if not realistic detail. In the top story of the building on the right, another man has hanged himself. At the lower left, above the door to the Gin Royal, one of the only buildings in good condition, are these words: "Drunk for a penny / Dead drunk for two pence / Clean Straw for Nothing."

In *Gin Lane*, Hogarth turned his attention, not to the promise of the English Enlightenment, but to the reality of London at its worst. He did so with the savage wit and broad humor that marks the best social satire. And he did so with the conviction that his images of what he called "modern moral subjects" might not only amuse a wide audience, but would influence that audience's behavior as well. Hogarth usually painted his subjects first, but recognizing the limited audience of a painting, he produced engraved versions of them for wider distribution. Hogarth recognized

that his work appealed to a large popular audience, and that by distributing engravings of his works he might make a comfortable living by entertaining it.

A successful engraving had to sell enough impressions to pay for its production and earn a profit for its maker, who was not usually the artist. Before Hogarth's time, British printmakers had kept most of the profits from an illustration. But Hogarth marketed his prints himself by means of illustrated subscription tickets, newspaper advertisements, and broadsides, and kept the profits. Especially popular were three series of prints, each telling a different tale. One of the series, *Marriage à la Mode* [ah-luh-moad], was produced as both one-of-a-kind paintings and a subscription series of engravings. In six images, the series tells the story of a marriage of convenience between the son of a bankrupt nobleman, the Earl of Squanderfield, and the daughter of a wealthy tradesman. The moral bankruptcy of British society—not just the poor—is Hogarth's subject.

His **caricature**—a portrait that exaggerates each person's peculiarities or defects—of each of his cast of characters is underscored by their names: Squanderfield, Silvertongue, and so on. The loveless couple is sacrificed to the desires of their parents, for money or social position, and the results of this union go from bad to worse. By the time we arrive at the fourth image, *The Countess's Levée* [luh-VAY], or *Morning Party* (Fig. **24.5**), which encapsulates the morning ritual of the young wife, the moral depravity of the couple's lifestyle is clear. An Italian *castrato* [kah-STRAH-toh]—a singer castrated in his youth so that he might retain his high voice—sings to the inattentive crowd, accompanied by his flautist. Next to them, a hanger-on with his hair in curlers sips his tea. The lady of the house listens attentively to her illicit lover Silvertongue, the family lawyer, whose portrait overlooks the room. Below them, a black child-servant points to a statue of Actaeon. (In classical mythology, Actaeon was a hunter who was transformed into a stag for having observed the goddess Diana bathing. His horns traditionally signify a cuckold, a man whose wife is unfaithful.)

The Satires of Jonathan Swift Perhaps the most biting satirist of the English Enlightenment was Jonathan Swift. In a letter to fellow satirist and friend Alexander Pope, Swift confided that he hated the human race for having misused its capacity for reason simply to further its own corrupt self-interest. After a modestly successful career as a satirist in the first decade of the eighteenth century, Swift was named Dean of Saint Patrick's Cathedral in Dublin in 1713, and it was there that he wrote his most famous works, *Gulliver's Travels*, published in 1726, and the brief, almost fanatically savage *A Modest Proposal* in 1729. There, reacting to the terrible poverty he saw in Ireland, Swift proposed that Irish families who could not afford to feed their children breed them to be butchered and served to the English. With a tongue perhaps never before so firmly lodged in his cheek, Swift concludes **Reading 24.6:**

READING 24.6

from Jonathan Swift, "A Modest Proposal" (1729)

I am not so violently bent upon my own opinion as to reject any offer proposed by wise men, which shall be found equally innocent, cheap, easy and effectual. But before something of that kind shall be advanced in contradiction to my scheme, and offering a better, I desire the author or authors will be pleased maturely to consider two points. First, as things now stand, how they will be able to find food and raiment for 100,000 useless mouths and backs. And secondly, there being a round million of creatures in human figure throughout this kingdom, whose whole subsistence put into a common stock would leave them in debt 2,000,000£ sterling, adding those who are beggars by profession to the bulk of farmers, cottagers, and labourers, with the wives and children

who are beggars in effect; I desire those politicians who dislike my overture, and may perhaps be so bold as to attempt an answer, that they will first ask the parents of these mortals, whether they would not at this day think it a great happiness to have been sold for food at a year old in the manner I prescribe, and thereby have avoided such a perpetual scene of misfortunes as they have since gone through by the oppression of landlords, the impossibility of paying rent without money or trade, the want of common sustenance, with neither house nor clothes to cover them from the inclemencies of the weather, and the most inevitable prospect of entailing the like or greater miseries upon their breed for ever.

I profess, in the sincerity of my heart, that I have not the least personal interest in endeavouring to promote this necessary work, having no other motive than the *public good of my country, by advancing our trade, providing for infants, relieving the poor, and giving some pleasure to the rich.* I have no children by which I can propose to get a single penny; the youngest being nine years old, and my wife past child-bearing.

Such a solution to the problem of starving Irish families—they would, as it were, breed for profit—is meant to be understood as the symbolic equivalent of what was actually happening to Irish families and their children. In fact, many Irishmen worked farms owned by Englishmen who charged them such high rents that they were frequently unable to pay them, and consequently lived on the brink of starvation. As Dean of the Cathedral in Dublin, Swift was in a position to witness their plight on a daily basis. For all practical purposes, Swift believed, England was consuming the Irish young, if not literally then figuratively, sucking the lifeblood out of them by means of its oppressive economic policies.

In *Gulliver's Travels*, Swift's satire is less direct. Europeans were familiar with the accounts of travelers' adventures in far-off lands at least since the time of Marco Polo, and after the exploration of the Americas, the form had become quite common. Swift played off the travel adventure narrative to describe the adventures of one Lemuel Gulliver as he moves among lands peopled by miniature people, giants, and other fabulous creatures. But Swift employs his imaginary peoples and creatures to comment on real human behavior. In Book 1, the Lilliputians, a people that average 6 inches in height, are "little people" not just physically but ethically. In fact, their politics and religion are very much those of England, and they are engaged in a war with a neighboring island that very closely resembles France. Swift's strategy is to reduce the politics of his day to a level of triviality. In Book 4, Gulliver visits Houyhnhnms, a country of noble horses whose name sounds like a whinnying horse and is probably pronounced *hwinnum*. Gulliver explains that "the word Houyhnhnm, in their tongue, signifies a horse, and, in its etymology, the perfection of nature." Their ostensible nobility

contrasts with the bestial and degenerate behavior of their human-looking slaves, the Yahoos. Of course, Gulliver resembles a Yahoo as well. At one point, Gulliver's Houyhnhnm host compliments him, saying "that he was sure I must have been born of some noble family, because I far exceeded in shape, colour, and cleanliness, all the Yahoos of his nation." Gulliver's response is a model of Swift's satiric invective (**Reading 24.7**):

READING 24.7

from Jonathan Swift, *Gulliver's Travels*, Book IV, Chapter VI (1726)

I made his Honour my most humble acknowledgments for the good opinion he was pleased to conceive of me, but assured him at the same time, "that my birth was of the lower sort, having been born of plain honest parents, who were just able to give me a tolerable education; that nobility, among us, was altogether a different thing from the idea he had of it; that our young noblemen are bred from their childhood in idleness and luxury; that, as soon as years will permit, they consume their vigor, and contract odious diseases among lewd females; and when their fortunes are almost ruined, they marry some woman of mean birth, disagreeable person, and unsound constitution (merely for the sake of money), whom they hate and despise. That the productions of such marriages are generally scrofulous, rickety, or deformed children; by which means the family seldom continues above three generations, unless the wife takes care to provide a healthy father, among her neighbours or domestics, in order to improve and continue the breed. That a weak diseased body, a meager countenance, and sallow complexion, are the true marks of noble blood; and a healthy robust appearance is so disgraceful in a man of quality, that the world concludes his real father to have been a groom or a coachman. The imperfections of his mind run parallel with those of his body, being a composition of spleen, dullness, ignorance, caprice, sensuality, and pride.

Gulliver's Travels was an immediate best-seller, selling out its first printing in less than a week. "It is universally read," said his friend Alexander Pope, "from the cabinet council to the nursery." So enduring is Swift's wit that names of his characters and types have entered the language as descriptive terms—"yahoo" for a coarse or uncouth person, "Lilliputian" for anything small and delicate.

The Classical Wit of Alexander Pope The English poet Alexander Pope shared Swift's assessment of the English nobility. For 12 years, from 1715 until 1727, Pope spent the majority of his time translating Homer's *Iliad* and *Odyssey*, and producing a six-volume edition of Shakespeare, projects of such popularity that he became a wealthy man. But in 1727, his literary career changed directions and, as he wrote, he "stooped to truth, and moralized his song"—he turned, in

short, to satire. His first effort was the mock epic *Dunciad* [DUN-see-ad], published in 1728 and dedicated to Jonathan Swift. The poem opens with a direct attack on the king, George II (r. 1727–1760), who had recently succeeded his father, George I, to the throne. For Pope, this suggested the goddess Dullness reigned over an England where "Dunce the second rules like Dunce the first." Pope's dunces are the very nobility that Swift attacks in the fourth book of Gulliver—men of "dullness, ignorance, caprice, sensuality, and pride"—and the writers of the day whom Pope perceived to be supporting the policies of Walpole and the king.

Against what he believed to be the debased English court, Pope argues for honesty, charity, selflessness, and the order, harmony, and balance of the classics, values set forth in *An Essay on Man*, published between 1732 and 1734. Pope intended the poem to be the cornerstone of a complete system of ethics that he never completed. His purpose was to show that despite the apparent imperfection, complexity, and rampant evil of the universe, it nevertheless functions in a rational way, according to natural laws. The world appears imperfect to us only because our perceptions are limited by our feeble moral and intellectual capacity. In reality, as he puts it at the end of the poem's first section (**Reading 24.8**):

READING 24.8

from Alexander Pope, *An Essay on Man* (1732)

All Nature is but Art, unknown to thee;
All Chance, Direction, which thou canst not see;
All Discord, Harmony not understood;
All partial Evil, universal good;
And, spite of Pride in erring Reason's spite,
One truth is clear: WHATEVER IS, IS RIGHT.

Pope does not mean to condone evil in this last line. Rather, he implies that God has chosen to grant humankind a certain imperfection, a freedom of choice that reflects its position in the universe. At the start of the second section of the poem, immediately after this passage, Pope outlines humankind's place:

Know then thyself, presume not God to scan;
The proper study of Mankind is Man.
Placed on this isthmus of a middle state,
A Being darkly wise, and rudely great;
With too much knowledge for the Sceptic side,
With too much weakness for the Stoic's pride.
He hangs between, in doubt to act, or rest;
In doubt to deem himself a God, or Beast;
In doubt his Mind or Body to prefer;
Born but to die, and reas'ning but to err;
Alike in ignorance, his reason such,
Whether he thinks too little, or too much:

> Chaos of Thought and Passion, all confused;
> Still by himself abused, or disabused;
> Created half to rise, and half to fall;
> Great lord of all things, yet a prey to all;
> Sole judge of Truth, in endless Error hurled:
> The glory, jest, and riddle of the world!

In the end, for Pope, humankind must strive for good, even if in its frailty it is doomed to fail. But the possibility of success also looms large. Pope suggests this through the very form of his poem—**heroic couplets**, rhyming pairs of iambic pentameter lines (the meter of Shakespeare, consisting of five short-long syllabic units)—that reflect the balance and harmony of classical art and thought.

Isaac Newton: The Laws of Physics

In 1735, eight years after the death of the great English astronomer and mathematician Isaac Newton (1642–1727), Pope wrote a heroic couplet epitaph, "Intended for Sir Isaac Newton":

> Nature and Nature's laws lay hid in night;
> God said, Let Newton be! and all was light.

With the 1687 publication of his *Mathematical Principles of Natural Philosophy*, more familiarly known as the *Principia* [prin-CHIP-ee-uh], from the first word of its Latin title, Newton had demonstrated to the satisfaction of almost everyone that the universe was an intelligible system, well-ordered in its operations and guiding principles. This fact appealed especially to the author of *An Essay on Man*, Pope. First and foremost, Newton computed the law of universal gravitation in a precise mathematical equation, demonstrating that each and every object exerts an attraction to a greater or lesser degree on all other objects. Thus, the sun exercises a hold on each of the planets, and the planets to a lesser degree influence each other and the sun. The Earth exercises a hold on its moon, and Jupiter on its several moons. All form a harmonious system functioning as efficiently and precisely as a clock or machine. Newton's conception of the universe as an orderly system would remain unchallenged until the late nineteenth and early twentieth centuries, when the new physics of Albert Einstein and others would once again transform our understanding.

Newton's *Principia* marked the culmination of the forces that had led, earlier in the century, to the creation of the Royal Society in England and the Académie des Sciences in France. Throughout the eighteenth century, the scientific findings of Newton and his predecessors—Kepler and Galileo, in particular—were widely popularized and applied to the problems of everyday life. Experiments demonstrating the laws of physics became a popular form of entertainment. In his *An Experiment on a Bird in the Air-Pump* (Fig. **24.6**), the English painter Joseph Wright (1734–1797) depicts a scientist conducting an experiment before the members of a middle-class household. He stands in his red robe behind an

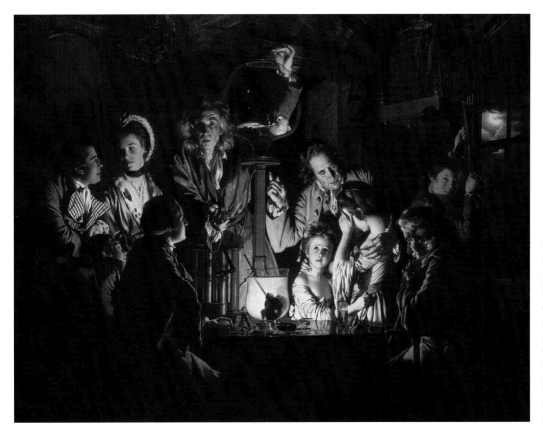

Fig. 24.6 Joseph Wright, *An Experiment on a Bird in the Air-Pump.* 1768. Oil on canvas, 6′ × 8′. The National Gallery, London. The resurrection of apparently dead birds was a popular entertainment of the day, a trick usually performed by self-styled magicians. In this painting, however, Wright takes the idea seriously, demonstrating to his audience the power of science.

air pump, normally used to study the properties of different gases but here employed to deprive a white cockatoo of oxygen by creating a vacuum in the glass bulb above the pump. The children are clearly upset by the bird's imminent death, while their father points to the bird, perhaps to demonstrate that we all need oxygen to live.

Wright had almost certainly seen such an experiment conducted by the Scottish astronomer James Ferguson, who made scientific instruments in London and toured the country, giving lectures. However, Ferguson rarely used live animals. As he explains in the 1760 edition of his lecture notes:

> If a fowl, a cat, rat, mouse or bird be put under the receiver, and the air be exhausted, the animal is at first oppressed as with a great weight, then grows convulsed, and at last expires in all the agonies of a most bitter and cruel death. But as this experiment is too shocking to every spectator who has the least degree of humanity, we substitute a machine called the "lung-glass" in place of the animal; which, by a bladder within it, shows how the lungs of animals are contracted into a small compass when the air is taken out of them.

Wright illustrated the crueler demonstration, and the outcome is uncertain. Perhaps, if the bird's lungs have not yet collapsed, the scientist can bring it back from the brink of death. Whatever the experiment's conclusion, life or death, Wright not only painted the more horrific version of the experiment but drew on the devices of Baroque painting—dramatic, nocturnal lighting and chiaroscuro—to heighten the emotional impact of the scene. The painting underscores the power of science to affect us all.

The Industrial Revolution

Among Wright's closest friends were members of a group known as the Lunar Society. The Society met in and around Birmingham each month on the night of the full moon (providing both light to travel home by and the name of the society). Its members included prominent manufacturers, inventors, and naturalists. Among them were Matthew Boulton (1728–1809), whose world-famous Soho Manufactury produced a variety of metal objects, from buttons and buckles to silverware; James Watt (1736–1819), inventor of the steam engine, who would team with Boulton to produce it; Erasmus Darwin (1731–1802), whose writings on botany and evolution anticipate by nearly a century his grandson Charles Darwin's famous conclusions; William Murdock (1754–1839), inventor of gas lighting; Benjamin Franklin (1706–1790), who was a corresponding member; and Josiah Wedgwood (1730–1795), Charles Darwin's other grandfather and the inventor of mass manufacturing at his Wedgwood ceramics factories. From 1765 until 1815, the group discussed

chemistry, medicine, electricity, gases, and any and every topic that might prove fruitful for industry. It is fair to say that the Lunar Society's members inaugurated what we think of today as the **Industrial Revolution**. The term itself was invented in the nineteenth century to describe the radical changes in production and consumption that had transformed the world.

Wedgwood opened his first factory in Burslem, Staffordshire, on May 1, 1759, where he began to produce a highly durable cream-colored earthenware (Fig. **24.7**). Queen Charlotte, wife of King George III, was so fond of these pieces that Wedgwood was appointed royal supplier of dinnerware. Wedgwood's production process was unique. Instead of shaping individual pieces by hand on the potter's wheel—the only way ceramic ware had been produced—he cast liquid clay in molds and then fired it. This greatly increased the speed of production, as did mechanically printing decorative patterns on the finished china rather than painting them. The catalog described Queen's Ware, as it came to be known, as "a species of earthenware for the table, quite new in appearance . . . manufactured with ease and expedition, and consequently cheap." It was soon available to mass markets in both Europe and America, and Wedgwood's business flourished.

Wedgwood's Queen's Ware is an exemplary product of the Industrial Revolution. New machinery in new factories created a supply of consumer goods unprecedented in history, answering an ever-increasing demand for everyday items, from toys, furniture, kitchen utensils, and china, to silverware, watches, and candlesticks. Textiles were in particular demand, and in many ways, advances in textile manufacture could be called the driving force of the Industrial Revolution. At the beginning of the eighteenth century, textiles were made of wool from sheep raised in the English Midlands. A thriving

Fig. 24.7 Transfer-printed Queen's Ware. ca. 1770. The Wedgwood Museum, Barlaston, England. Elaborate decorations such as the one on this coffee pot were mechanically printed on ceramic tableware at Wedgwood's factory. Queen's Ware became so popular that pattern books, showing the available designs, were available across Europe by the turn of the century.

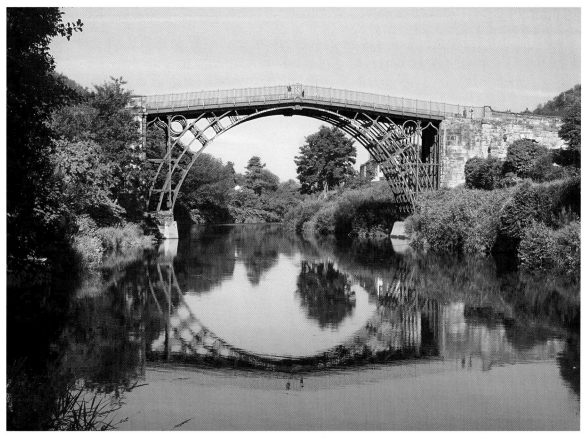

Fig. 24.8 Thomas Farnolls Pritchard, Iron Bridge, Coalbrookdale, England. 1779. Cast iron. Pritchard was keenly aware that the reflection of the bridge would form a visual circle, a form repeated in the ironwork at the corners of the bridge.

LEARN MORE Gain insight from an architectural simulation on cast iron at **www.myartslab.com**

cottage industry, in which weavers used handlooms and spinning wheels, textile manufacture changed dramatically in 1733 when John Kay in Lancashire invented the flying shuttle. Using this device, a weaver could propel the shuttle, which carries the yarn that forms the weft through the fibers of the warp, beyond the weaver's reach. Cloth could be made both wider and more rapidly. Invention after invention followed, culminating in 1769 when Richard Arkwright (1732–1792) patented the water frame, a waterwheel used to power looms. With their increased power, looms could operate at much higher speeds. Arkwright had duped the actual inventors out of their design, and in 1771 installed the water frame in a cotton mill in Derbyshire, on the river Derwent. These first textile mills, needing water power to drive their machinery, were built on fast-moving streams like the Derwent. But after the 1780s, with the application of Watts's steam power, mills soon sprang up in urban centers. In the last 20 years of the eighteenth century, English cotton output increased 800 percent, accounting for 40 percent of the nation's exports.

Another important development was the discovery of techniques for producing iron of unprecedented quality in a cost-effective manner. Early in the century, Abraham Darby (1678–1717) discovered that it was possible to fire cast iron with coke—a carbon-based fuel made from coal. Darby's grandson, Abraham Darby III (1750–1791), inherited the patent rights to the process; to demonstrate the structural strength of the cast iron he was able to manufacture, he proposed to build a single-arch cast-iron bridge across the River Severn, high enough to accommodate barge traffic on the river. The bridge at Coalbrookdale (Fig. 24.8) was designed by a local architect, while its 70-foot ribs were cast at Darby's ironworks. The bridge's 100-foot span, arching 40 feet above the river, demonstrated once and for all the structural potential of iron. A century later, such bridges would carry railroad cars, as the need for transporting new mass-produced goods exploded.

Handel and the English Oratorio

The sense of prosperity and promise created by the Industrial Revolution in England found expression, particularly, in the music of German-born George Frederick Handel (1685–1759). Handel had studied opera in Italy for several years, and was serving as Master of the Chapel in the Hanover court when George I was named king of England. He followed the king to London in the autumn of 1712. He was appointed composer to the Chapel Royal in 1723,

became a British citizen in 1727, and, when George II was crowned in 1728, composed four anthems for the ceremony. Over the course of his career, Handel composed several orchestral suites (musical series of thematically related movements) that remain preeminent examples of the genre. *Water Music* was written for a royal procession down the River Thames in 1717, and *Music for the Royal Fireworks* (1749) celebrated the end of a war with Austria. He wrote concertos for the oboe and the organ, performing the latter himself between acts of his operas and oratorios at London theaters. Opera was, in fact, his chief preoccupation—he composed 50 in his lifetime, 46 in Italian and 4 in German—but it was the oratorio, the same genre that so attracted Johann Sebastian Bach (see Chapter 26), that made his reputation.

An **oratorio** is a lengthy choral work, usually employing religious subject matter, performed by a narrator, soloists, choruses, and orchestra. It resembles opera in that it includes arias, recitatives, and choruses (see Chapter 25), but unlike opera, it does not have action, scenery, or costumes. To compensate for the lack of action, a narrator often connected threads of the plot. Handel composed his oratorios in English rather than Italian, the preferred opera language at that time. It is not clear just why he wrote oratorios, but a displeased bishop of London may have had something to do with it. The bishop banned Handel's biblical opera, *Esther*, in 1732, asserting that a stage production of the Bible was inappropriate. By using the oratorio form, Handel could treat biblical themes decorously.

Handel's greatest achievement is the oratorio *Messiah*. Written in 24 days, the work premiered in Dublin, Ireland, in 1742, as a benefit for Irish charities. It is probably the best known of all oratorios, although it is thoroughly atypical of the genre: The *Messiah* has no narrator, no characters, and no plot. Instead, Handel collected loosely related verses from the Old and New Testaments. It was an immediate success. Many Englishmen thought of their country as enjoying God's favor as biblical Israel had in the Old Testament, and Handel tapped into this growing sense of national pride. It recounts, in three parts, the biblical prophecies of the coming of a Savior, the suffering and death of Jesus, and the Resurrection and redemption of humankind. *Messiah* is sometimes remarkable in its inventiveness. When, for instance, Handel scored the text "All we, like sheep, have gone astray," he made the last words scatter in separate melodies across the different voices, mimicking the scattering referred to in the text. This technique, known as *word painting*, had been used during the Renaissance—the mood of the musical elements imitated the meaning of the text (see Chapter 15). Tradition has it that in 1743 when ((• **HEAR MORE at** George II first heard the now famous "Hallelujah www.myartslab.com Chorus" (track **24.1**), which concludes the second part of the composition, he rose from his seat—whether in awe or simply because he was tired of sitting, no one knows—a gesture that has since become standard practice for all English-speaking audiences. For the rest of Handel's

life, he performed *Messiah* regularly, usually with a chorus of 16 voices and an orchestra of 40, both relatively large for the time.

LITERACY AND THE NEW PRINT CULTURE

Since the seventeenth century, literacy had risen sharply in England, and by 1750 at least 60 percent of adult men and between 40 and 50 percent of adult women could read. Not surprisingly, literacy was connected to class. Merchant-class men and women were more likely to read than those in the working class. And among the latter, city dwellers had higher literacy rates than those in rural areas. But even the literate poor were often priced out of the literary marketplace. Few had enough disposable income to purchase even a cheap edition of Milton, which cost about 2 shillings at mid-century. (At Cambridge University, a student could purchase a week's meals for 5 shillings.) And even though, by the 1740s, circulating libraries existed in towns and cities across Britain, the poor generally could not afford the annual subscription fees. Nevertheless, libraries broadened considerably the periodicals and books—particularly, that new, increasingly popular form of fiction, the novel—available to the middle class. Priced out of most books and libraries, the literate poor depended on an informal network of trading books and newspapers. Sharing reading materials was so common, in fact, that the publisher of one popular daily periodical estimated "twenty readers to every paper." The publisher was Joseph Addison (1672–1719), who with Richard Steele (1672–1729) published the periodical *The Spectator* every day except Sunday from March 1711 to December 1712.

The Tatler and *The Spectator*

Since their schooldays in London, Addison and Steele, men of very different temperaments, had been friends. Addison was reserved and careful, Steele impulsive and flamboyant. Addison was prudent with his money, Steele frequently broke. In fact, it was Steele's need for money that got him into the newspaper business in April 1709 when he launched *The Tatler* under the assumed name of Isaac Bickerstaff. Published three times a week until January 1711, *The Tatler*, its name purposefully evocative of gossip so that it might appeal to a female audience, mixed news and personal reflections and soon became popular in coffeehouses and at breakfast tables throughout London. Steele wrote the vast majority of *Tatlers*, although Addison and other friends occasionally contributed. *The Spectator* began its nearly 2-year run 2 months after the last *Tatler* appeared, with Addison assuming a much larger role.

Addison and Steele invented a new literary form, the **journalistic essay**, a form perfectly suited to an age dedicated to the observation of daily life, and drawing from life's experiences, in Locke's terms, an understanding of the world. Forced daily to describe—and reflect upon—English

society, Addison and Steele's *Spectator* left almost no aspect of their culture unexamined. They instructed their readership in good manners, surveyed the opportunities that London offered the prudent shopper, and described the goings-on at the Royal Exchange, the city's financial center, where, in Addison's words, one could witness "an assembly of countrymen and foreigners consulting together . . . and making this metropolis a kind of emporium for the whole earth." They reviewed the city's various entertainments, both high and low, offered brief, usually fictionalized biographies of both typical and atypical English citizens, and very often expounded upon more literary and philosophical issues, such as John Locke's reflections upon the nature of wit.

One of Addison and Steele's greatest creations in *The Spectator* was the Tory eccentric Sir Roger de Coverley. Described by Steele in the second issue of the newspaper, Sir Roger was "a gentleman very singular in his behavior . . . [whose] humor creates him no enemies . . . [and who is] now in his fifty-sixth year, cheerful, gay, and hearty; keeps a good house both in town and in country; a great lover of mankind . . . [with] such a mirthful cast in his behavior that he is rather beloved than esteemed." Sir Roger is the ancestor of many similar characters that inhabit English fiction. In fact, the cast of characters that inhabit Addison and Steele's *Spectator* anticipate, to an astonishing degree, those found in English fiction as a whole.

The Rise of the English Novel

The novel as we know it was not invented in eighteenth-century England—Cervantes's *Don Quixote*, written a century earlier, is often considered the first example of the form in Western literature (see Chapter 20). But the century abounded in experiments in fiction writing that anticipate many of the forms that novelists have employed down to the present day. Works that today are called novels (from the French *nouvelle* and Italian *novella*, meaning "new") were rarely called "novels" in the eighteenth century itself. That term did not catch on until the very end of the century. Typically, they were referred to as "histories," "adventures," "expeditions," "tales," or—Hogarth's term—"progresses." They were read by people of every social class. What the novel claimed to be, and what appealed to its ever-growing audience, was a realistic portrayal of contemporary life. It concentrated almost always on the trials of a single individual, offering insight into the complexities of his or her personality. It also offered the promise, more often than not, of upward social mobility through participation in the expanding British economy and the prospect of prosperity that accompanied it. As London's population swelled with laborers, artisans, and especially young people seeking fame and fortune, and as the Industrial Revolution created the possibility of sudden financial success for the inventive and imaginative, the novel endorsed a set of ethics and a morality that were practical, not idealized. Above all, the novel was entertaining. Reading novels offered some respite from the drudgery of everyday life and, besides, was certainly a healthier addiction than drinking gin.

Daniel Defoe's Fictional Autobiographies One of the first great novels written in English is *Robinson Crusoe* by Daniel Defoe [dih-FOH] (1660–1731). Published in 1719, the full title of this sprawling work is *The Life and Strange Surprising Adventures of Robinson Crusoe of York, Mariner; Who lived Eight and Twenty Years, all alone in an un-inhabited Island on the coast of America, near the Mouth of the Great River of Oronoque; Having been cast on Shore by Shipwreck, wherein all the Men perished but himself. With An Account how he was at last as strangely deliver'd by Pirates. Written by Himself* (Fig. 24.9). The last three words are crucial, for they establish Defoe's claim that this novel is actually an autobiography.

Fig. 24.9 Frontispiece to *The Life and Strange Surprising Adventures of Robinson Crusoe of York, Mariner . . .*, by Daniel Defoe. London: W. Taylor, 1719. First edition. No other book in the history of Western literature has spawned more editions and translations, including Eskimo, Coptic, and Maltese.

Defoe's audience was used to reading accounts of real-life castaways that constituted a form of voyage literature. But far from falling into the primitive degradation and apathy of the average castaway, Robinson Crusoe rises above his situation, realizing, in his very ability to sustain himself, his God-given human potential. So many of Defoe's readers felt isolated and alone, like castaways, in the sea of London. For them, Crusoe represented hope and possibility.

This theme of the power of the average person to survive and flourish is what assured the novel's popularity and accounted for four editions by the end of the year. Defoe followed *Robinson Crusoe* with a series of other fictitious autobiographies of adventurers and rogues—*Captain Singleton* (1720), *Moll Flanders* (1722), *Colonel Jack* (1722), and *Roxanna* (1724). In all of them, his characters are in one way or another "shipwrecked" by society and as determined as Crusoe to overcome their situations through whatever means—not always the most virtuous—at their disposal.

The Epistolary Novel: Samuel Richardson's *Pamela* One of the most innovative experiments in the new novelistic form was devised by Samuel Richardson (1689–1761). He fell into novel writing as the result of his work on a "how-to" project commissioned by two London booksellers. Aware that "Country Readers" could use some help with their writing, the booksellers hired Richardson to write a book of "sample letters" that could be copied whenever necessary. Richardson was both a printer and the author of a history based on the letters of a seventeenth-century British ambassador to Constantinople and India. He had never written fiction before, but two letters in his new project suggested the idea of a novel—"A Father to a Daughter in Service, on hearing of her Master's attempting her Virtue," and "The Daughter's Answer." Richardson wrote *Pamela, or Virtue Rewarded*, in just over two months. It is the first example of what we have come to call the **epistolary novel**—that is, a novel made up of a series of "epistles," or letters. It was published in two volumes in 1740.

Pamela is a poor servant girl, of even poorer parents, in the service of a good lady who dies on page one. The good lady's son, Mr. B., promises to take care of her and all of his mother's servants: "For my Master said," Pamela reports in a letter home, "I will take care of you all, my Lasses; and for you, Pamela (and took me by the Hand; yes he took me by the Hand before them all) for my dear Mother's sake, I will be a Friend to you, and you shall take care of my Linen." From the outset, then, Richardson established Pamela's naiveté through the ambiguity implied in his "friendship" and, particularly, the word "linen," which includes, in the meaning of the day, his underwear. Indeed, Mr. B. abducts Pamela to his estate in Lincolnshire, where she is kept a prisoner and is continuously accosted to surrender her virginity. Thus virtue

confronts desire, a confrontation that over the course of the novel is compounded by Pamela's own growing desire for Mr. B. (**Reading 24.9**):

READING 24.9

from Samuel Richardson's *Pamela* (1740)

My dear master is all love and tenderness. He sees my weakness, and generously pities and comforts me! I begged to be excused [from] supper; but he brought me down himself from my closet, and placed me by him. . . . I could not eat, and yet I tried, for fear he should be angry. . . . Well, said he, if you won't eat with me, drink at least with me: I drank two glasses by his over-persuasions, and said, I am really ashamed of myself. Why, indeed, said he, my dear girl, I am not a very dreadful enemy, I hope! I cannot bear any thing that is the least concerning to you. Oh, sir! said I, all is owing to the sense I have of my own unworthiness!—To be sure, it cannot be any thing else.

He rung for the things to be taken away; and then reached a chair, and sat down by me, and put his kind arms about me, and said the most generous and affecting things that ever dropt from the honey-flowing mouth of love. All I have not time to repeat: some I will. And oh! indulge your foolish daughter, who troubles you with her weak nonsense; because what she has to say, is so affecting to her; and because, if she went to bed, instead of scribbling, she could not sleep.

Finally, after more than 1,000 pages of letters, Pamela's high moral character is rewarded by her marriage to her would-be seducer, Mr. B., and the novel's subtitle is justified. The success of Richardson's novel rested not only on the minute analysis of its heroine's emotions but also in the combination of its high moral tone and the sexual titillation of its story, which readers found irresistible.

The Comic Novels of Henry Fielding The morality of Richardson's *Pamela* was praised from church pulpits, recommended to parents skeptical of the novel as a form, and generally celebrated by the more Puritan elements of British society, who responded favorably to the heroine's virtue. Pamela herself asked a question that women readers found particularly important: "How came I to be his Property?" But the novel's smug morality (and the upward mobility exhibited by the novel's heroine) offended many, most notably Richardson's contemporary Henry Fielding (1707–1754), who responded, a year after the appearance of *Pamela*, with *Shamela*. Fielding's title tips the reader off that his work is a **parody**, a form of satire in which the style of an author or work is closely imitated for comic effect or ridicule. In Fielding's parody, his lower-class heroine's sexual appetite is every bit a match for her Squire

Booby's—and from Fielding's point of view, much more realistic (**Reading 24.10**):

READING 24.10

from Henry Fielding, *Shamela* (1741)

I was sent for to wait on my Master. I took care to be often caught looking at him, and then I always turn'd away my Eyes, and pretended to be ashamed. As soon as the Cloth was removed, he put a Bumper of Champagne into my Hand, and bid me drink—O la I can't name the Health. . . . I then drank towards his Honour's good Pleasure. Ay, Hussy, says he, you can give me Pleasure if you will; Sir, says I, I shall be always glad to do what is in my power, and so I pretended not to know what he meant. Then he took me into his Lap.—O Mamma, I could tell you something if I would—and he kissed me—and I said I won't be slobber'd about so, so I won't; and he bid me get out of the Room for a saucy Baggage, and said he had a good mind to spit in my Face.

Sure no Man ever took such a Method to gain a Woman's Heart.

Fielding presents Pamela's ardent defense of her chastity against her upper-class seducer as a sham; it is simply a calculated strategy, an ambitious hussy's plot to achieve financial security.

Fielding's greatest success came with the publication in 1749 of *The History of Tom Jones, a Foundling*. Fielding's model was Cervantes's *Don Quixote*, a loosely structured picaresque plot in which its outcast hero wanders through England and the streets of London. Fielding called it "a comic epic-poem in prose," which contrasts its generous, good-natured, and often naïve hero with cold-hearted and immoral British society. As Fielding himself explained, his purpose was to show "not men, but manners; not an individual, but a species." His characters are generally products, not of individual psychology, but of class. As opposed to Richardson, in Fielding's novels, plot takes precedence over character, the social fabric over individual consciousness. This is crucial to the comedy of his narrative. If readers were to identify too closely with Fielding's characters, they might not be able to laugh at them. It is, after all, the folly of human behavior that most intrigues Fielding himself.

The World of Provincial Gentry: Jane Austen's *Pride and Prejudice* Not all readers were charmed and entertained by Fielding's lavish portraits of vice. Many found his narratives deplorable. These readers found an antidote to Fielding in the writings of Jane Austen (1775–1817). Although Austen's best-known novels were published in the first quarter of the nineteenth century, she was more in tune

with the sensibilities of the late eighteenth century, especially with Enlightenment values of sense, reason, and self-improvement.

None of Austen's heroines better embodies these values than the heroine of *Pride and Prejudice* (1813), Elizabeth Bennett, one of five daughters of a country gentlemen whose wife is intent on marrying the daughters off. The novel famously opens (**Reading 24.11a**):

READING 24.11a

from Jane Austen, *Pride and Prejudice*, Chapter 1 (1813)

It is a truth universally acknowledged, that a single man in possession of a good fortune, must be in want of a wife.

However little known the feelings or views of such a man may be on his first entering a neighbourhood, this truth is so well fixed in the minds of the surrounding families, that he is considered the rightful property of some one or other of their daughters.

The level of Austen's irony in these opening sentences cannot be overstated, for while she describes the fate that awaits any single, well-heeled male entering a new neighborhood, these lines are a less direct, but devastating reflection upon the possibilities for women in English society. Their prospect in life is to be married. And if they are not themselves well-heeled and attractive—that is, marriageable—their prospects are less than that.

Austen first told this story in *First Impressions* (1796–97), in the form of an exchange of letters between Elizabeth and Fitzwilliam Darcy, an English gentleman. When we first meet him in *Pride and Prejudice*, Austen describes him as follows: "He was looked at with great admiration for about half the evening, till his manners gave a disgust which turned the tide of his popularity; for he was discovered to be proud, to be above his company, and above being pleased; and not all his large estate in Derbyshire could then save him from having a most forbidding, disagreeable countenance. . . ." The novel's plot revolves around the two words of its title, *pride* and *prejudice*. Where Elizabeth at first can only see Darcy's pride, she comes to realize that her view is tainted by her prejudice. Darcy's disdain for country people and manners is a prejudice that Elizabeth's evident pride helps him to overcome. Together, they come to understand not only their own shortcomings but their society's.

This reconciliation begins when Elizabeth tours Darcy's estate at Pemberley in the company of her aunt and uncle, the Gardiners. The scene Austen describes is quite literally the quintessential English garden, a new form of landscape

design (see Chapter 25), but it is also an extended metaphor for its owner (**Reading 24.11b**):

READING 24.11b

from Jane Austen, *Pride and Prejudice*, Chapter 43 (1813)

Elizabeth, as they drove along, watched for the first appearance of Pemberley Woods with some perturbation; and when at length they turned in at the lodge, her spirits were in a high flutter.

The park was very large, and contained great variety of ground. They entered it in one of its lowest points, and drove for some time through a beautiful wood, stretching over a wide extent.

Elizabeth's mind was too full for conversation, but she saw and admired every remarkable spot and point of view. They gradually ascended for half a mile, and then found themselves at the top of a considerable eminence, where the wood ceased, and the eye was instantly caught by Pemberley House, situated on the opposite side of a valley, into which the road, with some abruptness, wound. It was a large, handsome, stone building, standing well on rising ground, and backed by a ridge of high woody hills;—and in front, a stream of some natural importance was swelled into greater, but without any artificial appearance. Its banks were neither formal nor falsely adorned. Elizabeth was delighted. She had never seen a place for which nature had done more, or where natural beauty had been so little counteracted by an awkward taste. They were all of them warm in their admiration; and at that moment she felt that to be mistress of Pemberley might be something!

They descended the hill, crossed the bridge, and drove to the door; and, while examining the nearer aspect of the house, all her apprehensions of meeting its owner returned.

By subtly identifying Darcy with his estate, Austen affirms the commonly held belief that a man's estate and grounds were a reflection of the man himself. The description is certainly analogous to Elizabeth's aunt's assessment of Darcy toward the end of the chapter: "There is something a little stately in him to be sure . . . but it is confined to his air, and is not unbecoming. I can now say with the housekeeper, that though some people may call him proud, I have seen nothing of it." Austen's language here prepares us in fact for Darcy's own "large" and "handsome . . . eminence."

The subtle manipulation of descriptive language apparent in this passage is indicative of Austen's great talent. Her novels track, with uncanny precision, distinctions of class, rank, and social standing that mark her times. And she looks upon the English class system with a sense of both irony and compassion, and with a sensitivity to the pressures challenging it in her own day. But perhaps above

all, she understands the weight that individual words can bear, how mere description—the use of the word "large," for instance—can influence and manipulate feeling.

Samuel Johnson: Stylist and Moralist The English novel, and the state of the society reflected in it, was of special concern to Samuel Johnson (1709–1784) (Fig. **24.10**). Johnson was editor of two coffeehouse magazines, *The Rambler* (1750–52) and *The Idler* (1758–60), author of the groundbreaking *Dictionary of the English Language*, published in 1755, the moral fable *Rasselas, Prince of Abyssinia* (1759), and the critical and biographical text *The Lives of the Most Eminent English Poets* (ten volumes, 1779–81), as well as editor of a completely annotated edition of Shakespeare's plays (1765). He was also subject of what is arguably the first great biography of the modern era, *The Life of Samuel Johnson* by James Boswell (1740–1795), published in 1791, and unique in its inclusion of conversations among Johnson and his contemporaries that Boswell recorded in his journals at the time.

Born to a poor bookseller in Lichfield, Stratfordshire, he had been forced to leave Oxford for lack of funds and arrived in London penniless in 1737. For three decades, he supported himself by his writing, until awarded a government pension in 1762. Three years later, he received an honorary doctorate from Trinity College, Dublin, and another from

Fig. 24.10 Sir Joshua Reynolds, *Samuel Johnson*. 1756–57. Oil on canvas, 50¼″ × 40″. National Portrait Gallery, London. Given by an anonymous donor, 1911. NPG 1597. Reynolds was a close associate of Johnson's. The most prolific portrait painter of the era, he produced over 1,500 portraits of the English nobility and was the first president of the English Royal Academy.

Oxford ten years after that—which explains his commonly used title, Dr. Johnson.

Johnson's concerns about the novel are best articulated in an essay on fiction that appeared in *The Rambler*, an essay that demonstrates Johnson's considerable talents as a literary critic (**Reading 24.12**):

READING 24.12

from Samuel Johnson, *The Rambler* No. 4, Saturday, March 31,1750

The works of fiction with which the present generation seems more particularly delighted are such as exhibit life in its true state, diversified only by accidents that daily happen in the world, and influenced by passions and qualities which are really to be found in conversing with mankind.

This kind of writing may be termed, not improperly, the comedy of romance. . . . Its province is to bring about natural events by easy means, and to keep up curiosity without the help of wonder: it is therefore precluded from the machine and expedients of the heroic romance, and can neither employ giants to snatch away a lady from the nuptial rites, nor knights to bring her back from captivity; it can neither bewilder its personages in deserts, nor lodge them in imaginary castles. . . .

The task of our present writers . . . requires, together with that learning which is to be gained from books, that experience which can never be attained by solitary diligence, but must arise from general converse and accurate observation of the living world. . . . These books are written chiefly to the young, the ignorant, and the idle, to whom they serve as lectures of conduct, and introductions into life. They are the entertainment of minds unfurnished with ideas, and therefore easily susceptible of impressions; not fixed by principles, and therefore easily following the current of fancy; not informed by experience, and therefore open to every false suggestion and partial account. . . .

I cannot discover why there should not be exhibited the most perfect idea of virtue; of virtue not angelical, nor above probability (for what we cannot credit, we shall never imitate), but the highest and purest humanity can reach, which, exercised in such trials as the various revolutions of things shall bring upon it, many, by conquering some calamities and enduring others, teach us what we may hope, and what we can perform. Vice (for vice is necessary to be shown), should always disgust. . . . Wherever it appears, it should raise hatred by the malignity of its practices, and contempt by the meanness of its stratagems. It is therefore to be steadily inculcated that virtue is the highest proof of understanding, and the only solid basis of greatness; and that vice is the natural consequence of narrow thoughts; that it begins in mistake, and ends in ignominy.

This last paragraph sums up what Johnson disliked in Fielding's novels, whose characters, he complained, were "of very low life."

Perhaps Johnson's most important contribution to English letters is his *Dictionary of the English Language*, published in 1755. A quintessential Enlightenment effort, it represents an attempt to standardize the English language, especially its wildly inconsistent spelling. Johnson's *Dictionary* consists of definitions for some 40,000 words, illustrated with about 114,000 quotations gathered from English literature. This dictionary has served as the basis for all English dictionaries since. Occasionally, Johnson's considerable wit surfaces in the text. His definition of "patron," for example, reads: "Patron: One who countenances, supports, or protects. Commonly a wretch who supports with insolence, and is repaid with flattery." "Angling" is treated even more amusingly: "A stick and a string, with a worm on one end and a fool on the other."

Johnson is notorious for the **aphorisms**—concise and clever observations—which are scattered throughout his essays. Here are a few examples:

> Promise, large promise, is the soul of an advertisement. (from *The Idler*)
> Language is the dress of thought. (from *The Lives of the English Poets*)
> Marriage has many pains, but celibacy has no pleasures. (from *Rasselas*)

With his piercing wit, Johnson expressed his deep skepticism regarding the perfectibility of human nature. Humanity needed to be saved from itself, and doing that required a strict social and moral order. Most of the great thinkers of the Enlightenment shared his view.

EXPLORATION IN THE ENLIGHTENMENT

When, on August 26, 1768, Captain James Cook (1728–1779) set sail on the *Endeavor* from Plymouth, England, for the uncharted waters of the South Pacific, both his sponsors, the Royal Society and the British Admiralty, and Cook himself believed the enterprise to be consistent with the aims of the Enlightenment. While Cook would claim new territories for the British crown, his primary mission was to extend human knowledge: to map the South Seas, record his observations, and otherwise classify a vast area of the world then unknown to European civilization. Although he was careful to document the lives of the people he encountered, his primary mission was to visit Tahiti in order to chart the transit of Venus, that moment in time when the planet Venus crosses directly between the sun and the Earth. This phenomenon occurs twice, eight years apart, in a pattern that repeats every 243 years; in the eighteenth century, that was in 1761 and 1769. (Astronomers around the world watched in fascination when it occurred in June 2004, and will study it again in June 2012.) The measurement of the transit of Venus was understood to be useful in calculating the size of the solar system.

The Royal Society knew of Tahiti because one of its members, the Frenchman Louis-Antoine de Bougainville [deh boo-gahn-VEEL] (1729–1811), had landed on its

shores just months before, in April 1768. Bougainville's descriptions of Tahitian life, published in 1771 as *Voyage around the World*, captured the Enlightenment's imagination. Denis Diderot [dee-DROH] (see Chapter 25) quickly penned a *Supplement* to Bougainville's text, arguing that the natives of Tahiti were truly Rousseau's "noble savages." They were free from the tyrannical clutches of social hierarchy and private property—in Diderot's words, "no king, no magistrate, no priest, no laws, no 'mine' and 'thine.'" All things were held for the common good, including the island's women, who enjoyed, in Diderot's eyes, the pleasures of free love. By following their natural instincts, these people had not fallen into a state of degradation and depravity, as Christian thinkers would have predicted, but rather formed themselves into a nation of gentleness, general well-being, and harmonious tranquility.

Cook, upon his return, took exception to Diderot's picture of Tahitian life. The careful observer would have noticed, he pointed out, a highly stratified social hierarchy of chiefs and local nobility, that virtually every tree on the island was the private property of one of the natives, and that the sexual lives of the Tahitians were in general as morally strict as those of the English (although women in port were as likely in Tahiti as in Plymouth to sell their sexual favors to visiting sailors). But if Cook's position seems at odds with that of the Enlightenment, it was, in its way, also consistent. Enlightenment philosophers had argued that human nature and behavior were the same all over the world, and in his view the Tahitians proved that point. In addition, Enlightenment economists had argued that private property and social stratification were the basic features of a complex and flourishing society. Cook found both in Tahitian society, and this accounted for the general well-being of their society, he believed.

Cook's Encounters in the South Pacific

The islands of the South Pacific that Cook and others explored in the late eighteenth century consist of three primary groups and the continent of Australia (Map 24.3). Melanesia is a long crescent of relatively large islands stretching east from Indonesia and including New Guinea, the largest. Micronesia consists of many smaller islands to the north, most formed from coral reefs growing over submerged volcanoes. Polynesia, meaning "many islands," is a large, triangular area in the central Pacific Ocean defined by New Zealand in the southwest, Easter Island in the southeast, and the Hawaiian Islands in the north.

New Zealand The people that Bougainville and Cook encountered in Tahiti had arrived in the islands around 200 CE from the vicinity of Tonga and Samoa to the west. Easter Island, the easternmost island in Polynesia, was first inhabited in about 300 CE, probably by Marquesas [mar-KAY-zuz] islanders. The peoples of Hawaii, the northernmost islands of Polynesia, arrived there about 100 years later, probably from the Marquesas also. A second wave of Tahitians populated the Hawaiian Islands between about 900 and 1200 CE. Finally, New Zealand, the western- and southernmost islands of Polynesia, was inhabited by the Maori [MAUR-ee] in about 900 CE. The Maori also may have come from Tahiti. In the course of his three voyages to the South Seas, beginning in 1768 and ending 11 years later, Cook visited all of these islands.

One of the most distinctive art forms that Cook and his crew encountered in Polynesia was tattooing, a word derived from *tatau* [ta-ta-OO], the Tahitian term for the practice. One of Cook's crew, Sydney Parkinson, a young draftsman on board to record botanical species, captured the tattooed face of a Maori warrior during the first voyage

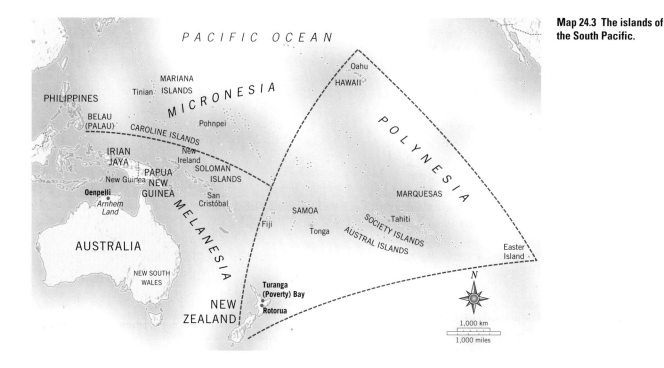

Map 24.3 The islands of the South Pacific.

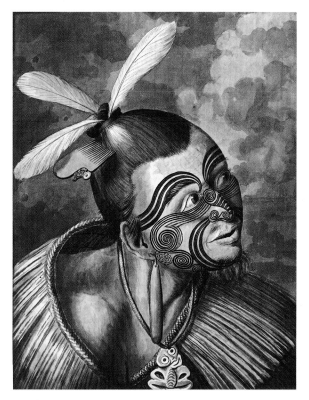

Fig. 24.11 Sydney Parkinson, _Portrait of a Maori_. 1769. Wash drawing, 15¹/₂″ × 11⁵/₈″, later engraved and published as Plate XVI in Parkinson's _Journal_, 1773. The British Library, London. Add. 23920 f.55. Parkinson's drawings provide some of the earliest archeological records of Polynesian life.

(Fig. **24.11**). The Maori had imported the practice from the Polynesian islands to the north.

Tattooing is an aspect of complex sacred and ritual traditions found throughout the Pacific Islands. The islanders believed that individuals, many places, and a great many objects are imbued with **mana** [MAH-nah], a spiritual substance that is the manifestation of the gods on earth. Chiefs, considered descendants of the gods, were supposedly born with considerable quantities of _mana_, nobility with less, and commoners with almost none. Anything or anyone possessing _mana_ was protected by _tapu_, a strict state of restriction indicating that an object or person cannot be touched or a place entered. A chief's food might be protected by _tapu_. A person might increase his or her _mana_ by skillful or courageous acts, or by wearing certain items of dress, including tattoos. Thus, the warrior depicted by Parkinson possesses considerable _mana_. This derives from the elegance of his tattoo, from his headdress and comb, his long earring, probably made of greenstone (a form of jade), and his necklace. From it hangs a _hei-tiki_, a stylized carving of a human figure, a legendary hero or ancestor figure whose _mana_ the warrior carries with him.

Among the Maori, the most sacred part of the body was the head, and so it was the most appropriate place for a tattoo. All high-ranking Maori were tattooed, including women (although less elaborately). The first tattoos were inscribed during the rituals marking the passage into adulthood.

Tattoos generally consisted of broad, curving, parallel lines from nose to chin, spiral forms on the cheeks, and broad, parallel lines between the bridge of the nose and the ears following the curve of the brow. Their design mirrors the human form and is meant to celebrate it. The design was almost always bilaterally symmetrical, but each one was so distinctive that, after coming in contact with Western practice, many Maori began signing documents with them. The tattoo artist possessed great skill and thus considerable _mana_, and was also _tapu_, in no small part because the process was extremely painful. Using a bone chisel, the tattoo artist cut deeply into the skin. Pigment made from burnt Kauri gum or burnt vegetable caterpillars was then pushed into the cuts by tapping, the sound of which, "ta-ta," gives the process its name.

Easter Island Cook arrived on Easter Island in 1794, where he discovered monumental heads with torsos known as **moai** [moe-eye] (Fig. **24.12**), the remains of an abandoned civilization. Like the _hei-tiki_ figures in Maori culture, the _moai_ may well represent ancestors' figures. Around 1000 CE, the Easter Islanders began erecting _moai_ on stone platforms, called _ahu_, around the steep hillsides of the island facing the sea or turned away from the sea overlooking villages. They were probably designed to protect the island's people, and they possessed great _mana_, but not until inlaid coral and stone eyes were set in place (today, these eyes exist only in a few restorations). The _ahu_ average about 190 feet in

Fig. 24.12 Thin _moai_ at Rano Raraku, Easter Island. ca. 1000–1600 CE. Rano Raraku is a volcanic crater with a crater lake in its center. Of the 394 _moai_ at Rano Raraku, approximately 150 lie unfinished in the quarry.

length and 15 feet in height, and the *moai* range from 6 to about 70 feet in height. *M*oai of between 12 and 20 feet high are common. Carved out of compressed volcanic ash at Rano Raraku, a quarry where 394 *moai* are still visible today, the majority weigh between 18 and 20 tons, the largest as much as 80 or 90 tons.

The *moai* were carved out of large rock outcroppings that were still attached to the hillside as if lying on their backs, face up. Working from the front of the face and around the side to the back, the artists gradually carved out the entire form until only a narrow spine of stone connected the sculpture to the rock outcrop. Once cut free from the hill, the sculptures were transported around the island on sledges or rollers, and levered into place on the *ahu*.

The quarries in Rano Raraku appear to have been abandoned abruptly, with many incomplete statues still in place. Deforestation was at least partly responsible, since it became increasingly difficult to create the rollers and levers necessary to erect the statues. Some scholars believe that the religious or social system responsible for erecting the *moai* was overthrown by a cult that identified itself with bird imagery and that exercised rituals to ensure the fertility of the land. The deforestation associated with creation of the *moai* might have been perceived by this new cult as a threat. Whatever the reason, by the nineteenth century, within a few years of Captain Cook's visit to the island in 1774, the standing *moai* had all been toppled to lie on their faces and sides on the hillsides.

Melanesia The largest island in Melanesia, and the second largest island in the world after Australia, is New Guinea, which Cook first visited in 1778. Here he encountered an extremely hostile and fearless native population. The eastern half of the island is Papua, known for its elaborate displays of ritual objects in ceremonial houses where young farmers are initiated into agricultural cults dedicated especially to growing yams as large as 7 feet long. The Asmat people of Irian Jaya, the western half of the island, were headhunters, and it is likely that it was the Asmat whom Cook first encountered in New Guinea. The Asmat created monumental sculptures in connection with the rituals surrounding the act of headhunting. They believed that in displaying the head of an enemy warrior, they could possess that warrior's strength.

Elaborate *bis* poles (Fig. **24.13**), carved in connection with the Asmat funeral rituals, reflect each step in the headhunting process. First a tree is cut (symbolic of the decapitation of the enemy), its bark removed (skinning the victim), and its sap allowed to run like blood. Then artists carve various images into the poles. In addition to images of deceased ancestors, there are birds eating fruit, which symbolize the headhunter eating the brains of his victim. Hollows at the base of the poles were meant to hold the heads of enemies. Long, elaborately carved elements project from the groins of the topmost figures, whose bent knees are meant to suggest the praying mantis. (The female praying mantis eats the head of its mate—symbolic to the Asmat of headhunting.) The projections are called *tsjemen*

Fig. 24.13 *Bis* **poles. Mid-twentieth century. New Guinea, Irian Jaya, Faretsj River, Omadesep village, Asmat people.** Wood, paint, fiber, height 18′. The Michael C. Rockefeller Memorial Collection, Bequest of Nelson A. Rockefeller, 1979 (1979.206.1611). © The Metropolitan Museum of Art/Art Resource, New York. After the *bis* ceremonies were concluded, the poles were moved to groves of sago palms, the primary food source of the Asmat. There, the poles were allowed to decay and nourish the palms.

(literally "enlarged penis") and symbolize the virility and strength of the warrior and his ancestors. The ceremonies involving these poles were meant to restore balance to the Asmat village after the death of one or more of their members created an imbalance.

Australia Captain Cook first sailed along the eastern coast of Australia in 1770, claiming it for the British crown. He and his crew were the first Westerners to encounter the Australian Aboriginal culture. The British established their first permanent settlement there in 1788, in New South Wales, and the colony's first governor, Arthur Philip, reported seeing Aboriginal rock art (Fig. **24.14**), which represents the longest continuously practiced artistic tradition anywhere in the world. In Arnhem Land, in northern Australia, a great

many rock formations and caves are decorated with rock art dating from the earliest periods (40,000–6,000 BCE) to works created within living memory. The earliest works are sticklike figures that represent ancestral spirits, or *mimis*. Some of these are visible behind the kangaroo in Figure 24.14. According to Arnhem legend, *mimis* made the earliest rock paintings and taught the art to present-day Aborigines, who, in painting such figures, release the power of the *mimis*. Aboriginal artists do not believe that they create or invent their subjects; rather, the *mimis* give them their designs, which they then transmit for others to see. The act of painting creates a direct link between the present and the past.

The kangaroo in this prehistoric rock painting is rendered in what has come to be known as the *x-ray style*, where the skeletal structure, heart, and stomach of an animal are painted over its silhouetted form as if the viewer can see the life force of the animal through its skin. Painting of this kind was still prevalent when European settlers arrived in the nineteenth century, and even today bark painters from western Arnhem Land continue to work in the x-ray style. Although two centuries of contact with European culture significantly altered Aboriginal culture, many of their longstanding traditions and rituals survive.

Fig. 24.15 *Kukailimoku,* **Hawaii. ca. 1790–1810.** Wood, height 77″. The British Museum, London. Gift of W. Howard. Ethno 1839, 4-26.8. © The Trustees of the British Museum. The figure is probably a vehicle for the god to enter and make himself present in the temple.

Hawaii On his last voyage in the Pacific, in January 1778, Cook visited the Hawaiian Islands for the first time. It was the middle of the rainy season and the Hawaiians at first treated him with reverence and awe, believing him to be an incarnation of the rain god Lono, father of waters and god of thunder and lightning, which they probably associated with his guns and cannon. From Hawaii, Cook traveled along the western coast of North America, all the way to the Bering Sea, and then returned to Hawaii. At first he was treated with the same respect and honor he had encountered previously, but his overreaction to the Hawaiians' theft of one of his small boats and the demands of his company upon the diminishing food supplies of the natives turned the islanders against him. On February 14, 1779, he was clubbed and stabbed to death in a skirmish on the beach at Kealakekua Bay on the Kona coast of the Island of Hawaii, the so-called Big Island.

Legend has it that among the warriors who attacked Cook was a young Kamehameha I (ca. 1758–1819), the Hawaiian king who first consolidated the islands under one rule. In Hawaiian society, each man worshiped a specific deity related to his work. The king worshiped the war god Kukailimoku ("Ku, Snatcher of Islands"), and Kamehameha was dedicated to him. A well-preserved wood statue of Kukailimoku captures the god's ferocity (Fig. **24.**15). The god's head is disproportionately large because it is the site of his *mana*. His nostrils flare

menacingly, and his mouth, surrounded by what may be tattoos or scarification, is ferociously open, perhaps in a war cry, suggesting his *tapu*. Small, stylized pigs, possibly symbols of wealth, decorate his headdress. The statue is meant to convey the ferocity of Kamehameha I himself, the ferocity that was required in bringing all of the islands of Hawaii under his rule, "snatching" them, as Kukailimoku's name suggests.

Cook in the North Pacific

Cook's expedition to the northern reaches of the Pacific Basin, which occurred between his two visits to Hawaii, were inspired by the hope that he might find a "Northwest Passage" connecting the Atlantic and the Pacific Oceans. As always on his voyages, Cook was accompanied by illustrators and scientists. On the island of Unalaska (called by Cook "Oonalashka") in the Aleutian Chain, approximately 800 miles southwest of present-day Anchorage, artist John Webber captured the likeness of a native Aleut, his lower lip pierced with bead-covered bones (Fig. **24.16**). Here, he also made contact with Russian fur traders, who were making a considerable fortune selling furs in China.

Taking particular notice of the possibilities of the fur trade was Connecticut-born John Ledyard (1751–1789), who would publish his *Journal of Captain Cook's Last Voyage in the Pacific* in Hartford, Connecticut in 1783. Recalling the wealth of furs the Cook expedition had encountered in Nootka Sound off Vancouver Island, he wrote (**Reading 24.13**):

READING 24.13

from John Ledyard, *A Journal of Captain Cook's Last Voyage* (1783)

The light in which this country will appear most to advantage respects the variety of its animals, and the richness of their furr. They have foxes, sables, hares, marmosets, ermines, weazles, bears, wolves, deer, moose, dogs, otters, beavers, and a species of weazel called the glutton; the skin of this animal was sold at Kamchatka, a Russian factory on the Asiatic coast for sixty rubles, which is near 12 guineas, and had it been sold in China it would have been worth 30 guineas. . . . Neither did we purchase a quarter part of the beaver and other furr skins we might have done, and most certainly should have done had we known of meeting the opportunity of disposing of them to such an astonishing profit.

By 1784, Ledyard was in Paris, where he was quickly befriended by Thomas Jefferson, at that time American ambassador to France. Jefferson suggested that he attempt to be the first person to cross the American continent by foot, leaving France to cross Russia, continue across the Bering Strait to Alaska, and eventually reach Virginia. Ledyard in

fact set out from St. Petersburg in June 1787 and made it as far as the Siberian capital of Irkutsk before Catherine the Great of Russia had him arrested as a spy and deported. He died of fever in Cairo, at the age of 37, while attempting to organize an expedition across Africa from the Red Sea to the Atlantic Ocean. But Ledyard's dream of crossing the continent became, almost obsessively, Jefferson's own, and it would inspire, finally, Jefferson's persuading the United States Congress to finance the expedition of Meriweather Lewis and William Clark across the continent and back in 1804 to 1806 after Jefferson's purchase of the Louisiana Territory in 1803. And Ledyard's sense of the potential of a fur trade with China would soon be realized by John Jacob Astor (1763–1848), who founded the American Fur Company in 1808 and, in 1811, opened a trading post at the mouth of the Columbia River, Fort Astor, at the site of present-day Astoria, Oregon. Astor would become America's first millionaire.

A MAN of OONALASHKA.

Fig. 24.16 John Webber (ca. 1752–1798), artist, William Sharp (1749–1825), engraver, *A Man of Oonalashka*. ca. April 1778. Engraving, from the atlas volume of James Cook's *A Voyage to the Pacific Ocean. Undertaken, by the Command of His Majesty, for Making Discoveries in the Northern Hemisphere. To Determine the Position and Extent of the West Side of North America; Its Distance from Asia; and the Practicability of a Northern Passage to Europe. . . .* (London: Printed by W. and A. Strahan, for G. Nicol, Bookseller to His Majesty, in the Strand, and T. Cadell in the Strand, 1784). Wisconsin Historical Society, Madison, WI. Cook wrote of the Native Americans he met in Alaska: "In this wretched extremity of earth, situated beyond everything that we conceived to be most barbarous and inhospitable, and, as it were, out of the very reach of civilization, barricaded with ice, and covered with summer snow . . . we met with feelings of humanity, joined to a greatness of mind, and elevation of sentiment, which would have done honour to any nation or climate."

The Growing Crisis of the Slave Trade

The most troubling instance of cross-cultural encounter during the Enlightenment revolved around slavery. Since the Portuguese introduced the slave trade in the sixteenth century (see Chapter 18), hundreds of thousands of Africans had been forcibly transported to the Americas in conditions so appalling that many, even most, died in transit. Those who survived the voyage then experienced the brutality of slavery itself.

American slave owners sought to suppress their slaves' identification with their African heritage. Rarely were slaves from the same locales in Africa allowed to work on the same plantation. Even more radically, slave families were generally broken up—men, women, and children sold separately—in order to undermine their ability to carry on African traditions and practices.

Many leading Enlightenment thinkers in America defended the institution of slavery. Thomas Jefferson wrote in his *Notes on the State of Virginia*, "Comparing [blacks] by their faculties of memory, reason, and imagination, it appears to me that in memory they are equal to whites; in reason much inferior. . . . I advance it . . . as a suspicion only, that the blacks, whether originally a distinct race, or made distinct by time and circumstances, are inferior to the white in the endowments both of body and mind. . . . This unfortunate difference of color, and perhaps of faculty, is a powerful obstacle to the emancipation of these people." Nevertheless, Jefferson did attempt, unsuccessfully, to incorporate a paragraph condemning slavery in his Declaration of Independence, one of the great documents of Enlightenment thought—although he owned 187 slaves of his own.

In Britain, Jefferson was considered a hypocrite, and that hypocrisy would come to play a major role in the Revolutionary War. The British, as we will see in the next chapter, could not understand how the Declaration's call for "life, liberty, and the pursuit of happiness" was consistent with the defense of slavery as an institution. And, although the British were deeply involved in the slave trade, an increasingly large number of English Enlightenment thinkers had come to condemn it. John Zoffany's double portrait of Dido Elizabeth Belle Lindsay and Lady Elizabeth Murray (Fig. 24.17) underscores the difference between British and American attitudes. Nothing like this portrait exists in eighteenth- or nineteenth-century American painting. Dido was the daughter of an English Captain and an enslaved African woman. Dido was raised by the Captain's uncle, Lord Chief Justice William Murray, First Earl of Mansfield, together with another of Mansfield's nieces, Elizabeth Murray. The girls were best friends and apparently equal in all things. When the colonial governor of Massachusetts, Thomas Hutchinson, saw them arm in arm at Mansfield's estate, Kenwood House on Hampstead Heath, he was shocked and outraged. ∎

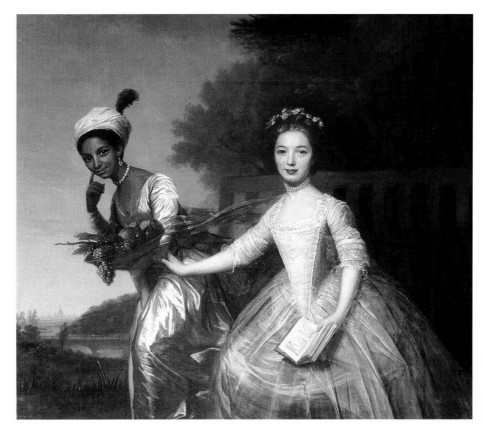

Fig. 24.17 John Zoffany, *Dido Elizabeth Belle Lindsay and Lady Elizabeth Murray.* 1779–81. Oil on canvas, 35 1/2″ × 28 1/4″. From the Collection of the Earl of Mansfield, Scone Place, Scotland.

Who were Hobbes and Locke?

On September 2, 1666, the better part of London was destroyed by fire. Among the achievements of this rebuilding campaign is Christopher Wren's Saint Paul's Cathedral (and indeed the 51 other churches that he rebuilt). At the same time, English intellectuals began to advocate rational thinking as the means to achieve a comprehensive system of ethics, aesthetics, and knowledge. Political strife inevitably raised the question of who should govern and how. In *Leviathan*, Thomas Hobbes argued that ordinary people were incapable of governing themselves and should willingly submit to the sovereignty of a supreme ruler. John Locke argued in opposition that humans are "by nature free, equal, and independent." Can you provide two or three examples of how their positions play out in the politics of the era? How do they play out in John Milton's *Paradise Lost*?

What is satire, and how did it shape the Enlightenment in England?

Deeply conscious of the fact that English society fell far short of its ideals, many writers and artists turned to satire. William Hogarth's prints, produced for a popular audience, satirized the lifestyles of all levels of English society. Jonathan Swift aimed the barbs of his wit at the same aristocracy and lambasted English political leaders for their policies toward Ireland in his *Modest Proposal*. Alexander Pope's *Dunciad* took on not only the English nobility, but the literary establishment that supported it. In a more serious vein, his *Essay on Man* attempts to define a complete ethical system in classical terms of balance and harmony.

After the Glorious Revolution, in fact, English politics settled into a state of comparative harmony. How did the scientific discoveries of Isaac Newton contribute to Enlightenment thinking? How did the Lunar Society, the group that arguably launched what we think of today as the Industrial Revolution, reflect this same thinking?

In music, composer George Frederick Handel's oratorio *Messiah* captured Britain's sense of identification with biblical Israel. What distinguishes the *Messiah* from most other oratorios?

What gave rise to the novel?

The growing literacy of the English population, matched by an explosion in publishing, gave rise to new genres of writing. Newspapers such as Joseph Addison and Richard Steele's *The Tatler* and *The Spectator* introduced the journalistic essay, which described and reflected upon all aspects of English society. Fiction writers experimented with many types of novel, from Daniel Defoe's fictive autobiographies to Samuel Richardson's epistolary works, Fielding's "comic epic-poems in prose," and Jane Austen's novels extolling the virtues of good sense, reason, and self-improvement. In what ways does Samuel Johnson's assessment of the novel in his *Rambler* essay of 1850 apply to the works of Defoe, Richardson, and Fielding?

What was the purpose of Captain Cook's voyages to the Pacific Ocean?

The peoples of the South Seas were seen by many Enlightenment thinkers to be unfettered by social hierarchy and private property. But Captain Cook saw things otherwise. How does Cook's thinking equally reflect Enlightenment values?

In New Zealand, Cook encountered the Maori, whose tattoo practices were connected to the *mana*, or invisible spiritual force, a manifestation of the gods on earth, with which, the culture believed, certain individuals, places, and objects were endowed. How did the concept of *mana* influence the cultural production of the South Seas islanders? On Easter Island, Cook discovered the remnants of a culture that had erected *moai*, monumental heads with torsos, since about 1000 CE. In the western half of New Guinea, he encountered the Asmat, headhunters. Why did these peoples display the heads of enemy warriors on *bis* poles? In Australia, Cook was the first to encounter Australian Aborigines, whose rock art represents the longest continuously practiced artistic tradition in the world.

Before Cook was killed in Hawaii, he traveled to the northern Pacific, up the Canadian and Alaska coasts, as far as the Bering Sea. For what was he searching? What possibilities for trade did his expedition discover?

PRACTICE MORE Get flashcards for images and terms and review chapter material with quizzes at **www.myartslab.com**

GLOSSARY

aphorism A concise and clever observation.

caricature A portrait that exaggerates a person's peculiarities or defects.

epistolary novel A novel made up of a series of epistles, or letters.

heroic couplet A rhyming pair of iambic pentameter lines.

Industrial Revolution The term used to describe a change in practices of production and consumption that occurred in the nineteenth century.

journalistic essay A reportorial set of observations of current events or other issues of interest to the author.

liberalism A political theory that argues that people are by nature free, equal, and independent and that they consent to government for protection but not by surrendering sovereignty to a ruler.

mana Among the Maori, an invisible spiritual substance that is the manifestation of the gods on earth.

moai Monumental heads with torsos found on Easter Island that probably represent ancestral figures.

oratorio A lengthy choral work, usually religious, performed by a narrator, soloists, choruses, and orchestra.

parody A form of satire in which a serious author or work is ridiculed or mocked in a humorous way through exaggerated imitation.

social contract An agreement by which a person gives up sovereignty over him- or herself and bestows it on a ruler.

READINGS

READING 24.2

from Thomas Hobbes, *Leviathan* (1651)

Leviathan *argues that the "natural condition of mankind" is a state of nature where life is "solitary, poor, nasty, brutish, and short." Born into this condition, human beings are motivated only by fear of violent death and accept the governance of a higher authority only to be protected from it and to guarantee their peace and security. When* Leviathan *was published, just 2 years after England's antiroyalist faction had beheaded Charles I, Hobbes's treatise shocked his contemporaries and caused others, such as John Locke, to construct very different theories in open opposition to it.*

PART I CHAPTER 13: OF THE NATURAL CONDITION OF MANKIND AS CONCERNING THEIR FELICITY AND MISERY

Nature has made men so equal in the faculties of the body and mind as that, though there be found one man sometimes manifestly stronger in body or of quicker mind than another, yet, when all is reckoned together, the difference between man and man is not so considerable as that one man can thereupon claim to himself any benefit to which another may not pretend as well as he. For as to the strength of body, the weakest has strength to kill the strongest, either by secret machination or by confederacy with others that are in the same danger with himself. . . .

From this equality of ability arises equality of hope in the at- 10
taining of our ends. And therefore if any two men desire the same thing, which nevertheless they cannot both enjoy, they become enemies; and in the way to their end, which is principally their own conservation, and sometimes their delectation only, endeavor to destroy or subdue one another. And from hence it comes to pass that where an invader has no more to fear than another man's single power, if one plant, sow, build, or possess a convenient seat, others may probably be expected to come prepared with forces united to dispossess and deprive him, not only of the fruit of his labor, but also of his life or liberty. 20
And the invader again is in the like danger of another. . . .

So that in the nature of man we find three principal causes of quarrel: first, competition; secondly, diffidence; thirdly, glory.

The first makes men invade for gain, the second for safety, and the third for reputation. The first use violence to make themselves masters of other men's persons, wives, children, and cattle; the second, to defend them; the third, for trifles, as a word, a smile, a different opinion, and any other sign of undervalue, either direct in their persons or by reflection in their kindred, their friends, their nation, their profession, or their name. 30

Hereby it is manifest that, during the time men live without a common power to keep them all in awe, they are in that condition which is called war, and such a war as is of every man against every man. For WAR consists not in battle only, or the act of fighting, but in a tract of time wherein the will to contend by battle is sufficiently known; and therefore the notion of *time* is to be considered in the nature of WAR as it is in the nature of weather. For as the nature of foul weather lies not in a shower or two of rain but in an inclination thereto of many days together, so the nature of war consists not in actual fighting but in 40
the known disposition thereto, during all the time there is no assurance to the contrary. All other time is PEACE.

Whatsoever, therefore, is consequent to a time of war where every man is enemy to every man, the same is consequent to the time wherein men live without other security than what their own strength and their own invention shall furnish them withal. In such condition there is no place for industry, because the fruit thereof is uncertain; and consequently no culture of the earth; no navigation nor use of the commodities that may be imported by sea; no commodious building; no instruments 50
of moving and removing such things as require much force; no knowledge of the face of the earth; no account of time; no arts; no letters; no society; and, which is worst of all, continual fear and danger of violent death; and the life of man solitary, poor, nasty, brutish, and short. . . .

PART II CHAPTER 17: OF THE CAUSES, GENERATION, AND DEFINITION OF A COMMONWEALTH

The final cause, end, or design of men, who naturally love liberty and dominion over others, in the introduction of that restraint upon themselves in which we see them live in 60
commonwealths, is the foresight of their own preservation, and

of a more contented life thereby—that is to say, of getting themselves out from that miserable condition of war which is necessarily consequent . . . to the natural passions of man when there is no visible power to keep them in awe and tie them by fear of punishment to the performance of their covenants and observations of [the] laws of nature. . . .

For the laws of nature—as *justice, equity, modesty, mercy,* and, in sum, *doing to others as we would be done to*—of themselves, without the terror of some power to cause them to be observed, are contrary to our natural passions, that carry us to partiality, pride, revenge, and the like. And covenants without the sword are but words, and of no strength to secure a man at all. Therefore, notwithstanding the laws of nature . . . if there be no power erected, or not great enough for our security, every man will—and may lawfully—rely on his own strength and art for caution against all other men. . . .

The only way to erect such a common power as may be able to defend them from the invasion of foreigners and the injuries of one another, and thereby to secure them in such sort as that by their own industry and by the fruits of the earth they may nourish themselves and live contentedly, is to confer all their power and strength upon one man, or upon one assembly of men that may reduce all their wills, by plurality of voices, unto one will; which is as much as to say, to appoint one man or assembly of men to bear their person, and everyone to own and acknowledge to himself to be author of whatsoever he that so bears their person shall act or cause to be acted in those things which concern the common peace and safety, and therein to submit their wills every one to his will, and their judgments to his judgment. This is more than consent or concord; it is a real unity of them all in one and the same person, made by covenant of every man with every man, in which manner as if every man should say to every man, *I authorize and give up my right of governing myself to this man, or to this assembly of men, on this condition, that you give up your right to him and authorize all his actions in like manner.* This done, the multitude so united in one person is called a COMMONWEALTH, in Latin CIVITAS. This is the generation of that great LEVIATHAN (or rather, to speak more reverently, of that *mortal god*) to which we owe, under the *immortal God,* our peace and defense. For by this authority, given him by every particular man in the commonwealth, he has the use of so much power and strength conferred on him that, by terror thereof, he is enabled to form the wills of them all to peace at home and mutual aid against their enemies abroad. And in him consists the essence of the commonwealth, which, to define

it, is *one person, of whose acts a great multitude, by mutual covenants one with another, have made themselves every one the author, to the end he may use the strength and means of them all as he shall think expedient for their peace and common defense.* And he that carries this person is called SOVEREIGN and said to have *sovereign power,* and everyone besides, his SUBJECT.

The attaining to this sovereign power is by two ways. One, by natural force. . . . The other is when men agree among themselves to submit to some man or assembly of men voluntarily, on confidence to be protected by him against all others. This latter may be called a political commonwealth, or commonwealth by *institution,* and the former a commonwealth by *acquisition.* . . .

PART II CHAPTER 30: OF THE OFFICE OF THE SOVEREIGN REPRESENTATIVE

The office of the sovereign, be it a monarch or an assembly, consists in the end for which he was trusted with the sovereign power, namely, the procuration of the *safety of the people,* to which he is obliged by the law of nature, and to render an account thereof to God, the author of that law, and to none but him. But by safety here is not meant a bare preservation but also all other contentments of life which every man by lawful industry, without danger or hurt to the commonwealth, shall acquire to himself.

And this is intended should be done, not by care applied to individuals further than their protection from injuries when they shall complain, but by a general providence contained in public instruction, both of doctrine and example, and in the making and executing of good laws, to which individual persons may apply their own cases.

And because, if the essential rights of sovereignty . . . be taken away, the commonwealth is thereby dissolved and every man returns into the condition and calamity of a war with every other man, which is the greatest evil that can happen in this life, it is the office of the sovereign to maintain those rights entire, and consequently against his duty, first, to transfer to another or to lay from himself any of them. For he that deserts the means deserts the ends. . . .

READING CRITICALLY

How does the figure of the Leviathan, the mythological marine monster described in the Bible, contribute to the power of Locke's thesis?

READING 24.4

from John Locke, *The Second Treatise of Government* (1690)

As opposed to Thomas Hobbes, John Locke argued that human beings can attain their maximum development only in a society free of the unnatural constraints placed upon them by absolute rulers. In his Two Treatises on Civil Government, *published the same year as his* Essay Concerning Human Understanding, *as something of a practical companion to the more philosophical* Essay, *and as a kind of applied theory, Locke argued that government must rest upon the consent of the governed. The work would deeply influence many thinkers in the eighteenth century, not least of all Thomas Jefferson, who drew heavily upon the work in drafting the American Declaration of Independence (see Chapter 26).*

FROM CHAPTER II: OF THE STATE OF NATURE

4. To UNDERSTAND political power right and derive it from its original, we must consider what state all men are naturally in, and that is a state of perfect freedom to order their actions and dispose of their possessions and persons as they think fit, within the bounds of the law of nature, without asking leave or depending upon the will of any other man.

A state also of equality, wherein all the power and jurisdiction is reciprocal, no one having more than another; there being nothing more evident than that creatures of the same species and rank, promiscuously born to all the same advantages of nature and the use of the same faculties, should also be equal one amongst another without subordination or subjection; unless the lord and master of them all should, by any manifest declaration of his will, set one above another, and confer on him by an evident and clear appointment an undoubted right to dominion and sovereignty.

FROM CHAPTER V: OF PROPERTY

26. God, who has given the world to men in common, has also given them reason to make use of it to the best advantage of life and convenience. The earth and all that therein is given to men for the support and comfort of their being. And though all the fruits it naturally produces and beasts it feeds belong to mankind in common, as they are produced by the spontaneous hand of nature; and nobody has originally a private dominion exclusive of the rest of mankind in any of them, as they are thus in their natural state; yet, being given for the use of men, there must of necessity be a means to appropriate them some way or other before they can be of any use or at all beneficial to any particular man. The fruit or venison which nourishes the wild Indian, who knows no enclosure and is still a tenant in common, must be his, and so his, i.e., a part of him, that another can no longer have any right to it before it can do him any good for the support of his life.

27. Though the earth and all inferior creatures be common to all men, yet every man has a property in his own person; this nobody has any right to but himself. The labor of his body and the work of his hands, we may say, are properly his. Whatsoever then he removes out of the state that nature has provided and left it in, he has mixed his labor with, and joined to it something that is his own, and thereby makes it his property.

FROM CHAPTER VIII: OF THE BEGINNING OF POLITICAL SOCIETIES

95. MEN BEING, as has been said, *by nature all free, equal, and independent, no one can be put out of this estate and subjected to the political power of another without his own consent.* The only way whereby any one divests himself of his natural liberty and puts on the bonds of civil society is by agreeing with other men to join and unite into a community for their comfortable, safe, and peaceable living one amongst another, in a secure enjoyment of their properties and a greater security against any that are not of it. This any number of men may do, because it injures not the freedom of the rest; they are left as they were in the liberty of the state of nature. When any number of men have so consented to make one community or government, they are thereby presently incorporated and make one body politic wherein the majority have a right to act and conclude the rest.

96. For when any number of men have, by the consent of every individual, made a community, they have thereby made that community one body, with a power to act as one body, which is only by the will and determination of the majority . . . And therefore we see that in assemblies impowered to act by positive laws, where no number is set by that positive law which impowers them, the act of the majority passes for the act of the whole and, of course, determines, as having by the law of nature and reason the power of the whole.

97. And thus every man, by consenting with others to make one body politic under one government, puts himself under an obligation to every one of that society to submit to the determination of the majority and to be concluded by it; or else this original compact, whereby he with others incorporates into one society, would signify nothing, and be no compact, if he be left free and under no other ties than he was in before in the state of nature.

FROM CHAPTER IX: OF THE ENDS OF POLITICAL SOCIETY AND GOVERNMENT

123. IF MAN in the state of nature be so free, as has been said, if he be absolute lord of his own person and possessions, equal to the greatest, and subject to nobody, why will he part with his freedom, why will he give up his empire and subject himself to the dominion and control of any other power? To which it is obvious to answer that though in the state of nature he has such a right, yet the enjoyment of it is very uncertain and constantly exposed to the invasion of others; for all being kings as much as he, every man his equal, and the greater part no strict observers of equity and justice, the enjoyment of the property he has in this state is very unsafe, very unsecure. This makes him willing to quit a condition which, however free, is full of fears and continual dangers; and it is not without reason that he seeks out and is willing to join in society with others who are already united, or have a mind to unite, for the mutual preservation of their lives, liberties, and estates, which I call by the general name "property."

124. The great and chief end, therefore, of men's uniting into commonwealths and putting themselves under government is the preservation of their property.

FROM CHAPTER XVIII: OF TYRANNY

199. AS USURPATION is the exercise of power which another has a right to, so tyranny is the exercise of power beyond right, which nobody can have a right to. And this is making use of the power any one has in his hands, not for the good of those who are under it, but for his own private separate advantage—when the governor, however entitled, makes not the law, but his will, the rule, and his commands and actions are not directed to the preservation of the properties of his people, but the satisfaction of his own ambition, revenge, covetousness, or any other irregular passion . . .

202. Wherever law ends, tyranny begins if the law be transgressed to another's harm. And whosoever in authority exceeds the power given him by the law, and makes use of the force he has under his command . . . ceases in that to be a magistrate and, acting without authority, may be opposed as any other man who by force invades the right of another.

203. May the commands, then, of a prince be opposed? May he be resisted as often as any one shall find himself aggrieved, and but imagine he has not right done him? This will

unhinge and overturn all polities, and, instead of government and order, leave nothing but anarchy and confusion.

204. To this I answer that force is to be opposed to nothing but to unjust and unlawful force; whoever makes any opposition in any other case draws on himself a just condemnation both from God and man; and so no such danger or confusion will follow, as is often suggested.

READING CRITICALLY

Without looking forward to Jefferson's Declaration of Independence, what aspects of Locke's argument here do you recognize as fundamental to your own definition of American liberty?

READING 24.5

from John Milton, *Paradise Lost,* Book 6 (1667)

The following section opens Book 6 of Milton's epic poem. The passage opens with the angel Abdiel, referred to in the book's first line as the "dreadless" or fearless angel because in the previous book he had refused to join Satan's rebellion and had prophesized his downfall, flying about heaven as the other angels gather to confront Satan under the leadership of Gabriel and Michael. The passage takes us up to the moment that the two armies meet. The ensuing battle, in which Abdiel and Michael engage in hand-to-hand combat with Satan, is purposefully reminiscent of Homer's Iliad *(see Chapter 4).*

All night the dreadless angel unpursued
Through heav'n's wide champaign held his way, till Morn,
Waked by the circling Hours, with rosy hand
Unbarred the gates of light. There is a cave
Within the mount of God, fast by his throne,
Where light and darkness in perpetual round
Lodge and dislodge by turns, which makes through heav'n
Grateful vicissitude, like day and night;
Light issues forth, and at the other door
Obsequious darkness enters, till her hour 10
To veil the heav'n, though darkness there might well
Seem twilight here; and now went forth the Morn
Such as in highest heav'n, arrayed in gold
Empyreal; from before her vanished night,
Shot through with orient beams: when all the plain
Covered with thick embattled squadrons bright,
Chariots and flaming arms, and fiery steeds
Reflecting blaze on blaze, first met his view:
War he perceived, war in procinct, and found
Already known what he for news had thought 20
To have reported: gladly then he mixed
Among those friendly Powers who him received
With joy and acclamations loud, that one
That of so many myriads fall'n, yet one
Returned not lost: on to the sacred hill
They led him high applauded, and present
Before the seat supreme; from whence a voice
From midst a golden cloud thus mild was heard.

"Servant of God, well done, well hast thou fought
The better fight, who single hast maintained 30
Against revolted multitudes the cause
Of truth, in word mightier than they in arms;
And for the testimony of truth hast borne
Universal reproach, far worse to bear
Than violence: for this was all thy care
To stand approved in sight of God, though worlds
Judged thee perverse: the easier conquest now
Remains thee, aided by this host of friends,
Back on thy foes more glorious to return
Than scorned thou didst depart, and to subdue 40
By force, who reason for their law refuse,
Right reason for their law, and for their King
Messiah, who by right of merit reigns.
Go Michael of celestial armies prince,
And thou in military prowess next
Gabriel, lead forth to battle these my sons
Invincible, lead forth my armed saints
By thousands and by millions ranged for fight;
Equal in number to that godless crew
Rebellious, them with fire and hostile arms 50
Fearless assault, and to the brow of heav'n
Pursuing drive them out from God and bliss,
Into their place of punishment, the gulf
Of Tartarus, which ready opens wide
His fiery chaos to receive their fall."

[3]**Hours:** four beautiful daughters of love, goddesses of the seasons and guards of the gates of heaven.
[8]**vicissitude:** (L. *vicissim* in turn, *vicis* change, alternation) alternating succession of contrasting things.
[10]**Obsequious:** (L *ob* toward + *sequi* to follow) compliant.
[14]**Empyreal:** (CK *pyr* fire) heavenly.
[16]**embattled:** in battle array.
[19]**in procinct:** prepared.

[29]**Servant of God:** the literal meaning of the Hebrew word *abdiel*. Cf Matt. 25.21: "His lord said unto him. Well done, thou good and faithful servant." 2 Tim. 4.7: "I have fought a good fight, I have finished my course, I have kept the faith."
[33–34]Cf. Ps. 69.7: "Because for thy sake I have borne reproach."
[36]Cf. 2 Tim. 2.15: "Study to show thyself approved unto God."

So spake the Sovran Voice, and clouds began
To darken all the hill, and smoke to roll
In dusky wreaths reluctant flames, the sign
Of wrath awaked: nor with less dread the loud
Ethereal trumpet from on high gan blow: 60
At which command the powers militant,
That stood for heav'n, in mighty quadrate joined
Of union irresistible, moved on
In silence their bright legions, to the sound
Of instrumental harmony that breathed
Heroic ardor to advent'rous deeds
Under their godlike leaders, in the cause
Of God and his Messiah. On they move
Indissolubly firm; nor obvious hill,
Nor strait'ning vale, nor wood, nor stream divides 70
Their perfect ranks; for high above the ground
Their march was, and the passive air upbore
Their nimble tread; as when the total kind
Of birds in orderly array on wing
Came summoned over Eden to receive
Their names of thee; so over many a tract
Of heav'n they marched, and many a province wide
Tenfold the length of this terrene: at last
Far in th' horizon to the north appeared
From skirt to skirt a fiery region, stretched 80
In battailous aspect, and nearer view
Bristled with upright beams innumerable
Of rigid spears, and helmets thronged, and shields
Various, with boastful argument portrayed,
The banded powers of Satan hasting on
With furious expedition; for they weened
That selfsame day by fight, or by surprise
To win the mount of God, and on his throne
To set the envier of his state, the proud

Aspirer, but their thoughts proved fond and vain 90
In the mid-way: though strange to us it seemed
At first, that angel should with angel war,
And in fierce hosting meet, who wont to meet
So oft in festivals of joy and love
Unanimous, as sons of one great Sire
Hymning th' Eternal Father: but the shout
Of battle now began, and rushing sound
Of onset ended soon each milder thought.
High in the midst exalted as a god 100
Th' Apostate in his sun-bright chariot sat
Idol of majesty divine, enclosed
With flaming Cherubim, and golden shields;
Then lighted from his gorgeous throne, for now
'Twixt host and host but narrow space was left,
A dreadful interval, and front to front
Presented stood in terrible array
Of hideous length: before the cloudy van,
On the rough edge of battle ere it joined,
Satan with vast and haughty strides advanced, 110
Came tow'ring, armed in adamant and gold;
Abdiel that sight endured not, where he stood
Among the mightiest, bent on highest deeds,
And thus his own undaunted heart explores. . . .

READING CRITICALLY

How do the opening 20 lines, with their description of darkness and light, reminiscent of the opening lines of the Book of Genesis in the Bible, contribute to both the emotional and moral thrust of the poem as the angels prepare for battle?

58**reluctant:** L *re back* + *luctari* to struggle.
62**quadrate:** a square military formation in close order.
69**obvious:** standing in the way of.
78**terrene:** (an adjective used as a noun) terrain.
81**battailous:** warlike.
83–84On the shields were drawn heraldies emblems with their mottoes.
86**furious:** (L *furia tage*) rushing expedition: speed

90**fond:** (ME. *fon* fool) foolish vain; L *vanus empty*.
93**hosting:** hostile encounter.
100**Apostate:** Gk *apo* out from, against + *stēnai* to stand.

25 The Rococo and the Enlightenment on the Continent
Privilege and Reason

THINKING AHEAD

What is the Rococo?

Who are the philosophes*?*

What are the characteristics of Classical music?

How did China and the West influence one another?

Until his death in 1715, Louis XIV had opened his private apartments in Versailles three days a week to his courtiers, where they entertained themselves by playing games. After his death, such entertainments continued, only not at Versailles but in the *hôtels*—or Paris townhouses—of the French nobility, where the same crowd who had visited the king's apartments now entertained on their own. The new king, Louis XV, was only 5 years old, and so there was no point in staying so far out of town in the rural palace where the Sun King had reigned supreme.

The *hôtels* all had a salon, a room designed especially for social gatherings. Very soon the term *salon* came to refer to the social gathering itself. A number of these rooms still survive, including the Salon de la Princesse, which was designed by Germain Boffrand to commemorate the 1737 marriage of the 80-year-old prince de Soubise to the 19-year-old Marie-Sophie de Courcillon (Fig. 25.1). Decorated around the top of the room with eight large paintings by Charles-Joseph Natoire [nah-TWAHR] (1700–1777) depicting the story of Cupid and

Psyche from Ovid's *Metamorphoses* (Fig. 25.2), the room embodies the eroticism that dominated the art of the French aristocracy in the eighteenth century.

These **salons** became the center of French culture in the eighteenth century, and by 1850 they were emulated across Europe (see Map 25.1). The new princesse de Soubise was perhaps too young to be herself an active *salonnière* [sah-lohn-YAIR], one of the hostesses who presided over the weekly gatherings that soon dominated Parisian social life. Among the most popular salons were those of Jeanne-Julie-Eleonore de Lespinasse [deh less-peen-AHSS] (1732–1776). In his memoirs, Friederich Melchior, Baron von Grimm (1723–1807), a frequent guest, recalls the ambiance:

> Her circle met daily from five o'clock until nine in the evening. There we were sure to find choice men of all orders in the State, the Church, the Court—military men, foreigners, and the most distinguished men of letters. Every one agrees that though the name of M. d'Alembert [an intellectual who lived with Julie de Lespinasse, and

◄ **Fig. 25.1 Germain Boffrand, *Salon de la Princesse de Soubise (Salon ovale)*, Hôtel de Soubise, Paris. ca. 1740.** Oval shape, 33′ × 26′. Photo: Bulloz. Reunion des Musees Nationaux/Art Resource, New York. In his 1745 *Livre d'architecture* (*Book on Architecture*), Boffrand compared architecture to theater, arguing that it had both a tragic and pastoral mode. In the lightness of its ornament and the eroticism of its paintings, the Salon de la Princesse is an example of the pastoral mode.

HEAR MORE Listen to an audio file of your chapter at **www.myartslab.com**

Fig. 25.2 Charles-Joseph Natoire, *Cupid and Psyche*, Salon de la Princesse, Hôtel de Soubise, Paris. 1738.
Oil on canvas, 5′7 3/4″ × 8′6 3/8″. Peter Willi/The Bridgeman Art Library. Here Psyche has been brought to the palace of Love where Cupid, under cover of darkness, has consummated their union. Psyche had promised never to seek to know his identity. Here she breaks her oath by lighting her lamp to reveal Cupid's face.

who is discussed later in the chapter] may have drawn them thither, it was she alone who kept them there. Devoted wholly to the care of preserving that society, of which she was the soul and the charm, she subordinated to this purpose all her tastes and all her personal intimacies. She seldom went to the theatre or into the country, and when she did make an exception to this rule it was an event of which all Paris was notified in advance. . . . Politics, religion, philosophy, anecdotes, news, nothing was excluded from the conversation, and, thanks to her care, the most trivial little narrative gained, as naturally as possible, the place and notice it deserved. News of all kinds was gathered there in its first freshness.

The baron numbered among his friends many of the most influential Parisian thinkers of the day, the so-called ***philosophes*** [FILL-loh-sof], "philosophers," who frequented the salons and dominated the intellectual life of the French Enlightenment, a movement that emphasized reason and rationality and sought to develop a systematic understanding of divine and natural law. Not philosophers in the strict sense of the word because they did not concentrate on matters metaphysical,

but turned their attention to secular and social concerns, the *philosophes* were almost uniformly alienated from the Church, despising its hierarchy and ritual. They were also if not totally committed to the abolition of the monarchy, which they saw as intolerant, unjust, and decadent, then at least deeply committed to its reform.

The tension in the eighteenth century between the *philosophes*, who aspired to establish a new social order of superior moral and ethical quality, and the French courtiers, whose taste favored a decorative and erotic excess that the *philosophes* abhorred, is the subject of this chapter. The two often collided at the salons. Consider, for instance, the salons of Madame de Pompadour [mah-DAHM deh pohm-pah-DOOR] (1721–1764), born into a middle-class family involved in Parisian financial circles. She was a great defender of the *philosophes*, but she was also mistress to Louis XV after he assumed full power in 1743. She blocked efforts to have the works of the *philosophes* suppressed by censors and was successful in keeping works attacking the *philosophes* out of circulation. And yet, she was also the king's trusted advisor and the subject of many erotic

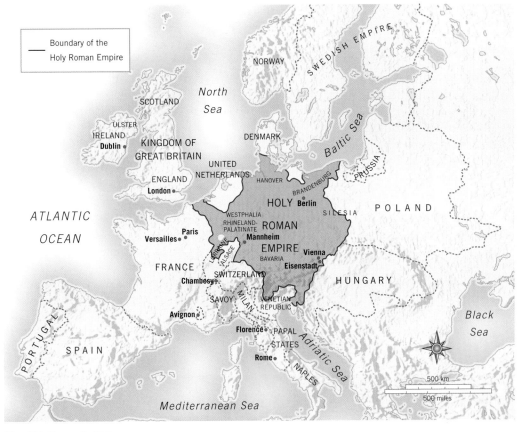

Map 25.1 Europe in 1750.

paintings done at court depicting her as Venus. The competing styles of Louis XIV's Baroque court survived into the eighteenth century, but now were no longer united or comfortable together. Whereas at Versailles essentially classical architecture was embellished with Baroque ornamentation, the nobility now appreciated only an ever-more-elaborate decoration and ornament, while the *philosophes* shunned ornamentation altogether, preferring the order, regularity, and balance of the classical tradition. These tensions were apparent across Europe, particularly in Prussia, where an absolutist monarchy consciously emulated the courts of Louis XIV and XV. In painting, the absolutist courts preferred a sensual style of painting indebted to Rubens, while the *philosophes* admired paintings that were representational and conveyed emotional truth. In France, Germany, and England, a taste soon developed for gardens dominated by winding and circuitous paths, inspired by the curvilinear ornamentation of the Baroque, as opposed to the geometric regularity of the French gardens at Versailles. By the middle of the eighteenth century, these Baroque gardens were made even more exotic with the addition of elements inspired by Western interaction with China. In fact, a taste for all things Chinese became one of the chief characteristics of the age. And in music, the intricate and charming melodies of the court composers gave way to Classical form and structure, while *opera seria* gave way to *opera buffa* and to a hybrid form called *dramma giocoso*.

THE ROCOCO

The decorative style fostered by the French court in the eighteenth century and quickly emulated by royal courts across Europe was known as the **Rococo** [ruh-KOH-koh]. The term is thought to derive from the French word *rocaille* [roh-KYE], a type of decorative rockwork made from round pebbles and curvilinear shells. But it also derives from *barocco*, the Italian word for "baroque." In fact, the Rococo style is probably best understood as the culmination of developments in art and architecture that began in the late work of Michelangelo and progressed through Mannerism and the Baroque into the eighteenth century. Along the way, the style became increasingly elaborate, with architectural interiors employing a vocabulary of S- and C-curves, shell, wing, scroll, and plant tendril forms, and rounded, convex, often asymmetrical surfaces surrounded by elaborate frames, called **cartouches** [car-TOOSH]. In its decorative excess, the Rococo is related to the ornate *retablos* of Mexican churches (see Chapter 23). But, even if the style sometimes found its ways into religious architecture, it is more a secular decorative tradition, conceived for the residences and palaces of Europe's nobility and for the art and objects that filled them.

Rococo Painting in France: The *Fête Galante* and the Art of Love

Most eighteenth-century French painters still relied on the court for commissions. But once the courtiers had moved back from Versailles to the comfort of their Paris townhouses and country estates, they were less interested in commissioning paintings that glorified them than those that entertained. The new Rococo style as applied to French painting suited this domestic goal perfectly. Its subject matter is often frivolous, emphasizing the pursuit of pleasure, particularly love. Its compositions were generally asymmetrical, and its color range was light, emphasizing gold, silver, and pastels.

Jean-Antoine Watteau The Rococo found its most eloquent expression in France in the paintings of Jean-Antoine Watteau [wah-TOH] (1684–1721). This is ironic because he did not have aristocratic patrons and was little known during his lifetime beyond a small group of bourgeois buyers, such as bankers and dealers. One of his most famous paintings in fact served as a signboard for the shop of a Paris art dealer (see *Closer Look*, pages 804–805).

In a very short time, however, Watteau's work became a favorite of the Prussian ruler Frederick the Great (discussed in the next section of this chapter), and a great many of his paintings entered Frederick's collection.

Watteau was best known for his paintings of *fêtes galantes* [fet gah-LAHNT]—gallant, and by extension amorous, celebrations or parties enjoyed by an elite group in a pastoral or garden setting. The erotic overtones of these *fêtes galantes* are immediately apparent in *The Embarkation from Cythera* in the pedestal statue of Venus at the right side of the painting and the flock of winged cupids darting about among the revelers (Fig. **25.3** and see detail, page 674). The scene is the island of Cythera, the mythical birthplace of the goddess. Below her statue, which the pilgrims have decked with garlands of roses, a woman leans across her companion's lap as three cupids try to push the two closer together. Behind them, a gentleman leans toward his lady to say words that will be overheard by another woman behind them, who gathers roses with her lover as she leans over them both. Further back in the scene, a gentleman helps his lady to her feet while another couple turns

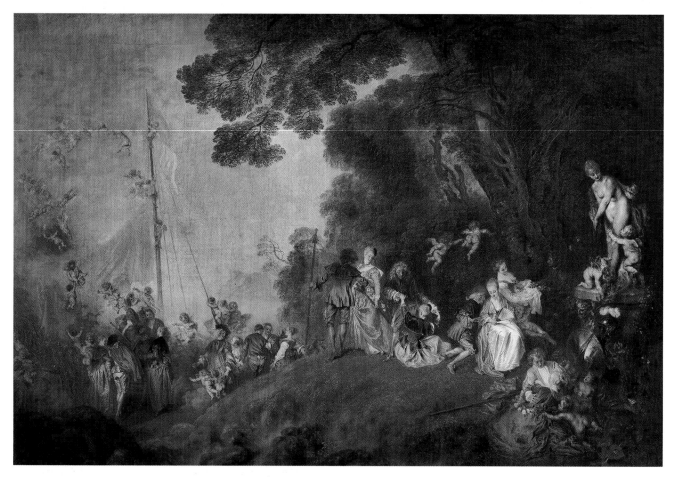

Fig. 25.3 Jean-Antoine Watteau, *The Embarkation from Cythera*. ca. 1718–19. Oil on canvas, 50³/₄″ × 76³/₈″. Staatliche Museen, Schloss Charlottenburg, Berlin. This painting and the one in *Closer Look* (pages 804–805) were purchased by Frederick the Great of Prussia for his own collection. Frederick often staged *fêtes galantes* at Sanssouci.

LEARN MORE Gain insight from a primary source document on Antoine Watteau at **www.myartslab.com**

to leave, the woman looking back in regret that they must depart the garden island.

François Boucher Madame de Pompadour's favorite painter was François Boucher [BOO-shay] (1703–1770), who began his career, in the mid-1720s, copying the paintings of Watteau owned by Jean de Jullienne, the principal collector of Watteau's works in France. Jullienne, a manufacturer of dyes and fine fabrics, had conceived the idea of engraving Watteau's work so that a wider public could enjoy it, and Boucher was easily the best of Jullienne's copyists. Boucher himself felt he needed more training, so he set off for Rome with his profits from Jullienne. Once there, he found the work of Raphael "trite" and that of Michelangelo "hunchbacked," perhaps a reference to the well-developed musculature of his figures. By the time Madame de Pompadour established herself as Louis XV's mistress, Boucher had returned from Rome and was firmly established as Watteau's heir, the new master of *fêtes galantes*.

In the 33 years since the death of Louis XIV, the court had enjoyed relatively free reign, and the younger king, Louis XV, essentially adapted himself to its carefree ways. He felt free to take a mistress. Madame de Pompadour was by no means the first, though by 1750 the king had apparently left her bed because, so the story went, her health was frail. But she remained his closest and probably most trusted advisor, and she happily arranged for other women to take her place in the king's bed. Given this context, it is hardly surprising that many of Boucher's portraits of Madame de Pompadour are like the portrait of 1756, which portrays her as an intellectual supporter of the French Enlightenment, reading a book, her writing table nearby with her quill inserted in the inkwell (Fig. **25.4**). What *is* somewhat surprising are his many paintings of nude goddesses in which the nude bears a striking resemblance to the king's mistress. (Boucher was notoriously famous for such nudes.) *The Toilet of Venus*, for instance, was commissioned by Madame de Pompadour for the bathing suites of the château of Bellevue, one of six residences just outside Paris that Louis built for her (Fig. **25.5**). She had played the title role in a production called *La Toilette de Vénus* staged at Versailles a year earlier, and evidently this is a scene—or more likely an idealized version—of one from that production. The importance of the work is that it openly acknowledges both Madame de Pompadour's sexual role in the court and the erotic underpinnings of the Rococo as a whole.

Jean-Honoré Fragonard Boucher's student Jean-Honoré Fragonard [frah-goh-NAHR] (1732–1806) carried his

Fig. 25.4 François Boucher, *Madame de Pompadour*. 1756. Oil on canvas, 79 1/8" × 61 7/8". The Bridgeman Art Library. Bayerische Hypo und Vereinsbank, Alte Pinakothek, Bayerische Staatsgemäldesammlungen, Munich. Boucher's playful and fragile imagery, evident here in the elaborate frills decorating Madame's dress and in the decorative details on the column behind her, was miniatured within gold cartouches on the surfaces of the vases and urns of the Royal Porcelain Manufactory at Sevres, Madame de Pompadour's pet project.

Fig. 25.5 François Boucher, *The Toilet of Venus*. 1751. Oil on canvas, 42 5/8" × 33 1/8". Signed and dated (lower right): f-Boucher-1751. Bequest of William K. Vanderbilt, 1920 (20.155.9). Photograph © 1. The Metropolitan Museum of Art, New York. Boucher's contemporaries likened his palette, which favored pinks, blues, and soft whites, to "rose petals floating in milk."

Jean-Antoine Watteau's *The Signboard of Gersaint* [zhair-SAHNT], painted in about 1721, is quite literally a signboard. A little over 5 feet high and 10 feet long, it was commissioned to hang outside Gersaint's art gallery in Paris, and later, in about 1744, it entered the collection of Frederick the Great of Prussia. Gersaint called his gallery Au Grand Monarque ("At the Sign of the Great King"), and in this painting the artist alludes to the recently departed Sun King by showing gallery workers putting a portrait of Louis XIV, probably painted by Hyacinthe Rigaud, into a box for storage. A woman in a pink satin gown steps over the threshold from the street, ignoring, for a moment, her companion's out-stretched hand to gaze down at the portrait as it descends into its coffinlike confines. It is as if she is taking one last look at the fading world of Louis XIV before turning her back on it once and for all. In fact, just one day after Louis's death, the aristocracy abandoned the palace and returned to Paris.

Jean-Antoine Watteau, *The Signboard of Gersaint*. ca. 1721. Oil on canvas, 5'4" × 10'1". Staatliche Museen zu Berlin, Preussischer Kulturbesitz, Verwaltung der staatl. Schlösser und Gärden Kunstsammlungen. After it was sold, the work was cut in two halves and displayed as two separate paintings. Its two halves were reunited in the twentieth century.

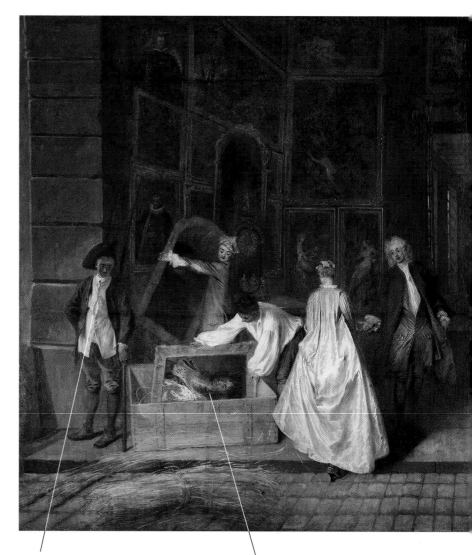

Watteau's painting is really the signboard of a social world dominated by the leisure, elegance, and refinement of the aristocratic Parisian elite. But here, he adds an ominous note. An unkempt passerby, stick in hand, stands just to the left of the crate. He, too, stares down at the Grand Monarque's picture as it is lowered into place, but with a certain disdain. He is the other France, the France that, so marginalized, will erupt in revolution in 1789.

A portrait of King Louis XIV, probably one of several painted by Hyacinth Rigaud (see Fig. 23.1), is deposited in a storage crate.

Something to Think About . . .

What do the dog, on the far right side of the painting, and the working-class passerby, on the far left, have in common? How do they frame, both literally and figuratively, the world of the painting?

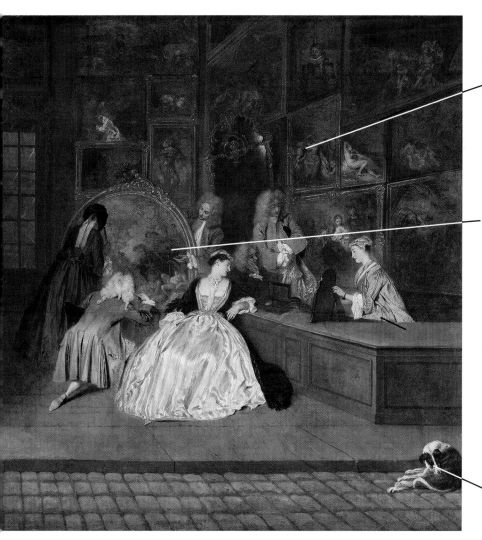

Watteau was a great admirer of Rubens and copied his work often. He shared with Rubens a great love of painting flesh, as well as the ability to reflect in the sensuality of his brushwork and color the sensuality of his subject matter. In *The Signboard of Gersaint*, for instance, Watteau fills the room with Rubeniste canvases. One canvas appears to depict a drunken Silenus, a figure from Greek mythology who is the rotund, older tutor of the god of wine, Dionysius, a scene very much in the spirit of Rubens's many paintings of the same theme.

Beside it is a reclining nude. Two customers are being shown a reclining nude in the painting with magnifying glasses, emphasizing the eroticism of the exchange between viewer and painting.

The dog is an echo of Rubens's frequent use of a dog as an emblem of the sensual appetites. Art historian Svetlana Alpers has, in fact, identified Watteau's dog as an outright copy, in reverse, of one painted by Rubens in *The Coronation of Marie de' Medici*, one of the 21 paintings in the series commissioned to celebrate the life of the queen (see Fig. 23.6).

Peter Paul Rubens, *The Coronation of Marie de' Medici*. 1622–25. Oil on canvas, 12′11″ × 23′10″ Musée du Louvre, Paris.

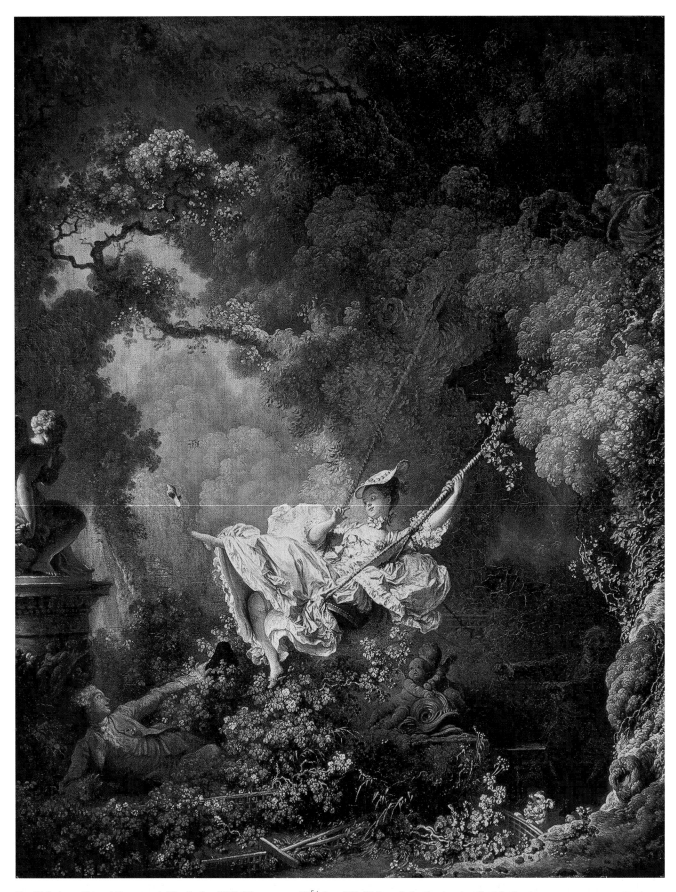

Fig. 25.6 Jean-Honoré Fragonard, *The Swing*. 1767. Oil on canvas, $32\,^5/_8''\times 26''$. Wallace Collection, London. Contributing to the erotic overtones of the composition is the lush foliage of the overgrown garden into which the male lover has inserted himself.

master's tradition into the next generation. Fragonard's most important commission was a series of four paintings for Marie-Jeanne Bécu, comtesse du Barry [kohn-TESS dew bah-REE], the last mistress of Louis XV. Entitled *The Progress of Love*, it was to portray the relationship between Madame du Barry and the king, but in the guise of young people whose romance occurs in the garden park of the countess's château at Louveciennes, itself a gift from Louis.

The most famous painting in the series, *The Swing*, suggests an erotic intrigue (Fig. **25.6**) between two lovers. It implies as well the aesthetic intrigue between the artist and the patron, a conspiracy emphasized by the sculpture of Cupid to the left, holding his finger to his mouth as if to affirm the secrecy of the affair. The painting's subject matter was in fact suggested by another artist, Gabriel-François Doyen (1726–1806), who was approached by the baron de Saint-Julien to paint his mistress "on a swing which a bishop is setting in motion. You will place me in a position in which I can see the legs of the lovely child and even more if you wish to enliven the picture." Doyen declined the commission but suggested it to Fragonard.

Much of the power of the composition lies in the fact that the viewer shares, to a degree, the voyeuristic pleasures of the reclining lover. The entire image is charged with an erotic symbolism that would have been commonly understood at the time. For instance, the lady on the swing lets fly her shoe—the lost shoe and naked foot being a well-known symbol of lost virginity. The young man reaches toward her, hat in hand—the hat that in eighteenth-century erotic imagery was often used to cover the genitals of a discovered lover. Even more subtly, and ironically, the composition echoes the central panel of Michelangelo's Sistine Ceiling, the *Creation of Adam* (see Fig. 15.11). The male lover assumes Adam's posture, and the female lover God's, although she reaches toward Adam—to bring him to life, as it were—with her foot, not her hand.

Rococo Architecture and Landscape Design in Central Europe and England

Rococo architecture, as the Salon de la Princesse at the Hôtel de Soubise in Paris (see Fig. 25.1) demonstrates,

CONTINUITY & CHANGE

Plan of San Carlo alle Quattro Fontane, p. 688

is both a refined and exaggerated realization of the curvilinear Baroque architecture of such seventeenth-century masters as Borromini (see Fig. 21.11.) By the 1690s, architects in the Catholic regions of Central Europe began to explore the possibilities of this elaborate curvilinear style in a series of buildings designed to glorify the princes of the many small states that comprised the region, some of which, like Prussia, were extremely

Fig. 25.7 Balthasar Neumann, Kaisersaal, Residenz, Würzburg, Germany. 1719–44. Frescoes by Giovanni Battista Tiepolo, 1751–52. The chandeliers were specially designed to contribute to the overall effect.

powerful. They turned their attention to the grounds as well, where a new type of garden design that had originated in England captured the Rococo imagination.

Balthasar Neumann and Giovanni Tiepolo in Bavaria One of the most magnificent statements of the Rococo in Central Europe is the Residenz (Episcopal Palace) for the prince-bishop of Würzburg in Bavaria. It is the work of Balthasar Neumann (1687–1753), a military engineer turned designer. To complete the work, the prince-bishop sent him to Paris and Vienna in 1723 to consult with the leading architects. Ribbonlike moldings that rise above columns and pilasters that serve no structural purpose dominate the decorative scheme for the oval-shaped Kaisersaal [kye-zur-ZAHL], or Imperial Hall (Fig. **25.7**). The entire white surface of the interior is covered with irregular cartouches and garlands of floral motifs.

Fig. 25.8 Giovanni Battista Tiepolo, ceiling fresco (detail). 1751. Kaisersaal, Residenz, Würzburg. Ninety percent of Würzburg was destroyed in an Allied bombing raid in March 1945. Tiepolo's paintings were saved by a U.S. Army officer whose assignment was to protect and save threatened art objects. He temporarily replaced the vital section of the Residenz roof, which had burned to ashes, and so prevented rain water from pouring through into the vault beneath.

The paintings decorating the room seem to open the interior to the sky. They are the work of the Italian painter Giovanni Battista Tiepolo [tee-EH-po-lo] (1696–1770). The central panel is remarkable for its pastel colors and asymmetrical organization, in which a few figures seem to poke out from behind the clouds and even the frame of the **cartouche** itself (Fig. **25.8**). Notice, for instance, how the two small openings at the top of the composition seem continuous with the space of the main painting, making the ceiling seem weightless and expansive. Yet the work feels remarkably different from ceiling paintings of the earlier Baroque, with their avalanches of figures propelled into space by dramatic bursts of light.

Prussia and the Rococo The Kingdom of Prussia, with its two royal capitals of Berlin and Potsdam (Map **25.2**), exerted an almost uncanny power over Europe in the eighteenth century. As a state, Prussia demanded obedience to its rulers, the Hohenzollern [ho-un-TSOLL-urn] family. They had controlled the German territory of Brandenburg since 1417 and, over the next couple of centuries and through the good fortune of inheritance, had acquired additional scattered holdings in the west along the Rhine to New East Prussia in the east as far as present-day Lithuania, including most of northern Poland. By 1740, it was a

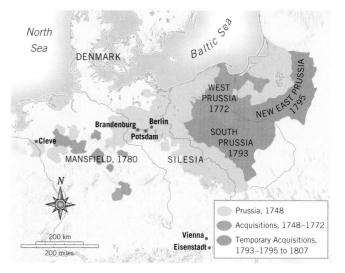

Map 25.2 Prussia in the late eighteenth and early nineteenth centuries.

military giant, its army numbering almost 80,000 men, the third largest in Europe. Its values were, at least to some degree, military: Discipline was valued above all else. The Prussian social elite was the officer corps, which was composed largely of Junkers, the sons of the German nobility.

The first Prussian ruler to assert himself in European affairs was Frederick William (r. 1640–1688), known as the Great Elector (an elector was one of the princes who elected the Holy Roman emperor). It was the Great Elector who first began to build a sizable Prussian army. His son, Frederick (r. 1701–1713), put this army at the disposal of the Habsburg Holy Roman Emperor in 1701, and in return was permitted to call himself "King Frederick I in Prussia"—that is, king in Prussia, but not beyond its bounds, and not to be confused with the emperor. He passed this title on to his son, King Frederick William I (r. 1713–1740).

Frederick I's personal taste leaned toward ostentation and extravagance. During his first year in power, he used more than half the state's annual revenue to support his Berlin court. But he balanced this tendency for pomp with an almost intolerant style of bureaucratic austerity and discipline. For instance, he disbanded the prestigious Berlin court orchestra, putting many musicians out of work. (This delighted Johann Sebastian Bach, who hired seven of the best ones to work with him in the small town of Coethen, where he was chapel master, and provide him with the musicianship required for what would later come to be known as the Brandenburg Concertos.) Following in his father's footsteps, Frederick William I created a centralized bureaucracy, known as the General Directory. He imposed taxes on the nobility and enforced them by means of his army, which included his personal bodyguards. Known as the "Tall Fellows" for their extraordinary stature, the tallest among them was an Irishman who at nearly 7 feet was one of the tallest men of the age. In 1730, when the 18-year-old Crown Prince Frederick attempted to flee his father's tyrannical rule with a friend, Frederick William ordered the friend executed in front of the prince as a lesson in obedience.

This same crown prince would himself become Frederick II (r. 1740–1786), more commonly known as Frederick the Great. He assumed this mantle following a series of campaigns against the Habsburg province of Silesia (see Map 29.1), home of Maria Theresa (1717–1780), who had succeeded to the Habsburg throne in 1740. In defeating the House of Habsburg, which up to this time had been the leading power in Central Europe, and expanding his own holdings by over a third, Frederick II established Prussia as a force at least equal to the Habsburgs. But whereas his father had focused largely on matters of state, Frederick II turned his attention to the arts. For instance, the construction in Berlin that his father had overseen consisted of a series of meticulously laid out streets with houses that one contemporary described as looking like "a line of soldiers, their bay windows resembling grenadiers' caps." By contrast, Frederick the Great, immediately upon assuming the throne, ordered construction of a new opera house, and he added an elaborate new wing to the Charlottenburg Palace, his principal residence in the city. Voltaire [vohl-TAIR], the French intellectual with whom Frederick had been corresponding since the 1730s (and who is discussed later in the chapter), described the change through a simple analogy with the two most important city-states of ancient Greece: "Things changed visibly: Sparta became Athens." In other words, Spartan and militaristic Prussia became a center of culture on a par with Athenian and artistic Paris.

The taste for elegance, luxury, and the arts that exemplified Frederick the Great's court in fact derived largely from Paris during the Rococo period. This is most evident at the palace of Sanssouci [sahn-soo-SEE], Frederick's summer residence in the countryside outside Potsdam. Georg Wenzeslaus von Knobelsdorff (1699–1753) designed it between 1745 and 1747 so that Frederick might escape the pomp and ceremony of the Berlin court. Frederick lavished his attention on the palace. The music room was decorated with mirrors opposite its windows—a trick learned, perhaps, from the Hall of Mirrors at Versailles (see Fig. 23.3) to increase the amount of light in an age still illuminated by candles (Fig. 25.9). Here, musicians daily entertained Frederick, who often joined in on his own flute—"my best friend," he called it. Alternating with paintings depicting Ovid's *Metamorphoses*, the mirrors reflected the surrounding gardens, visually doubling the size of the room.

The most notable feature of the music room is its elaborate gilded stucco decorations. Executed under the direction of Johann August Nahl (1710–1781), whom Frederick

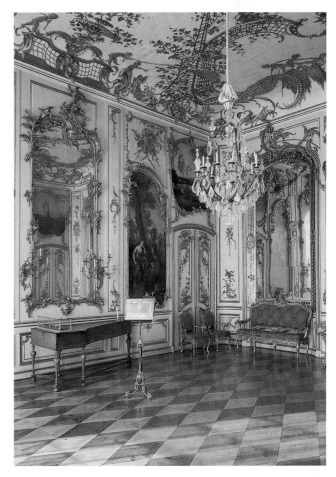

Fig. 25.9 Concert hall, Sanssouci Palace, Potsdam. ca. 1746–47. The wall painting depicts a scene from Ovid's *Metamorphoses* by French painter Antoine Pesne, who had settled in Prussia by 1735.

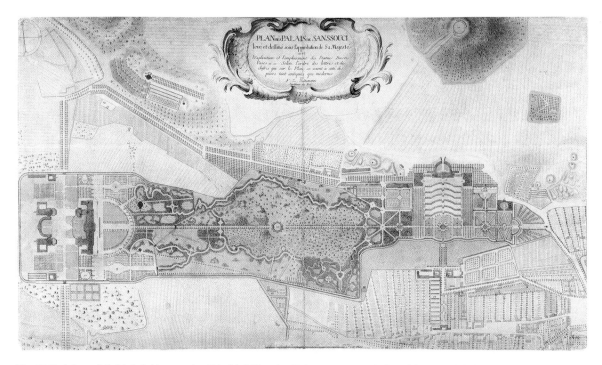

Fig. 25.10 Johann Friedrich Schleuen, after Friedrich Zacarias Saltzmann, general plan of Sanssouci Palace, Potsdam. 1772. Etching, colored, 18 $^1/_8$″ × 32 $^3/_8$″. Stiftung Preussische Schlösser und Gärten, Berlin-Brandenburg, Plansammlung, Potsdam. The original palace, with its terraced vineyards, is at the right. The pleasure garden extends to the left, ending before the much larger New Palace, constructed between 1763 and 1769.

appointed director of ornaments in 1741, they are among the finest examples of the Rococo style. The relationship between these interior details and the natural world is explicit in the general plan of Sanssouci, with its cartouche title at top center (Fig. 25.10). It shows the original palace and vineyard at the right and the larger New Palace at the left, joined by an extensive pleasure garden. In the pleasure garden, there are none of the straight paths and manicured flowerbeds of the formal gardens of Versailles (see Figs. 23.4 and 23.5). Instead, the left-to-right axis is framed by two winding and serpentine paths that contain a lightly forested deer park. The ensemble appeared entirely rural and natural but was actually "put into order by artistic means." These paths contrast dramatically with the architectural symmetry and geometry of the old and new palaces. They suggest a growing awareness of the need to acknowledge or balance the conflicting claims of order, reason, and intellect with those of the senses, pleasure, and the imagination—between what might be called the *useful*, or practical, and the *aesthetic*, or beautiful.

For Frederick the Great, the conflict amounted to the tension between what he called the "abominable work" of state—at which he was, incidentally, very skilled—and the pleasure of decorating his palaces and grounds, every detail of which he oversaw. So the architectural regularity and symmetry of Frederick's palaces represented an emblem of his public life—a symbol of the state and its orderly workings—whereas the interior rooms and the grounds suggested his private life. And indeed this monarch had a powerful imagination, for in 1746 he composed his own

Symphony in D Major (a genre discussed later in the chapter), for two flutes (one part expressly for himself), two oboes, two horns, string orchestra, and bass continuo.

The English Garden The inspiration for Frederick's garden park at Sanssouci was a new kind of garden that became very popular in England beginning in about 1720 and that aspired to imitate rural nature. Instead of the straight, geometrical layout of the French garden, the walkways of the **English garden** are, in the words of one garden writer of the day, "serpentine meanders . . . with many twinings and windings." The English found precedent for this new garden in the pastoral poetry of Virgil and Horace (see Chapter 8) and, especially, in Pliny's descriptions of the gardens of his Roman contemporaries, translated in 1728 by Robert Castell in *Villas of the Ancients Illustrated*. According to Castell, Pliny described three styles of Roman garden: the plain and unadorned; the "regular," laid out "by the Rule and Line"; and the *Imitatio Ruris*, or the imitation of rural landscapes. This last consisted of "wiggly" paths opening on "vast amphitheaters such as could only be the work of nature." But Castell understood that such landscapes were wholly artificial. For him, the *Imitatio Ruris* was

> . . . a close Imitation of Nature; where, tho' the Parts are disposed with the greatest Art, the Irregularity is still preserved; so that their Manner may not improperly be said to be an artful Confusion, where there is no Appearance of that Skill which is made use of, their Rocks, Cascades, and Trees, bearing their natural Forms.

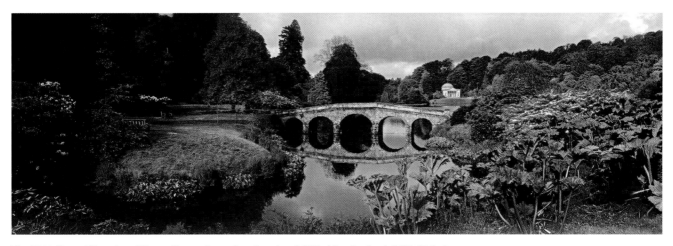

Fig. 25.11 Henry Flitcroft and Henry Hoare, the park at Stourhead, Wiltshire, England. 1744–65. Each vista point along the Stourhead path looks over an artificial ruin that tells the story of Aeneas's visit to the underworld in Books 3 through 6 of Virgil's *Aeneid*.

The ideal estate was to be "thrown open" in its entirety to become a vast garden, its woods, gardens, lakes, and marshes all partaking of a carefully controlled "artificial rudeness" (in the sense of raw, primitive, and undeveloped).

The gardens at Stowe, in Buckinghamshire, are exemplary. Prior to about 1730, they were composed of straight pathways bordering geometrically shaped woods and by lakes with clearly defined linear forms, including, at the bottom of the hill below the house, an octagonal pool. These more regular gardens were adorned by artificial Greek temples designed by James Gibbs (1682–1754) and William Kent (1685–1748). Kent's Temple of Ancient Virtue, built in 1734, contained life-size statues of Homer, Lycurgus (a Spartan lawgiver), Socrates, and Epaminondas (a Theban general and statesman). Across the valley, on lower ground, was a Shrine of British Worthies, containing the busts of 16 famous Englishmen, including Shakespeare, Isaac Newton, and John Locke. After 1740, Lancelot "Capability" Brown (1716–1783) took over the gardens' design. Brown was nicknamed "Capability" because, he argued, any landscape is capable of improvement.

Brown was inspired by the gardens at Stourhead, built in the 1740s by wealthy banker Henry Hoare (Fig. **25.11**). Hoare had built dams on several streams to raise a lake, around which he created a serpentine path offering many views and vistas. These included a miniature Pantheon that he probably modeled after similar buildings in the landscape paintings of the seventeenth-century French artist Claude Lorrain [klohd loh-REHN]. His Italian pastoral landscapes, with their winding streams and arched bridges framed by ruins and deftly placed trees, were widely popular in England (Fig. **25.12**).

Fig. 25.12 Claude Lorrain, *The Rest on the Flight into Egypt (Noon)*. 1661. Oil on canvas, $45\frac{5}{8}'' \times 62\frac{7}{8}''$. Hermitage Museum, Saint Petersburg, Russia. The Bridgeman Art Library. Collection of Empress Josephine, Malmaison, 1815. Note how the artist makes the viewer's eye move through the painting from the grouping at the lower right diagonally, across the bridge (following the shepherd boy and his dog) toward the ruin at the left, then in a zigzag down the road and over the arched bridge into the hazy light of the distant landscape. This serpentine organization directly inspired English garden design.

Fig. 25.13 Charles Bridgeman and Lancelot "Capability" Brown, Plan of the Gardens of the Most Noble Marquis of Buckingham at Stowe, from the *Visitor's Guide Book*. 1797. Lithograph. English School (eighteenth century). Private collection. The Bridgeman Art Library. This reflects the site plan of Stowe as it has appeared since the mid-eighteenth century. Although the landscape looks completely natural, it is as thoroughly designed as a modern-day golf course.

"Capability" Brown, too, was inspired by Claude. By the early 1750s, the edges of the lakes at Stowe, once neatly regular, were completely naturalized, and the landscape had been reformed into an almost entirely pastoral setting, with wide vistas and broad views. Brown's site plan for the garden shows this more natural-looking arrangement (Fig. **25.13**).

Aristocratic visitors to Stowe would have arrived at the estate with their special "Claude" glasses, tinted yellow so that the landscape would glow with the same warmth as a Claude painting. On the one hand, they would have admired the classical ruins and the classical facade of the manor house itself. On the other, they would have discovered, in the grounds, a space in which they might escape emotionally, as Frederick the Great did at Sanssouci, from the very civilization that classical architecture symbolized. The English garden, in other words, embodied many of the same contradictions as the Parisian salon, where the demands of reason championed by the *philosophes* confronted the excesses of the French court.

THE *PHILOSOPHES*

When in 1753 the French painter Jean-Baptiste-Siméon Chardin [shar-DEHN] (1699–1779) exhibited his *Philosopher Occupied with His Reading* in Paris, one French commentator described the painting (Fig. **25.14**) as follows:

> This character is rendered with much truth. A man wearing a robe and a fur-lined cap is seen leaning on a table and reading very attentively a large volume in bound parchment. The painter has given him an air of intelligence, reverie, and obliviousness that is infinitely pleasing. This is a truly philosophical reader who is not content merely to read, but who meditates and ponders, and who appears so deeply absorbed in his meditation that it seems one would have a hard time distracting him.

In short, this is the very image of the French *philosophe*.

Most *philosophes* were **Deists** [DEE-ists], who accepted the idea that God created the universe but did not believe he had much, if anything, to do with its day-to-day workings. Rather, the universe proceeded according to what they termed **natural law**, law derived from nature and binding upon human society. In Newtonian terms, God had created a great clock, and it ran like clockwork, except for the interference of inept humanity. So humans had to take control of their own destinies. Deists viewed the Bible as a work of mythology and superstition, not the revealed truth of God. They scoffed at the idea of the divine right of kings. The logic of their position led the *philosophes* to a simple proposition, stated plainly by the *philosophe* Denis Diderot (1713–1784): "Men will not be free until the last king is strangled with the entrails of the last priest."

Denis Diderot and the *Encyclopédie*

The crowning achievement of the *philosophes* was the *Encyclopédie* [on-see-kloh-pay-dee], begun in 1751 and completed in 1772. Its editors were the teacher and translator Denis Diderot and Jean le Rond d'Alembert [DAHL-ohm-behr] (1717–1783), a mathematician who was in charge of the articles on mathematics and science. Both were active participants in salon society, and d'Alembert in fact lived with the great hostess Julie de Lespinasse. The work was unpopular in the French court: Louis XV claimed that the *Encyclopédie* was doing "irreparable damage to morality and religion" and twice banned its printing. But despite the opposition, the court's salons proved useful to the Encyclopedists. In his memoirs, d'Alembert would recall a conversation with Madame Geoffrin [zhoh-fren] (1699–1777), the hostess who was Julie de Lespinasse's mentor:

> As she had always among the circle of her society persons of the highest rank and birth, as she appeared even to seek an acquaintance with them, it was supposed that this flattered her vanity. But here a very erroneous opinion

Fig. 25.14 Jean-Baptiste-Siméon Chardin, *A Philosopher Occupied with His Reading.* 1734. Oil on canvas, 54 3/8″ × 41 3/8″. Photo: Hervè Lewandowski/ Musee du Louvre/RMN Reunion des Musees Nationaux, France. SCALA/Art Resource, New York. This is actually a portrait of Joseph Aved, a painter who was a friend of Chardin's.

was formed of her; she was in no respect the dupe of such prejudices, but she thought that by managing the humours of these people, she could render them useful to her friends. "You think," said she, to one of the latter, for whom she had a particular regard, "that it is for my own sake I frequent ministers and great people. Undeceive yourself,—it is for the sake of you, and those like you who may have occasion for them."

It is very likely that d'Alembert was the "friend" to whom she addressed these words.

Although the *Encyclopédie* was rather innocently subtitled a *Classified Dictionary of the Sciences, Arts, and Trades,* the stated intention of the massive 35-volume text, which employed more than 180 writers, was "to change the general way of thinking." Something of the danger that the *Encyclopédie* presented to the monarchy is evident in the entry on natural law written by French lawyer Antoine-Gaspard Boucher d'Argis [boo-SHAY dar-ZHEES] (1708–1791) (**Reading 25.1**):

Such thinking was fundamental to the Enlightenment's emphasis on human liberty and would fuel revolutions in both America and France. Similar thinking could be found in the sections of the *Encyclopédie* on political science written by the baron de Montesquieu (1689–1755), a deep believer in the writings of John Locke and England's parliamentary democracy. In his 1748 treatise *The Spirit of the Laws,* he had argued for the separation of powers, dividing government into executive, legislative, and judicial branches—an argument that would provide one of the foundations for the American Constitution in the 1780s. Freedom of thought was, in fact, fundamental to the transmission of knowledge, and any state that suppressed it was considered an obstacle to progress. So when Louis XV's censors halted publication of the *Encyclopédie* in 1759, the *philosophes* affirmed the despotism of the French state, even if other government officials, prompted by the salon hostesses, secretly worked to ensure the work's continued viability.

Funded by its 4,000 subscribers, the *Encyclopédie* was read by perhaps 100 times that many people, as private circulating libraries rented it to customers throughout the country. In its comprehensiveness, it represents a fundamental principle of the Enlightenment, also evident in Samuel Johnson's *Dictionary of the English Language* (see Chapter 24), to accumulate, codify, and

preserve human knowledge. Like the *Histoire Naturelle* (*Natural History*) of Georges-Louis Leclerc (1707–1788) [leh-kler], published in 36 volumes from 1749 to 1788, which claimed to include everything known about the natural world up to the moment of publication, the *Encyclopédie* claimed to be a collection of "all the knowledge scattered over the face of the earth." The principle guiding this encyclopedic impulse is **rational humanism**, the belief that through logical, careful thought, progress is inevitable. In other words, the more people knew, the more likely they would invent new ways of doing things. Thus, the *Encyclopédie* illustrated manufacturing processes in the most careful detail, imagining that astute readers might recognize better, more efficient methods of manufacturing even as the processes were demystified (Fig. **25.15**).

Jean-Jacques Rousseau and the Cost of the Social Contract

Another contributor to the *Encyclopédie* was Jean-Jacques Rousseau [roo-SOH] (1712–1778), an accomplished composer originally hired by Diderot to contribute sections on music. Rousseau had been born Protestant, in Geneva, was orphaned early in life, and converted to Catholicism while wandering in Italy. He eventually arrived in Paris. Published after his death, the *Confessions* is an astonishingly frank account of his troubles, from sexual inadequacy to a bizarre marriage, including his decision to place each of his five children in an orphanage soon after birth (see **Reading 25.2**, pages 832–833). More forthcoming and revealing than any autobiography previously written, it explains in large part the origins of Rousseau's tendency to outbursts of temper and erratic behavior, and makes it very clear why he eventually fell out with the other *philosophes*. Rousseau was not a social being, even though his writings on social issues were among the most influential of the age.

In the semifictional work *Émile* [ay-MEEL], published in 1762, Rousseau created a theory of education that would influence teaching to the present day. He believed that the education of a child begins at birth. *Émile*'s five books correspond to the five stages of its hero's social development. The first two books outline the youth's growth to age 12, what Rousseau calls the Age of Nature. The third and fourth books describe his adolescence, and the fifth, the Age of Wisdom, his growing maturity between age 20 to 25. The most important years, Rousseau believed, were early adolescence, from age 12 to 15. Entering the teenage years, the child, named Émile by Rousseau, begins formal education, turning his attention to only what he finds "useful" or "pleasing." As a result, the child finds education a pleasurable and exciting experience that naturally leads his imagination to the enjoyment and contemplation of beauty. In his early twenties, Émile is introduced to the corrupting forces of society. Not until he has absorbed these lessons is it safe for Émile to enter society without fear of submitting to its corrupting influence.

As advanced as Rousseau was in his ideas about education, he saw little reason to educate women in the same manner as men. In Book V, Émile encounters woman, in the form of Sophie, Émile's ideal mate: "Her education is in no way exceptional. She has taste without study, talents without art, judgment without knowledge. Her mind is still vacant but has been trained to learn; it is well-tilled land only waiting for the grain. What a pleasing ignorance! Happy is the man destined to instruct her." Within a very few years, women would reject such thinking and assert their equal right to liberty and education.

As *Émile* demonstrates, Rousseau believed in the natural goodness of humankind, a goodness corrupted by society and the growth of civilization. Virtues like unselfishness and kindness were inherent—a belief that

Fig. 25.15 *A Brazier's Workshop,* **illustration from the** *Encyclopédie,* **edited by Denis Diderot. 1751–72.** The metalsmiths at work are making hunting horns. In the center, a worker pounds copper around a rod to make the horn's tube. Behind him, a worker standing above a fireplace pours molten lead into the tube to make it more malleable. At the left, the flared end of the horn is soldered to the tube. And at the right, a worker curves the horn into its final, snail-like form.

gives rise to what he termed the "noble savage"—but he strongly believed that a new social order was required to foster them. In *The Social Contract*, published in 1762, Rousseau describes an ideal state governed by a somewhat mystical "General Will" of the people that delegates authority to the organs of government as it deems necessary. In Chapter 4, "Slavery," Rousseau addresses the subjugation of a people by their monarch (**Reading 25.3**):

READING 25.3

from Jean-Jacques Rousseau, *The Social Contract*, Book 1, Chapter 4 ("Slavery") (1762)

No man has a natural authority over his fellow, and force creates no right. . . .

If an individual . . . can alienate his liberty and make himself the slave of a master, why could not a whole people do the same and make itself subject to a king? There are in this passage plenty of ambiguous words which would need explaining; but let us confine ourselves to the word *alienate*. To alienate is to give or to sell. Now, a man who becomes the slave of another does not give himself; he sells himself, at the least for his subsistence: but for what does a people sell itself? A king is so far from furnishing his subjects with their subsistence that he gets his own only from them; and, according to Rabelais, kings do not live on nothing. Do subjects then give their persons on condition that the king takes their goods also? I fail to see what they have left to preserve.

It will be said that the despot assures his subjects civil tranquility. Granted; but what do they gain, if the wars his ambition brings down upon them, his insatiable avidity, and the vexatious conduct of his ministers press harder on them than their own dissensions would have done? What do they gain, if the very tranquility they enjoy is one of their miseries? Tranquility is found also in dungeons; but is that enough to make them desirable places to live in? The Greeks imprisoned in the cave of the Cyclops lived there very tranquilly, while they were awaiting their turn to be devoured.

To say that a man gives himself gratuitously, is to say what is absurd and inconceivable; such an act is null and illegitimate, from the mere fact that he who does it is out of his mind. To say the same of a whole people is to suppose a people of madmen; and madness creates no right.

Even if each man could alienate himself, he could not alienate his children: they are born men and free; their liberty belongs to them, and no one but they has the right to dispose of it. Before they come to years of discretion, the father can, in their name, lay down conditions for their preservation and well-being, but he cannot give them irrevocably and without conditions: such a gift is contrary to the ends of nature, and exceeds the rights of paternity. It would therefore be necessary, in order to

legitimise an arbitrary government, that in every generation the people should be in a position to accept or reject it; but were this so, the government would be no longer arbitrary.

To renounce liberty is to renounce being a man, to surrender the rights of humanity and even its duties.

This passage explains the famous opening line of *The Social Contract*: "Man is born free, and everywhere he is in chains." What Rousseau means is that humans have enslaved themselves, and in so doing have renounced their humanity. He is arguing here, in many ways, against the precepts of the Enlightenment, for it is their very rationality that has enslaved humans.

Even though he was a contributor to it, Rousseau came to reject the aims of the *Encyclopédie*, especially its celebration of manufacturing and invention. In his 1755 *Discourse on the Origin of Inequality among Men*, he writes (**Reading 25.4**):

READING 25.4

from Jean-Jacques Rousseau, *Discourse on the Origin of Inequality among Men* (1755)

As long as men were content with their rustic huts, as long as they confined themselves to sewing their garments of skin with thorns or fish-bones, and adorning themselves with feathers or shells, to painting their bodies with various colors, to improving or decorating their bows and arrows; and to using sharp stones to make a few fishing canoes or crude musical instruments; in a word, so long as they applied themselves only to work that one person could accomplish alone and to arts that did not require the collaboration of several hands, they lived as free, healthy, good and happy men. . . . but from the instant one man needed the help of another, and it was found to be useful for one man to have provisions enough for two, equality disappeared, property was introduced, work became necessary, and vast forests were transformed into pleasant fields which had to be watered with the sweat of men, and where slavery and misery were soon seen to germinate and flourish with the crops.

Given such thinking, it is hardly surprising that Rousseau ultimately withdrew from society altogether, suffering increasingly acute attacks of paranoia, and died insane.

Voltaire and French Satire

The third great figure among the Parisian *philosophes* was François-Marie Arouet, known by his pen name, Voltaire (1694–1778). So well-schooled, so witty, and so distinguished was Voltaire that to many minds he embodies all the facets of a very complex age. He wrote voluminously—plays, novels, poems, and history. More

than any other *philosophe*, he saw the value of other, non-Western cultures and traditions and encouraged his fellow *philosophes* to follow his lead (Fig. **25.16**). He was a man of science and an advisor to both Louis XV and Frederick the Great of Prussia. He believed in an enlightened monarchy, but even as he served these rulers, he satirized them. This earned him a year in the Bastille prison in 1717 to 1718, and later, in 1726, another year in exile in London.

Voltaire's year in England convinced him that life under the British system of government was far preferable to life under what he saw as a tyrannical French monarchy. He published these feelings in his 1734 *Philosophical Letters*. Not surprisingly, the court was scandalized by his frankness, so in order to avoid another stint in prison, Voltaire removed himself to the country town of Cirey, home of his patroness the marquise du Châtelet [dew SHAHT-lay], a woman of learning who exerted an important intellectual influence on him. In 1744 he returned once again to court, which proved tedious and artificial, but in 1750 he discovered in the court of Frederick the Great what he believed to be a more congenial atmosphere. While there he published his greatest historical work, *Le Siècle de Louis XIV* (*The Century of Louis XIV*; 1751). In four brief years he wore out his welcome in Prussia and had to remove himself to the countryside once again. From 1758 to 1778, he lived in the village of Freney in the French Alps. Here he was the center of what amounted to an intellectual court of artists and intellectuals who made regular pilgrimages to sit at his feet and talk.

Voltaire did not believe in the Bible as the inspired word of God. "The only book that needs to be read is the great book of nature," he wrote. He was, more or less, a Deist. What he championed most was freedom of thought, including the freedom to be absolutely pessimistic. This pessimism dominates his most famous work, *Candide* [kahn-DEED], or *Optimism* (1758). It is a prose satire, based in part on the philosophical optimism of Alexander Pope's *Essay on Man* (see Chapter 28). Voltaire's work tells the tale of Candide, a simple and good-natured but star-crossed youth, as he travels the world struggling to be reunited with his love, Cunegonde.

Candide's journey leads from Germany to Portugal to the New World and back again, as he follows the belief

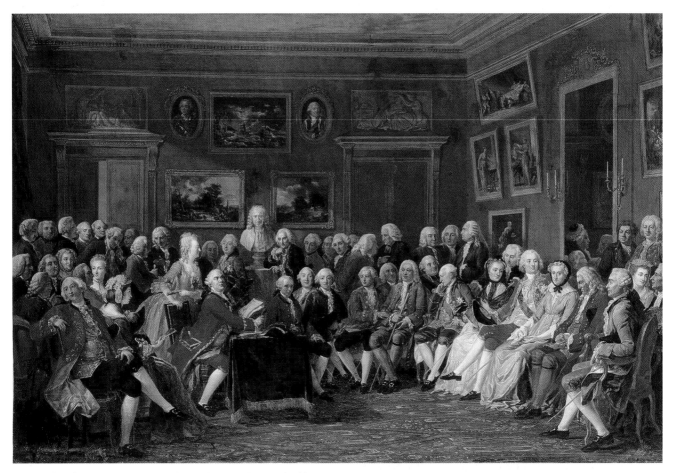

Fig. 25.16 Anicet-Charles-Gabriel Lemonnier, after a drawing by François Boucher, *Reading of Voltaire's Tragedy 'L'orphelin de la Chine' at the Salon of Madame Geoffrin in 1755*. 1812. Oil on canvas. Photo: D. Arnaudet. Châteaux de Malmaison et Bois-Preau, Rueil-Malmaison, France. RMN Reunion des Musees Nationaux/Art Resource, New York. Here Jean le Rond d'Alembert reads Voltaire's new play *L'Orphélin de Chine* (*The Orphan of China*), a tragedy based on an actual fourteenth-century Chinese play brought to Paris by a Jesuit priest in 1735. Voltaire's bust looks on from the back of the room.

that, in the words of German philosopher Gottfried Leibniz, "everything is for the best in the best of all possible worlds." This is a sentiment Candide learns from Dr. Pangloss, his tutor. Pangloss, whose name with its first syllable *pan* ("all" in Latin) suggests the ability to gloss over everything, lacks the clear vision needed to see life's darker sides. On his journey Candide finds himself beset by disasters of all kinds, including the 1755 Lisbon earthquake (see **Reading 25.5**, pages 834–835). He discovers a world filled with stupidity, plagued by evil, mired in ignorance, and completely boring. Although Candide survives his adventures—a testament to human resilience—and eventually finds his Cunegonde, the book concludes with the famous sentiment: "We must cultivate our garden." We must, in other words, give up our naïve belief that we live in "the best of all possible worlds," tend to the small things that we can do well—thus keeping total pessimism at bay—and leave the world at large to keep on its incompetent, evil, and even horrific way.

Art Criticism and Theory

One of the "gardens" most carefully cultivated by the French intellectuals (and those with intellectual pretensions) was art. By the last half of the eighteenth century, it was becoming increasingly fashionable for educated upper-class people to experience what the English called the Grand Tour and the French and Germans referred to as the Italian Journey. Art and architecture were the focal points of these travels, along with picturesque landscapes and gardens. A new word was coined to describe the travelers themselves—*tourist*.

Tourists then, as they do today, wanted to understand what they were seeing. Among the objects of their travel were art exhibitions, particularly the Paris Salon—the official exhibition of the French Royal Academy of Painting and Sculpture. It took place in the Salon Carré [kah-ray] of the Louvre, which lent the exhibition its name. It ran from August 25 until the end of September almost every year from 1737 until 1751, and every other year from 1751 to 1791. But few visitors were well-equipped to appreciate or understand what they were seeing, so a new brand of writing soon developed in response: art criticism.

Diderot's *Salons* Denis Diderot began reviewing the official exhibitions of the Paris Salon in 1759 for a private newsletter circulated to a number of royal houses outside France. Many consider these essays (there are nine of them) the first art criticism. Boucher and his fellow Rococo artists were the object of his wrath. In 1763, Diderot asked, "Haven't painters used their brushes in the service of vice and debauchery long enough, too long indeed?" Painting, he argued, ought to be "moral." It should seek "to move, to educate, to improve us, and to induce us to virtue." And in his *Salon of 1765*, Diderot would complain about Boucher:

I don't know what to say about this man. Degradation of taste, color, composition, character, expression, and drawing have kept pace with moral depravity. . . . And then there's such a confusion of objects piled one on top of the other, so poorly disposed, so motley, that we're dealing not so much with the pictures of a rational being as with the dreams of a madman.

An artist who did capture his imagination was the still-life and genre painter Jean-Baptiste-Siméon Chardin (1699–1779) (see Fig. 25.14). Considering the small Chardin still life *The Brioche* (Fig. **25.17**), a painting of the famous French bread or cake eaten at the breakfast table, Diderot in the *Salon of 1767* wrote: "One stops in front of a Chardin as if by instinct, as a traveler tired of his journey sits down almost without being aware of it in a spot that offers him a bit of greenery, silence, water, shade, and coolness." What impressed Diderot most was Chardin's use of paint: "Such magic leaves one amazed. There are thick layers of superimposed color and their effect rises from below to the surface. . . . Come closer, and everything becomes flat, confused, and indistinct; stand back again, and everything springs back into life and shape." What Diderot valued especially in Chardin's work was its detail, what amounts to an almost encyclopedic attention to the everyday facts of the world. As opposed to the Rococo artists of the court, whose *fêtes galantes*, he complained, conveyed only the affected and therefore false manners and conventions of polite society, Chardin was able to convey the truth of things. "I prefer rusticity to prettiness," Diderot proclaimed.

Despite Diderot's preference for subject matter of a "truthful" kind, he was fascinated with the individual work of art. He expressed this fascination in his description of its painterly surface beyond whatever "subject matter" it

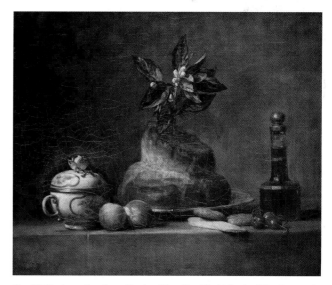

Fig. 25.17 Jean-Baptiste-Siméon Chardin, *The Brioche (The Dessert)*. *1763*. Oil on canvas, 18 1/2″ × 22″. Photo: Hervè Lewandowski. Musee du Louvre/RMN Reunion des Musees Nationaux, France. SCALA/Art Resource, New York. Chardin painted from dark to light, the brightest parts of the canvas coming last.

might possess. This fascination was part of a broader change in the way that the eighteenth century approached the arts in general.

Gotthold Ephraim Lessing's *Laocoön* At the beginning of the century, painting, sculpture, architecture, poetry, and music had begun to separate themselves from the traditional "liberal arts," to be recast as the "fine arts." In the process, these fine arts began to distinguish themselves from each other, most notably in the writings of Gotthold Ephraim Lessing [LESS-ing] (1729–1781), a native of Frederick the Great's Prussia. His major work, written while serving as secretary to a Prussian general, is *Laocoön: or, An Essay upon the Limits of Painting and Poetry*, published in 1766.

Since the Renaissance, painting and poetry had been considered "sister arts." The saying *"ut pictura poesis"* ("as is painting so is poetry") of the ancient Roman Horace in his *Ars Poetica* had prevailed. Lessing took a different approach. Basing his argument on his understanding of the famous Hellenistic statue *Laocoön* (see Fig. 5.26), he argued that the visual arts and poetry were essentially different. "Painting," and by extension a sculpture like *Laocoön*, "can use only one single moment of the action, and must therefore choose the most pregnant, from which what precedes and follows will be most easily apprehended." On the other hand, poetry consists of a *series* of actions in time. Images unfold in space, texts in time. While the distinction is a bit superficial since it takes time to look at a painting carefully, it was deeply influential. The German Romantic playwright, poet, and novelist Johann Wolfgang von Goethe (see Chapter 27) was only 17 when the book was published, but he would later recall its impact. "It lifted us up from the region of miserably limited observation into the wide open spaces of thought," he wrote. "That long misunderstood dictum, *ut pictura poesis*, was instantly dispensed with; the difference between plastic and verbal arts was now clear."

CONTINUITY & CHANGE

Laocoön, p. 165

ROCOCO AND CLASSICAL MUSIC

The growing distaste for the Rococo and the moral depravity associated with it was epitomized in the eighteenth century in the rise of what we have come to call **Classical music**. It would almost completely supplant Rococo music, which was characterized by pieces written for the harpsichord, a keyboard instrument the strings of which are plucked rather than struck with hammers as on a piano. Its sound, as a result, is delicate and light. The two most important Rococo composers were French: François Couperin [koop-uh-RAN] (1668–1733) and Jean-Philippe Rameau [rah-MOH] (1683–1764). Their harpsichord music was composed of graceful melodies, many of them dance pieces with charmingly simple harmonies displayed in intricate and complex rhythms that mirror the Rococo's taste for

ornamentation. Their work epitomized what came to be known as the *style galant* [steel gah-LAHN], the perfect accompaniment to the *fêtes galantes* of Rococo art. At least one of Couperin's pieces in the *style galant*, "The Chimes of Cythera," directly evokes Watteau. Rameau, in addition, composed dramatic operas that featured ballet sequences for a large corps of dancers, as Lully's had for the court of Louis XIV (see Chapter 27). These operas exploit the sexual tensions inherent in their stories, just as so much Rococo art did.

The style of music we have come to call Classical, on the other hand, developed first in Vienna about 1760, and lasted into the nineteenth century. It represents an almost total rejection of the values associated with the Rococo and Baroque. In fact, we call this style Classical because it shares with Greek and Roman art the essential features of symmetry, proportion, balance, formal unity, and, perhaps above all, clarity. This clarity was a direct result of the rise of a new musical audience, a burgeoning middle class that demanded from composers a more accessible and recognizable musical language than found in the ornate and complex structures of Baroque and Rococo music.

The Symphonic Orchestra

The most important development of the age, designed specifically to address the new middle-class audience, was the **symphonic orchestra**. This musical ensemble was much larger than the ensemble used by Baroque composers such as Vivaldi (see Chapter 21). Its basic structure was established in the 1740s by Johann Stamitz [SHTAH-mits] (1717–1757), concertmaster and conductor of the orchestra in Mannheim, located in the Rhine Palatinate (now southwestern Germany). Although Renaissance and Baroque instruments were already organized into families of instruments, the relatively large size of Stamitz's ensemble set it apart (Fig. **25.18**).

Stamitz divided his orchestra into separate sections according to type of instrument: the *strings*, made up of violins, violas, cellos, and double basses; *woodwinds*,

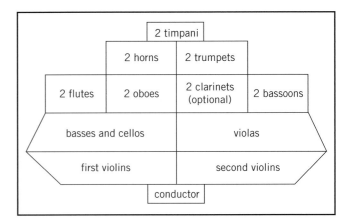

Fig. 25.18 The Classical symphonic orchestra in the time of Mozart and Haydn. From Jay Zorn, *Listening to Music*, second edition. Used by permission of Prentice Hall, Inc.

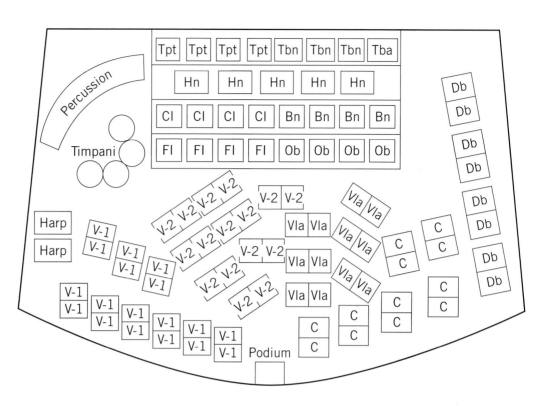

Fig. 25.19 The Classical symphonic orchestra today. From Jay Zorn, *Listening to Music,* second edition. Used by permission of Prentice Hall, Inc. Over the years, the symphonic orchestra has added new instruments as composers increasingly experimented with them, and larger numbers of traditional instruments as they sought a fuller and richer sound. V-1: first violin; V-2: second violin; Via: viola; C: cello; Db: double bass; Ob: oboe; Fl: flute; Cl: clarinet; Bn: bassoon; Hn: French horn; Tpt: trumpet; Tbn: trombone; Tba; tuba.

consisting of flutes, oboes, clarinets, and bassoons; a *brass* section of trumpets and French horns (by the end of the century, trombones were added); and a *percussion* section, featuring the kettledrums and other rhythm instruments. Gradually the piano, invented around 1720, was increasingly refined in design until it replaced the clavichord and harpsichord as the favored solo instrument at the heart of the orchestra. This improved piano was known as the **pianoforte** because it could play both soft (*piano*) and loud (*forte* [FOR-tay]), which the harpsichord could not. The composer himself usually led the orchestra and often played part of the composition on the piano or harpsichord in the space now reserved for the conductor. The modern symphony orchestra (Fig. **25.19**) is a dramatically enlarged version of Stamitz's.

Stamitz's orchestra was the first to use an overall **score**, which indicated what music was to be played by each instrument. This let the composer view the composition as a whole. In addition, each instrument section was given its own individual part. The **time signature** (number of beats per measure), **key signature** (showing the scale upon which the piece will be played), **dynamics** (*forte*, for instance, for loud, *piano* for soft), **pace** (*allegro* [uh-LEG-roh], for fast; *lento* [LEN-toe], for slow), and interpretative directions (*affettuoso* [ah-fet-too-OH-soh] for "with feeling") were indicated both in the score as a whole and the individual parts. These devices have remained part of the vocabulary of Western musical composition ever since (Fig. **25.20**).

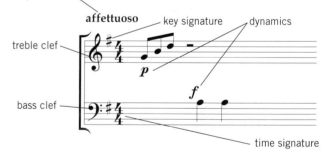

Fig. 25.20 Devices of standard musical notation.

Symphonic Form

The music most often played by the symphonic orchestra was the **symphony**. The term derives from the Italian *sinfonia*—the three-movement, fast–slow–fast, introduction or overture to Italian operas. In Mannheim, however, Stamitz began to popularize a four-movement form, consisting of a first movement played in a fast tempo (*allegro*); a second movement that is slow (*adagio* [ah-DAHZ-oh] or *andante* [ahn-DAHN-tay]) and reflective; a third that picks up the pace again, often in the stately rhythms of the minuet; and a fourth movement which is generally *allegro* once again, spirited and lively. The predictability of the form is the source of its drama, since audiences anticipated the composer's inventiveness as the composition proceeded through the four

movements. The first *allegro* movement (and occasionally the fourth) possessed its own distinct **sonata form**, a kind of small form within the larger symphonic form.

Each movement in the sonata form was divided into three parts: exposition, development, and recapitulation (Fig. **25.21**). In the *exposition*, the composer "exposes" the main theme in the composition's "home" key and then contrasts it with a second theme in a different key. In the *development*, the composer further develops the two themes in contrasting keys, and then, in the *recapitulation*, restates the two themes, but both now in the home key. Use of the home key in the restatement resolves the tension between the two themes. A short *coda* (or "tail") is often added to bring the piece to a definitive end, typically with a strong harmonic closing (called by musicians a *cadence*).

There were several other important forms at the disposal of Classical composers in which they might write an individual movement of a composition. The most important of these are theme-and-variations form, aria form, minuet-and-trio form, and rondo form. One main musical theme dominates the theme-and-variations form. The theme repeats throughout the movement, each succeeding section presenting a variation or modification of it, but still in recognizable form so that its transformations are easy to follow. Aria form was a popular choice for slow movements, and it has already been discussed in connection with opera. However, in the symphony it is an instrumental not a vocal form. It consists of three parts, ABA. A slow, lyrical opening section (A), often in triple meter, is followed by a central section in a new key (B), and, finally, by a repeat of the opening section (A), usually with variation of some kind.

The minuet-and-trio form was favored for the third movement of symphonies. It originates in the minuet dance form so popular in the Baroque courts. In the Classical symphony, minuet-and-trio movements are always in ¾ meter, played at a moderate tempo, and consist of three sections: a minuet (in two parts, each repeated, AABB); a trio, which follows the same pattern (CCDD), contrasting with the minuet in instrumentation, texture, dynamics, key, or some combination of these. Then the first minuet is played again, often without repeats (AABB, or simply AB):

MINUET	TRIO	MINUET
AABB	CCDD	AABB, or AB

The final form common to the Classical symphony is rondo form. It consists of a lively or catchy tune, played at a relatively fast pace, that keeps on returning or coming round again (hence the name "rondo"). Between occurrences of this main theme (A), contrasting episodes occur (ABACADA). Composers seeking a more balanced or symmetrical form often repeat the first episode just before the last occurrence of the main theme (ABACABA).

Although individual composers often modified and played with these main forms, the most common structure of a four-movement symphony would generally follow the scheme shown here.

Symphonic Movement	Form
I	Sonata
II	Aria, Sonata, or Theme and Variations
III	Minuet and Trio
IV	Rondo or Sonata

Some symphonies reverse the position of the middle two movements, putting the slower movement third instead of second. Sonata form was sometimes used twice, once for the first movement and then again, often in the fourth movement.

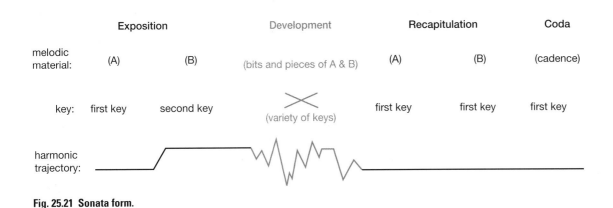

Fig. 25.21 Sonata form.

The String Quartets of Joseph Haydn

One of the most important contributors to the development of the symphonic form was the composer Joseph Haydn [HY-din] (1732–1809). In 1761, at the age of 29, he was appointed musical director to the court of the Hungarian nobleman Prince Paul Anton Esterházy. Haydn worked for Esterházy for nearly 30 years, isolated at Esterháza Palace in Eisenstadt, about 30 miles south of Vienna. The palace, modeled on Versailles, included two theaters (one for opera) and two concert halls. In these surroundings, Haydn composed an extraordinary amount of music: operas, oratorios, concertos, sonatas, overtures, liturgical music, and above all, the two genres that he was instrumental in developing—the classical symphony and the string quartet. (He composed 106 of the former and 67 of the latter.) He also oversaw the repair of instruments, trained a chorus, and rehearsed and performed with a symphony of about 25 musicians.

The **string quartet**, the first of the new Classical genres that Haydn played such a large role in developing, features four string instruments: two violins, a viola, and a cello. Since all the instruments are from the same family, the music has a distinctly uniform sound. Its form closely followed that of the symphony. The string quartet was a product of the Classical age of music, performed almost exclusively in private settings, such as salons, for small audiences that understood the form to be a musical variation of their own conversations, an intimate exchange among friends.

Haydn was able to create new genres such as the string quartet precisely because Esterházy gave him the freedom to do so. "I could make experiments," Haydn told a biographer, "observe what elicited or weakened an impression, and thus correct, add, delete, take risks. I was cut off from the world . . . and so I had to become original." When Esterházy died in 1790, his son disbanded the orchestra and a London promoter, Johann Peter Salomon, invited Haydn to England. There he composed his last 12 symphonies for an orchestra of some 60 musicians. Among the greatest of the London symphonies is *Symphony No. 94*, the so-called *"Surprise" Symphony*. It was so named for a completely unanticipated *fortissimo* [for-TIS-uh-mo] ("very loud") percussive stroke that occurs on a weak beat in the second movement of the piece. This moment was calculated, so the story goes, to awaken Haydn's dozing audience, since concerts usually lasted well past midnight.

(((• HEAR MORE at www.myartslab.com The third movement of *Symphony No. 94* (track **25.1**) is in minuet and trio form. It is among Haydn's greatest works. In the very first section of the movement, the graceful cadences of the minuet last for only about 13 seconds, but in that short span, Haydn changes dynamics four times. He then repeats this first section, so that in the first 30 seconds of the composition, a total of eight changes in dynamics occur. The violins alone play the quiet, or *piano*, passages, and the full orchestra the loud, or *fortissimo*, passages. This opening theme, with all its contrasting elements, is followed by the second theme of the opening minuet, after which the first theme briefly repeats, followed in turn by a repetition of the entire second theme. The trio manipulates the themes of the first minuet, lending them an entirely different texture, as first horns and violins alternate and then oboes and bassoons replace the horns, adding a sudden and surprising shift to a minor key. Finally, the entire minuet repeats exactly. The full effect is one of almost stunning emotional range.

Wolfgang Amadeus Mozart: Classical Complexity

The greatest musical genius of the Classical era was Haydn's younger contemporary and colleague, Wolfgang Amadeus Mozart [MOHT-sart] (1756–1791). Mozart wrote his first original composition at age six, in 1762, the year after Haydn assumed his post with Prince Esterházy. When he was just eight, the prodigy penned his first symphony. Over the course of his 35-year life, he would write 40 more, plus 70 string quartets, 20 operas, 60 sonatas, and 23 piano concertos. (All of Mozart's works were catalogued and numbered in the nineteenth century by Ludwig von Köchel, resulting in each of them being identified with the letter *K*.) Haydn told Mozart's father that the boy was simply "the greatest composer I know in person or by name," and in 1785 Mozart dedicated six string quartets to the older composer. On several occasions the two met at parties, where they performed string quartets together, Haydn on the violin, Mozart on the viola.

By the time Mozart was six years old, his father, Leopold, began taking him and his sister, Anna, also a talented keyboard player, on concert tours throughout Europe (Fig. **25.22**). The tours exposed the young genius to virtually every musical development in eighteenth-century Europe, all of which he absorbed completely. As Mozart grew into adulthood, he suffered from depression and illness. He was unable to secure a position in the Habsburg court in Vienna until late in his life, when he was given the minor task of writing new dances for New Year's and other celebrations, so he was forced to teach composition to supplement his income. By the mid-1780s, he had also begun to perform his piano concertos in public concerts, from which he derived some real income.

Despite the stunning successes of his operas, Mozart's music was generally regarded as overly complicated, too demanding emotionally and intellectually for a popular audience to absorb. When the Habsburg Emperor Joseph II commented that the opera *Don Giovanni* was beautiful "but no food for the teeth of my Viennese"—meaning too refined for their taste—Mozart reportedly replied, "Then give them time to chew it." Indeed, his work often took time to absorb. Mozart could pack more distinct melodies into a single movement than most composers could write for an entire symphony, and each line would arise and grow naturally from the beginning to the end of the piece. But the reaction of Joseph II to another of his operas is typical: "Too many notes!" Ironically, it is exactly this richness that we value today.

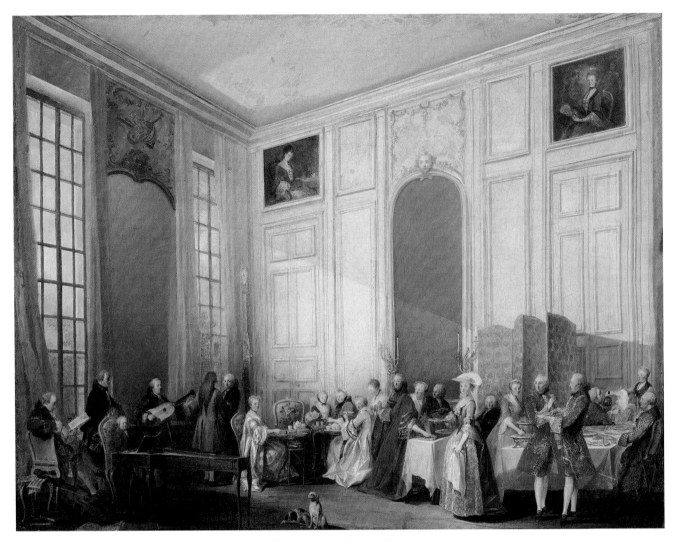

Fig. 25.22 Michel Barthélémy Ollivier, *Tea at Prince Louis-François de Conti's in the Temple, Paris.*
1766. Oil on canvas. Musée du Louvre, Paris. The painting depicts an actual salon in the summer of 1766, during Mozart's second visit to Paris when he was about ten years old. The prodigy is seated at the harpsichord, about to accompany the singer Pierre Jéylotte, seen tuning his guitar.

An example of Mozart's complexity is his *Symphony No. 40*, composed in the course of eight weeks in the summer of 1788. Unlike Haydn, who had a standing orchestra at his disposal, Mozart had no compelling reason to compose symphonies on a regular basis. *Symphony No. 40* and the two others he wrote in 1788 were probably undertaken with an eye toward an upcoming trip to London, where he planned to showcase his talents. The symphony is marked by almost perfect balance and control, and although its sonata form is easy to hear and follow, it is also easy to hear the ways in which Mozart manipulates the form in order to play with his audience's expectations. In the first movement, Mozart uses the sonata form in a way that is very easy for the listener to hear, and yet the movement is full of small— and sometimes larger—surprises (track **25.2**). The composition shifts dramatically between loud and soft passages, woodwinds and strings, rising and falling phrasings, and major and minor keys. Particularly dramatic is the way Mozart leads the listener to anticipate the beginning of the recapitulation, only to withhold it. As developed in the clear forms originated by Haydn and Mozart, the Classical symphony is nearly the antithesis of the delicately ornate *style galant* of the Rococo. As such, it announces the demise of the Rococo style.

The Popularization of Opera

The musical form that most clearly announces the death of the Rococo is opera. Its chief genre in the seventeenth and eighteenth centuries was ***opera seria*** ("serious opera"), a very formal kind of opera characterized by mythological or historical subjects and complex arias. *Opera seria* developed in Italy after Monteverdi's initial example (see Chapter 21). Sung almost exclusively in Italian, its tragic mode had found favor throughout Europe.

By the middle of the eighteenth century, the conventions of *opera seria* had come under attack. As early as 1728,

in London, *The Beggar's Opera* by John Gay (1685–1732) openly lampooned them. Instead of mythological figures or historical heroes, it portrayed common criminals. Where in France, opera always opened with an overture honoring the king, Gay began his with a song attacking the prime minister. The setting (a prison as opposed to a grand hall) and score (69 songs, including 28 English ballads) stand in marked contrast to the elaborate scenery (including mechanical devices for grand spectacles) and arias and recitative of *opera seria*. In fact, Gay dispensed with recitative altogether, substituting spoken dialogue.

The Beggar's Opera was an instant success, so popular that it was soon performed in the American colonies. It is said to have been George Washington's favorite opera. For the remainder of the eighteenth century it was performed in one city or another throughout the English-speaking world at least once a year.

Opera Seria versus Opera Buffa Meanwhile, a new style of opera had developed in Italy—*opera buffa* ("comic opera")—which, like the novel or Gay's *Beggar's Opera*, took everyday people for its characters and their more or less everyday activities for its plot. Its melodies, like Gay's, were generally simple and straightforward, unlike the complex solo arias that mark *opera seria*.

But even those who were dedicated to *opera seria* sought to reform it. Leading the way was Christoph Willibald Gluck (1714–1787). A prolific composer of operas himself, he resolved "to free [Italian opera] from all the abuses which have crept in either through ill-advised vanity on the part of the singers or through excessive complaisance on the part of composers." The **da capo aria**, which comprised the vast majority of *opera seria* arias, particularly annoyed him. Meaning "from the head," or, as we would say today, "from the top," or the beginning, the da capo aria had an ABA form. Singers were expected to embellish the A section in its repetition, transforming long notes into runs, adding new higher notes, and generally showing off their singing skills. When an aria ended, the singer usually left the stage, thus allowing for curtain calls and even encores. A singer who performed the A section the second time around with little or no change would be booed off the stage or pelted with rotten vegetables. The way in which the audience interrupted the flow of the performance as it expressed its approval or disapproval frustrated Gluck. He therefore proposed replacing the da capo aria with a more syllabic setting of text to music. This would eliminate needless embellishment and make the words more intelligible. He also advocated simpler and more flowing melodies.

Opera buffa accepted Gluck's propositions and went even further, eliminating the chief practitioners of the da capo aria. These practitioners were **castrati**, men who were subjected to castration in their youth in order to preserve their high voices. The best of them enjoyed great financial success, comparable to a modern-day rock star. Their disproportionately long limbs and extremely high voices left

them open to broad satire, which contributed to the growing image of *opera seria* as an "unnatural" or artificial art form. By eliminating castrati from its productions, *opera buffa* underscored the closeness of its comedies to real life.

Mozart's Stylistic Synthesis Mozart wrote five *opera seria*, but in his last four great operas—*The Marriage of Figaro, Don Giovanni, Cosi fan tutte*, and *The Magic Flute*—he united *opera seria* and *opera buffa*. Mozart referred to these four operas as **dramma giocoso**, "comic drama." The first three bring together nobles and commoners in stories that are at the same time comic and serious. What distinguishes them most, however—and the Italian librettist Lorenzo da Ponte (1749–1838) must be given some credit for this—is the depth of their characters. From the lowest to the highest class and rank, all are believable as they sort out their stormy relationships and love lives.

Based on the legend of Don Juan, a seducer of women who killed the father of one of his noble conquests and then got his comeuppance when the father's funerary statue accepted the Don's playful invitation to dinner and dragged the Don down to Hell, Mozart's *Don Giovanni* is a tour de force. The lead character is at once attractive and repulsive, a defier of all social convention and ethical norms. Opposite him are two noble female leads, Donna Anna and Donna Elvira, and a peasant girl, Zerlina, whom Don Giovanni is also intent on seducing.

As the curtain rises, Don Giovanni's servant Leporello guards the courtyard outside the bedroom where his master is trying to seduce Donna Anna. His opening aria is a complaint lamenting the wicked ways of his master yet asserting the desire to be a "gentleman" himself. Harmonically, rhythmically, and melodically simple, it sets a distinct *opera buffa* tone. But no sooner does Leporello finish than the noblewoman Donna Anna and Don Giovanni himself sing a duet of an entirely different tone. The Don has evidently failed to seduce Donna Anna and is trying to escape her cries of alarm, but she pursues him. Leporello, standing safely apart but observing the interchange, soon makes the duet a trio, commenting on the action and predicting his master's behavior will lead to his ultimate ruin. Donna Anna's father, the Commendatore, answers his daughter's cries and challenges Don Giovanni to a duel. The Don reluctantly agrees and quickly kills the Commendatore, who dies slowly as Leporello comments on his master's behavior again, this time even more despondently. When Donna Anna returns with her fiancé, Don Ottavio, to find her father dead, the two swear to avenge the murder.

So the opera's comic opening is transformed into a drama of high seriousness and consequence. Throughout this scene, Mozart does not provide a single moment in which the audience can applaud. In the next scene, the *opera buffa* tone resumes as Leporello mockingly consoles Donna Elvira, whom Don Giovanni has already seduced and deserted. His aria, "Madamina," sometimes called the "Catalog Aria," enumerates Don Giovanni's numerous

HEAR MORE at
www.myartslab.com conquests throughout Europe and is a masterpiece of comic composition (track **25.3**). As nobility confront peasantry, and then work together to bring Don Giovanni to justice, the concerns of *opera seria* and *opera buffa* coalesce into highly entertaining drama.

After debuting triumphantly in Prague, *Don Giovanni* was received with less enthusiasm in Vienna, at least at first. But Haydn loved it. "If every music-lover, especially among the nobility, could respond to Mozart's inimitable works with the depth of emotion and understanding which they arouse in me, the nations would compete to have such a jewel within their frontiers."

CHINA AND EUROPE: CROSS-CULTURAL CONTACT

Unlike the cultures of the South Pacific, which were unknown to Europeans until the expeditions of Cook and Bougainville, China and India were well known (Map **25.3**). The *philosophes* were especially attracted to China. They recognized that in many respects, China was more advanced than any society in the West. Its people were better educated, with over a million graduates of its highly sophisticated educational system, and its industry and commerce more highly developed. It was also a more egalitarian society (at least for males) than any in the West, for, although a wealthy, landed nobility did exist, it was subject to a government of scholar-bureaucrats drawn from every level of society.

The first Portuguese trading vessels had arrived in China in 1514 (see Chapter 18), and by 1715, every major

Fig. 25.23 Jean-Étienne Liotard. *Still Life: Tea Set.* **ca. 1781–83.** Oil on canvas mounted on board, 14 $^{7}/_{8}$" × 20 $^{5}/_{16}$". The J. Paul Getty Museum, Los Angeles, CA. The lacquer tray upon which the tea service is set was probably made in Europe in imitation of Chinese lacquerware.

European trading nation had an office in Canton. Chinese goods—porcelains, wallpapers, carved ivory fans, boxes, lacquerware, and patterned silks—flooded the European markets, creating a widespread taste for what quickly became known as **chinoiserie** [sheen-WAHZ-ree] (meaning "all things Chinese"). Jean-Étienne Liotard's (1702–1789) *Still Life: Tea Set* (Fig. **25.23**) captures the essence of chinoiserie taste. Central to the image is tea itself, the trade in which was dominated by the Dutch. Across Europe, tea consumption rose from 40,000 pounds in 1699 to an annual average

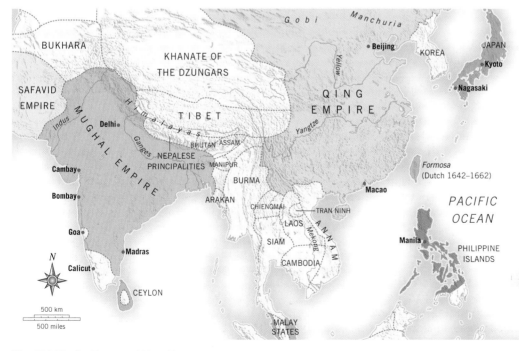

Map 25.3 The Far East. ca. 1600–1799.

SEE MORE View a Closer Look about Chinoiserie at **www.myartslab.com**

Fig. 25.24 William Marlow, *View of the Wilderness at Kew*, 1763. Watercolor; sheet: 11 $\frac{1}{16}$" × 17 $\frac{17}{16}$". Metropolitan Museum of Art, New York. The Chinese pagoda built by Chambers in 1761 still stands in the gardens today.

of 240,000 pounds by 1708. The Chinese tea service that is Liotard's primary focus was made in China for export to Europe.

The craze for chinoiserie even reached the English garden (Fig. **25.24**). A Chinese pagoda in London's Kew Gardens was designed by Sir William Chambers (1726–1796). Chambers visited China in the 1740s, and his work on garden architecture, published in 1762 as *Dissertation on Oriental Gardening*, was widely influential, creating a craze that swept France at the end of the eighteenth century—the *jardin anglo-chinois*, the English–Chinese garden. Likewise, blue-on-white porcelain ware—"china" as it came to be known in the West—was especially desirable (see Fig. 18.21) and before long ceramists at Meissen [MY-sen], near Dresden [DREZ-den], Germany, had learned how to make their own porcelain. This allowed for almost unbounded imitation and sale of Chinese designs on European-manufactured ceramic wares. Even the Rococo court painter François Boucher imitated the blue-on-white Chinese style in oil paint (Fig. **25.25**). The scene is simply a *fête galante* in Chinese costume. A balding Chinese man bends to kiss

Fig. 25.25 François Boucher, *Le Chinois Galant*. 1742. Oil on canvas, 41" × 57". The David Collection, inv.B275. Photo: Pernille Klemp. Boucher also created a suite of tapestries on Chinese themes for the king. The style of both this painting and the tapestries is decidedly Rococo, including, here, an elaborate Rococo cartouche border.

the hand of his lady, who sits with her parasol beneath a statue, not of Venus (as might be appropriate in a European setting), but of Buddha. A blue-on-white Chinese vase of the kind Boucher is imitating rests on a small platform behind the lady, and the whole scene is set in a Rococo-like cartouche.

European thinkers were equally impressed by Chinese government. In his *Discourse on Political Economy*, 1755, Jean-Jacques Rousseau praised the Chinese fiscal system, noting that in China, "taxes are great and yet better paid than in any other part of the world." That was because, as Rousseau explained, food was not taxed, and only those who could afford to pay for other commodities were taxed. It was, for Rousseau, a question of tax equity: "The necessaries of life, such as rice and corn, are absolutely exempt from taxation, the common people are not oppressed, and the duty falls only on those who are well-to-do." And he believed the Chinese emperor to be an exemplary ruler, resolving disputes between officials and the people according to the dictates of the "general will"—decidedly different from the practices of the French monarchy.

Likewise, in his 1756 *Essay on the Morals and Customs of Nations*, Voltaire praised the Chinese emperors for using government to protect civilization, creating a social stability unmatched in Europe and built upon Confucian principles of respect and service. He somewhat naively believed that the Chinese ruling class, in cultivating virtue, refined manners, and an elevated lifestyle, set an example that the rest of its people not only followed but revered. In England, Samuel Johnson praised China's civil-service examination system as one of the country's highest achievements, far more significant than their invention of the compass, gunpowder, or printing. He wished Western governments might adopt it.

The Arts in the Qing Dynasty (1644–1911)

The China that the West so idealized was ruled by Qing [ching] ("clear" or "pure") Manchus, or Manchurians, who had invaded China from the north, capturing Beijing in 1644. They made Beijing their capital and ruled China continuously until 1911, but they solidified their power especially during the very long reign of the Qianlong emperor (r. 1736–1795). By 1680, the Qing rulers had summoned many Chinese artists and literati to the Beijing court, and under the Qianlong, the imperial collections of art grew to enormous size, acquired as gifts or by confiscating large quantities of earlier art. (Today the collection is divided between the National Palace

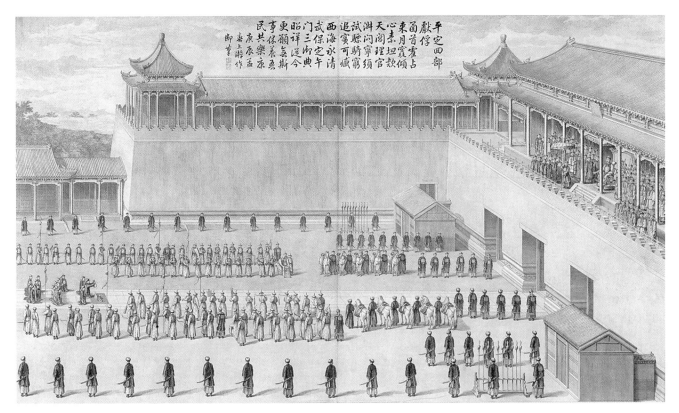

Fig. 25.26 Jean Denis Attiret, *The Presentation of Uigur Captives*. From *Battle Scenes of the Quelling of Rebellions in the Western Regions, with Imperial Poems*. ca. 1765–74; poem dated 1760. Etching, mounted in album form, 16 leaves plus 2 additional leaves of inscriptions; 51 × 87 cm. © The Cleveland Museum of Art, John L. Severance Fund. 1998.103.14. In order to indicate his pride in the Qing military, the Qianlong emperor wrote a poem to accompany each etching.

Fig. 25.27 **Detail of porcelain punch bowl, painted in overglaze enamels in Guangzhou (Canton) with a copy of William Hogarth's print, *The Gates of Calais.* ca. 1750–55.** Diameter 16″. Board of Trustees of the Victoria and Albert Museum, London (Basil Ionides Bequest), C. 23–1951.

Museum in Taipei and the Palace Museum in Beijing.) The collection was housed in the Forbidden City (see Figs. 18.18 and 18.19), which the Qing emperors largely rebuilt.

While many court artists modeled their work on the earlier masterpieces collected by the emperor, others turned to the study of Western techniques introduced by the Jesuits. Among these Jesuits were Giuseppe Castiglione [kah-steel-YOH-nay] (1688–1766) and Jean Denis Attiret [ah-teer-RAY] (1702–1768), both of whom had been trained as painters of religious subjects before being sent to China in 1715. Once there, Castiglione virtually abandoned his religious training and worked in the court, where he was known as Lang Shi'ning. He painted imperial portraits, still lifes, horses, dogs, and architectural scenes, and even designed French-style gardens on the model of Versailles. A series of prints made for the Qianlong emperor celebrated the suppression of rebellions in the Western provinces (present-day Xingjiang). The print illustrated here, *The Presentation of Uigur*

Captives, from the series *Battle Scenes of the Quelling of Rebellions in the Western Regions, with Imperial Poems,* is a fine example of the representation of space through careful scientific perspective, a practice virtually unknown in Chinese painting before 1700 (Fig. **25.26**). It is the kind of work that made painters like Castiglione and Attiret extremely popular in the Qianlong court, for it combines an Eastern appreciation for the order of the political state with the Western use of perspective.

But it was not at court that Western conventions were most fully expressed. In the port cities such as Yangzhou and Guangzhou, throughout the eighteenth century, Chinese artists created images for export to both the West and Japan. At the same time, Westernized ceramics became very popular with the increasingly wealthy Chinese mercantile class. Local commercial artists decorated ceramic wares with images provided by European traders, such as the bowl illustrating Hogarth's print of *The Gates of Calais* [kah-LAY] (Fig. **25.27**). As Western trading companies placed large orders to meet the European demand for ceramics,

Chinese artists mastered the art of perspective. Especially popular were aerial views of cities (Fig. **25.28**). Perspectival space appealed to the Chinese audience because it was both novel and exotic. The Western audience, used to perspective, found the views of urban China exotic in themselves.

As much as the Qianlong emperor enjoyed Western artistic conventions, he valued traditional Chinese art more. He commissioned large numbers of works painted in the manner of earlier masters, especially those of the Song [soong] dynasty (see Chapter 11). A perfect example is A *Thousand Peaks and Myriad Ravines* (Fig. **25.29**), painted by Wang Hui [wahng hwee] (1632–1717). In typical literati fashion, the artist has added a poem at the top of the painting, by Li Cheng [lee-chung], a Tang dynasty master:

Moss and weeds cover the rocks and mist hovers over the water
The sound of dripping water is heard in front of the temple gate.
Through a thousand peaks and myriad ravines the spring flows,
And brings the flying flowers into the sacred caves.

Below these lines Wang Hui states his artistic sources:

In the fourth month of the year 1693, in an inn in the capital, I painted this based on a Tang dynasty poem in the manner of the [painters] Dong [Yuan] and Ju[ran].

Both poem and painting display the conventional elements of Chinese painting. Mountains rise over the valley

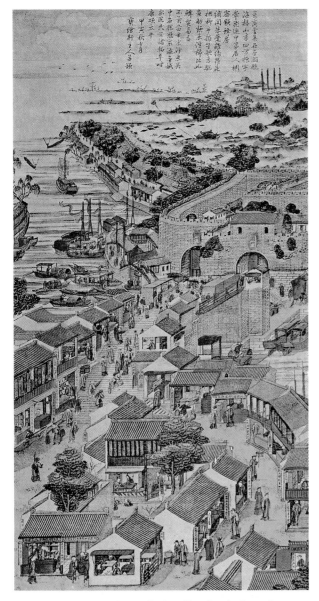

Fig. 25.28 Anonymous, *View of Suzhou Showing the Gate of Changmen*. 1734. Color print from woodblock, 42 $^3/_4$″ × 22″ (108 × 56 cm). Ohsha'joh Museum of Art, Hiroshima, Japan. Suzhou was a center of printmaking and luxury manufactured goods and was a popular tourist destination. Notice the three-masted Western ship in the harbor.

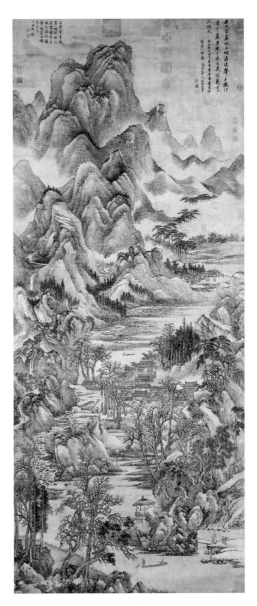

Fig. 25.29 Wang Hui, *A Thousand Peaks and Myriad Ravines*. Qing dynasty. 1693. Hanging scroll, ink on paper, 8′ 2 $^1/_2$″ × 3′ 4 $^1/_2$″. National Palace Museum, Taipei, Taiwan. Wang Hui was known, even in his own day, for his ability to synthesize the techniques of the old masters.

as prominently as the emperor overseeing his people (see *Closer Look*, Chapter 11, pages 366–367). A vast cosmic flow of river and stream, cascading waterfalls, jagged rock, and trees ready to flower dwarf all evidence of human life, including a temple on the right bank in the middle distance and the barely noticeable fishermen, wandering scholars, and priests who fill the scene.

Celebrating Tradition: The Great Jade Carving

The Qianlong emperor had already celebrated the conquest of the far western city of Khotan [koe-THAN] by commissioning a series of etchings from the Jesuit artists in his court (see Fig. 25.26). Not long after, in the late 1770s, he would have reason to celebrate again. Digging not far from Khotan, workers unearthed the largest single boulder of jade ever discovered. It was 7 feet 4 inches high, over 3 feet in diameter, and it weighed nearly 6 tons. It took three years to bring the stone to Beijing, transported on a huge wagon drawn by 100 horses, and a retinue of 1,000 men to construct the necessary roads and bridges.

The Qianlong emperor immediately understood the stone's value—not just as an enormous piece of jade, but as a natural wonder of potentially limitless propagandistic value. He himself picked the subject to be carved on the stone: it would be based on an anonymous Song painting in his collection depicting the mythical emperor Yu [yoo] the Great (2205–2197 BCE) taming a flood. In this way, it would connect the Qianlong emperor to one of the oldest emperors in Chinese history and, implicitly, establish the continuity of the Qing dynasty with all that had preceded it.

The Qianlong court kept meticulous records of the jade's carving. Workers first made a full-size wax model of the stone. Then artists in the imperial household carved it to resemble what was to be the finished work. The emperor personally viewed and approved the carved model. Then, because he felt that Beijing jade-carvers were not as accomplished as those in Yangzhou [yahng-joe], the center of luxury goods manufacturing, he decided to ship the model south. But fearing that the excessive heat of Yangzhou's southern climate would melt the wax model, he ordered another model to be made in wood. A team of Yangzhou craftsmen carved the stone in 7 years, 8 months—a total of 150,000 working days!

Meanwhile, the wooden model was shipped back to Beijing, where the emperor tried it out in various locations around the palace. When the actual jade returned in 1787, he placed it in the spot in the palace where it still stands today (Fig. **25.30**). On the base of the stone, a carved inscription eulogized both Yu the Great and the great stone itself, and linked them to the magnificence of the Qianlong emperor himself.

The story of Yu the Great first appears in *The Book of History*, a collection edited by Confucius in the fourth century BCE (see Chapter 4). When the farmlands of the Yellow River valley were inundated by a great flood, the emperor Shun ordered Yu to devise some means of controlling it. With the help of all the princes who ruled in the valley, Yu organized an army of people who, over the course

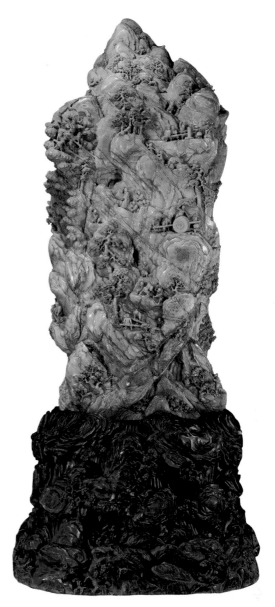

Fig. 25.30 *Yu the Great Taming the Waters.* **Qing Dynasty, completed 1787.** Jade carving, 7'1/4" × 3'1 3/4". Collection of The Palace Museum, Beijing. The black area at the sculpture's base, full of swirling waves, represents the waters that Yu the Great is in the process of taming. The implication is that as the water recedes, the green plenty of the earth (represented by the green jade) will be restored.

of 13 years, cut channels in the land to drain the flood waters into the sea. *Yu the Great Taming the Waters* is not, in other words, the representation of a miracle, but a celebration of hard work, organizational skill, and dedicated service to one's ruler—traditional Confucian [kun-FYOO-shun] values. It is hard to say just which of the many humans carved onto the surface of the stone is Yu, because all are equally at work, digging, building, and pumping the waters of the Yellow River to the sea. Formally, in the way that a set of flowing curves seem to hold the strong diagonals of the jade and broad sweeps of stone balance its intimate detail, the sculpture also suggests the overall unity of purpose that characterizes the ideal Chinese state.

The End of the Rococo

A major talent of the Rococo era was the painter Marie-Louise-Elisabeth Vigée-Lebrun (1755–1842), whose career spanned two centuries. By 1775, when she was only 20 years old, her paintings were commanding the highest prices in Paris. Vigée-Lebrun painted virtually all the famous members of the French aristocracy, including on many occasions Marie-Antoinette, Louis XVI's queen, for whom she served as official portraitist.

Vigée-Lebrun was an ardent royalist, deeply committed to the monarchy. When she submitted *Marie-Antoinette en chemise* (Fig. **25.31**) to the Salon of 1783, she was asked to withdraw it, because many on the committee thought the very expensive gown the queen wore in the painting was lingerie—*chemise*, in French usage, refers to undergarments. But the queen herself adored the painting, with its soft curves and petal-like textures. It presents her as the ideal Rococo female, the *fête galante*'s very object of desire.

Within six years, the French nation was convulsed by revolution and Marie-Antoinette had fallen completely from grace. When Jacques-Louis David (1748–1825) sketched her from a second-story window as she was transported by cart to the guillotine on October 16, 1793, she was dressed in a much humbler chemise and cap (Fig. **25.32**). Her chin is thrust forward in defiance and perhaps a touch of disdain, but her erect posture hints at the aristocratic grandeur she once enjoyed. David was one of the great painters of the period, and his career, like Vigée-Lebrun's, spanned two centuries. In fact, and as we shall soon see, his large-scale paintings with their classical structure and balance explicitly reject the Rococo values of the French monarchy. Instead, they embrace the moral authority of the French people who overthrew so corrupt a court.

Meanwhile, Marie-Antoinette's favorite painter, Vigée-Lebrun, escaped from Paris, traveling first to Italy, then Vienna, and finally Saint Petersburg. In all of these places, she continued to paint for royal patrons in the Rococo style she had used in France. Finally, in 1802, after 255 fellow artists petitioned the government, she was allowed to return to France, where, ever the ardent royalist, she lived in obscurity for the next 40 years. ■

Fig. 25.31 Elisabeth-Louise Vigée, *Marie-Antoinette en* **Chemise. 1783.** Oil on canvas, 33 ½″ × 28 ¼″. Hessische Hausstiftung (Hessian House Foundation) Museum Schloss Fasanerie.

Fig. 25.32 Jacques-Louis David, *Marie-Antoinette conduite au supplice* (*Queen Marie-Antoinette on the way to the guillotine*)**. 1793.** Ink drawing. DR 3599 Coll. Rothschild. Musee du Louvre/RMN Reunion des Musees Nationaux, France. SCALA/Art Resource, New York.

What is the Rococo?

The Rococo is a decorative style of art that originated in the *hôtels* and salons of Paris. It is characterized by S- and C-curves, shell, wing, scroll, and plant tendril forms, and cartouches. Parisian court life was conducted in the Rococo salons of the city's hostesses, where *philosophes*, artists, and intellectuals gathered, and where there was a continuing tension between the aims and values of the French monarchy and the Enlightenment views of the *philosophes*. On the one hand, artists, such as Jean-Antoine Watteau, captured the court's Rococo style in paintings of *fêtes galantes*. How would you characterize the emotional content of Watteau's *fêtes galantes*? How is this emotional content carried forward in the paintings of François Boucher and his pupil, Jean-Honoré Fragonard?

Across the royal courts of Europe, the Rococo style of the French court was widely emulated. In Germany at Würzburg, the architect Balthasar Neumann and the painter Giovanni Tiepolo created an elaborate Rococo interior for the prince-bishop's Residenz. In Prussia, Frederick the Great decorated his country palace of Sanssouci in a Rococo style. The palace's surrounding gardens forsook the straight and geometrical layout of the French garden, substituting the new English garden design. What are the characteristics of the English garden?

Who are the philosophes?

In France, the *philosophes* carried the ideals of the Enlightenment forward, often in open opposition to the absolutist French court. What were the primary sources of the conflict between the *philosophes* and the French court? The *philosophes* were mostly Deists, who accepted the idea that God created the universe but did not have much, if anything, to do with its day-to-day workings. What was the guiding principle of Diderot's *Encyclopédie*? In what ways was Jean-Jacques Rousseau's profoundly personal autobiography, *Confessions*, antagonistic to Enlightenment ideals? How, nevertheless, did his other writings—like *Émile* and *The Social Contract*—influence Enlightenment thinking? Finally, the satirist Voltaire challenged all the forms of absolutism and fanaticism that he saw in the world, especially in his satirical narrative *Candide*. How would you compare Voltaire's satires to those of his English contemporaries such as Jonathan Swift and Alexander Pope?

The *philosophes* also contributed to the development of art criticism and theory. In his critical reviews called *Salons*, Diderot declared Boucher's work depraved. Why did he champion the paintings of Jean-Baptiste-Siméon Chardin? It was at this time that the fine arts began to distinguish themselves from the liberal arts, and that Gotthold Ephraim Lessing distinguished between the visual arts and poetry in his treatise *Laocoön*. What, according to Lessing, distinguishes the one from the other?

What are the characteristics of Classical music?

Rococo musical taste centered on light, airy tunes with intricate and complex rhythms generally played on the harpsichord in what came to be known as the *style galant*. François Couperin and Jean-Philippe Rameau were its chief proponents. Classical music is very different and developed in opposition to the Rococo style. It shares with Greek and Roman art the essential features of symmetry, proportion, balance, formal unity, and clarity. The symphony orchestra, the primary vehicle of Classical music, was first conceived by Johann Stamitz in the 1740s. What are the major structural divisions of the Classical symphony? Two of the greatest composers of symphonies were Joseph Haydn and Wolfgang Amadeus Mozart. Haydn was also instrumental in developing the form of the string quartet. Mozart was able to bring competing musical elements into a state of classical balance like no composer before him, but why was it criticized in his own day? Mozart also synthesized the two contrasting types of opera most popular at the time: *opera seria* and *opera buffa*. What is the difference between the two? Mozart called the new form *opera giocoso* and used it in four operas, of which *Don Giovanni* is a good example. How does the popularity of opera reflect the decline of the Rococo?

How did China and the West influence one another?

Trade with China brought luxury goods from Asia to European markets in vast quantities, creating a widespread taste in Europe for "things Chinese"—chinoiserie. How would you define *chinoiserie*? European thinkers such as Rousseau and Voltaire thought that China offered a model of exemplary government, and Samuel Johnson believed that the West should adopt the Chinese civil-service examination system. During the Qing dynasty, the West influenced China as well. What Western art technique did the Jesuit priest Giuseppe Castiglione introduce to the court of the Qianlong emperor? Traders also introduced Western conventions of representation as they gave Chinese artisans images for reproduction on ceramic ware and other luxury goods destined for Europe. But the Qianlong emperor valued traditional Chinese art above all else. His court painters copied the masters of the Song era, and the emperor modeled his giant jade carving of *Yu the Great Taming the Waters* on Song precedents.

PRACTICE MORE Get flashcards for images and terms and review chapter material with quizzes at **www.myartslab.com**

GLOSSARY

cartouche An elaborate frame.

castrato A male singer who, in order to retain his high voice, was castrated before puberty.

chinoiserie A term used to define the European taste for "all things Chinese."

Classical music A style of music that developed in Europe about 1760 and lasted into the nineteenth century as an alternative to and rejection of the Rococo and Baroque; it shares with Greek and Roman art the essential features of symmetry, proportion, balance, formal unity, and, perhaps above all, clarity.

da capo aria A type of aria in the ABA form in which the singer was expected to embellish the music, especially in the return of the A.

Deist One who accepts the idea that God created the universe but does not believe that God is actively involved in its day-to-day workings.

dramma giocoso Literally "comic drama," Mozart's name for his last four operas, which combine both *opera seria* and *opera buffa* styles.

dynamics A notation in a musical score that indicates relative loudness (for example, *forte* for loud; *piano* for soft).

English garden A type of garden design of artificial naturalness that became popular in England beginning in the early 1700s with irregular features and winding walkways.

fête galante A gallant and, by extension, amorous celebration or party.

key signature The scale upon which a piece is based.

natural law Law derived from nature and binding upon human society.

opera buffa Comic opera, featuring everyday characters.

opera seria Literally "serious opera," emphasizing virtuoso singing, featuring themes from ancient history and mythology.

pace A notation in a musical *score* that indicates rate of movement (for example, *allegro*, for fast; *lente*, for slow).

philosophes The "philosophers" who dominated the intellectual life of the French Enlightenment and who frequented *salons*.

pianoforte A type of piano that could play both soft (*piano*) and loud (*forte*) sounds.

rational humanism The belief that through logical, careful thought, progress is inevitable.

Rococo The highly decorative and ornate style employed by the French court that was quickly emulated by royal courts across Europe, especially in Germany.

salon A room designed especially for social gatherings; later, also referred to the social gathering itself.

salonnière The hostess of a French salon.

score A musical composition that indicates what music is to be played by each instrument.

sonata form A kind of small form within the larger symphonic form.

string quartet A group of musicians playing four instruments from the same family—two violins, a viola, and a cello—thus lending the music a distinctly homogenous sound.

style galant A *Rococo* style of music characterized by graceful melodies, many of them dance pieces with charmingly simple harmonies.

symphony A musical composition typically consisting of a first movement played in a fast tempo (*allegro*); a second movement that is slow (*adagio* or *andante*) and reflective; a third that picks up the pace again; and a fourth that is generally *allegro* once again, spirited and lively.

symphonic orchestra A large ensemble that organized the orchestra into separate sections according to type of instrument: strings, woodwinds, brass, and percussion.

time signature The number of beats per measure.

READINGS

READING 25.2

from Jean-Jacques Rousseau, *Confessions*, Book 1 (completed 1770, published 1780)

The first two paragraphs of Confessions *set out the author's intention of total revelation, which he claims is totally new. In fact,* Confessions *does reveal more about the writer's private self than any other work before it. Only Montaigne's* Essais *come close. The* Confessions *are sometimes almost unbearably honest. In the longer excerpt below, Rousseau reveals his "spanking" fetish. Above all, the* Confessions *stands out as a supreme example of the autobiographical impulse in Enlightenment thought, the need to know oneself in as much detail as possible.*

[1712–1719]—I am commencing an undertaking, hitherto without precedent, and which will never find an imitator. I desire to set before my fellows the likeness of a man in all the truth of nature, and that man myself.

Myself alone! I know the feelings of my heart, and I know men. I am not made like any of those I have seen; I venture to believe that I am not made like any of those who are in existence. If I am not better, at least I am different. Whether Nature has acted rightly or wrongly in destroying the mold in which she cast me, can only be decided after I have been read. . . . 10

As Mademoiselle Lambercier had the affection of a mother for us, she also exercised the authority of one, and sometimes carried

it so far as to inflict upon us the punishment of children when we had deserved it. For some time she was content with threats, and this threat of a punishment that was quite new to me appeared very terrible; but, after it had been carried out, I found the reality less terrible than the expectation; and what was still more strange, this chastisement made me still more devoted to her who had inflicted it. It needed all the strength of this devotion and all my natural docility to keep myself from doing something which would have deservedly brought upon me a repetition of it; for I had found in the pain, even in the disgrace, a mixture of sensuality which had left me less afraid than desirous of experiencing it again from the same hand. No doubt some precocious sexual instinct was mingled with this feeling, for the same chastisement inflicted by her brother would not have seemed to me at all pleasant. But, considering his disposition, there was little cause to fear the substitution; and if I kept myself from deserving punishment, it was solely for fear of displeasing Mademoiselle Lambercier; for, so great is the power exercised over me by kindness, even by that which is due to the senses, that it has always controlled the latter in my heart.

The repetition of the offense, which I avoided without being afraid of it, occurred without any fault of mine, that is to say, of my will, and I may say that I profited by it without any qualm of conscience. But this second time was also the last; for Mademoiselle Lambercier, who had no doubt noticed something which convinced her that the punishment did not have the desired effect, declared that it tired her too much, and that she would abandon it. Until then we had slept in her room, sometimes even in her bed during the winter. Two days afterwards we were put to sleep in another room, and from that time I had the honor, which I would gladly have dispensed with, of being treated by her as a big boy.

Who would believe that this childish punishment, inflicted upon me when only eight years old by a young woman of thirty,[1] disposed of my tastes, my desires, my passions, and my own self for the remainder of my life, and that in a manner exactly contrary to that which should have been the natural result? When my feelings were once inflamed, my desires so went astray that, limited to what I had already felt, they did not trouble themselves to look for anything else. In spite of my hot blood, which has been inflamed with sensuality almost from my birth, I kept myself free from every taint until the age when the coldest and most sluggish temperaments begin to develop. In torments for a long time, without knowing why, I devoured with burning glances all the pretty women I met; my imagination unceasingly recalled them to me, only to make use of them in my own fashion, and to make of them so many Mlles. Lambercier.

Even after I had reached years of maturity, this curious taste, always abiding with me and carried to depravity and even frenzy, preserved my morality, which it might naturally have been expected to destroy. If ever a bringing-up was chaste and modest, assuredly mine was. My three aunts were not only models of propriety, but reserved to a degree which has long since been unknown amongst women. My father, a man of pleasure, but a gallant of the old school, never said a word, even in the presence of women whom he loved more than others, which would have brought a blush to a maiden's cheek; and the respect due to children has never been so much insisted upon as in my family and in my presence. In this respect I found M. Lambercier equally careful; and an excellent servant was dismissed for having used a somewhat too free expression in our presence. Until I was a young man, I not only had no distinct idea of the union of the sexes, but the confused notion which I had regarding it never presented itself to me except in a hateful and disgusting form. For common prostitutes I felt a loathing which has never been effaced: the sight of a profligate always filled me with contempt, even with affright. My horror of debauchery became thus pronounced ever since the day when, walking to Little Sacconex[2] by a hollow way, I saw on both sides holes in the ground, where I was told that these creatures carried on their intercourse. The thought of the one always brought back to my mind the copulation of dogs, and the bare recollection was sufficient to disgust me.

This tendency of my bringing-up, in itself adapted to delay the first outbreaks of an inflammable temperament, was assisted, as I have already said, by the direction which the first indications of sensuality took in my case. Only busying my imagination with what I had actually felt, in spite of most uncomfortable effervescence of blood, I only knew how to turn my desires in the direction of that kind of pleasure with which I was acquainted, without ever going as far as that which had been made hateful to me, and which, without my having the least suspicion of it, was so closely related to the other. In my foolish fancies, in my erotic frenzies, in the extravagant acts to which they sometimes led me, I had recourse in my imagination to the assistance of the other sex, without ever thinking that it was serviceable for any purpose than that for which I was burning to make use of it.

In this manner, then, in spite of an ardent, lascivious and precocious temperament, I passed the age of puberty without desiring, even without knowing of any other sensual pleasures than those of which Mademoiselle Lambercier had most innocently given me the idea; and when, in course of time, I became a man, that which should have destroyed me again preserved me. My old childish taste, instead of disappearing, became so associated with the other, that I could never banish it from the desires kindled by my senses; and this madness, joined to my natural shyness, has always made me very unenterprising with women, for want of courage to say all or power to do all. The kind of enjoyment, of which the other was only for me the final consummation, could neither be appropriated by him who longed for it, nor guessed by her who was able to bestow it. Thus I have spent my life in idle longing, without saying a word, in the presence of those whom I loved most. Too bashful to declare my taste, I at least satisfied it in situations which had reference to it and kept up the idea of it. To lie at the feet of an imperious mistress, to obey her commands, to ask her forgiveness—this was for me a sweet enjoyment; and, the more my lively imagination heated my blood, the more I presented the appearance of a bashful lover. It may be easily imagined that this manner of making love does not lead to very speedy results, and is not very dangerous to the virtue of those who are its object. For this reason I have rarely possessed, but have none the less enjoyed myself in my own way—that is to say, in imagination. Thus it has happened that my senses, in harmony with my timid disposition and my romantic spirit, have kept my sentiments pure and my morals blameless, owing to the very tastes which, combined with a little more impudence, might have plunged me into the most brutal sensuality.

READING CRITICALLY

One of the great questions Rousseau's *Confessions* raises concerns the quality of its purported honesty. Is such self-revelation evidence of Rousseau's sincerity and humility or the manifestation of a kind of perverse pride?

[1]Actually, at the time described, Mlle. Lambercier was about 38 and Rousseau about 11.

[2]A village on the outskirts of Geneva.

from Voltaire, *Candide* (1758)

The following excerpt narrates a few of the many adventures of Candide and Dr. Pangloss. In Chapter 6, the Inquisition punishes Candide and Pangloss, blaming them for the earthquake that destroyed Lisbon on November 1, 1755. Pangloss is hanged, and Candide believes the philosopher to be dead. Not until Chapter 28 does he learn otherwise, when the two are reunited and Pangloss tells him how he narrowly escaped death. These two passages convey Voltaire's conviction that religion is based in superstition and illusion even as they satirize the foolishness of Pangloss's philosophical optimism.

CHAPTER 6

HOW THE PORTUGUESE MADE A SUPERB AUTO-DA-FÉ TO PREVENT ANY FUTURE EARTHQUAKES, AND HOW CANDIDE UNDERWENT PUBLIC FLAGELLATION

After the earthquake which had destroyed three-quarters of the city of Lisbon[1] the sages of that country could think of no means more effectual to preserve the kingdom from utter ruin, than to entertain the people with an *auto-da-fé*,[2] it having been decided by the University of Coimbra that burning a few people alive by a slow fire, and with great ceremony, is an infallible secret to prevent earthquakes.

In consequence thereof they had seized on a Biscayan for marrying his godmother, and on two Portuguese for taking out the bacon of a larded pullet they were eating.[3] After dinner, they came and secured Dr. Pangloss, and his pupil Candide; the one for speaking his mind, and the other for seeming to approve what he had said. They were conducted to separate apartments, extremely cool, where they were never incommoded with the sun. Eight days afterwards they were each dressed in a *fanbenito*,[4] and their heads were adorned with paper mitres. The mitre and *fanbenito* worn by Candide were painted with flames reversed, and with devils that had neither tails nor claws; but Dr. Pangloss's devils had both tails and claws, and his flames were upright. In these habits they marched in procession, and heard a very pathetic sermon, which was followed by a chant, beautifully intoned. Candide was flogged in regular cadence, while the chant was being sung; the Biscayan, and the two men who would not eat bacon, were burnt, and Pangloss was hanged, although this is not a common custom at these solemnities. The same day there was another earthquake, which made most dreadful havoc.[5]

Candide, amazed, terrified, confounded, astonished, and trembling from head to foot, said to himself, 'If this is the best of all possible worlds, what are the others? If I had only been whipped, I could have put up with it, as I did among the Bulgarians; but, O my dear Pangloss! thou greatest of philosophers! that ever I should live to see thee hanged, without knowing for what!

CHAPTER 28

WHAT BEFELL CANDIDE, CUNEGUNDE, PANGLOSS, MARTIN, &C.

"But how happens it that I behold you again, my dear Pangloss?" said Candide.

"It is true," answered Pangloss, "you saw me hanged, though I ought properly to have been burnt; but you may remember that it rained extremely hard when they were going to roast me. The storm was so violent that they found it impossible to light the fire; so they hanged me because they could do no better. A surgeon purchased my body, carried it home, and prepared to dissect me. He began by making a crucial incision from my navel to the clavicle. It is impossible for any one to have been more lamely hanged than I had been. The executioner of the Holy Inquisition was a subdeacon, and knew how to burn people very well, but as for hanging, he was a novice at it, being quite out of the way of his practice; the cord being wet, and not slipping properly, the noose did not join. In short, I still continued to breathe; the crucial incision made me scream to such a degree that my surgeon fell flat upon his back; and imagining it was the devil he was dissecting, ran away, and in his fright tumbled downstairs. His wife hearing the noise flew from the next room, and, seeing me stretched upon the table with my crucial incision, was still more terrified than her husband. She took to her heels and fell over him. When they had a little recovered themselves, I heard her say to her husband, 'My dear, how could you think of dissecting an heretic? Don't you know that the devil is always in them? I'll run directly to a priest to come and drive the evil spirit out.' I trembled from head to foot at hearing her talk in this manner, and exerted what little strength I had left to cry out, 'Have mercy on me!' At length the Portuguese barber took courage, sewed up my wound, and his wife nursed me; and I was upon my legs in a fortnight's time. The barber got me a place as lackey to a Knight of Malta who was going to Venice; but finding my master had no money to pay me my wages, I entered into the service of a Venetian merchant, and went with him to Constantinople."

"One day I happened to enter a mosque, where I saw no one but an old imam and a very pretty young female devotee, who was

[1]Lisbon was destroyed by an earthquake on November 1, 1755.

[2]An *auto-da-fé*, literally, an "act of faith." In the Inquisition, it was the announcement of judgment generally followed by execution.

[3]By marrying his godmother, the Biscayan is guilty of spiritual incest. By not eating bacon, the two Portuguese are assumed to be Jews.

[4]A long yellow garment worn by the criminals of the Inquisition.

[5]Lisbon suffered a second earthquake on December 21, 1755.

saying her prayers; her neck was quite bare, and in her bosom she had a beautiful nosegay of tulips, roses, anemones, ranunculuses, hyacinths, and auriculas. She let fall her nosegay. I ran immediately to take it up, and presented it to her with a most respectful bow. I was so long in delivering it, that the imam began to be angry; and, perceiving I was a Christian, he cried out for help; they carried me before the cadi, who ordered me to receive one hundred bastinadoes, and sent me to the galleys. I was chained in the very galley, and to the very same bench with my lord the Baron. On board this galley there were four young men belonging to Marseilles, five Neapolitan priests, and two monks of Corfu, who told us that the like adventures happened every day. The Baron pretended that he had been worse used than myself; and I insisted that there was far less harm in taking up a nosegay, and putting it into a woman's bosom, than to be found stark naked with a young Icoglan. We were 80 continually in dispute, and received twenty lashes a-day with a thong, when the concatenation of sublunary events brought you on board our galley to ransom us from slavery."

"Well, my dear Pangloss," said Candide to him, "when you were hanged, dissected, whipped, and tugging at the oar, did you continue to think that every thing in this world happens for the best?" 90

"I have always abided by my first opinion," answered Pangloss; "for, after all, I am a philosopher …

READING CRITICALLY

In what way does Pangloss's philosophical optimism directly contradict the philosophy of John Locke and by extension other Enlightenment thinkers?

The BLOODY MASSACRE perpetrated in King—l—Street BOSTON on March 5th 1770, by a party of the 29th REGt.

BUTCHER'S HALL

Engrav'd Printed & Sold by PAUL REVERE BOSTON

Unhappy BOSTON! see thy Sons deplore,
Thy hallow'd Walks besmear'd with guiltless Gore:
While faithless P—n and his savage Bands,
With murd'rous Rancour stretch their bloody Hands;
Like fierce Barbarians grinning o'er their Prey,
Approve the Carnage, and enjoy the Day.

If scalding drops from Rage from Anguish Wrung,
If speechless Sorrows lab'ring for a Tongue,
Or if a weeping World can ought appease
The plaintive Ghosts of Victims such as these:
The Patriot's copious Tears for each are shed,
A glorious Tribute which embalms the Dead.

But know, FATE summons to that awful Goal,
Where JUSTICE strips the Murd'rer of his Soul:
Should venal C—ts the scandal of the Land,
Snatch the relentless Villain from her Hand,
Keen Execrations on this Plate inscrib'd,
Shall reach a JUDGE who never can be brib'd.

The unhappy Sufferers were Messrs. Saml. GRAY SAML. MAVERICK, JAMS. CALDWELL, CRISPUS ATTUCKS & PATK. CARR
Killed. Six wounded, two of them (CHRISTR. MONK & JOHN CLARK) Mortally

26

The Rights of Man
Revolution and the Neoclassical Style

THINKING AHEAD

What do the American and French Revolutions have in common? How do they differ?

How did women respond to the promise of revolution?

What is Neoclassicism?

What values shaped Napoleonic France?

How did the issue of slavery undermine the idealism of the era?

On March 5, 1770, an angry mob of Bostonians attacked a small band of British troops stationed at the Boston Custom House to protect its customs agents and tax collectors. Five years earlier, in 1765, the British had challenged the American colonies' growing sense of independence by imposing a Stamp Act, which taxed all sorts of items, from legal documents to playing cards, calendars, liquor licenses, newspapers, and academic degrees. The colonists were infuriated, calling the Stamp Act a "manifest" example of the British desire "to subvert the rights and liberties of the colonies." Tensions finally erupted at the Boston Customs House. The mob was yelling "Kill them! Kill them!" when the British troops opened fire, killing five, including Crispus Attucks, an African American who had escaped slavery 20 years earlier. The silversmith and engraver Paul Revere (1735–1818) quickly produced a print depicting the event called *The Bloody Massacre* (Fig. 26.1). It was widely distributed, arousing the colonists

to even greater resistance, although its depiction of the troops' brutally attacking a defenseless crowd misrepresented the facts.

By the last half of the eighteenth century, the demand for freedom had become a rallying cry in America and throughout Europe. In Germany, in fact, the philosopher Immanuel Kant (1724–1804) argued in his essay "What Is Enlightenment?" (1784) that the very precondition of the Enlightenment was freedom:

> *Dare to know!* "Have the courage to use your own understanding"—that is the motto of Enlightenment. . . .
>
> [T]hat the public should enlighten itself is more possible; indeed, if only freedom is granted enlightenment is almost sure to follow. For there will always be some independent thinkers, even among the established guardians of the great masses, who, after throwing off the yoke of tutelage from their own shoulders, will

◀ **Fig. 26.1 Paul Revere, after Henry Pelham,** *The Bloody Massacre.* **1770.** Hand-colored engraving, 8 15/16″ × 10 3/16″. The Metropolitan Museum of Art, New York. © Massachusetts Historical Society, Boston, MA. The Bridgeman Art Library. Though it served to inflame the nation, Revere's print was largely fiction. John Adams defended the British troops in court, arguing that the soldiers had been attacked by a mob. "Facts are stubborn things," he concluded, "and whatever may be our wishes, our inclinations, or the dictums of our passions, they cannot alter the state of facts and evidence." The jury acquitted the British commander and six of the eight soldiers.

HEAR MORE Listen to an audio file of your chapter at **www.myartslab.com**

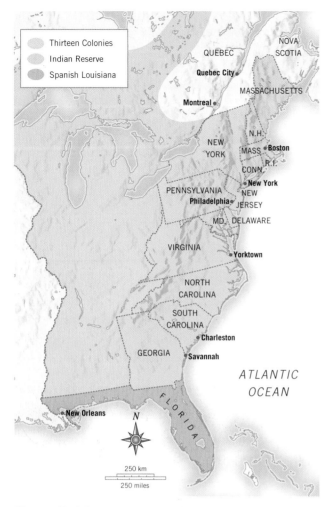

Map 26.1 North America in 1763, after the conclusion of the Seven Years' War.

disseminate the spirit of the rational appreciation of both their own worth and every man's vocation for thinking for himself. It is more nearly possible, however, for the public to enlighten itself; indeed, if it is only given freedom, enlightenment is almost inevitable. . . .

For this enlightenment, however, nothing is required but freedom, and indeed the most harmless among all the things to which this term can properly be applied. It is the freedom to make public use of one's reason at every point.

Enlightenment historian Peter Gay sums up the driving forces of the era as "freedom from arbitrary power, freedom of speech, freedom of trade, freedom to realize one's talents, freedom of aesthetic response, freedom, in a word, of moral man to make his way in the world."

The drive for these freedoms, first expressed in violence at the Boston Custom House, was repeated in May 1773, when the British introduced another law allowing direct importation of tea into the Americas without the usual colonial tax. It was met with opposition not only

because it thus reduced an important colonial revenue stream without the colonists' consent, but also because it removed colonial middlemen from participation in the tea trade. The following December, Massachusetts Bay colonists gathered at the Boston waterfront and cheered as a group of men dressed as Native Americans, almost all of them with a financial stake in the tea market, emptied three ships of thousands of pounds of tea, dumping it into the harbor. The so-called Boston Tea Party outraged the British, and they soon retaliated. The Revolutionary War was about to begin.

In Paris, 16 years later, on July 14, 1789, a mob gathered outside the Bastille, a prison on the eastern edge of the city, upset by rumors, probably true, that King Louis XVI (r. 1774–1792) was about to overthrow the National Assembly. The prison governor panicked and ordered his guard to fire on the crowd. In retaliation, the mob stormed the Bastille, decapitating the prison governor and slaughtering six of the guards. The only practical effect of the battle was to free a few prisoners, but the next day Louis XVI asked if the incident had been a riot. "No, your majesty," was the reply, "it was a revolution."

The social changes produced by these two revolutions strongly influenced world history, and would spur the nineteenth-century revolutions in South America, again in France, and, in 1848, all across Europe. The American Revolution was essentially the revolt of an upper class that felt disenfranchised by its distant king, while the French Revolution was a revolt against an absolute monarch whose abuse of power had disenfranchised his own people. But both the French and the Americans looked to classical antiquity for models upon which to build their new societies. Theirs would be Neoclassical societies—stable, balanced, and rational cultures that might imitate their admittedly idealized view of Rome and Athens. In the arts, classical traditions were expressed in a style known as Neoclassicism, literally a "new classicism." The style was most eloquently expressed in Britain, in the architectural and interior designs of Robert Adam and in the decorative ceramics of Josiah Wedgwood. Both were widely imitated in the fledgling United States, where Thomas Jefferson was Neoclassicism's principal advocate. Jefferson designed his own home at Monticello, the Virginia capital, and even laid out the new national capital of Washington, D.C., using the trademarks of the Neoclassical style—balance and order. Leading the way in France were painters Jacques-Louis David [dah-VEED] (1748–1825), probably the most influential artist of the era, and Angelica Kauffmann (1741–1807), probably the most popular.

The idealism embodied in Neoclassicism, its call for order, balance, and proportion, was countermanded in America by the inequalities embodied in the slave trade, and in France by the chaos and terror that followed hard upon the Revolution of 1789. By 1700, the slave trade had helped make England the wealthiest nation in the world, and the economy of the American South depended

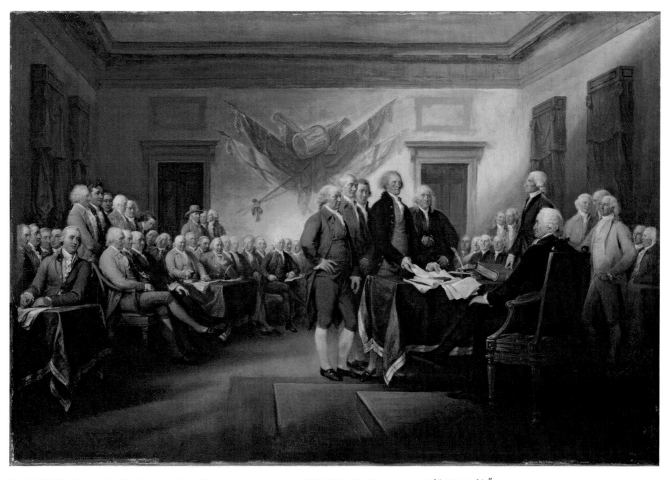

Fig. 26.2 John Trumbull, *The Declaration of Independence, 4 July 1776*. 1786–97. Oil on canvas, 21 1/8″ × 31 1/8″.
Trumbull Collection. 1832.3, Yale University Art Gallery, New Haven, CT/Art Resource, New York. The canvas portrays 47 of the
56 delegates who signed the Declaration of Independence, and Trumbull painted 36 of them from life. Standing in front of John
Hancock are, from left to right, John Adams, Roger Sherman, Robert R. Livingston, Thomas Jefferson, and Benjamin Franklin.

on it, to say nothing of the port cities of the North, particularly Providence and Boston. But no one could long ignore the hypocrisy of demanding human rights and freedom for some while subjugating others to abject misery and enslavement. And women, in both France and America, argued for their own equality in the same terms. Were they not, they argued, entitled to the same freedoms as their husbands and brothers? In France, the revolution deposed the monarchy, executing both Louis XVI and his queen, Marie Antoinette, and, as a result, Europe's other monarchies—especially those in Germany—threatened it from without even as royalists from within worked to reinstate the crown. France soon fell into a state of mutual distrust and vindictive retribution. Hardly anyone was exempt from the charge of betraying the revolution—and from the sentence of execution by guillotine. Not until Napoleon Bonaparte, a young military leader risen from within the army's ranks, took control of the country was order restored and with it the values of Neoclassicism.

THE AMERICAN AND FRENCH REVOLUTIONS

The American Declaration of Independence was signed on July 4, 1776 (Fig. **26.2**), and the French Declaration of the Rights of Man and Citizen on August 26, 1789. The two documents are monuments of Enlightenment thinking, both looking to the writings of John Locke for inspiration (see Chapter 24), and the French Declaration of the Rights of Man and Citizen influenced as well by the American Declaration.

The Road to Revolt in America: War and Taxation

Since August 1774, representatives from the 13 British colonies in North America (see Map **26.1**) had periodically gathered in the city of Philadelphia to consider what action the colonies might take against the tyrannical behavior of the British king. Philadelphia was the largest

city in the colonies, boasting 7 newspapers, 23 printing presses, 30 bookstores, and over 60 taverns and coffeehouses. It produced more goods than any other American city—from hardware to carriages to the Franklin stove. That stove's inventor, Benjamin Franklin (1706–1790), had founded the American Philosophical Society in the city in 1743. (The Society predated the English Lunar Society, which had many of the same aims as its American counterpart.) (See Chapter 24.) The American Philosophical Society was dedicated, Franklin wrote, to the study of anything that might "let light into the nature of things . . . all new-discovered plants, herbs, roots, and methods of propagating them. . . . New methods of curing or preventing diseases. . . . New mechanical inventions for saving labor. . . . All new arts, trades, manufacturers, etc. that may be proposed or thought of." Therefore, when the 48 representatives of the 13 colonies gathered in Philadelphia's State House, now known as Independence Hall, on July 4, 1776, to sign the Declaration of Independence from Britain, the city was the center of the burgeoning nation's economic prosperity and a dominant force in shaping its ideas and policies. The revolt of the colonies followed nearly 200 years of British rule, but the most recent tensions began with the Seven Years' War (1756–1763) fought by Britain and France. The war spread to North America, where the two powers were competing for land and control.

Britain's victory left it the most powerful colonial power in the Americas. The British felt that they had saved the colonists from the French. They had borne almost the entire cost of the war themselves, and they continued to provide protection from Indian uprisings on the western frontier. Consequently, they felt entitled to tax the colonies as needed. The colonists did not agree. The battle at the Boston Custom House and the Boston Tea Party were the expression of their frustration.

The so-called Boston Tea Party especially outraged the British. In 1774, they deeded all the land west of the Alleghenies to Canada and passed what soon became known as the Intolerable Acts, closing the port of Boston to trade, suspending elections in Massachusetts colony, allowing British troops to be quartered in private homes, and providing for the trials of customs officials to take place in England. The colonists responded by forming the First Continental Congress. Meeting in Philadelphia, the Congress declared the Intolerable Acts unconstitutional and called for the people to begin organizing for war. The first gunshots of the Revolutionary War were fired at Lexington and Concord, in Massachusetts, on April 19, 1775, when the British sent a regiment to confiscate arms and arrest revolutionaries. A Second Continental Congress in that year created the Continental Army under the leadership of George Washington and attempted to reconcile with the king, but failed.

In January 1776, in Philadelphia, an anonymous pamphlet written by an English immigrant named Thomas Paine argued for a new **republicanism**. The only solution to the colonists' problems with Britain, he wrote, was independence followed by a republican form of government. Such a government would have a chief of state who is not a monarch. Paine asked, "Why is it that we hesitate? . . . The birthday of a new world is at hand." The pamphlet was called *Common Sense*, and within a matter of months, 100,000 copies were in circulation. Colony-wide war was inevitable. Six months later, the colonies ratified the Declaration of Independence.

The Declaration of Independence

The American Declaration of Independence is one of the Enlightenment's boldest assertions of freedom. The chairman of the committee that prepared the document and its chief drafter was Thomas Jefferson (1743–1826) of Virginia. Jefferson's argument came from his reading of English philosopher John Locke's vigorous denial of the divine rights of kings (see Chapter 24). In *Two Treatises on Government* (1689), Locke asserted that humans are "by nature free, equal, and independent." Jefferson's denunciation of the monarchy was further stimulated by Rousseau's *Social Contract* (1763), and its principal point: "No man has a natural authority over his fellow," wrote Rousseau, "and force creates no right" (see Chapter 29). Jefferson was influenced, too, by the writings of many of his colleagues in the Continental Congress, who were themselves familiar with the writings of Locke and Rousseau. George Mason (1725–1792) had written: "All men are born equally free and independent and have certain inherent natural rights . . . among which are the enjoyment of life and liberty." An even greater source of inspiration came from the writings of Jefferson's friend John Adams (1735–1826), whose Preamble to the Massachusetts State Constitution (1779) reflects their common way of thinking:

> The end of the institution, maintenance, and administration of government is to secure the existence of the body politic; to protect it; and to furnish the individuals who compose it with the power of enjoying, in safety and tranquility, their natural rights and the blessings of life; and whenever these great objects are not obtained, the people have a right to alter the government, and to take measures necessary for their safety, happiness, and prosperity.

But as powerful as the thinking of Mason and Adams might be, neither man could rise to the level of Jefferson's eloquence (**Reading 26.1**):

READING 26.1

from The Declaration of Independence (1776)

When in the Course of human events, it becomes necessary for one people to dissolve the political bands which have connected them with another, and to assume among the powers of the earth, the separate

and equal station to which the Laws of Nature and of Nature's God entitle them, a decent respect to the opinions of mankind requires that they should declare the causes which impel them to the separation.

We hold these truths to be self-evident, that all men are created equal, that they are endowed by their Creator with certain unalienable Rights, that among these are Life, Liberty and the pursuit of Happiness.— That to secure these rights, Governments are instituted among Men, deriving their just powers from the consent of the governed,—That whenever any Form of Government becomes destructive of these ends, it is the Right of the People to alter or to abolish it, and to institute new Government, laying its foundation on such principles and organizing its powers in such form, as to them shall seem most likely to effect their Safety and Happiness.

As indebted as it is to John Locke's *Two Treatises of Government*, Jefferson's Declaration extends and modifies Locke's arguments in important ways. While Locke's writings supported a government *for* the people, he did not reject the idea of a monarchy per se. The people would tell the king what he should do, and the king was obligated to respect their rights and needs. But Jefferson rejected the idea of a monarchy altogether and argued that the people were themselves sovereign, that theirs was a government not *for* the people but *of* and *by* the people. Where Locke, in his *Two Treatises*, had argued for "life, liberty, and property," Jefferson argued for "Life, Liberty, and the pursuit of Happiness." Locke's basic rights are designed to guarantee justice. Jefferson's are aimed at achieving human fulfillment, a fulfillment possible only if the people control their own destiny.

After reading Jefferson's document, John Adams wrote to his wife, Abigail, that he was "delighted with its high tone and [the] flights of oratory with which it abounded." When it was read in New York the day after its first presentation in Philadelphia, an enthusiastic mob pulled down a larger-than-life equestrian statue of England's King George III (r. 1760–1820). Later, in August, when the text finally made its way south to Savannah, Georgia, the largest crowd in the colony's history gathered for a mock burial of George III. The document had the power to galvanize the colonies to revolution.

A year after the colonists signed the Declaration of Independence, they adopted the Articles of Confederation, combining the 13 colonies into a loose confederation of sovereign states. The war itself continued into the 1780s and developed an international scope. France, Spain, and the Netherlands supported the revolutionaries with money and naval forces in order to dilute British power. This alliance was critical in helping the Americans defeat the British at Yorktown, Virginia, in 1781. This victory convinced the British that the war was lost and paved the way for the Treaty of Paris, signed on September 3, 1783. The war was over.

The Declaration of the Rights of Man and Citizen

In France, the situation leading to the signing of the Declaration of the Rights of Man and Citizen was somewhat more complicated. It was, in fact, the national debt that abruptly brought about the events leading to revolution, the overthrow of the royal government, and the country becoming a republic. In the 15 years after Louis XVI ascended to the throne in 1774, the debt tripled. In 1788, fully one-half of state revenues were dedicated to paying interest on debt already in place, despite the fact that two years earlier, bankers had refused to make new loans to the government. The cost of maintaining Louis XVI's court was enormous, so the desperate king attempted to levy a uniform tax on all landed property. Riots, led by aristocrat and bourgeois alike, forced the king to bring the issue before an Estates General, an institution little used and indeed half-forgotten (it had not met since 1614).

The Estates General convened on May 5, 1789, at Versailles. It was composed of the three traditional French **estates**. The First Estate was the clergy, which comprised a mere 0.5 percent of the population (130,000 people) but controlled nearly 15 percent of French lands. The Second Estate was the nobility, consisting of only 2 percent of the population (about 500,000 people) but controlling about 30 percent of the land. The Third Estate was the rest of the population, composed of the bourgeoisie (around 2.3 million people), who controlled about 20 percent of the land, and the peasants (nearly 21 million people), who controlled the rest of the land, although many owned no land at all.

Traditionally, each estate deliberated separately and each was entitled to a single vote. Any issue before the Estates General thus required a vote of at least 2:1—and the consent of the crown—for passage. The clergy and nobility usually voted together, thus silencing the opinion of the Third Estate. But from the outset, the Third Estate demanded more clout, and the king was in no position to deny it. The winter of 1788 to 1789 had been the most severe in memory. In December, the temperature had dropped to −19° Celsius (or −2° Fahrenheit), freezing the Seine over to a considerable depth. The ice blockaded barges that normally delivered grain and flour to a city already filled by unemployed peasants seeking work. With flour already in short supply after a violent hailstorm had virtually destroyed the crop the previous summer, the price of bread almost doubled. As the Estates General opened, Louis was forced to appease the Third Estate in any way he could. First he "doubled the third," giving the Third Estate as many deputies as the other two estates combined. Then he was pressured to bring the three estates together to debate and "vote by head," each deputy having a single vote. Louis vacillated on this demand, but on June 17, 1789, the Third Estate withdrew

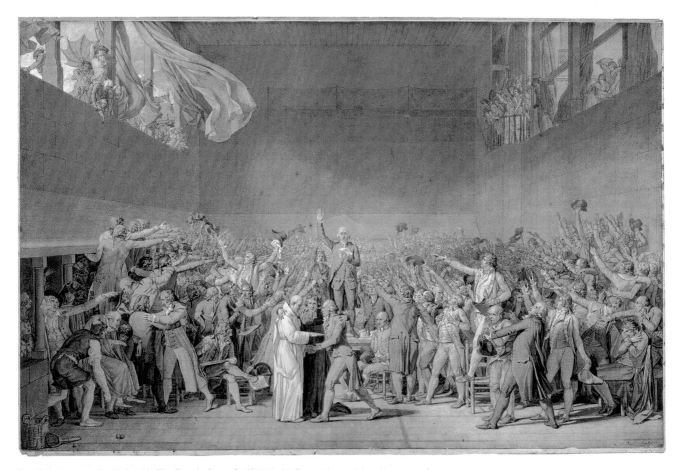

Fig. 26.3 Jacques-Louis David, *The Tennis Court Oath.* **1789–91.** Pen and brown ink and brown wash on paper, 26″ × 42″. Musée National du Château, Versailles. MV 8409: INV Dessins. Photo: Gerard Blot. RMN Réunion des Musées Nationaux/Art Resource, New York. Note how the figures in this painting, all taking an oath, stretch out their hands in the manner of David's earlier Neoclassical masterpiece, *The Oath of the Horatii* (see Fig. 26.17).

from the Estates General, declared itself a National Assembly, and invited the other two estates to join them.

A number of the First Estate, particularly parish priests who worked closely with the common people, accepted the Third Estate's offer, but the nobility refused. When the king banned the commoners from their usual meeting place, they gathered nearby at the Jeu de Paume [zhurd pohm], an indoor tennis court at Versailles that still stands, and there, on June 20, 1789, swore an oath never to disband until they had given France a constitution. Jacques-Louis David recreated the scene a year later in a detailed sketch for a painting that he would never finish, as events overtook its subjects (Fig. **26.3**). David's plan, like Trumbull's celebration of the signing of the Declaration of Independence, was to combine exact observation (he drew the major protagonists from life) with monumentality on a canvas where everyone would be life-size (many of his subjects would soon fall out of favor with the revolution itself and be executed). The "winds of freedom" blow in through the windows as commoners look on. At the top left, these same winds turn an umbrella inside out, signaling the change to come. In the middle of the room, the man who would soon become mayor of Paris reads the proclamation aloud. Below him a trio of figures, representing

each of the three estates, clasp hands as equals in a gesture of unity. At the actual event, all of the members of the National Assembly marched in alphabetical order and signed the Tennis Court Oath, except for one. He signed, but wrote after his name the word "opposed." David depicts him, an object of ridicule, seated at the far right, his arms folded despairingly across his chest. Faced with such unanimity, Louis gave in, and on June 27 ordered the noble and clerical deputies to join the National Assembly.

But the troubles were hardly over. While the harvest was good, drought had severely curtailed the ability of watermills to grind flour from wheat. Just as citizens were lining up for what bread was available, a false rumor spread through the Paris press that the queen, Marie Antoinette, had flippantly remarked, on hearing that the people lacked bread, "Let them eat cake!" The antiroyalists so despised the queen that they were always willing to believe anything negative said about her. Peasant and working-class women, responsible for putting bread on the table, had traditionally engaged in political activism during times of famine or inflation, when bread became too expensive, and would march on the civic center to demand help from the local magistrates. But now, on October 5, 1789, about

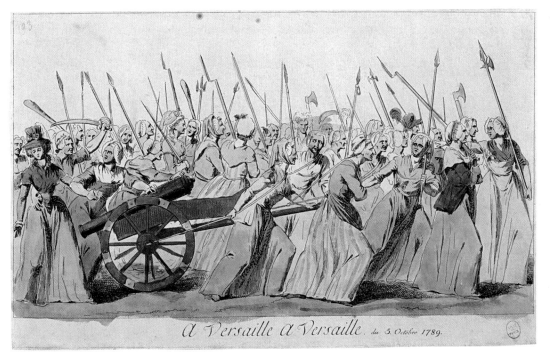

7,000 Parisian women, many of them armed with pikes, guns, swords, and even cannon, marched on the palace at Versailles demanding bread (Fig. **26.4**). The next day, they marched back to the city with the king and queen in tow. The now essentially powerless royal couple lived as virtual prisoners of the people in their Paris palace at the Tuileries.

The National Assembly, which also relocated to Paris after the women's march on Versailles, had passed, on August 26, 1789, the Declaration of the Rights of Man and Citizen. It was a document deeply influenced by Jefferson's Declaration of Independence, as well as the writings of John Locke. It listed 17 "rights of man and citizen," among them these first three, which echo the opening of the American document (**Reading 26.2**):

READING 26.2

from The Declaration of the Rights of Man and Citizen (1789)

1. Men are born and remain free and equal in rights. . . .
2. The aim of every political association is the preservation of the natural and imprescriptible [inherent or inalienable] rights of man. These rights are liberty, property, security, and resistance to oppression.
3. The principle of all sovereignty resides essentially in the nation. No body nor individual may exercise authority which does not proceed from the nation.

Due process of law was guaranteed, freedom of religion was affirmed, and taxation based on the capacity to pay was announced.

For a time, the king managed to appear as if he were co-operating with the National Assembly, which was busy drafting a constitution declaring a constitutional monarchy on the model of England. Then, in June 1791, just a couple of months before the new constitution was completed, Louis tried to flee France with his family, an act that seemed treasonous to most Frenchmen. The royals were evidently planning to join a large number of French nobility who had removed themselves to Germany, where they were actively seeking the support of Austria and Russia in a counterrevolution. A radical minority of the National Assembly, the **Jacobins** [zhak-oh-behns], had been lobbying for the elimination of the monarchy and the institution of egalitarian democracy for months. Louis's actions strengthened their position. When the Constitutional Convention convened, it immediately declared France a republic, the only question being just what kind. Moderates favored executive and legislative branches independent of one another and laws that would be submitted to the people for approval. But Jacobin extremists, led by Maximilien Robespierre [rohbz-pee-YAIR] (1758–1794), argued for what he called a "Republic of Virtue," a dictatorship led by a 12-person Committee for Public Safety, of which he was one of the members. A second Committee for General Security sought out enemies of the republic and turned them over to the new Revolutionary Tribunal, which over the course of the next three years executed as many as 25,000 citizens of France. These included not only royalists and aristocrats, but also good republicans whose moderate positions were in opposition to Robespierre. Louis XVI himself was tried and convicted as "Citizen Louis Capet" (the last of the Capetian dynasty) on January 21, 1793, and his queen, Marie Antoinette, referred to as "the widow

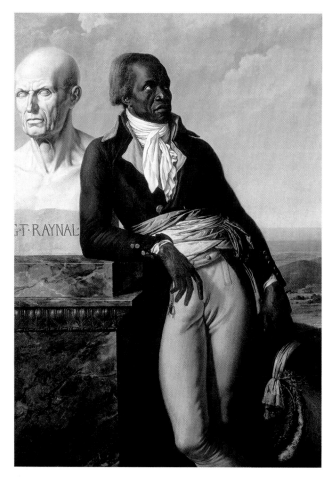

Fig. 26.5 Anne-Louis Girodet-Trioson, *Jean-Baptiste Bellay, Deputy from Santo Domingo*. 1797. Oil on canvas, 63″ × 45″. Musée National du Château de Versailles, France. Art Resource/Réunion des Musées Nationaux. Bellay delivered a strong speech to the Constitutional Convention pledging the support of his people to the French Revolution and asking the Convention to abolish slavery. His efforts helped convince the Convention to declare the liberty of all black people.

Capet," was executed ten months later (see Fig. 25.32). As Robespierre explained, defending his Reign of Terror:

> If virtue be the spring of popular government in times of peace, the spring of that government during a revolution is virtue combined with terror. . . . Terror is only justice prompt, severe and inflexible; it is then an emanation of virtue. . . .
>
> It has been said that terror is the spring of despotic government. . . . The government in revolution is the despotism of liberty against tyranny.

The Constitutional Convention instituted many other reforms as well. Some bordered on the silly—expunging the king and queen from the deck of cards and eliminating use of the formal *vous* ("thou") in discourse, substituting the informal *tu* ("you") in its place. Others were of greater import. The delegates banned slavery in all the French colonies, inspired by the contributions of representatives such as Jean-Baptiste Bellay [beh-LAY] (Fig. **26.5**, a former slave and one of three black delegates from Santo Domingo (now Haiti),

where slaves led by freed slave Toussaint-Louverture [too-SEHN loo-vair-tyoor] (ca. 1743–1803) had revolted in 1791. His portrait in the Neoclassical style by Anne-Louis Girodet [zhee-roh-DAY] (1767–1824), a student of Jacques-Louis David's, shows Bellay dressed in the French fashion and leaning against a bust of the Abbé Reynal [reh-NAHL]. With the assistance of *philosophe* Denis Diderot, Reynal had written a six-volume *Philosophical and Political History of the Settlements and Trades of the Europeans* (1770), which openly asserted the right of oppressed peoples in the colonies to revolt. Reynal's thinking paved the way for the convention's ban on slavery in the colonies. The painting is important as a tribute to Reynal and Bellay's egalitarian principles rather than as a great portrait of Bellay himself.

Another reform was the de-Christianization of the country, which required that all churches become "Temples of Reason." The calendar was no longer to be based on the year of the birth of Christ, but on the first day of the Republic. Year one began, then, on September 21, 1792. New names, associated with the seasons and the climate, were given to the months. "Thermidor," for instance, was the month of Heat, roughly late July through early August. Finally, the idea of the Sunday sabbath was eliminated, and every tenth day was a holiday.

Tensions remained high. On July 13, 1793, the day before the celebration honoring the storming of the Bastille, the Jacobin hero and fiery editor of *The Friend of the People*, Jean-Paul Marat (1743–1793), was assassinated in his bath, where he normally spent hours to treat a severe case of eczema. The assassin was Charlotte Corday [KOR-day], a young royalist who believed she was the new Joan of Arc, destined to liberate France from Jacobin radicalism. The Jacobins of the National Assembly asked David to paint a *Death of Marat* (Fig. **26.6**). This work is notable for its seemingly unflinching depiction of its hero at the moment of his brutal death and for David's ability to turn a lowly bathroom setting into a monumental image.

Marat had specifically designed a desk to fit over the bath to allow him to conduct business while attending to his terrible skin disease. The pose David chose for him is an instance of using a religious device for a secular image, for the revolutionary patriot confronts the viewer in a position reminiscent of the dead Christ at the Lamentation, traditionally depicted with his right arm dropping to his side. David also pushes Marat to the front of the picture plane so that the viewer seems to be in the same room with the body. Marat holds in one hand the letter from Corday that had gained her entry, and in the other his pen, with which he had been writing the note that hangs over the edge of the crate he used as a desk. The letter of introduction from Corday to Marat is partly legible. Translated from the French, it reads, "My unhappiness alone suffices to give a right to your good will." Her "unhappiness" was her distaste for Marat and the antiroyalist politics he represented, but Corday understood full well that Marat would misinterpret her meaning, supposing that she was complaining about the monarchy, not representing its interests.

When David presented the painting, on October 16, 1793, the day before Marie Antoinette was guillotined, he addressed the assembly in a remarkable speech:

> Hurry, all of you! Mothers, widows, orphans, oppressed soldiers, all whom he defended at the risk of his life, approach and contemplate your friend; he who was so vigilant is no more; his pen, the terror of traitors, his pen has slipped from his hand! Grieve! Our tireless friend is dead. He died giving you his last piece of bread; he died without even the means to pay for his funeral. Posterity, you will avenge him; you will tell our descendants how he could have possessed riches if he had not preferred virtue to fortune. . . .

In this image of self-enforced poverty, David has purposefully contrasted Marat's pen, which he holds in his right hand, with Corday's knife, on the floor beside him. The pen, "the terror of traitors," David seems to say, is mightier than the sword.

Marat's self-imposed poverty is represented by the *assignat* [ah-seen-YAH], French paper money, that lies on the writing table beside him. The accompanying note, translated, says, "You will give this *assignat* for the defense . . ." of a widow with five children whose father had died for his country, indicating that Marat is voluntarily giving up money for

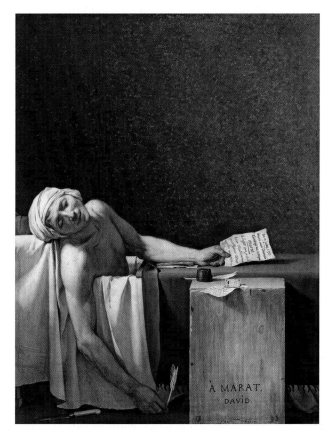

Fig. 26.6 Jacques-Louis David, *The Death of Marat*. 1793. Oil on canvas, 65″ × 50 1/2″. Musée Royal des Beaux-Arts, Brussels. David inscribed the makeshift writing table in trompe-l'oeil fashion, as if carved into the wood, "À MARAT DAVID"—"To Marat David"—his own name in smaller capital letters than his hero's, suggesting his own humility and that the work is an homage to the greater man.

a noble cause. The *assignat* is a sign of the same faith and conviction in the future of the republic that led Marat unsuspectingly to admit Charlotte Corday to his rooms.

The Reign of Terror ended suddenly in the summer of 1794. Robespierre pushed through a law speeding up the work of the Tribunal, with the result that in six weeks some 1,300 people were sent to death. Finally, he was hounded out of the Convention to shouts of "Down with the tyrant!" and chased to city hall. Here he tried to shoot himself but succeeded only in shattering his lower jaw. He was executed the next day with 21 others.

The last act of the convention was to pass a constitution on August 17, 1795. It established France's first bicameral (two-body) legislature, consisting of the Council of Five Hundred (modeled on the ancient Athenian Council of Five Hundred) and the Council of Elders. Only men who owned or rented property worth between 100 and 200 days' labor could serve as electors to choose the Councils, effectively limiting the number of voters to 30,000 people. The Council of Five Hundred nominated a slate of candidates to serve on a five-person executive Directory, and the Council of Elders, a smaller body, chose the five. Over the next four years, the Directory improved the lot of French citizens, but its relative instability worried moderates. So, in 1799, the successful young commander of the army, Napoleon Bonaparte (1769–1821), conspired with two of the five directors in the *coup d'état* that ended the Directory's experiment with republican government. This put Napoleon in position to assume control of the country.

THE RIGHTS OF WOMAN

It was obvious to most women in both revolutionary France and America that although the rights of "man" were forcefully declared, the rights of women were wholly ignored. Abigail Adams, in a letter to her husband in the spring of 1776, reminded him that

> if particular care and attention is not paid to the ladies we are determined to foment a rebellion, and will not hold ourselves bound by any laws in which we have no voice or representation.
>
> That your sex are naturally tyrannical is a truth so thoroughly established as to admit of no dispute, but such of yours as wish to be happy willingly give up the harsh title of master for the more tender and endearing one of friend. Why then not put it out of the power of the vicious and the lawless to use us with cruelty and indignity with impunity. Men of sense in all ages abhor those customs which treat us only as vassals of your sex. Regard us then as being placed by providence under your protection and in imitation of the Supreme Being make use of that power only for our happiness.

Sentiments such as these represent the dawn of the modern movement for gender equality. Although Adams expressed her feelings privately to her husband, other women, such as Olympe de Gouges in France and Mary Wollstonecraft in England, took a more public stand.

Olympe de Gouges: The Call for Universal Rights

Olympe de Gouges [duh goozh] (1748–1793) was one of the victims of the Reign of Terror. Born in the south of France to a butcher and a washerwoman, she moved to Paris after the death of her husband and began to write essays, manifestos, and plays concerning social injustice. She greeted the start of the French Revolution with enthusiasm, but when it became clear that equal rights to vote and hold political office were not being extended to women, she became disenchanted. In 1791 she joined a group of advocates for women's rights. In particular, they called for more liberal divorce laws that would grant women equal rights to sue for divorce, and for a revision of inheritance laws that would grant women equal rights in inheriting family property. In this haven of Enlightenment thinking de Gouges declared, "A woman has the right to mount the scaffold. She must possess equally the right to mount the speaker's platform." In that same year, she wrote a *Declaration of the Rights of Woman and the Female Citizen*, modeled on the Declaration of the Rights of Man and Citizen. It begins as follows (**Reading 26.3**):

READING 26.3

from Olympe de Gouges, *Declaration of the Rights of Woman and the Female Citizen* (1791)

Article I. Woman is born free and lives equal to man in rights. . . .

Article II. The purpose of any political association is the conservation of the natural and imprescriptible [inherent or inalienable] rights of woman and man; these rights are liberty, property, security, and especially resistance to oppression.

Article III. The principle of all sovereignty rests essentially with the nation, which is nothing but the union of woman and man; no body and no individual can exercise any authority which does not come expressly from it [the nation].

Article IV. Liberty and justice consist of returning all that belongs to others; thus, the only limits on the exercise of the natural rights of woman are perpetual male tyranny wielded; these limits are to be reformed by the laws of nature and reason. . . .

De Gouges also published a *Social Contract*, an intentionally radical revision of Jean-Jacques Rousseau's work of the same name proposing marriage based on male and female equality. De Gouges tirelessly lobbied the Constitutional Convention for passage of her *Declaration*, and as her efforts appeared fruitless, she became more vehement in her writings about injustice. (Most revolutionary males followed the thinking of Rousseau in *Émile* [see Chapter 25] and believed that the proper role for women remained in the home.) In 1793, the convention banned all women's clubs, ostensibly because of fights between women's club members and market women over proper revolutionary costume, but in reality because of widespread distaste for

women's involvement in political activity. Four days later the government put de Gouges to death. She was guillotined as a counterrevolutionary, for authoring a pamphlet arguing that the future government of the country should be determined by popular referendum, not by the National Convention.

Mary Wollstonecraft: An Englishwoman's Response to the French Revolution

Even as de Gouges was pleading her case before the Constitutional Convention, in England one of the great defenders of the French Revolution was Mary Wollstonecraft (1759–1797). She published *A Vindication of the Rights of Woman* in 1792, just a year before publishing her *History and Moral View of the Origin and Progress of the French Revolution*. The immediate incentive for the first of these two important publications was certain policies of the French Revolution unfavorable to women that were inspired by Rousseau. She accused Rousseau and others who supported traditional roles for women of trying to restrict women's experience and narrow their vision, thus keeping them as domestic slaves of men. Wollstonecraft, like Olympe de Gouges, broadened the agenda of the Enlightenment by demanding for women the same rights and liberties that male writers had been demanding for men. The tone of her attack is apparent in the following extract from the Introduction to *A Vindication* (**Reading 26.4**):

READING 26.4

from Mary Wollstonecraft, Introduction to *A Vindication of the Rights of Woman* (1792)

My own sex, I hope, will excuse me, if I treat them like rational creatures, instead of flattering their fascinating graces, and viewing them as if they were in a state of perpetual childhood, unable to stand alone. I earnestly wish to point out in what true dignity and human happiness consists—I wish to persuade women to endeavour to acquire strength, both of mind and body, and to convince them that the soft phrases, susceptibility of heart, delicacy of sentiment, and refinement of taste, are almost synonymous with epithets of weakness, and that those beings who are only the objects of pity and that kind of love, which has been termed its sister, will soon become objects of contempt.

Dismissing then those pretty feminine phrases, which the men condescendingly use to soften our slavish dependence, and despising that weak elegancy of mind, exquisite sensibility, and sweet docility of manners, supposed to be the sexual characteristics of the weaker vessel, I wish to show that elegance is inferior to virtue, that the first object of laudable ambition is to obtain a character as a human being, regardless of the distinction of sex. . . .

Liberty is the mother of virtue, and if women be, by their very constitution, slaves, and not allowed to breathe the sharp, invigorating air of freedom, they must ever languish like exotics, and be reckoned beautiful flaws in nature. . . .

Wollstonecraft's own personal life was not nearly as clearly organized as her arguments in *A Vindication*. During a turbulent affair with an American timber merchant, she mothered an illegitimate child and attempted suicide on at least two occasions. She married the novelist William Godwin (1756–1836) when she became pregnant by him, giving birth to a daughter Mary (1797–1851), the future wife of poet Percy Bysshe Shelley (1792–1822) and author of the novel *Frankenstein* (see Chapter 27). The placenta remained in Wollstonecraft's womb after the birth, and in 1797, at the age of 38, she died of blood poisoning resulting from her physician's attempt to remove it. But however troubled her personal life, the *Vindication of the Rights of Woman*, in contrast to the writings of her French contemporary Olympe de Gouges, was deeply influential. In many ways, Wollstonecraft fashioned the main points of what would later become the liberal feminist movement, arguing not for a radical restructuring of society, but for the right of women to access the same social and political institutions as men. She demanded, simply, equal opportunity.

THE NEOCLASSICAL SPIRIT

By the end of the eighteenth century, Neoclassicism had in many ways become an international style, dominating taste across Europe and extending to the newly formed United States. That a taste for classical order and calm would grow to major proportions in the last half of the eighteenth century is hardly surprising. Europe and America both needed a respite from the political and social chaos of the period. In Paris, Neoclassicism supplanted the ornate, decorative—and, in some minds, dissolute—styles of the Baroque and Rococo, the styles that, in fact, had been the hallmark of monarchical taste. In the United States, the classical style was seen as the direct expression of democracy itself.

Neoclassicism in Britain and America

The founders of the newly created United States of America modeled their new republic on classical precedents. Theirs would be a Neoclassical society—a stable, balanced, and rational culture that might imitate their admittedly idealized view of Rome and Athens. After the Federal Convention presented the states with a new constitution to replace the six-year-old Articles of Confederation on October 27, 1787, a series of 85 articles appeared that came to be known as *The Federalist*, arguing for ratification. They were signed "Publius," a collaborative pseudonym in honor of Publius Valerius Publicola (d. 503 BCE), whose surname means "friend of the people" and who is generally considered one of the founding fathers of the Roman Republic. The authors were actually Alexander Hamilton (1757–1804), John Jay (1745–1829), and James Madison (1751–1836). More than any other delegate to the convention, Madison had been responsible for drafting the constitution itself, and his inspiration came from ancient Greece and Rome. (Among his papers was a list of books he thought were essential for understanding the American political system, among them Edward Gibbon's *On the Decline of the Roman Empire*, Basil Kennett's *Antiquities of Rome*, Plutarch's *Lives*, Plato's *Republic*, and Aristotle's *A Treatise on Government*.)

Federalist No. 10, written by Madison, sums up the chief issue facing adoption of his new constitution—its argument for a centralized and strong federal government. To many, this appeared to be nothing short of a sure path to despotism. The country had fought a war in order to shake off one strong government. Why should it put itself under the yoke of another? Madison's key contribution revolved around his analysis of "factions": "A zeal for different opinions concerning religion, concerning Government and many other points . . . an attachment to different leaders ambitiously contending for pre-eminence and power . . . have divided mankind into parties, inflamed them with mutual animosity, and rendered them much more disposed to vex and oppress each other, than to co-operate for their common good." But Madison understood that in a large republic, these factions counteract each other. As a result, at the heart of the constitution was a system of checks and balances to guarantee that no faction or branch of government—each of which was vested with different, and sometimes opposing powers—could wield undue power over any other.

The fledgling United States also embraced Neoclassicism as an architectural style, both as a reflection of its classically inspired political system and to give a sense of ancient stability to the new republic. Many of the founding fathers had traveled extensively in Europe, where they viewed the antiquities of Greece and Rome and many of the later works inspired by them. As a young man, Thomas Jefferson had dreamed of taking the Grand Tour, the capstone experience of any Briton's formal education. The Grand Tour could last anywhere from a few months to a few years. It included visits to Paris, Florence, Pisa, Bologna, and Venice, followed by a journey to Rome, Naples, and the ruins of Herculaneum and Pompeii. Travelers would then go on to German-speaking cities, Holland, and Belgium. Although Jefferson never completed the Grand Tour, after his appointment as minister to the court of the French king, Louis XVI, in 1784, he traveled extensively. With John Adams, he toured the gardens and estates of England, visiting Stowe (see Chapter 25), Alexander Pope's garden at Twickenham, and other sites. Later, Jefferson visited Northern Italy and France, where he marveled at the Roman ruins (and also developed a deep enthusiasm for French wine). Jefferson also well knew that the next best thing to visiting the sights of Europe was to read about them.

Among the recently published books that described the antiquities of Rome and Athens, one of the most compelling was Johann Winckelmann's *History of Ancient Art* (1764)—the first book to include the words *history* and

art in its title. While working as the Prefect of Papal Antiquities in Rome, Winckelmann (1717–1768) saw and described the vast collection of antique classical art at the Vatican as possessing "a noble simplicity and quiet grandeur." Capturing this same simplicity and grandeur became the primary aim of artists and architects whose works came to be known as Neoclassical. In fact, the taste for these values was enormous, and so was the market for classical objects.

The British Influence: Robert Adam and Josiah Wedgwood

The rise of Neoclassical architecture in the United States was directly inspired by the architectural practice of Robert Adam (1728–1792) in England. Adam and his brother James had taken the Grand Tour in 1754, including visits to Pompeii and Herculaneum. What they saw inspired an

CONTINUITY&CHANGE

Arch of Constantine, p. 256

architectural style that interpreted and organized classical architectural forms and decorative motifs in innovative new ways. Adam's designs were so popular that he became the most sought-after architect of the day. He and his brother James employed a permanent staff that designed every detail of a house, both outside and in. His work was so influential that his Neoclassical style became more commonly known in England as the **Adam style**.

Adam's motifs came from a variety of antique sources. His facade for the south front of Lord Scarsdale's country house, Kedleston [KED-ul-stun] Hall in Derbyshire [DAR-bee-shir] (Fig. **26.7**), for instance, is a direct copy of the Arch of Constantine in Rome (see Fig. 8.7) but elevated on a platform with wings on each side and approached by a magnificent open-ended oval staircase. Adam filled the interior with opulent marbles, stucco decoration, Corinthian colonnades, and alcoves to contain sculpture copied from the ancients. He also decorated the walls with copies of ancient medallions, plaques, and other motifs that evoked what he labeled his "antique style." He placed a replica of the *Apollo Belvedere* at the far end of the Marble Hall (Fig. **26.8**), designed to suggest the open courtyard of a Roman villa. (See Fig. 6.27.)

House of the Silver Wedding, p. 203

Very often Adam decorated his interiors with the ceramics of Josiah Wedgwood, not the common earthenware that Wedgwood mass-produced known as Queen's Ware (see Chapter 24), but his stoneware known as **jasperware**, ornamented in Neoclassical style with a white relief on a colored ground. His primary markets were his native England, Russia, France, and North America. The latter was especially lucrative, as Wedgwood explained in a letter to a friend: "For the islands of North America we cannot make anything too rich and costly."

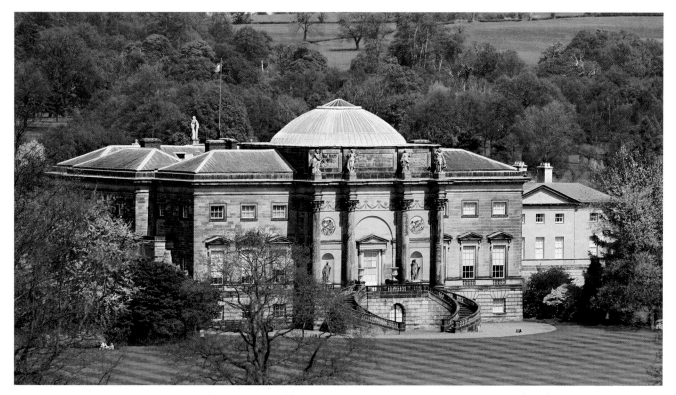

Fig. 26.7 Robert Adam, south front of Kedleston Hall, Derbyshire, England. ca. 1765–70. Not only did the Adam architectural firm design every aspect of a house—at no small expense—it also owned interests in timber, brick, cast iron, stone, stucco, and sand businesses. In essence, the firm was a high-end developer, employing over 2,000 people.

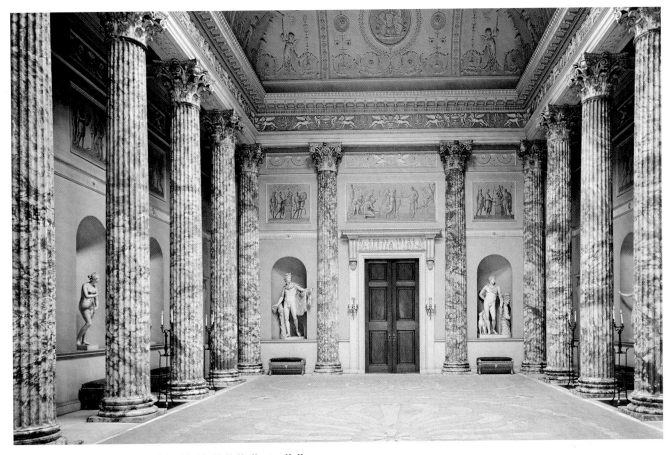

Fig. 26.8 Robert Adam, interior of the Marble Hall, Kedleston Hall, Derbyshire, England. ca. 1765–1770. 67′ × 42′. John Bethell. The Bridgeman Art Library. The *Apollo Belvedere*, which stands in the left niche at the end of the hall, was perhaps the most copied statue from Greek and Roman antiquity. Above the niches and door are panels with classical subjects.

Most of the relief designs on the vases were by sculptor and draftsman John Flaxman (1755–1826). Flaxman's design for a vase depicting the Muses (Fig. **26.9**) was modeled on an ancient Roman household altar. The design is divided into six sections by columns. The three Muses—Thalia, Urania, and Erato—fill three of these sections, alternating with symbols representing Jupiter (thunderbolt), Mars (spear and helmet), and Mercury (caduceus, or winged staff). Flaxman's designs echo the flat vase painting of the original designs in their own extreme linearity and their extremely low relief, barely raised sculptural surfaces. This planarity and linearity became synonymous with Neoclassicism itself as the Wedgwood manufactury popularized the Neoclassical look.

American Neoclassical Architecture The Neoclassical style of architecture dominated the architecture of the new American republic, where it became known as the **Federal style**. Its foremost champion was Thomas Jefferson. Like almost all leaders of the American colonies, Jefferson was well educated in the classics and knew well such works as Stuart and Revett's *Antiquities of Athens* (1758) and Adam's

Fig. 26.9 John Flaxman, Wedgwood vase. Late eighteenth century, ca. 1780–1800. Made by Josiah Wedgwood and Sons, Etruria/Staffordshire, England. Jasperware: height 6 ½″; diameter 5 ⅛″. Metropolitan Museum of Art, New York, Rogers Fund, 1909 (09.194.79). Depicted here is Urania, muse of astronomy, contemplating a globe.

Fig. 26.10 Thomas Jefferson, Monticello, Charlottesville, VA. 1770–84, 1796–1806. The colonnade at the entrance to Jefferson's Monticello, itself modeled on the work of Robert Adam, would inspire the architecture of countless antebellum Southern mansions.

Works in Architecture (3 volumes, 1773–82). His taste for the classical would affect the design, the furniture, and even the gardens at his home outside Charlottesville, Virginia (Fig. **26.10**). For the convenience of getting goods to the marketplace, most American estates had been located near rivers. Jefferson located his on the top of a hill, the traditional site for a Greek or Roman temple. He called the place Monticello [mon-tih-CHEH-loh], or "little mountain." He designed the building himself after the villas of Andrea Palladio (see Fig. 15.30) but augmented with features he had seen in France when he served as American minister there, such as French doors and tall, narrow windows, and the use of a balustrade above the cornice to mask the second story. The facade, with its six Corinthian columns and classical pediment, is modeled on the work of Robert Adam. He also decorated the fireplace of the Monticello dining room with Wedgwood panels (Fig. **26.11**).

The house was surrounded by an English garden similar to the one he had seen at Stowe (see Fig. 25.13) when he traveled with his friend John Adams. Its meandering hilltop pathway opened to vistas of the surrounding Virginia countryside. An accomplished gardener, in characteristic Enlightenment fashion, Jefferson documented the plants and animals of the entire Virginia region, cataloguing his findings in a volume that remains useful to Virginia gardeners to this day.

Jefferson's Neoclassical tastes were not limited to his private life. He designed the Virginia State Capitol in Richmond, Virginia, which was, first of all, a "capitol," the very name derived from Rome's Capitoline Hill. The building

Fig. 26.11 Thomas Jefferson, dining room with Wedgwood reliefs, Monticello, Charlottesville, VA. 1770–1784, 1796–1806. Jefferson kept books on this mantelpiece, and often read into the evening in front of this fireplace.

Fig. 26.12 Benjamin Henry Latrobe, *View of Richmond Showing Jefferson's Capitol from Washington Island.* 1796. Watercolor on paper, ink and wash, 7″ × 10³/₈″. Maryland Historical Society, Baltimore. No view of an American capitol in the eighteenth century better captures the almost audacious aspirations of the new nation.

(Fig. **26.12**) is a literal copy of the Maison Carrée [may-ZOHN kah-RAY] in Nîmes [neem], France, a Roman temple built in the first century BCE (Fig. **26.13**). The view of Richmond by Jefferson's disciple, architect Benjamin Henry Latrobe (1764–1820), gives some idea of the lack of harmony between the American landscape, in all its rustic and undeveloped expanse, and Jefferson's Neoclassical and highly cultivated vision. To prevent other such incongruities, Jefferson had proposed in 1785 that Congress pass a land ordinance requiring all new communities to be organized according to a grid. The measure—actually a call to order—resulted in a regular system of land survey across the American continent. It effectively installed a Neoclassical pattern on the American landscape.

The nation's new capitol in Washington, D.C., would, however, modify Jefferson's rectilinear scheme. President Washington believed that the swampy, humid site along the Potomac River required something more magnificent, so he hired Major Pierre-Charles L'Enfant [lahn-FAHN] (1754–1825) to create a more ambitious design. The son of a court painter at Versailles, L'Enfant had emigrated to America from Paris in 1776 to serve in the

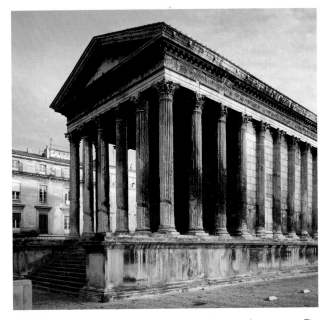

Fig. 26.13 Maison Carrée, Nîmes, France. Early second century CE. The six Corinthian columns across the front of this ancient temple may also have inspired the entrance to Monticello.

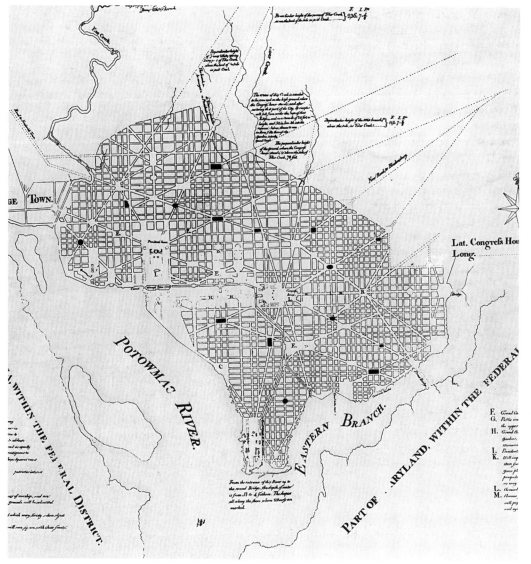

Fig. 26.14 Pierre-Charles L'Enfant, plan for Washington, D.C. (detail). 1791. Published in the *Gazette of the United States*, Philadelphia, January 4, 1792. The Bridgeman Art Library. Engraving after the original drawing, Library of Congress, Washington, D.C. The architect, L'Enfant, had served as a volunteer in the Revolutionary War. He also designed Federal Hall in New York City, which hosted the first Continental Congress in 1789.

Continental Army. His plan (Fig. **26.14**) is a conscious echo of the diagonal approaches and garden pathways at Versailles (see Fig. 23.4), superimposed upon Jefferson's grid. The result is an odd mixture of angles and straightaways that mirrored, though unintentionally, the complex workings of the new American state. Visiting in 1842, a half century later, English novelist Charles Dickens would be struck by the city's absurdity: "Spacious avenues . . . begin in nothing, and lead nowhere; streets, mile-long, that only want houses, roads, and inhabitants; public buildings that need but a public to be complete." It was, he wrote, a city of "Magnificent Intentions," as yet unrealized. Like the Latrobe painting of the capitol in Richmond, the city somewhat oddly combined Neoclassical cultivation with what might be called rural charm. Latrobe, in fact, was hired to rebuild the Capitol Building

CONTINUITY & CHANGE

Corinthian capital, p. 115

after the British burned it during the War of 1812. He invented a new design for the capitals of the Corinthian columns in the vestibule and rotunda of the Senate wing, substituting corncobs and tobacco for the Corinthian's acanthus leaves (Fig. **26.15**).

Neoclassical Sculpture in America During Jefferson's stay in France as minister to the court of Louis XVI, he became acquainted with the work of the two great Neoclassical sculptors of the day, the Italian Antonio Canova (1757–1822) and his French rival Jean-Antoine Houdon [oo-DOHN] (1741–1828). At Jefferson's recommendation, the Virginia Assembly commissioned Houdon in 1785 to create a full-length marble statue of George Washington for the Virginia State Capitol at Richmond. Convinced that a true likeness could only be achieved from life, Jefferson insisted that Houdon sail to America from France. Houdon traveled to Mount Vernon, Washington's Virginia estate, to

make a cast of the general's bust in plaster; the rest of the body would be created from traditional plaster models. He finished the sculpture in Paris in 1788, the year before Washington's inauguration as the first president of the United States (Fig. 26.16). Although Washington wears contemporary clothing, Houdon presents him as Cincinnatus [sin-sih-NAH-tus], the ancient Roman general who had returned to farming after a life of military service for his country, in the same way that the Roman poet Horace had done (see Chapter 6). The medal of the Order of Cincinnatus, an organization created by retiring officers after the Revolutionary War, projects from under Washington's waistcoat. He leans against a column of 13 *fasces*, or rods, symbols of Roman political office as well as the 13 colonies of the new nation. Behind him is a plowshare, beaten from a sword, signifying his role as a warrior who has brought peace and prosperity to his people. Washing-

CONTINUITY & CHANGE

Head of a Man, p. 182

ton's relaxed *contrapposto* pose and serene but dignified facial expression derive from classical statues and suggest the high moral purpose, or *gravitas*, of a Roman senator; they successfully link the father of his country—*pater patriae*, "father of the fatherland"—with the ancient leaders who preceded him.

Years later, when the North Carolina legislature decided to place a sculpture of Washington in the rotunda of their state house, Jefferson recommended

Fig. 26.16 Jean-Antoine Houdon, ***George Washington.*** **1788.** Marble, life-size. Virginia State Capitol, Richmond. Houdon also sculpted busts of Benjamin Franklin and Thomas Jefferson.

Fig. 26.15 Benjamin Henry Latrobe, tobacco leaf capital for the U.S. Capitol, Washington, D.C. ca. 1815. Despite this unique design, Latrobe used more traditional capitals elsewhere in the Capitol. For the Supreme Court area of the building, he designed Doric capitals in proportions similar to those at Paestum (see Fig. 4.16).

another sculptor, Canova. Jefferson insisted that the sculpture should depict Washington as a Roman senator, since, he wrote, "Our boots and regimentals have a very puny effect." Since the hall of the capitol in Raleigh was only 16 feet high, Washington was to be seated, attired in senatorial toga and sandals, signing the letter relinquishing command of the army, his sword at his feet. The sculpture stood in the capitol for ten years, until a fire destroyed both. But early in the twentieth century, Canova's original model was discovered and the Italian government donated the plaster replica to North Carolina.

Jacques-Louis David and the Neoclassical Style in France

No artist more fully exemplifies the values of Neoclassicism in France than the painter Jacques-Louis David (1748–1825). His career stretches from pre-Revolutionary Paris, through the turmoil of the Revolution and its aftermath, and across the reign of Napoleon Bonaparte. He was, without doubt, the most influential artist of his day. "I do not feel an interest in any pencil but that of David," Thomas Jefferson wrote in a flush of enthusiasm from Paris during his service as minister to the court of Louis XVI from 1785 to 1789. And artists flocked to David's studio for the privilege of studying with him. In fact, many of the major artists of the following century had been his students, and those who had not been such defined themselves against him.

David abandoned the traditional complexities of composition that had defined French academic history painting since at least the time of Rubens's series of paintings depicting the life of Marie de' Medici (see Fig. 23.6) and substituted a formal balance and simplicity that is fully Neoclassical. His work has a frozen quality to emphasize rationality, and the brushstrokes are invisible, to create a clear focus and to highlight details. At the same time, his works have considerable emotional complexity. A case in point is his painting *The Oath of the Horatii* (Fig. **26.17**), commissioned by the royal government in 1784 to 1785. The story derives from a play by French playwright Corneille (see Chapter 23), and is a sort of parable or example of loyal devotion to the state. It concerns the conflict between early Rome, ruled by Horatius [hor-AY-shus], and neighboring Alba, ruled by Curatius [kyoor-AY-shus]. In order to spare a war that would be more generally destructive, the two

Fig. 26.17 Jacques-Louis David, *The Oath of the Horatii*. 1784–85. Oil on canvas, 10'10" × 13'11^1/$_2$". Musée du Louvre, Paris. RMN Réunion des Musées Nationaux, France/Art Resource, New York. Corneille's play *Horace* inspired the painting (see Chapter 23).

LEARN MORE Gain insight from a primary source document on Jacques-Louis David at **www.myartslab.com**

leaders agreed to send their three sons—the Horatii [hor-AY-shee-eye] and the Curatii [kyoor-AY-shee-eye]—to battle each other. David presents the moment *before* the battle when the three sons of Horatius swear an oath to their father, promising to fight to the death. The sons on the left, the father in the middle, and the sisters to the right are each clearly and simply contained within the frame of one of three arches behind them. Except for Horatius's robe, the colors are muted and spare, the textures plain, and the paint itself almost flat. The male figures stand rigidly in profile, their legs extending forward tensely, as straight as the spear held by the foremost brother, which they parallel. Their orderly Neoclassical arrangement contrasts with that of the women, who are disposed in a more conventional, Baroque grouping. Seated, even collapsing, while the men stand erect, the women's soft curves and emotional despair contrast with the male realm of the painting. David's message here is that civic responsibility must eclipse the joys of domestic life, just as reason supplants emotion and classical order supplants Baroque complexity. Sacrifice is the price of citizenship (a message that Louis XVI would have been wise to heed).

David's next major canvas, *The Lictors Returning to Brutus the Bodies of his Sons*, was painted in 1789, the year of the Revolution but before it had begun. It is a more complex response to the issues of sacrifice for the state. The painting shares with the *Oath of the Horatii* the theme of a stoic father's sacrifice of his sons for the good of the state, as

Brutus's lictors (the officers in his service as ruler) return the sons' bodies to him after their execution. Although received by the public in 1789 as another assertion of the priority of the republic over the demands of personal life, the painting is emotionally far more complex. That is, it seems to question the wisdom of such acts of heroism (see *Closer Look*, pages 856–857). Although, as we have seen, David would serve the new French Republic with verve and loyalty as its chief painter after the Revolution, his paintings are rarely as straightforward as they at first appear. In David's work, it would seem, the austerity of the Neoclassical style is something of a mask for an emotional turbulence within, a turbulence that the style holds in check.

Angelica Kauffmann and Neoclassical Motherhood. *Cornelia Pointing to Her Children as Her Treasures*, painted in 1785 by Swiss-born Angelica Kauffmann (1741–1807), depicts a popular subject among late-eighteenth-century Neoclassical painters (Fig. **26.18**). Cornelia was the daughter of the Roman hero Scipio Africanus, the Roman general who defeated Hannibal in 202 BCE, and she is remembered as the model of Roman motherhood. In this painting, Cornelia responds to a visiting lady who had been showing Cornelia her jewels. When the visitor asks to see Cornelia's jewels, Cornelia points to her two sons and says, "These are my most precious jewels." The two sons, as Kauffmann's audience knew, would one day be great reformers of the Roman Republic, leading the effort to

Fig. 26.18 Angelica Kauffmann (born Swiss, 1741–1807), *Cornelia Pointing to Her Children as Her Treasures.* **ca. 1785.** Oil on canvas, 40 in. H × 50 in. W (101.6 × 127.0 cm). Signed on base of column at right: Angelica Kauffmann Pinx. Virginia Museum of Fine Arts, Richmond. The Adolph D. and Wilkins C. Williams Fund. Photo: Ann Hutchison. © Virginia Museum of Fine Arts. 75.22/50669.2. Kauffmann is unique in being the only female artist of the eighteenth century who became a successful history painter.

The French monarchy commissioned Jacques-Louis David to create *The Lictors Returning to Brutus the Bodies of His Sons*, and it was exhibited in 1789, just six weeks after the storming of the Bastille. As a result, the public closely identified it with the cause of the French Republic. The hero of the historical tale that is the subject of this painting is the founder of the Roman Republic, Lucius Junius Brutus (sixth century BCE; not to be confused with the Brutus who would later assassinate Julius Caesar). He had become head of Rome and inaugurated the republic by eliminating the former monarch, Tarquinius, who himself had assumed the throne by conspiring with the wife of the former king. She murdered her husband, and he his own wife, and the two married. Brutus's sons had conspired to restore the monarchy—their mother was related to Tarquinius—and under Roman law Brutus was required not only to sentence them to death but to witness the execution.

In David's painting, Brutus sits in shadow at the left, his freshly beheaded sons passing behind him on stretchers carried by his lictors (officers who served rulers). Brutus points ignominiously at his own head, as if affirming his responsibility for the deed, the sacrifice of family to the patriotic demands of the state. In contrast to the darkened shadows in which Brutus sits, the boys' mother, nurse, and sisters await the bodies in a fully lighted stage space framed by a draperied colonnade. The mother reaches out in a gesture reminiscent of Horatius's in the *Oath of the Horatii*. The nurse turns and buries her head in the mother's robe. One of the sisters appears to faint in her mother's arms, while the other shields her eyes from the terrible sight. Their spotlit anguish emphasizes the high human cost of patriotic sacrifice, whereas the *Oath of the Horatii* more clearly celebrates the patriotic sacrifice itself.

This shift in David's emphasis can be at least partly explained by his own biography. Early in 1888, his favorite apprentice, Jean-Germain Drouais, died of smallpox at the age of 25 (see Fig. 32.6). David was devastated by this loss of one of the best young painters in France. (Drouais was a winner of the Prize of Rome, which sent him to study in that city for five years.) *The Lictors* probably reflects the strength of David's feelings for his young companion.

Jacques-Louis David, details from *The Lictors Returning to Brutus the Bodies of His Sons*. 1789. Oil on canvas, 10'7 1/$_4$" × 13'10 1/$_4$". Musée du Louvre, Paris. RMN Réunion des Musées Nationaux, France. Gerard Blot/C. Jean/Art Resource, New York. Brutus's emotional exile from his proper place at the table as patriarch is emphasized by the subtle analogy that David draws between Brutus's own toes and the scrolling decoration at the base of the table where once he sat.

SEE MORE For a Closer Look at Jacques-Louis David's *The Lictors Returning the Bodies of His Sons*, go to **www.myartslab.com**

The **statue of Roma** represents the state and is darkened to suggest the turmoil that Rome is enduring.

The **Doric order** of the architecture underscores the severity of the scene and represents the reasonable and rational order of the Roman Republic—the very model of the new French Republic about to be born.

David reverses the structure of the *Horatii* by having Brutus's wife extend her hand as Horatius does in the earlier painting. Now the women stand, and the males sit (or lie dead). Female emotion stands triumphant over the demands of reason.

Much of the emotional tension of the painting derives from the contrast between the rigorous scientific perspective of the composition, most explicit in the floor tiles, and the soft, falling curves of the drapes and women's clothing.

This **central column** extends to the top of the painting, separating Brutus from his family and emphasizing the great gulf between them.

The graceful curve that defines the back of the empty chair in front of the central column suggests the powers of human feeling, compassion, and love. The chair is surely Brutus's own, from which he has been exiled.

The relief portraying the legend of the founders of Rome, **Romulus and Remus,** suckled by a wolf suggests how, at its origin, the Roman republic was integrally connected to the importance of family, especially after the rise of Augustus.

Something to Think About ...

How would you compare the emotional impact of this painting to that of David's *Death of Marat* (see Fig. 26.6)? How might the original audience of *Death of Marat*, depending upon its politics, have found itself in a position similar to either Brutus or his family?

Jacques-Louis David, *The Lictors Returning to Brutus the Bodies of His Sons.* **1789.** Oil on canvas, 10′7 1/4″ × 13′10 1/4″. Musée du Louvre, Paris. RMN Réunion des Musées Nationaux, France. Gerard Blot/C. Jean/Art Resource, New York.

redistribute to the poor the public lands that had been taken over by the rich.

Cornelia is at the center of the composition, balancing the painting's two halves. This balance is emphasized by the fold down the front of her dress, the line of which extends directly up the side of the square column behind her. Cornelia recognizes that her children represent the future of the state and hence her care for them is her greatest civic responsibility. What most distinguishes Kauffmann's painting is that it thus carries the weight and force of historical narrative even as it extols the virtues of motherhood.

Kauffmann was a great portraitist herself, in fact one of the most sought-after of the day. With Sir Joshua Reynolds, she was also one of the founding members of England's Royal Academy of the Arts. Kauffmann and her husband were employed by the architect Robert Adam (see Chapter 31) to decorate the homes he designed for the English aristocracy with ceiling and wall paintings illustrating historical themes. It is her dedication to painting historical subjects that earned her the admiration of her contemporaries, a rare feat for women artists in the eighteenth century.

NAPOLEON AND NEOCLASSICAL PARIS

Women's dissatisfaction with the outcome of the French Revolution was one of many problems facing the government. In fact, turbulence was the political reality of post-Revolutionary France. The Directory was not providing stability. On November 9 and 10, 1799, Napoleon Bonaparte staged a veritable **coup d'état** (violent overthrow of government) and forced three of the Directory's five directors to resign, barely managing to persuade the councils to accept himself and the two remaining directors. It was the threat of economic and international chaos—including a new coalition formed against France by England, Austria, Russia, and the Ottomans—that guaranteed his success. Order was the call of the day, and Napoleon was bent on restoring it. To this purpose he turned to models from classical antiquity.

The Consulate and the Napoleonic Empire: 1799–1814

Napoleon's coup d'état was intended to overthrow the existing constitution that the Directory had approved. The new constitution that he put in its place created a very strong executive called the Consulate, modeled on ancient Roman precedents. Composed of himself and the two directors, it established Napoleon as First Consul of the French Republic, relegating the other two to mere functionary status. The constitution also established something of a sham legislature composed of four bodies: a Council of State to propose laws; a Tribunate to debate them (though not vote on them); a Legislative Corps to vote (though not debate); and a Senate, which possessed the right to veto any legislation. The First Consul appointed the Council of State, and thus it proposed laws as Napoleon decreed. It was understood that the duty of the other three bodies was to "rubber stamp" the First Consul's wishes. France's experiment with a republican form of government was over.

By 1802, Napoleon had convinced the legislators to declare him First Consul of the French Republic for life, with the power to amend the constitution as he saw fit. In 1804, he instigated the Senate to go a step further and declare that "the government of the republic is entrusted to an emperor." This created the somewhat paradoxical situation of a "free" people ruled by the will of a single individual.

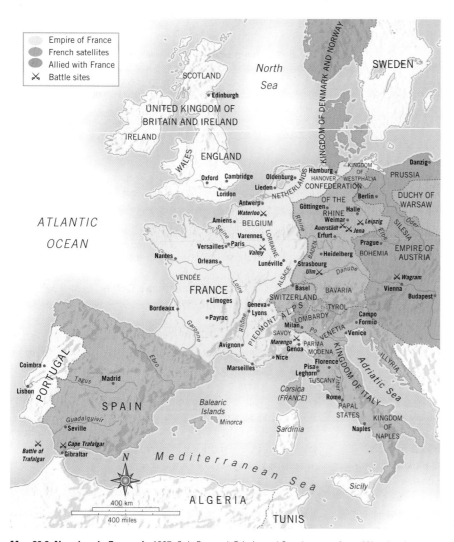

Map 26.2 Napoleonic Europe in 1807. Only Portugal, Britain, and Sweden were free of Napoleonic domination. Sicily and Sardinia, in the Mediterranean, were protected by the British fleet.

But Napoleon was careful to seek the consent of the electorate in all of these moves. When he submitted his constitution and other changes to the voters in a plebiscite, they ratified them by an overwhelming majority.

Napoleon justified voter confidence by moving to establish stability across Europe by force. To this end, in 1800 he crossed into Italy and took firm control of Piedmont and Lombardy. After establishing a position in Italy, he prepared to invade England, his chief enemy. Financed in no small part by the sale of the Louisiana Territory to the United States in 1803 for 80 million francs (roughly $16 million), Napoleon assembled over 100,000 troops and a thousand landing craft on the straits of Dover. His tactics were arguably flawless, but they were not executed as planned. In order to cross the Channel, he needed to lure away Vice Admiral Horatio Nelson (1758–1805), commander of the British fleet. To this end, in the fall of 1805, he dispatched the French fleet to the West Indies under the command of Admiral Pierre de Villeneuve. The plan was for Villeneuve to give Nelson the slip and return to escort the French army across the Channel. But Nelson caught up to Villeneuve off Cape Trafalgar near the southwest corner of Spain in October and, at the cost of his own life, destroyed nearly half the French fleet without the loss of any of his own ships.

Although Napoleon never defeated the British navy—and thus never controlled the seas—from 1805 to 1807 he launched a succession of campaigns against Britain's allies, Austria and Prussia. He defeated both, and by 1807 the only European countries outside Napoleon's sphere of influence were Britain, Portugal, and Sweden. Through ten years of war and short periods of armed truce, Napoleon changed the map of Europe (see Map **26.2**). Everywhere he was victorious, he brought the reforms that he had established in France and overturned much of the old political and social order. Eventually the subdued lands became resentful. A series of military defeats, including the so-called Battle of the Nations at Leipzig in October 1813, led to his abdication and exile and then final defeat by the English under the Duke of Wellington and the Prussians under Field Marshall von Blücher at Waterloo, Belgium, on June 18, 1815.

Art as Propaganda: Painting, Architecture, Sculpture

Napoleon celebrated major events by commissioning paintings, sculpture, and architecture. The paintings and sculptures were prominently displayed in public settings and the architecture was situated at important junctions in Paris. All were meant to present the physically small but extremely ambitious man as hero and leader of France or to remind the public of his efforts on their behalf. The Neoclassical style was perfect for these purposes. It was already associated with the republicanism and liberty of the French Revolution, and it could easily be adapted to the needs of empire and authority. So Napoleon adopted it as First Consul and continued to

Fig. 26.19 Jacques-Louis David, *Napoleon Crossing the Saint-Bernard.* 1800–01. Oil on canvas, 8'11" × 7'7". Musée National du Château de la Malmaison, Rueil-Malmaison, France. RMN Réunion des Musées Nationaux/Art Resource, New York. David would claim to everyone, "Bonaparte is my hero!" This is one of five versions of the painting, which differ significantly in color, painted by David and his workshop. There are also many copies in French museums and elsewhere done by others.

do so after he crowned himself emperor in 1804. Contributing to these efforts were the painters Jacques-Louis David and Jean-Auguste-Dominique Ingres [eng], the architect Pierre-Alexandre Vignon [veen-YOHN], and the sculptor Antonio Canova [kuh-NOH-vah].

David as Chronicler of Napoleon's Career David, who had survived the revolutionary era and painted many of its events, went on to portray many of the major moments of Napoleon's career. He celebrated the Italian campaign in *Napoleon Crossing the Saint-Bernard* (Fig. **26.19**). Here he depicts Napoleon on horseback leading his troops across the pass at Saint-Bernard in the Alps. In its clearly drawn central image and its emphasis on right angles (consider Napoleon's leg, the angle of his pointing arm to his body, the relation of the horse's head and neck, and the angle of its rear legs), the painting is fully Neoclassical. In the background, as is typical of David, is a more turbulent scene as Napoleon's troops drag a cannon up the pass. In the foreground, inscribed on the rocks, are the names of the only generals who crossed the Alps into Italy: Hannibal, whose brilliance in defeating the Romans in the third century BCE Napoleon sought to emulate; Karolus Magnus (Charlemagne); and Napoleon.

Actually, Napoleon did not lead the crossing of the pass but crossed it with his rear guard, mounted on a mule led by a peasant. So the work is pure propaganda, designed to create a proper myth for the aspiring leader. Though still four years from crowning himself emperor, the First Consul's aspirations to unite Europe and rule it are made clear in his identification with the great Frankish emperor of the Holy Roman Empire, Charlemagne. Napoleon was boldly creating a myth that is probably nowhere better expressed than by the great German philosopher Georg Wilhelm Friedrich Hegel [HAY-gul] (1770–1831) in a letter of October 13, 1806: "I have seen the emperor, that world soul, pass through the streets of the town on horseback. It is a prodigious sensation to see an individual like him who, concentrated at one point, seated on a horse, spreads over the world and dominates it."

Ingres's Glorification of the Emperor No image captures Napoleon's sense of himself better than the 1806 portrait by Jean-Auguste-Dominique Ingres (1780–1867) of *Napoleon on His Imperial Throne* (Fig. **26.20**). Ingres was David's student, a winner of the Rome prize, and a frequent exhibitor at the annual Salon of the French Academy of Fine Arts. He sought a pure form of classicism, characterized by clarity of line, a dedication to detail, and a formal emphasis on balance and symmetry.

In this commission from Napoleon, Ingres depicts him as a monarch who embodies the total power of his country. Ingres combines two well-known frontal images of the deities Jupiter, or Zeus, and God the Father with the imperial attributes of the historical emperors Charlemagne and Charles V of Spain. The Jupiter image was a lost sculpture known only in gemstone but attributed to Phidias, the master of the Greek Golden Age. The God the Father image was in Jan van Eyck's *Ghent Altarpiece* (see Figure 16.6), which Napoleon had taken from Ghent during his Prussian campaign and installed in the Louvre. Ingres establishes the emperor's identification with Charlemagne by the sword beneath his left forearm and the ivory hand of justice, both of which were believed to have originally belonged to Charlemagne. And he evokes the Habsburg Holy Roman Emperor Charles V of Spain through the scepter in Napoleon's right hand, thus symbolically uniting France and Austria for the first time since Charlemagne's reign in the early Middle Ages. Like David's portrait, *Napoleon Crossing the Saint-Bernard*, Ingres's painting is a conscious act of propaganda, cementing in the public mind the image of the emperor as nearly godlike in his power and dominion. The David and Ingres portraits underscore the fact that Napoleon understood quite well the ability of art to move and control the popular imagination.

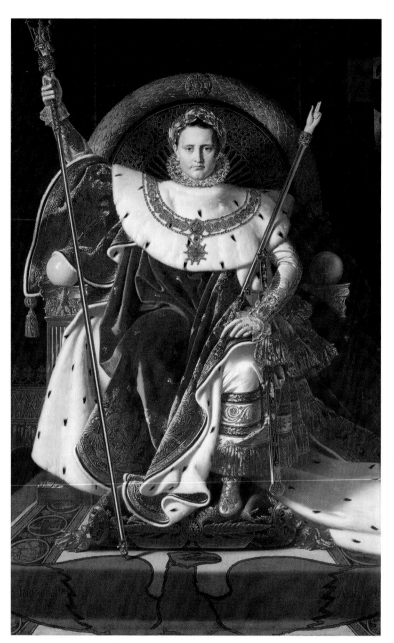

Fig. 26.20 Jean-Auguste-Dominique Ingres, *Napoleon on His Imperial Throne.* 1806. Oil on canvas, 102″ × 64″. Musée de l'Armée, Paris. The carpet at Napoleon's feet is an imperial eagle flanked by signs of the zodiac, including Scorpio, Libra, and Virgo, at the left, and Pisces and Taurus at the right, as if the emperor's fame were written in the stars.

Vignon's La Madeleine Napoleon reasoned that if he was now the new emperor, Paris should be the new Rome. The city already tended to be dominated by Neoclassical architecture, from the east facade of the Louvre to Sainte-Geneviève (see Fig. 32.1) rising above the Left Bank. Napoleon sought to extend the sense of order and reason these buildings suggested. He soon commissioned the construction of Roman arches of triumph and other classically inspired monuments to commemorate his victories and convey the political message of the glory of his rule. One of

LEARN MORE Gain insight from a primary source document from Jean-Auguste-Dominique Ingres at **www.myartslab.com**

Fig. 26.21 Pierre-Alexandre Vignon, La Madeleine, Paris. 1806–42.
Length, 350′, width 147′, height of podium 23′, height of columns 63′. The church of La Madeleine was built to culminate a north–south axis that began on the left bank of the Seine at the Chamber of Deputies (newly refurbished with a facade of Corinthian columns), crossing a new bridge northward into the Place de la Concorde.

the most impressive works was the redesign of a church that had been started under Louis XVI but that Napoleon wanted to see reinterpreted as a new Temple of the Glory of the Grand Army. This work, commissioned in 1806 from Pierre-Alexandre Vignon (1763–1828), was to have been identified by the following dedicatory inscription: "From the Emperor to the soldiers of the Great Army." It was another of the many Parisian churches, like Sainte-Geneviève, that were converted to secular temples during this epoch. Ironically, Napoleon reversed his decision to honor the army in 1813 after the unfortunate Battle of Leipzig and the loss of Spain. Although work continued on the building, its original name, the church of La Madeleine, was restored.

Not completed until after Napoleon's downfall, but nevertheless to Vignon's original design, La Madeleine is imperially Roman in scale and an extraordinary example of Neoclassical architecture (Fig. **26.21**). Eight 63-foot-high Corinthian columns dominate its portico, and 18 more rise to the same height on each side. Beneath the classical roofline of its exterior, Vignon created three shallow interior domes that admit light through oculi at their tops that are hidden by the roofline. They light a long nave without aisles that culminates in a semicircular apse roofed by a semidome. This interior evokes traditional Christian architecture, even as the exterior announces its classicism through the Roman temple features.

Canova and the Bonapartes Napoleon did not limit his propagandistic commissions to French artists and architects. In 1802 he had invited to Paris the highly reputed Italian sculptor Antonio Canova (1757–1822) to model a larger-than-life-size marble statue of him to celebrate his being named consul for life. Napoleon expected a portrait of himself in full military dress, but the artist believed that he should be depicted in the nude as the

modern embodiment of Mars, the Roman god of war (Fig. **26.22**). As it turned out, by the time Canova's sculpture arrived in Paris in 1811, Napoleon was embroiled in the military campaigns that would end his career, and he rejected the statue, understanding that as a nude its propagandistic uses were limited. For Napoleon understood quite well the role of Neoclassical art in the service of the state: In its order and majesty it projected, like the sculpture of Caesar Augustus at the Primaporta (see Fig. 6.13), his own dignity and power. To present himself to the public in the nude, however idealized, would be to subject himself to ridicule. Ironically, the sculpture would eventually be purchased by the British government as a gift—and sort of trophy—for the Duke of Wellington, who defeated Napoleon at the Battle of

Fig. 26.22 Antonio Canova, *Napoleon as Mars the Peacemaker.*
1802–06. Marble, height 10′8″. The Wellington Collection, Apsley House, London. Napoleon had argued with Canova about being portrayed in the nude and the sculptor had replied: "We, like the poets, have our own language. If a poet introduced into a tragedy, phrases and idioms used habitually by the lower classes in the public streets, he would be rightly reprimanded. . . . We sculptors cannot clothe our statues in modern costume without deserving a similar reproach."

Fig. 26.23 Antonio Canova, *Paolina Borghese as Venus.* 1808. Marble, life-size. Galleria Borghese, Rome. Canova's sculpture was originally mounted on a pivot so that it might be turned toward the window for viewing in natural light or adjusted at night to be illuminated in torchlight from within.

Waterloo on June 18, 1815. Wellington would place it in the stairwell of his house in London.

In 1808, by which time the consul had had himself crowned as emperor, Canova had less trouble convincing Napoleon's sister, Paolina Bonaparte Borghese [bor-GAY-zeh] (1780–1825), to allow him to depict her in the nude as well. Perhaps this was because she understood that her sexuality was the means by which she had attained her position as the wife of one of the richest men in all of Europe, Prince Camillo Borghese.

Canova was bent on showing that his art was equal if not superior to that of the ancients. Following the recommendations of Winckelmann, he searched for beauty in clear forms, harmonious lines, and all-around viewpoints. His portrait busts and sculptural groups ranged from delicately lyric to formal and symbolic. His sculpture of Paolina Borghese (Fig. **26.23**) is life-size, and its pedestal is a different-colored marble, replicating a chaise

(reclining chair). She holds an apple, the traditional symbol of Venus, and thus, like her brother, appropriates mythical status, the personification of a goddess, untouchable by mortal hands. In its elegant contours and astonishingly smooth representation of flesh (unequaled by any of Canova's many imitators), the work aspires to the noble simplicity and calm grandeur that Winckelmann found in ancient classical sculpture (see Fig. 5.20).

Paolina Borghese never intended this sculpture to be viewed by a public any wider than her immediate social circle, and then only at night, under the dramatic lighting of torchlight. Thus, the sculpture is a sort of dramatic set piece, unlike the statue of her brother, which had a political intent. Her nudity was understood to suggest a goddess of antiquity and thus be aristocratic, not demeaning. It was a form of *personal* propaganda that belied her beginnings as the daughter of a poor family of lesser nobles.

THE ISSUE OF SLAVERY

In America, the high-minded idealism reflected in the adoption of Neoclassicism in art and architecture was clouded, from the outset, by the issue of slavery. In the debates leading up to the revolution, slavery had been lumped into the debate over free trade. Americans had protested not only the tax on everyday goods shipped to the colonies from Britain, including glass, paint, lead, paper, and tea, but the English monarchy's refusal to allow the colonies to trade freely with other parts of the world, and that included trade in enslaved Africans.

The Atlantic slave trade followed an essentially triangular pattern (Map **26.3**). Europe exported goods to Africa, where they were traded for African slaves (see Chapter 18), who were then taken to the West Indies and traded for sugar, cotton, and tobacco; these goods were then shipped either back to Europe or north to New England for sale. Since the slaves provided essentially free labor for the plantation owners, these goods, when sold, resulted in enormous profits. Although a port like Boston might seem relatively free of the slave trade, Boston's prosperity and the prosperity of virtually every other port on the Atlantic depended on slavery as an institution. And the American taste for Neoclassical art, epitomized by Wedgwood's assertion that for "North America we cannot make anything too rich and costly," was in very large part made possible by the slave trade.

No nation had profited more from the slave trade than England. It had been late to get into the business, leaving it largely to the Portuguese until 1672. By then, the English government needed labor for its sugar plantations in the Caribbean and its tobacco plantations in Virginia. England chartered the Royal African Company, granting it a monopoly in the slave trade. From 1680 to 1686, the company traded approximately 5,000 slaves a year. In 1698, Parliament yielded to the demands of English merchants eager to share in the Royal African Company's profits and opened the slave trade to all. The trafficking of African slaves on English ships increased fourfold to an average of more than 20,000 a year, and by the start of the eighteenth century, England's was the largest slave trade in the world.

Throughout the eighteenth century, slaves continued to be sold in Britain, especially in Bristol and Liverpool, which the trade had turned into boom towns. In fact, it became fashionable among aristocratic British women to have a black child servant. (See the black child at the lower right-hand corner of the *The Countess's Levée* in Hogarth's *Marriage À la Mode* series, Fig. 24.5.)

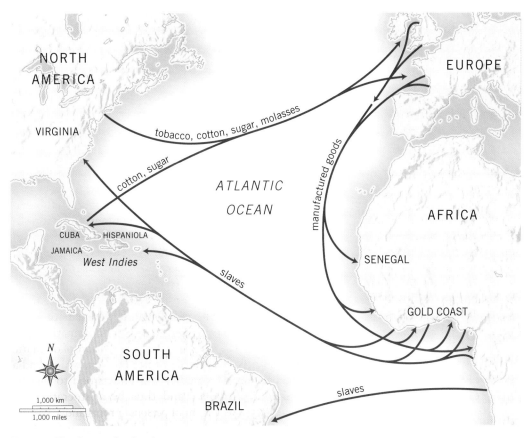

Map 26.3 The slave trade triangle.

Autobiographical and Fictional Accounts of Slavery

The conditions on board slave ships have been described by Olaudah Equiano [ay-kee-AH-noh], a native of Benin [ben-EEN], in West Africa, who was kidnapped and enslaved in 1756 at age 11 (Fig. **26.24**). Freed in 1766, he traveled widely, educated himself, and mastered the English language. In his autobiography, published in England in 1789 (see **Reading 26.5**, pages 871–873, for a fuller account of this passage), he describes the transatlantic journey (**Reading 26.5a**):

READING 26.5a

from Olaudah Equiano, *The Interesting Narrative of the Life of Olaudah Equiano, or Gustavus Vassa the African* (1789)

The stench of the hold while we were on the coast [of Africa] was so intolerably loathsome that it was dangerous to remain there for any time, and some of us had been permitted to stay on the deck for the fresh air, but now that the whole ship's cargo were confined together it became absolutely pestilential. The closeness of the place and the heat of the climate, added to the number in the ship, which was so crowded that each had scarcely room to turn himself, almost suffocated us. This produced copious perspirations, so that the air soon became unfit for respiration from a variety of loathsome smells, and brought on a sickness among the slaves, of which many died, thus falling victims to the improvident avarice, as I may call it, of their purchasers. This wretched situation was again aggravated by the galling of the chains, now become insupportable; and the filth of the necessary tubs, into which the children often fell and were almost suffocated. The shrieks of the women and the groans of the dying soon rendered the whole a scene of horror almost inconceivable.

Recent biographical discoveries cast doubt on Equiano's claim that he was born and raised in Africa and that he endured the Middle Passage (the name given to the slave ships' journey across the Atlantic Ocean) as he describes. Baptismal and naval records suggest, instead, that he was born around 1747 in South Carolina. Still, if Equiano did fabricate his early life, it appears that he did so based on the verbal accounts of his fellow slaves, for the story he tells, when compared to other sources, is highly accurate. Whatever the case, Equiano's book became a bestseller among the over 100 volumes on the subject of slavery published the same year, and it became essential reading for the ever-growing abolitionist movement in both England and the Americas.

The lot of the slaves, once they were delivered to their final destination, hardly improved. One of the most interesting accounts is *Narrative of a Five Years' Expedition against the Revolted Negroes of Surinam, in Guiana, on the Wild Coast of South America, from the Year 1772 to 1777*, written by John Gabriel Stedman (1747–1797) and illustrated by William Blake (1757–1827) (Figs. **26.25** and **26.26**). Blake was already an established engraver and one of England's leading poets. Stedman had been hired by the Dutch to suppress rebel slaves in Guiana, but once there, he was shocked to see the conditions the slaves were forced to endure. Their housing was deplorable, but worse, they were routinely whipped, beaten, and otherwise tortured for the nonperformance of impossible tasks, as a means of instilling a more general discipline. Female slaves endured sexual abuses that were coarse beyond belief. The planters maintained what amounted to harems on their estates and freely indulged their sexual appetites.

Even as Stedman moved on from Guiana to Surinam, Phillis Wheatley (ca. 1753–1784) became the first black American to publish a book. Wheatley had been kidnapped as a child in Senegal and raised in Boston by John Wheatley along with his own children, where she was also a maidservant to Wheatley's wife. Wheatley had begun writing poems when she was 13 and was regarded as a

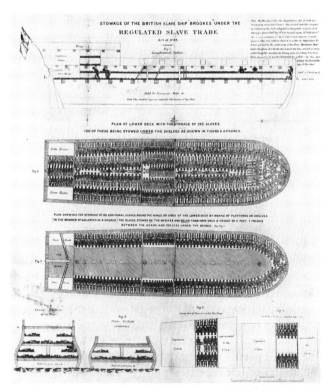

Fig. 26.24 *Stowage of the British Slave Ship "Brookes" Under the Regulated Slave Trade (Act of 1788).* 1788. Conditions on slave ships were appalling. Food was bad, space so cramped that movement was virtually impossible, and disease devastating.

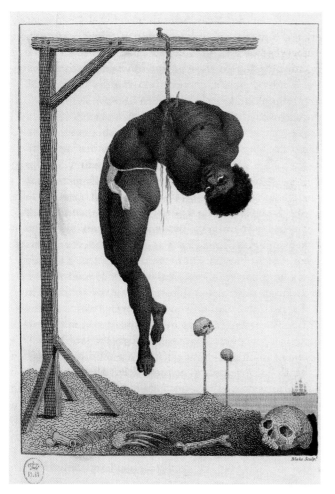

Fig. 26.25 William Blake, *Negro Hung Alive by the Ribs to a Gallows*, engraved illustration to John Gabriel Stedman's *Narrative of a Five Years' Expedition against the Revolted Slaves of Surinam . . .* 1796. Library of Congress, Catalog no. 1835. Private Collection, Archives Charmet/The Bridgeman Art Library. Blake executed the etchings for Stedman's volume after original drawings by Stedman himself. Stedman was impressed that the young man being tortured here stoically endured the punishment in total silence.

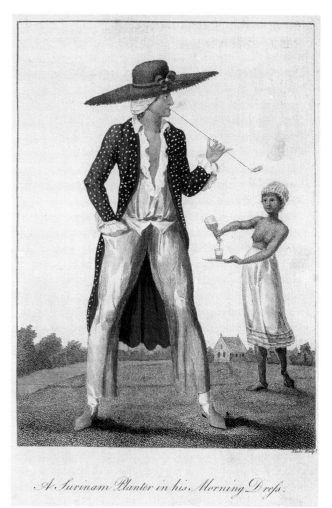

A Surinam Planter in his Morning Dress.

Fig. 26.26 William Blake, *A Surinam Planter in His Morning Dress*, engraved illustration to John Gabriel Stedman's *Narrative of a Five Years' Expedition against the Revolted Slaves of Surinam . . .* 1796. Library of Congress, Catalog no. 1835. Of the plantation owners, Stedman wrote: "Such absolute power . . . cannot help but be peculiarly delightful to a man who was, in all probability, in his own country, Europe, a nothing."

prodigy in Boston. When she went to England with the Wheatleys in 1773, she achieved great popularity, perhaps most of all because she seemed to have so thoroughly accepted and adopted the attitudes of her new culture. It was in England that she published her *Poems on Various Subjects: Religious and Moral* in 1773. Most of Phillis Wheatley's poems reflect her religious and classical New England upbringing and stress the theme of Christian salvation. She accepts her plight as divinely ordained, but in one of her poems she argues for equality with others and the ability of her race to attain the "refinement" of her European contemporaries. The poem, in fact, reflects what many in America and Britain, both pro-slavery and abolitionist, would hold up as the ideal aspiration of all African-Americans (**Reading 26.6**):

READING 26.6

Phillis Wheatley, "'Twas mercy brought me from my Pagan land" (1773)

'TWAS mercy brought me from my Pagan land,
Taught my benighted soul to understand
That there's a God, and there's a Saviour too:
Once I redemption neither sought nor knew.
Some view our sable race with scornful eye,
"Their color is a diabolic die [dye]."
Remember, Christians, Negros, black as Cain,
May be refin'd, and join th' angelic train.

Soon after Phillis Wheatley returned home from England, she was given her freedom. The beneficent treatment of Wheatley is, however, rare in the annals of American slavery, and more often than not, the Christianity of the kind she adopted and her acceptance of its values were seen by other slaves as hypocritical, even as a betrayal of her race. As Olaudah Equiano put it in his autobiography (see Reading 31.3): "O, ye nominal Christians! might not an African ask you—learned you this from your God, who says unto you, Do unto all men as you would men should do unto you?"

One of the earliest accounts of slavery is the short novel *Oroonoko* by Aphra Behn (1640–1689) published in 1688. As author of 20 plays for the stage, Behn was the first woman in the Western world to have made her living as a writer. *Oroonoko* tells the story of an African prince and the woman he loves, both of whom are sold separately into slavery and carried to Surinam, where Behn, a white woman, had lived for a time and where the British had begun importing slaves for the sugar cane plantations. In Surinam the two lovers are reunited, and Oroonoko, exerting his royal nature, organizes a slave revolt, for which he is punished by the deputy governor with public execution by dismemberment. Although Behn never criticizes slavery as an institution, she portrays her hero as a natural king and clearly superior to the whites around him (see **Reading 26.7** page 873).

Like Stedman, Behn is conflicted about her relationship to slavery. Although she was a lifelong militant royalist and opposed to democracy in favor of a strong king, she clearly identified as a woman with her hero's oppression by a sadistic deputy governor. But she was equally convinced of her own English culture's social superiority, even if some of her kind were capable of the Surinam deputy governor's act of atrocity.

The Economic Argument for Slavery and Revolution: Free Trade

In an odd conflict of interests and allegiances, slavery pitted abolitionist sentiments against freethinking economic theory. Free-trade economists, such as Adam Smith (1723–1790), would argue that people should be free to do whatever they might to enrich themselves. Thus Smith would claim that a **laissez-faire** [lay-say-FAIR], "let it happen as it will," economic policy was the best. "It is the maxim of every prudent master of a family," Smith wrote in *The Wealth of Nations*, published in 1776, "never to make at home what it will cost him more to make than to buy. . . . What is prudence in the conduct of every private family, can scarce be folly in that of a great kingdom. If a foreign country can supply us with a commodity cheaper than we ourselves can make it, better buy it of them." Labor, it could be argued, was just such a commodity and slavery its natural extension. At the same time, ironically, Smith was against the very tariffs and taxes that England had imposed on its colonies. He argued that free trade among nations, which the British had denied the colonies by asserting their own right to the accumulation of wealth over and above that of the colonists, should be the basis of economic policy.

Thus, in 1776, the arguments both for and against slavery as an institution seemed, to many people, to balance each other out. Economics and practicality favored the practice of slavery, while human sentiment and, above all, the idea of freedom, denied it. Although at the time he wrote the Declaration of Independence, Jefferson himself owned about 200 slaves and knew that other Southern delegates supported slavery as necessary for the continued growth of their agricultural economy, in his first draft he had forcefully repudiated the practice. Abigail Adams (1744–1818), who, like her husband John, knew and respected Jefferson, but unlike him owned no slaves, was equally adamant on the subject: "I wish most sincerely," she wrote her husband in 1774, as he was attending the First Continental Congress in Philadelphia, "that there was not a slave in the province. It always seemed a most iniquitous scheme to me—fight for ourselves what we are daily robbing and plundering from those who have as good a right to freedom as we have."

The Abolitionist Movement in Britain and America

Many Britons, looking from across the Atlantic at the American Revolution, shared Abigail Adams's sentiments. As long as the colonies tolerated slavery, their demand for their own liberty seemed hypocritical. The English poet Thomas Day (1748–1789) described the typical American as "signing resolutions of independence with one hand, and with the other brandishing a whip over his affrighted slaves."

Abolitionist opposition to slavery in both England and the American colonies began to gain strength in 1771

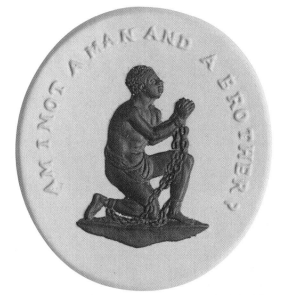

Fig. 26.27 William Hackwood, for Josiah Wedgwood, *"Am I Not a Man and a Brother?"* 1787. Black-and-white jasperware, $1^3/_8$" × $1^3/_8$". The Wedgwood Museum, Barlaston, Staffordshire, England. The image illustrated Erasmus Darwin's poem "The Botanic Garden," which celebrates not only the natural world, but also the rise of British manufacturing at the dawn of the Industrial Revolution. The poem nevertheless severely criticized British involvement in the slave trade, which it deemed highly "unnatural."

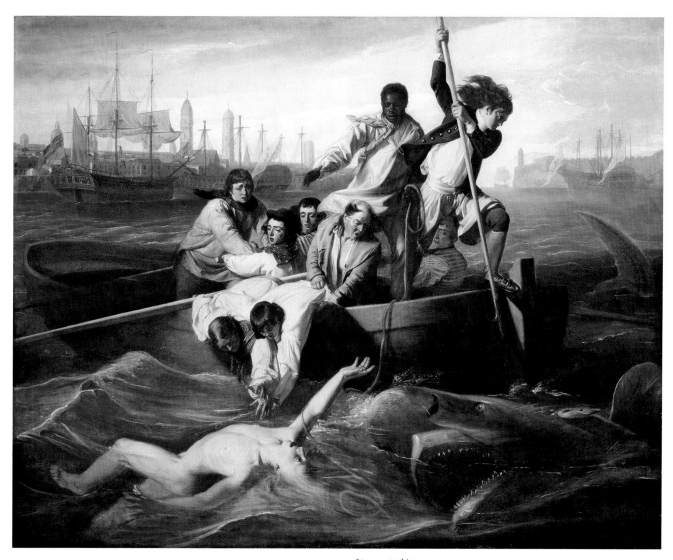

Fig. 26.28 John Singleton Copley, *Watson and the Shark*. 1778. Oil on canvas, 71 ³/₄″ × 90 ¹/₂″. Museum of Fine Arts, Boston. Ferdinand Lammot Belin Fund. Photograph © 2006 Board of Trustees, National Gallery. The shark-infested waters are perhaps a metaphor for slavery itself, especially since it was well known that some slave traders threw slaves overboard into shark-infested waters in order to collect insurance.

when Granville Sharp pled the case of an escaped American slave, James Somerset, before the Lord Chief Justice, Lord Mansfield. Somerset's American owner had recaptured him in England, but the Lord Chief Justice set Somerset free, ruling that the laws governing another country carried no weight in England. Leading the fight against slavery were the Quakers as well as the members of the Lunar Society (see Chapter 24). In 1787, Josiah Wedgwood made hundreds of ceramic cameos of a slave in chains, on bent knee, pleading, "Am I Not a Man and a Brother?" (Fig. 26.27). He distributed them widely, and the image quickly became the emblem for the abolitionist movement as a whole. In Philadelphia, Benjamin Franklin, president of the Philadelphia Abolitionist Society, received a set.

The sentiments of Wedgwood's cameo find expression even in paintings that seem to have no direct reference to slavery. *Watson and the Shark* by John Singleton Copley (1738–1815) is a case in point (Fig. 26.28). The painting

was commissioned by its subject, Brook Watson, a wealthy English merchant and Tory leader who was deeply opposed to slavery. As a young man, in 1749, Watson had lost his leg when a shark attacked him as he swam in Havana harbor. The ship he had been serving on had been involved with the triangular slave trade described earlier. It carried timber, dried fish, and other goods from Boston to Africa, where it had exchanged this merchandise for slaves, who were in turn traded in the West Indies for sugar and molasses, commodities then brought back to Boston. Even as Copley was at work on this painting, Watson was attacking the colonists in Parliament for the hypocrisy of their position. The black man who forms the focus of the composition serves an interesting purpose. Though the man's attitude seems ambiguous—as if not quite sure he should go so far as to save a white man—he holds the lifeline that has been thrown to Watson. Their relationship is thus affirmed, even as its complexities and tensions are openly acknowledged.

Fig. 26.29 **Thomas Coram (American, 1756–1811),** *View of Mulberry House and Street.* **ca. 1800.** Oil on paper. Gibbes Museum of Art/Carolina Art Association, 1968. 1968.18.01. The steep-pitched roofs of the slave quarters allowed rain to wash rapidly off the roof, a fact that in Africa helped prevent the thatched roofs from leaking.

The African Diaspora

All told, about 14 million Africans survived the Atlantic crossing, the largest forced scattering of a people in history and now known as the **African diaspora**. In some places, particularly in Brazil and the Caribbean, people from the same African homelands and speaking the same language were gathered together on plantations, where they were able to revive and continue cultural practices from their native lands. For instance, the Haitian religious practice known as Vodou combines recognizable elements from Yoruba, Kongo, and Dahomey. (The commonly used term *Voodoo* is considered offensive by practicing communities.) But in North America, slaveholders made a conscious effort to gather together only Africans of differing cultural and linguistic backgrounds, believing this would reduce the possibility of rebellion. Still, many forms of African culture survived. A late eighteenth-century painting of the Mulberry Plantation in South Carolina (Fig. **26.29**) depicts slave houses with steeply pitched roofs similar to the thatched roof houses of the same era found in West Africa. The roof comprises over half the height of the house, allowing warm air to rise in the interior and trapping cooler air beneath it—a distinct advantage in the hot climate of both Africa and the Carolinas.

The cultural form that most thoroughly survived the African diaspora was music. Sub-Saharan African cultures, despite their enormous size and diversity, all shared certain fundamental characteristics. Almost all of these cultures played drums, in an array of rhythms and tones that may involve several rhythms produced simultaneously or two or more interwoven melodies (see Chapter 23). In addition, almost all of these cultures played one form or another of **mbira** [em-BEER-ah], an instrument made of a small wooden box or gourd that acts as a resonator, attached to which is a row of thin metal strips that vibrate when plucked. Music performed on the drum or the mbira is largely improvisational, each performance involving a lengthy combination of repetition and gradual variation. Like drum music, mbira music displays the African fascination with complex rhythms and melodies [HEAR MORE at www.myartslab.com] (track **26.1**). In the mbira musical selection on the CD, two traditional songs of the Shona people of Zimbabwe, the widely popular *Chemutengure* and *Mudendero* (a children's song accompanying circle games), combine in a slow pattern of repetition and gradual variation. In this we can hear the patterns and movements that would, in the West, survive in American jazz.

The Romantics and Napoleon

On February 8, 1807, during a fierce blizzard near the town of Eylau, Russia's General Bennigsen, with an army of 74,500 men, engaged Napoleon Bonaparte and his much smaller army of less than 50,000 in battle. Napoleon struck first, knowing that he had reinforcements in the wings. But the blizzard hampered both sides. The Russians withdrew, and Bonaparte claimed victory. There were 23,000 Russian casualties who had died for their emperor, Alexander I, but the battlefield was also strewn with 22,000 dead and wounded French.

Five weeks after Napoleon's "victory," a competition was announced in France for a painting commemorating the great day. The director of French museums declared that it should depict "The moment . . . when, His Majesty visiting the battlefield at Eylau in order to distribute aid to the wounded, a young Lithuanian hussar, whose knee had been shot off, rose up and said to the Emperor, 'Caesar, you want me to live. . . . Well, let them cure me and I will serve you as faithfully as I did Alexander!'" Antoine Jean Gros [groh] (1771–1835) won the competition with the painting illustrated here (Fig. 26.30). The painting made an odd piece of official propaganda. The larger-than-life-size pile of bodies, frozen blue, at the bottom of the painting is so terrifying and so openly hostile to the idea of victory that it seems impossible Napoleon would have approved it. Yet he did, just as he would ignore the advice of his aides in the fall of 1812 not to push into Russia, where his army "took" the city of Moscow, even as the Russians burned it. Napoleon abandoned his troops to return to Paris. He had begun his march into Russia with over 1 million men. Only about 100,000 returned. Never before had the term "heroism" seemed more hollow.

The promise of Napoleon—his ability to impose classical values of order, control, and rationality upon a French society that had been wracked with revolution and turmoil—was thus undermined by a darker reality. The Romantics, whose fascination with the powers of individual intuition and creativity had led them to lionize Napoleon, would react to his failure and to the ensuing disorder that marked the first half of the nineteenth century. Artists, composers, and writers would express in their works a profound pessimism about the course of human events. The optimistic spirit we find in Wordsworth and Constable, Emerson and Thoreau, would be challenged, not merely by the sense of darkness and foreboding expressed by Coleridge and Melville, but by a pessimism that undermined the Romantics' faith in the powers of nature to heal and restore humanity's soul. ∎

Fig. 26.30 Antoine Jean Gros, *Napoleon at Eylau*. 1808. Oil on canvas 17'5 ¹/₂" × 26'3". Musée du Louvre, Paris. RMN Réunion des Musées Nationaux, France. Erich Lessing/Art Resource, New York.

What do the American and French Revolutions have in common? How do they differ?

The idea of human freedom was fundamental to the Enlightenment, finding two of its greatest expressions in the Declaration of Independence, ratified by the 13 colonies on July 4, 1776, and, in France, the Declaration of the Rights of Man and Citizen, passed by the National Assembly in August 1789. Jefferson's argument that the American colonies should be self-governing was preceded by British taxation of the colonies. In France, the national debt, and taxes associated with paying it, produced events leading to revolution. What do you think accounts for the fact that in America, revolution was followed with relative stability, while in France, chaos and terror followed?

How did women respond to the promise of revolution?

While the rights of "man" had been boldly asserted in both the American and French revolutions, the rights of women had been ignored. In France, Olympe de Gouges wrote a *Declaration of the Rights of Women*, for which she was sent to the guillotine. In England, Mary Wollstonecraft quickly followed with *A Vindication of the Rights of Woman*. For Wollstonecraft, how were women in eighteenth-century society equivalent to African slaves?

What is Neoclassicism?

The founders of the newly created United States modeled their republic on classical precedents and embraced Neoclassicism as an architectural style. What specific aspects of Neoclassical art and architecture attracted Thomas Jefferson to the Neoclassical style? Why did it become known in America as the "Federal style," and why did it seem so appropriate for governmental architecture? In France, Jacques-Louis David, the premier painter of the day, readily adopted the style in his painting *The Oath of the Horatii*, in which he champions heroism and personal sacrifice for the state. How do "gender politics" inform David's painting? How do they compare to David's treatment of similar issues in *The Lictors Returning to Brutus the Bodies of His Sons* and Angelica Kauffmann's treatment of gender in *Cornelia Pointing to Her Children as Her Treasures*?

What values shaped Napoleonic France?

As Napoleon took greater and greater control of French political life in the opening decade of the nineteenth century, he turned to antiquity, modeling his government particularly upon the military and political structures of the Roman Empire. He commissioned paintings of himself that served the propagandistic purpose of cementing his image as an invincible, nearly godlike leader. In what ways is David's *Napoleon Crossing the Saint-Bernard* a work of propaganda? How does Ingres's *Napoleon on His Imperial Throne* continue this propagandistic tradition? Convinced that Paris was the new Rome, Napoleon commissioned architectural monuments based on Roman precedents. He hired the Italian sculptor Antonio Canova to celebrate his being named consul for life. How did Canova's Neoclassicism impress Napoleon?

How did the issue of slavery undermine the idealism of the era?

Autobiographical and fictional accounts of slavery intensified abolitionist sentiments in both Europe and North America. Olaudah Equiano exposed the conditions on board slave ships in his *Travels*, and John Gabriel Stedman revealed the shocking treatment of slaves in Guiana. The black poet Phillis Wheatley accepted her plight as divinely ordained, while novelist and playwright Aphra Behn, in *Oroonoko*, the first English novel to show blacks in a sympathetic light, identified with her hero's oppression despite her own sense of racial superiority. By 1700, England had become the largest trafficker of slaves in the world, and its own economy depended heavily on the trade. In what ways does John Singleton Copley's painting *Watson and the Shark* reflect the issues raised by slavery? How did African slaves, despite their circumstances, adapt the cultures of their native lands to their American conditions?

PRACTICE MORE Get flashcards for images and terms and review chapter material with quizzes at **www.myartslab.com**

GLOSSARY

Adam style The term for the Neoclassical style in England, where it became closely associated with the work of the architect Robert Adam.

African diaspora The forced scattering of millions of Africans as a result of the Atlantic crossing.

coup d'état A violent overthrow of government.

estate One of three traditional groups that comprised the Estates General in France. The First Estate was the clergy; the Second Estate was the nobility; and the Third Estate was the rest of the population, composed of the bourgeoisie and the peasants.

Federal style The term for the Neoclassical style as it appeared in the United States.

Jacobin A member of a radical minority of France's National Assembly who favored the elimination of the monarchy and the institution of egalitarian democracy.

jasperware A type of stoneware produced by Josiah Wedgwood that was ornamented in Neoclassical style with a white relief on a colored ground.

laissez-faire Literally "let it happen as it will," this economic policy argues that people should be free to do whatever they might to enrich themselves.

mbira An instrument made of a small wooden box or gourd—to which is attached a row of thin metal strips that vibrate when plucked—that acts as a resonator.

republicanism Sympathy for a republican form of government, that is, a government having a chief of state who is not a monarch.

READINGS

READING 26.5

from *The Interesting Narrative of the Life of Olaudah Equiano* (1789)

The following passage concludes Chapter 2 of Equiano's autobiography, entitled "Kidnapping and Enslavement," and it describes Equiano's passage to the Americas. Born in Benin, Equiano reports that he was first kidnapped (by fellow Africans) at the age of 11 and sold repeatedly to a succession of West African tribal families until finally sold to slavers bound for the Americas. Recent research has brought his account into question, but he undoubtedly captures experiences shared by many. The majority of his narrative concerns his life in the Americas, first on a Virginia plantation, then in the service of a British naval officer (who helped educate him), and then as the slave of a Philadelphia merchant, who finally helped him purchase his freedom. By the time he published his autobiography, he was a permanent resident in England, working for the abolition of slavery.

The first object that saluted my eyes when I arrived on the coast was the sea, and a slave ship, which was then riding at anchor, and waiting for its cargo. These filled me with astonishment, that was soon converted into terror, which I am yet at a loss to describe, and much more the then feelings of my mind when I was carried on board. I was immediately handled and tossed up to see if I was sound, by some of the crew; and I was now persuaded that I had got into a world of bad spirits, and that they were going to kill me. Their complexions too, differing so much from ours, their long hair, and the language they spoke, which was very different from any I had ever heard, united to confirm me in this belief. Indeed such were the horrors of my views and fears at the moment, that if ten thousand worlds had been my own, I would have freely parted with them all to have exchanged my condition with the meanest slave in my own country. When I looked round the ship too, and saw a large furnace or copper boiling and a multitude of black people, of every description, chained together, every one of their countenances expressing dejection and sorrow, I no longer doubted of my fate; and, quite overpowered with horror and anguish, I fell motionless on the deck, and fainted. When I recovered a little, I found some black people about me, who I believed were some of those who brought me on board, and had been receiving their pay: they talked to me in order to cheer me, but all in vain. I asked them if we were not to be eaten by those white men with horrible looks, red faces, and long hair. They told me I was not: and one of the crew brought me a small portion of spirituous liquor in a wine glass; but, being afraid of him, I would not take it out of his hand. One of the blacks therefore took it from him and gave it to me, and I took a little down my palate, which, instead of reviving me, as they thought it would, threw me into the greatest consternation at the strange feeling it produced, having never tasted any such liquor before.

Soon after this the blacks who brought me on board went off, and left me abandoned to despair. I now saw myself deprived of all chance of returning to my native country, or even the least glimpse of gaining the shore, which I now considered as friendly; and I even wished for my former slavery, in preference to my present situation, which was filled with horrors of every kind, still heightened by my ignorance of what I was to undergo. I was not long suffered to indulge my grief. I was soon put down under the decks, and there I received such a salutation in my nostrils as I had never experienced in my life: so that, with the loathsomeness of the stench, and with my crying together, I became so sick and low that I was not able to eat, nor had I the least desire to taste any thing. I now wished for the last friend, death, to relieve me; but soon, to my grief, two of the white men offered me eatables; and, on my refusing to eat, one of them held me fast by the hands, and laid me across, I think, the windlass, and tied my feet, while the other flogged me severely. I had never experienced any thing of this kind before, and although, not being used to the water, I naturally feared that element the first time I saw it, yet nevertheless, could I have got over the nettings, I would have jumped over the side, but I could not; and besides the crew used to watch us very closely, who were not chained down to decks, lest we should leap into the water. I have seen some of these poor African prisoners most severely cut for attempting to do so, and hourly whipped for not eating. This indeed was often the case with myself. In a little time after, amongst the poor chained men, I found some of my own nation, which in a small degree gave ease to my mind. I inquired of these what was to be done with us. They gave me to understand we were to be carried to these white people's country to work for them. I was then a little revived, and thought if it were no worse than working, my situation was not so desperate. But still I feared I should be put to death, the white people looked and acted, as I thought, in so savage a manner; for I had never seen among any people such instances of brutal cruelty: and this is not only shewn towards us blacks, but also to some of the whites themselves. One white man in particular I saw, when we were permitted to be on deck, flogged so unmercifully with a large rope near the foremast, that he died in consequence of it; and they tossed him over the side as they would have done a brute. This made me fear these people the more; and I expected nothing less than to be treated in the same manner. I could not help expressing my fearful apprehensions to some of my countrymen; I asked them if these people had no country, but lived in this hollow place, the ship. They told me they did not, but came from a distant one. 'Then,' said I, 'how comes it, that in all our country we never heard of them?' They told me, because they lived so very far off. I then asked, where their women were: had they any like themselves. I was told they had. And why, said I 'do we not see them?' They answered, because they were left behind. I asked how the vessel could go. They told me they could not tell; but that there was cloth put upon the masts by the help of the ropes I saw, and then the vessel went on; and the white men had some spell or magic they put in the water, when they liked, in order to stop the vessel. I was exceedingly amazed at this account, and really thought they were spirits. I therefore wished much to be from amongst them, for I expected they would sacrifice me; but my wishes were in vain, for we were so quartered that it was impossible for any of us to make our escape.

While we stayed on the coast I was mostly on deck; and one day, to my great astonishment, I saw one of these vessels coming in with the sails up. As soon as the whites saw it, they gave a great shout, at which we were amazed; and the more so as the vessel appeared larger by approaching nearer. At last she came to an anchor in my sight, and when the anchor was let go, I and my countrymen who saw it, were lost in astonishment to observe the vessel stop, and were now convinced it was done by magic. Soon after this the other ship got her boats out, and they came on board of us, and the people of both ships seemed very glad to see each other. Several of the strangers also shook hands with us black people, and made motions with their hands, signifying, I suppose, we were to go to their country; but we did not understand them. At last, when the ship, in which we were, had got in all her cargo, they made ready with many fearful noises, and we were all put under deck, so that we could not see how they managed the vessel.

But this disappointment was the least of my grief. The stench of the hold, while we were on the coast, was so intolerably loathsome, that it was dangerous to remain there for any time, and some of us had been permitted to stay on the deck for the fresh air; but now that the whole ship's cargo were confined together, it became absolutely pestilential. The closeness of the place, and the heat of the climate, added to the number in the ship, being so crowded that each had scarcely room to turn himself, almost suffocated us. This produced copious perspirations, so that the air soon became unfit for respiration, from a variety of loathsome smells, and brought on a sickness among the slaves, of which many died, thus falling victims to the improvident avarice, as I may call it, of their purchasers. This deplorable situation was again aggravated by the galling of the chains, now become insupportable; and the filth of necessary tubs, into which the children often fell, and were almost suffocated. The shrieks of the women, and the groans of the dying, rendered it a scene of horror almost inconceivable. Happily, perhaps, for myself, I was soon reduced so low here that it was thought necessary to keep me almost continually on deck; and from my extreme youth, I was not put in fetters. In this situation I expected every hour to share the fate of my companions, some of whom were almost daily brought upon deck at the point of death, and I began to hope that death would soon put an end to my miseries. Often did I think many of the inhabitants of the deep much more happy than myself; I envied them the freedom they enjoyed, and as often wished I could change my condition for theirs. Every circumstance I met with served only to render my state more painful, and heighten my apprehensions and my opinion of the cruelty of the whites. One day they had taken a number of fishes; and when they had killed and satisfied themselves with as many as they thought fit, to our astonishment who were on the deck, rather than give any of them to us to eat, as we expected, they tossed the remaining fish into the sea again, although we begged and prayed for some as well as we could, but in vain; and some of my countrymen,

being pressed by hunger, took an opportunity, when they thought no one saw them, of trying to get a little privately; but were discovered, and the attempt procured for them some very severe floggings.

One day, when we had a smooth sea and moderate wind, two of my wearied countrymen, who were chained together (I was near them at the time), preferring death to such a life of misery, somehow made through the nettings and jumped into the sea: immediately another quite dejected fellow, who on account of his illness was suffered to be out of irons also followed their example; and I believe many more would very soon have done the same, if they had not been prevented by the ship's crew, who were instantly alarmed. Those of us who were the most active were in a moment put down under the deck; and there was such a noise and confusion amongst the people of the ship as I never heard before, to stop her and get

160

the boat out to go after the slaves. However, two of the wretches were drowned; but they got the other, and afterward flogged him unmercifully, for thus attempting to prefer death to slavery. In this manner we continued to undergo more hardships than I can now relate, hardships which are inseparable from this accursed trade. Many a time we were near suffocation from the want of fresh air, being deprived thereof for days together. This, and the stench of the necessary tubs, carried off many.

170

READING CRITICALLY

Several times in this passage Equiano refers to magic, yet he clearly understands that what he describes is not magical. What is he seeking to convey to the reader, and why?

READING 26.7

from Aphra Behn, *Oroonoko, or The Royal Slave* (1688)

Behn's Oroonoko *is a "history" written during the time when the novel was just beginning to be defined as a form, and when the word "history" could mean any story true or false. To a certain degree, Behn's history is probably true. She was in the new sugar colony of Surinam, where much of this narrative takes place, in 1664. Whether she witnessed a slave rebellion while there, let alone met anyone resembling the displaced African prince Oroonoko, is a matter of pure conjecture. We can, though, be certain of her idealization of the "primitive." The following passage, from early in the narrative, describes Oroonoko's many virtues, virtues that more "civilized" Christians often fall short of matching.*

I have often seen and convers'd with this great Man and been a Witness to many of his mighty Actions; and do assure my Reader, the most Illustrious Courts cou'd not have produc'd a braver Man, both for Greatness of Courage and Mind, a Judgment more solid, a Wit more quick, and a Conversation more sweet and diverting. He knew almost as much as if he had read much: He had heard of, and admir'd the *Romans*; he had heard of the late Civil Wars in *England*, and the deplorable Death of our great Monarch[1] and wou'd discourse of it with all the Sense, and Abhorrence of the Injustice imaginable. He had an extream good and graceful Mien, and all the Civility of a well-bred great Man. He had nothing of Barbarity in his Nature, but in all Points address'd himself, as if his Education had been in some *European* Court.

This great and just character of *Oroonoko* gave me an extream Curiosity to see him, especially when I knew he spoke *French* and *English,* and that I cou'd talk with him. But though I had heard so much of him, I was as greatly surpriz'd when I saw him, as if I had heard nothing of him; so beyond all Report I found him. He came into the Room, and addresse'd himself to me, and some other Women, with the best Grace in the World. He was pretty tall, but of a Shape the most exact that can be fancy'd: The most famous Statuary cou'd not form the Figure of a Man more admirably turn'd from Head to Foot. His Face was not of that brown, rusty Black which most of that Nation are, but a perfect Ebony, or polish'd Jett. His Eyes were the most awful that cou'd be seen, and very piercing; the White of 'em being like Snow as were his Teeth. His Nose was rising and *Roman*, instead of *African* and flat. His Mouth, the finest shap'd that cou'd be seen; far from those great turn'd

10

20

30

Lips, which are so natural to the rest of the *Negroes*. The whole Proportion and Air of his Face was so noble, and exactly form'd that bating[2] his Colour there cou'd be nothing in Nature more beautiful, agreeable and handsome. There was no one Grace wanting, that bears the Standard of true Beauty: His Hair came down to his Shoulders, by the Aids of Art; which was, by pulling it out with a Quill, and keeping it comb'd; of which he took particular Care. Nor did the Perfections of his Mind come short of those of his Person; for his Discourse was admirable upon almost any Subject; and who-ever had heard him speak, wou'd have been convinc'd of their Errors, that all fine Wit is confin'd to the *White* Men, especially to those of *Christendom;* and wou'd have confess'd that *Oroonoko* was as capable even of reigning well, and of governing as wisely, had as great a Soul, as politick Maxims, and was as sensible of Power as any Prince civiliz'd in the most refin'd Schools of Humanity and Learning, or the most Illustrious Courts.

40

This Prince, such as I have describ'd him, whose Soul and Body were so admirably adorn'd, was (while yet he was in the Court of his Grandfather) as I said, as capable of Love, as 'twas possible for a brave and gallant Man to be; and in saying that, I have nam'd the highest Degree of Love; for sure, great Souls are most capable of that Passion.

50

READING CRITICALLY

Behn presents Oroonoko as a royalist or at least as a man sympathetic to the English royalist cause. Why does she portray the African prince in this way?

[1]Charles I

[2]excepting

INDEX

PHOTO CREDITS

Chapter 21

PO Erich Lessing / Art Resource, NY; 21-1 © Tibor Bognar / Alamy; 21-2 © Eddie Gerald / Alamy; 21-4 Scala / Art Resource, NY; 21-5 Erich Lessing / Art Resource, NY; 21-6 Canali Photobank, Milan, Italy; 21-7 Scala / Art Resource, NY; 21-8 © Achim Bednorz, Koln; 21-9 Scala / Art Resource, NY; 21-10 Electra/Art Resource, NY; 21-12 Alinari / Art Resource, NY; 21-13 Canali Photobank, Milan, Italy; 21-14 Canali Photobank, Milan, Italy; 21-15 The Art Archive / Galleria degli Uffizi Florence / Alfredo Dagli Orti; 21-16 Elisabetta Sirani (Italian, 1638-1665), "Virgin and Child". 1663 Oil on canvas, 34 × 27 1/2 in. National Museum of Women in the Arts, Washington, D.C. Gift of Wallace and Wilhelmina Holladay. Conservation funds generously provided by the Southern California State Committee of the National Museum of Women in the Arts.; 21-17 Atemisia Gentileschi, "Judith and Maidservant with the Head of Holofernes". 1625. The Detroit Institute of Arts. Gift of Leslie H. Green. 52.253. Photo ©1984 Detroit Institute of Arts/The Bridgeman Art Library, NY; 21-18 Cameraphoto Arte, Venice / Art Resource, NY; 21-19 Music Room (fresco), Guarana, Jacopo (1720-1808)/Santa Maria dei Derelitti, Venice, Italy/The Bridgeman Art Library; 21-20 Bernini, Gian Lorenzo (1598-1680). First project for the Louvre, elevation for the main facade, Rec1folio4. Photo: Michele Bellot. Musee du Louvre/RMN Reunion des Musees Nationaux, France. SCALA/Art Resource, NY; 21-21 © Achim Bednorz, Koln; page 685 (top), Scala / Art Resource, NY; page 685 (bottom), The Art Archive / Gianni Dagli Orti; pages 686-687, Scala / Art Resource, NY.

Chapter 22

22-1 Jan Vermeer, "The Geographer". 1668-69. Oil on Canvas. 20 1/8″ × 18 1/4″. Stadelsches Kunstinstitut, Frankfurt. Courtesy Blauel/Gramm—ARTHOTEK, Peissenberg. The Granger Collection, New York; 22-2 Amsterdams Historisch Museum; 22-3 Special Collections, Wageningen UR Library; 22-4 Peter Janswz (1597-1665), "Interior of the Choir of St. Bavo's Church at Haarlem". 1660. Oil on Panel. Worcester Art Museum, Massachusetts, USA. The Bridgeman Art Library, NY; 22-5 Hals, Frans (1580-1666), "Portrait of Rene Descartes". Musee du Louvre/RMN Reunion des Musees Nationaux, France. Erich Lessing/Art Resource, NY; 22-6 Courtesy of the Bancroft Library, University of California, Berkeley; 22-7 HIP / Art Resource, NY; 22-8 HIP / Art Resource, NY; 22-9 Johannes Goedaert, "Flowers in a Wan-li Vase with Blue-Tit". c. 1660. Medium. Photo: Charles Roelofsz/RKD Images. Bob P. Haboldt & Co., Inc. Art Gallery, N.Y.; 22-10 The Royal Cabinet of Paintings / Mauritshuis; 22-11 Jan Steen, "The Dancing Couple". 1663. Oil on Canvas, 1.025 × 1.425 cm (40 3/8″ × 56 1/8″); framed: 1.314 × 1.718 (51 3/4″ × 67 5/8″). Widener Collection. Photograph © 2007 Board of Trustees, National Gallery of Art, Washington, D.C.; 22-12 Leyster, Judith (c.1600-1660), "The Proposition (or The Rejected Offer)". 1631. Oil on panel, 309 × 242 mm. Mauritshuis, The Hague, The Netherlands. SCALA/Art Resource, NY; 22-13 Vermeer (van Delft), Jan (1632-1675), "Young Woman with a Pearl Necklace". Ca. 1662-1665. Oil on canvas, 55 × 45 cm. Post-restoration. Inv.: 912 B. Photo: Joerg P. Anders. Gemaeldegalerie, Staatliche Museen zu Berlin, Berlin, Germany. Bildarchiv Preussischer Kulturbesitz/Art Resource, NY; 22-14 Alinari / Art Resource, NY; 22-15 Frans Hals Museum, Harlem; 22-16 Rembrandt van Rijn, "Captain Frans Banning Cocq Mustering His Company (The Night Watch)". 1642. Oil on Canvas. 11′11″ × 14′4″ (3.63 × 4.37 m). Rijksmuseum, Amsterdam; 22-17 Giraudon / The Bridgeman Art Library, NY; 22-18 Rembrandt Harmensz van Rijn (1606-1669), "The Slaughtered Ox". 1655. Musee du Louvre/RMN Reunion des Musees Nationaux, France. Erich Lessing/Art Resource, NY; 22-19 Rembrandt Harmensz. van Rijn (1606-1669) Dutch, "Self-Portrait". 1658. Oil on Canvas (lined) 52 5/8″ × 40 7/8″ (133.7 × 103.8 cm). Signed and dated on the arm of the chair at right: Rembrandt/f.1658.Purchased in 1906. Acc #″06.1.97. The Frick Collection, NY; 22-20 The Royal Collection © 2006, Her Majesty Queen Elizabeth II; 22-21 Rijksmuseum; 22-22 Rembrandt Harmensz van Rijn (1606-1669), "Descent from the Cross". 1634. Alte Pinakothek, Munich, Germany. SCALA/Art Resource, NY; 22-23 Rubens, Peter Paul (1577-1640), "Descent from the Cross". Center panel from triptych. Cathedral, Antwerp, Belgium. SCALA/Art Resource, NY; page 721, Rembrandt van Rijn, "The Anatomy Lesson of Dr. Nicolaas Tulp". 1632. Oil on Canvas. 5′3 3/4″ × 7′ 1 1/4″ (169.5 × 216.5 cm). Royal Cabinet of Paintings Maurithsuis Foundation, The Hague, Netherlands.

Chapter 23

23-1 Rigaud, Hyacinthe (1659-1743). "Louis XIV, king of France (1638-1715)". 1701. Oil on Canvas. 277 × 194 cm. Musee du Louvre/RMN Reunion des Musees Nationaux, France. Herve Lewandowski/Art Resource, NY; 23-2 Mickael David/Robert Harding; 23-3 Artedia/Leemage.com; 23-4 © The Art Gallery Collection / Alamy; 23-5 © nobleIMAGES / Alamy; 23-6 Rubens, Peter Paul (1577-1640). "The Disembarkation of Marie de' Medici at the Port of Marseilles on November 3, 1600". Oil on Canvas. 394 × 395 cm. Musee du Louvre/RMN Reunion des Musees Nationaux, France. Erich Lessing/Art Resource, NY; 23-7 Rubens, Peter Paul (1577-1640), "La Kermesse". Musee du Louvre/RMN Reunion des Musees Nationaux, France. Erich Lessing/Art Resource, NY; 23-8 Poussin, Nicolas (1594-1665), "The Shepherds of Arcadia (Et in Arcadia Ego)". Oil on canvas. 85 × 121 cm. INV7300. Photo: René-Gabriel Ojéda. Musee du Louvre/RMN Reunion des Musees Nationaux, France. Art Resource, NY; 23-9 King Louis XIV of France in the costume of the Sun King in the ballet 'La Nuit', 1653 (b/w photo), French School, (17th century)/Bibliotheque Nationale, Paris, France, /The Bridgeman Art Library; 23-10 Interior of the Comedie Francaise Theatre in 1791, after an original watercolour (colour litho), French School, (19th century) / Bibliotheque Nationale, Paris, France, Archives Charmet / The Bridgeman Art Library; 23-11 Anthony van Dyck. "Portrait of Charles I Hunting". c. 1653. Oil on Canvas. 8′11″ × 6′11″ (2.7 × 2.1 m). Inv 1236. Musee du Louvre/RMN Reunion des Musees Nationaux, France. SCALA/Art Resource, NY; 23-12 Purchased with assistance from the Art Fund and the Pilgrim Trust 1974; 23-13 RICHARD MATHER (1596-1669). American Congregational cleric. Woodcut, c1670, attributed to John Foster (1648-1681): the earliest portrait engraving known to have been made in America. Credit: The Granger Collection; 23-14 John Closterman. Daniel Parke II, 1706. Virginia Historical Society (1985.35); 23-15 John Freake, c.1671-74 (oil on canvas) (see 183406 for pair), American School, (17th century)/Worcester Art Museum, Massachusetts, USA /The Bridgeman Art Library; 23-16 Mrs Elizabeth Freake and Baby Mary, c.1671-74 (oil on canvas) (see 183405 for pair), American School, (17th century)/Worcester Art Museum, Massachusetts, USA/The Bridgeman Art Library; 23-17 Velazquez, Diego Rodriguez (1599-1660), "Triumph of Bacchus (Los Borrachos)". 1628. Oil on canvas, 165 × 225 cm. Location: Museo del Prado, Madrid, Spain. SCALA/Art Resource, NY; 23-18 © Rodrigo Balaguer/LATINPHOTO.org; 23-19 Luis Nino (Bolivian), "Our Lady of the Victory of Malaga. 1740. Gift of John C. Freyer for the Frank Barrows Freyer Collection. Denver Art Museum, CO; 23-20 Paul Franklin © Dorling Kindersley, Courtesy of the Catedral Metropolitana; 23-21 © Michael Freeman / CORBIS All Rights Reserved; 23-22 © A. T. Willett / Alamy; 23-23 Laguna Pueblo, New Mexico, United States. San Jose Mission church, interior with historically significant retablo. PR © Julien McRoberts / DanitaDelimont.com; 23-24 Testelin, Henri (1616-95), "Jean-Baptiste Colbert (1619-1683) Presenting the Members of the Royal Academy of Science to Louis XIV (1638-1715)". c.1667. Oil on Canvas. Chateau de Versailles, France, Lauros. Giraudon/The Bridgeman Art Library; page 738, © The Gallery Collection/Corbis; page 748, The Art Archive / Galleria degli Uffizi Florence / Alfredo Dagli Orti; page 751, Derechos reservados © Museo Nacional Del Prado–Madrid.

Chapter 24

24-1 Goodwood Trustees/The Goodwood Estate Company Limited; 24-2 ©Topham / The Image Works; 24-3 HIP / Art Resource, NY; 24-4 Hogarth, William (1697-1764). "Gin Lane". Published in London, 1751. Engraving. British Museum, London, Great Britain. © British Museum/Art Resource, NY; 24-5 © Erich Lessing/National Gallery, London / Art Resource, NY; 24-6 © National Gallery, London/Art Resource, NY; 24-7 Image by courtesy of the Wedgwood Museum Trust Limited, Barlaston, Staffordshire, England.; 24-8 © Adams Picture Library t/a apl / Alamy; 24-9 Special Collections and University Archives, Rutgers University Libraries; 24-10 National Portrait Gallery, London; 24-11 By permission of The British Library; 24-12 © James L. Amos/CORBIS All Rights Reserved; 24-13 Bis Pole. Mid 20th century. New Guinea, Irian Jaya, Faretsj River, Omadesep village, Asmat people. Wood, paint, fiber, H. 216 in (548.6 cm). The Michael C. Rockefeller Memorial Collection, Bequest of Nelson A. Rockefeller, 1979 (1979.206.1611). Image copyright © The Metropolitan Museum of Art / Art Resource, NY; 24-14 E. Brandl/Courtesy of AIATSIS Pictorial Collection; 24-15 © The Trustees of the British Museum; 24-16 Wisconsin Historical Society, Image ID: 23966; 24-17 Johann Zoffany, "Dido Elizabeth Belle Lindsay and Lady Elizabeth Murray". Oil on Canvas. 35 1/2″ × 28 1/.4″. From the Collection of the Earl of Mansfield, Scone Palace, Scotland; page 791, Image courtesy of John Vernor-Miles, Executor for A.F. Kersting.

Chapter 25

25-1 Boffrand, Germain (1667-1754), "Salon de la Princesse de Soubise (Salon ovale)". Photo: Bulloz. Hotel de Soubise, Paris, France. Reunion des Musees Nationaux/Art Resource, NY; 25-2 Charles Joseph (1700-77), "Psyche and Cupid".

Ceiling panel from the Salon de la Princesse, Natoire. Hotel de Soubise, Paris, France. Peter Willi/The Bridgeman Art Library; **25-3** Erich Lessing / Art Resource, NY; **25-4** Erich Lessing / Art Resource, NY; **25-5** Boucher, Francois (1703-70), "Madame de Pompadour". Alte Pinakothek, Munich, Germany. The Bridgeman Art Library; **25-6** Wallace Collection, Lodon/AKG-Images; **25-7** Erich Lessing/Art Resource, NY; **25-8** © Achim Bednorz, Koln; **25-9** Stiftung Preussische Schlosser und Garten Berlin-Brandenburg/Bildarchiv; **25-10** Stiftung Preussische Schlosser und Garten Berlin-Brandenburg/Bildarchiv; **25-11** Nick Meers/The National Trust Photo Library; **25-12** Claude Lorrain (Claude Gellee) (1600-82), "The Rest on the Flight into Egypt". Oil on Canvas. Hermitage, St. Petersburg, Russia. The Bridgeman Art Library; **25-13** A Plan of the Gardens of the Most Noble Marquis of Buckingham at Stowe, from the Visitor's Guide Book, published in 1797. Lithograph. English School, (18th century). Private Collection. The Bridgeman Art Library; **25-14** Hervé Lewandowski/Musee du Louvre/RMN Reunion des Musees Nationaux, France. SCALA/Art Resource, NY; **25-15** © Mary Evans Picture Library/The Image Works; **25-16** D. Arnaudet. Chateaux de Malmaison et Bois-Preau, Rueil-Malmaison, France. RMN Reunion des Musees Nationaux/Art Resource, NY; **25-17** SCALA/Art Resource, NY; **25-18** From Jay D. Zorn and June August, Listening to Music, 5th edition, © 2007 Pearson Education, Inc.; **25-19** From Jay D. Zorn and June August, Listening to Music, 5th edition, © 2007 Pearson Education, Inc.; **25-20** From Jay D. Zorn and June August, Listening to Music, 5th edition, © 2007 Pearson Education, Inc.; **25-21** From Jeremy Yudkin, "Understanding Music", 5/e © 2008, Pearson Education; **25-22** Scala / Art Resource, NY; **25-23** Jean-Etienne Liotard, "Still Life: Tea Set". The J. Paul Getty Museum, Los Angeles; **25-24** V & A Images/Victoria and Albert Museum/Art Resource, NY; **25-25** Francois Boucher, "Le Chinois Galant". Oil on Canvas. 41″ × 57″. The David Collection, inv.B275. Photo: Pernille Klemp; **25-26** Jean Denis Attiret, "The Presentation of Uigur Captives". From Battle Scenes of the Quelling of Rebellions in the Western Regions, with Imperial Poems. c. 1765-1774; poem dated 1760. Etching, mounted in album form, 16 leaves plus two additional leaves of inscriptions; 51 × 87 cm. © The Cleveland Museum of Art, John L. Severanc Fund. 1998.103.14; **25-27** V & A Images/Victoria and Albert Museum; **25-28** Color print from woodblock. 1734. 42 3/4″ × 22″ (108 × 56 cm). Ohsha'joh Museum of Art, Hiroshima, Japan; **25-29** Wang Hui, "A Thousand Peaks and Myriad Ravines". Qing Dynasty. 1693. Hanging Scroll. Ink on Paper. 8′2 1/2″ × 3′ 4 1/2″ (2.54 × 1.03 m). Collection of The Palace Museum, Beijing; **25-30** Yu the Great Taming the Waters. Qing Dynasty. Jade Carving 7′ 1/4″ × 3′ 1 3/4″. Collection of The Palace Museum, Beijing; **25-31** Elisabeth-Louise Vigee, "Marie Antoinette en Chimise". 1973. Oil on Canvas. 33 1/2″ × 28 1/4″. Hessische Hausstiftung (Hessian House Foundation) Museum Schloss Fasanerie; **23-32** SCALA/Art Resource, NY; pages 804-805, Erich Lessing / Art Resource, NY; page 805 (bottom), Scala / Art Resource, NY; page 807, © 1996 Harry N. Abrams, Inc.; page 818, Scala / Art Resource, NY.

Chapter 26

26-1 The Bloody Massacre on 5th March 1770, 1770 (coloured engraving), Revere, Paul (1735-1818). © Massachusetts Historical Society, Boston, MA, USA. The Bridgeman Art Library; **26-2** Yale University Art Gallery/Art Resource, NY; **26-3** Gérard Blot. Location: Chateaux de Versailles et de Trianon, Versailles, France. RMN Reunion des Musees Nationaux/Art Resource, NY; **26-4** Giraudon / Art Resource, NY; **26-5** Musee National du Chateau de Versailles. Art Resource/Reunion des Musees Nationaux; **26-6** Cussac/Musees Royaux des Beaux-Arts de Belgique; **26-7** © eye35.com / Alamy; **26-8** Robert Adam (1728-92), "Line Interior of the Marble Hall" (photo). Kedleston Hall, Derbyshire, UK, John Bethell. The Bridgeman Art Library; **26-9** Ceramics-Pottery. English, Wedgwood. 18th century, ca. 1780-1800. Flower pot, vase, and box w/cover. Metropolitan Museum of Art, Rogers Fund, 1909, (09.194.7-9). Art Resource, NY; **26-10** Courtesy of the Library of Congress; **26-11** C. Lautman/C. Lautman/Monticello/Thomas Jefferson Foundation, Inc.; **26-12** Courtesy of The Maryland Historical Society; **26-13** Archivo Iconografico, SA/Corbis; **26-14** Courtesy of the Library of Congress; **26-15** Sir Joshua Reynolds, "Benjamin Henry Latrobe, Tobacco Leaf Capital for the United States Capitol, Washington, D.C." c. 1815. Courtesy of the Architect of the Capitol, Washington, D.C.; **26-16** Courtesy of The Library of Virginia; **26-17** Musee du Louvre, Paris. RMN Reunion des Musees Nationaux/Art Resource, NY; **26-18** Angelica Kauffmann (born Swiss, 1741-1807), "Cornelia Pointing to her Children as her Treasures," ca. 1785. Oil on canvas, 40 in. H × 50 in. W (101.6 × 127.0 cm). Signed on base of column at right: Angelica Kauffmann pinxt. Virginia Museum of Fine Arts, Richmond. The Adolph D. and Wilkins C. Williams Fund. Photo: Ann Hutchison. © Virginia Museum of Fine Arts. 75.22/50669.2; **26-19** Musee National du Chateau de la Malmaison, Rueil-Malmaison. RMN Reunion des Musees Nationaux/Art Resource, NY; **26-20** © Erich Lessing/Art Resource, NY; **26-21** © Lebrecht Music and Arts Photo Library / Alamy; **26-22** © V&A Images / Alamy; **26-23** Scala/Ministero per i Beni e le Attività culturali / Art Resource, NY; **26-24** Snark / Art Resource, NY; **26-25** A Negro hung alive by the Ribs to a Gallows, from 'Narrative of a Five Years' Expedition against the Revolted Negroes of Surinam, in Guiana, on the Wild Coast of South America, from the year 1772, to 1777'. engraved by William Blake (1757-1827), published, Stedman, John Gabriel (1744-97) (after)/Private Collection, Archives Charmet/The Bridgeman Art Library; **26-26** This item is reproduced by permission of The Huntington Library, San Marino, California; **26-27** Image by courtesy of the Wedgwood Museum Trustees, Barlaston, Staffordshire, (England); **26-28** John Singleton Copley (American, 1738-1815), "Watson and the Shark". 1778. Oil on Canvas. 1.821 × 2.297 (71 3/4 × 90 1/2); Framed: 2.413 × 2.642 × .101 (95 × 104 × 4). Ferdinand Lammot Belin Fund. Photograph © 2006 Board of Trustees, National Gallery of Art, Washington, D.C.; **26-29** Thomas Coram (American, 1756-1811), "View of Mulberry House and Street". ca.1800. Oil on Paper. Gibbes Museum of Art/Carolina Art Association, 1968. 1968.18.01; **26-30** Musee du Louvre/RMN Reunion des Musees Nationaux, France. Erich Lessing/Art Resource, NY; page 848 (left) Araldo de Luca Archives/Index Ricerca Iconografica; page 848 (right) Pedicini/Index Ricerca Iconografica; page 852, John Decopoulos; page 856, G. Blot/C. Jean. Musee du Louvre/RMN Reunion des Musees Nationaux, France. Art Resource, NY; page 857, G. Blot/C. Jean. Musee du Louvre/RMN Reunion des Musees Nationaux, France. Art Resource, NY.

TEXT CREDITS

Chapter 21

Reading 21.1, page 680: Teresa of Avila, "Visions" from THE COMPLETE WORKS OF SAINT TERESA OF JESUS, Vol 1. trans. and ed. by E. Allison Peers. New York: Sheed and Ward, 1946. Reprinted by permission of Rowman & Littlefield Publishers, Inc. **Reading 21.2a,** page 684: Ignatius Loyola, from THE SPIRITUAL EXERCISES OF ST. IGNATIUS: A NEW TRANSLATION by Louis J. Puhl (Newman Press 1953, 1951; Loyola Press 1968).

Chapter 23

Reading 23.1a, page 741: Molière, excerpts from TARTUFFE by Moliere. English translation copyright © 1963, 1962, 1961 and renewed 1991, 1990 and 1989 by Richard Wilbur, reprinted by permission of Harcourt, Inc. **Reading 23.4,** page 754: Sor Juana Inés de la Cruz, "To Her Self-Portrait" trans. by Willis Barnstone, first published in SIX MASTERS OF THE SPANISH SONNET: ESSAYS AND TRANSLATIONS by Willis Barnstone. Copyright © 1993 by the Board of Trustees, Southern Illinois University. **Reading 23.1,** pages 761-763: Molière, excerpts from TARTUFFE by Moliere. English translation copyright © 1963, 1962, 1961 and renewed 1991, 1990 and 1989 by Richard Wilbur, reprinted by permission of Harcourt, Inc.

Chapter 24

Reading 24.5a, page 772: John Milton, from PARADISE LOST: A NORTON CRITICAL EDITION 2/e by John Milton, ed. by Scott Elledge. Copyright © 1993, 1975 by W.W. Norton & Company, Inc. Used by permission of W.W. Norton & Company Inc. **Reading 24.5b,** page 772: John Milton, from PARADISE LOST: A NORTON CRITICAL EDITION 2/e by John Milton, ed. by Scott Elledge. Copyright © 1993, 1975 by W.W. Norton & Company, Inc. Used by permission of W.W. Norton & Company Inc. **Reading 24.5,** page 796-797: John Milton, from PARADISE LOST: A NORTON CRITICAL EDITION 2/e by John Milton, ed. by Scott Elledge. Copyright © 1993, 1975 by W.W. Norton & Company, Inc. Used by permission of W.W. Norton & Company Inc.

Chapter 25

Reading 25.3, page 815: Jean-Jacques Rousseau, from THE SOCIAL CONTRACT AND DISCOURSES by Jean-Jacques Rousseau, translation by G.D.H. Cole revised by J.H. Brumfitt and John C. Hall. Originally published by J.M. Dent in 1973. Reprinted by permission of Everyman's Library, an imprint of Alfred A. Knopf (UK). **Reading 25.5,** pages 834-835: Voltaire, From CANDIDE by Voltaire, translation by Tobias Smollett edited by William F. Fleming. Originally published by J.M. Dent in 1937. Reprinted by permission of Everyman's Library, an imprint of Alfred A. Knopf (UK).

Chapter 26

Reading 26.3, page 846: Olympe de Gouges, from "Declaration of the Rights of Woman and the Female Citizen" by Olympe de Gouges, from WOMEN IN REVOLUTIONARY PARIS, 1789-1795: SELECTED DOCUMENTS, translators Darline Gay Levy, Harriet Branson Applewhite, and Mary Durham Johnson. Urbana, Ill.: University of Illinois Press, 1979.